Gothic Art in Ireland, 1169–1550

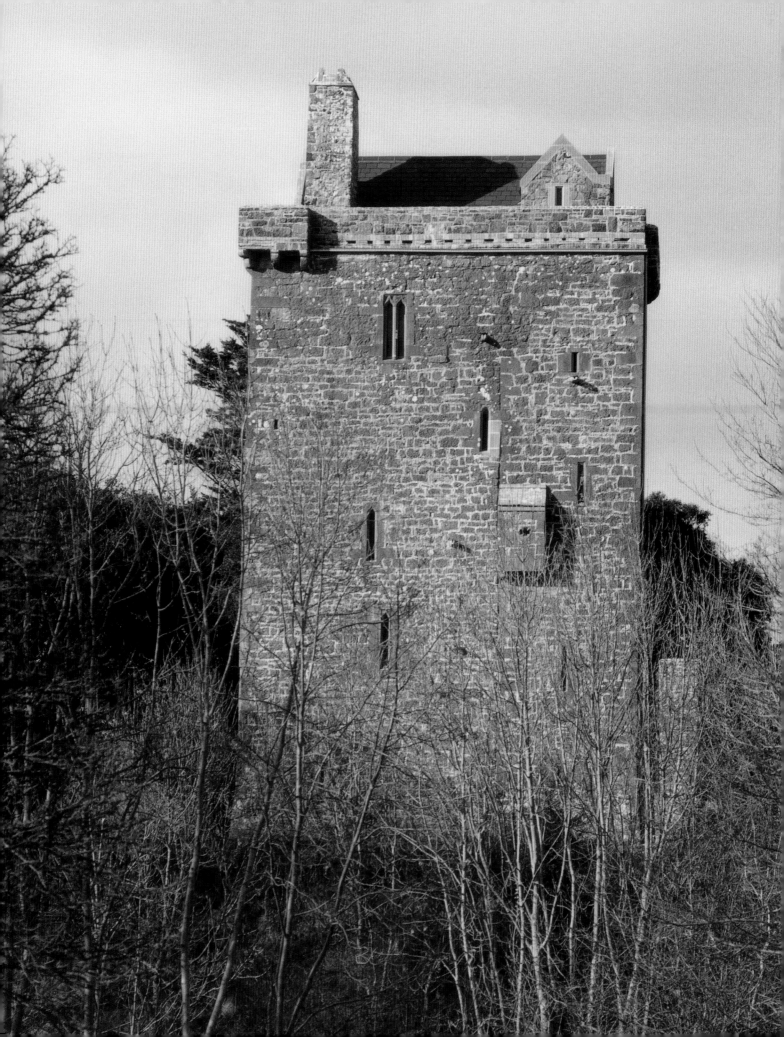

Gothic Art in Ireland, 1169–1550

Enduring Vitality

Colum Hourihane

Published for:
The Paul Mellon Centre for Studies in British Art
by:
Yale University Press
New Haven and London

For my mother, who selflessly gave of herself and encouraged her four sons to see the value and joy of learning

Published with the assistance of The Publications Committee, Department of Art and Archaeology, Princeton University.

Designed by Elizabeth McWilliams

Printed in China

A catalogue record for this book is available from The British Library

FRONTISPIECE: Ardamullivan Castle, Co. Galway, sixteenth century.

PAGE vi: Detail from the hood moulding of the piscina, Holycross Abbey, Co. Tipperary, mid-fifteenth century.

Library of Congress Cataloging-in-Publication Data

Hourihane, Colum, 1955–
 Gothic art in Ireland, 1169–1550 : enduring vitality / Colum
Hourihane.
 p. cm.
Includes bibliographical references and index.
 ISBN 0-300-09435-3
 1. Art, Irish. 2. Art, Gothic--Ireland. 3. Architecture, Gothic--Ireland. I. Title.
 N6784 .H68 2003
 709'.415'0902–dc21

2002151140

. . . and that lends to Gothic art its enduring vitality, this art being, one might fancy, especially the art of those whose minds have been troubled with the malady of reverie.

Oscar Wilde, *The Picture of Dorian Gray* (Chapter 2, 127)

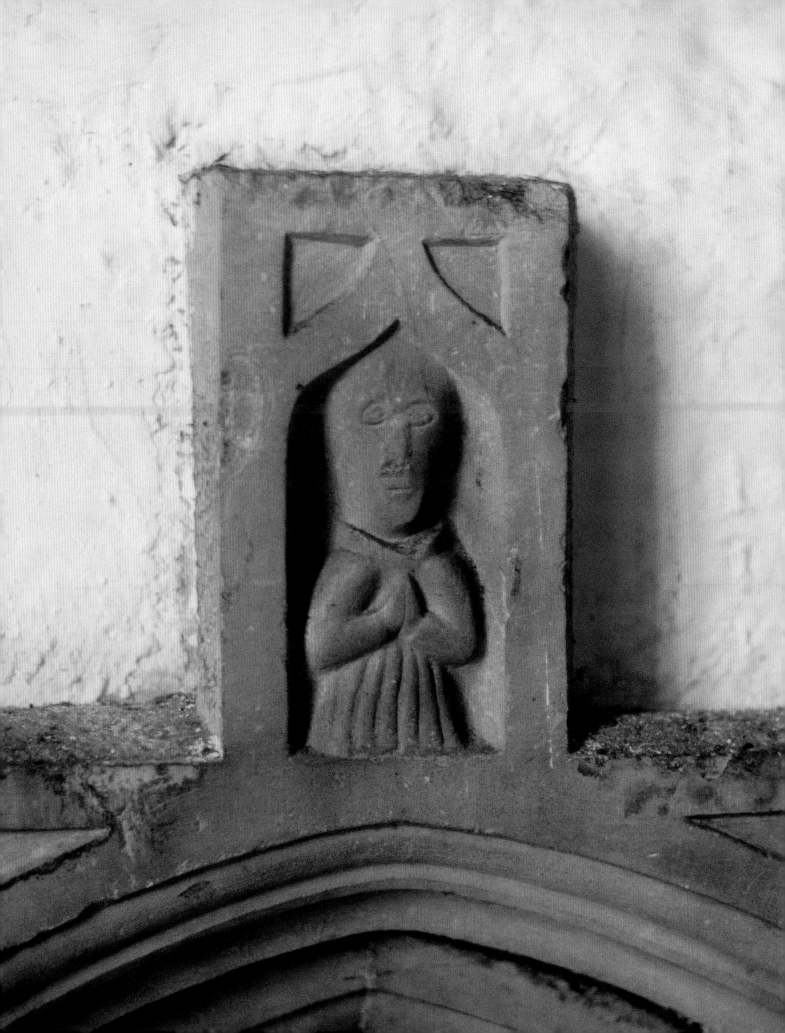

Contents

Acknowledgements

My formal training as an art historian first started at the Courtauld Institute of Art under the stewardship of George Zarnecki and it was he who initially made me aware, with his infectious enthusiasm, of the wealth of Gothic art in Ireland that had never been studied. Before this, however, my interests in the arts of the later medieval period in Ireland had been awakened while a student at University College Cork. The late Michael J. O Kelly and Elizabeth Twohig of the Department of Archaeology, as well as Roger Stalley of Trinity College, Dublin, encouraged and helped me in countless ways in these early years. It is with pleasure that I wish to acknowledge their guidance and support, which has remained constant throughout my career. The idea of writing a book on Gothic Irish art has been with me for several years and this present volume is but a start at looking at this enormous subject. Nevertheless, it could not have been accomplished without the assistance of many colleagues. These include Terry Barry, Cormac Bourke, David Brooker, Mary Cahill, Marian Campbell, Peter Harbison, Michael Holland, Martin Kauffmann, Heather King, Sue McNab, Nessa O Connor, Edwin Rae, Helen Roe, Etienne Rynne.

The illustrations for this book have come from a variety of sources and a debt has to be acknowledged to the many suppliers and providers, including Duchas, the Heritage Service. Tony Roche was always willing to assist in tracing an elusive image. The staff of the Conway Library at the Courtauld Institute also provided photographic assistance and suggestions, as did numerous other archives. John Blazejewski of the Index of Christian Art,

Princeton University, always gave that little bit extra to ensure the best possible result and my thanks are given to him for that effort. The staff of the many libraries, archives and museums I visited in preparing this book gave generously of their time and knowledge and in particular I would like to express my thanks to the staff of the Marquand Library, Princeton University, for their consideration and help. My thanks go to the staff of the National Museum, Dublin, the British Museum, the Royal Irish Academy and Trinity College, Dublin, who assisted in countless ways. Raighnall Ó Floinn, in particular, encouraged and helped in the study of the metalwork remains and Paul Mullarkey gave generously of his knowledge on the shrines. Much of my research was generously supported by a grant from the Spears Fund, Department of Art and Archaeology, Princeton University. The book was also generously supported by the Publications Committee, Department of Art and Archaeology, Princeton University. The Index of Christian Art and its staff proved to be the most valuable resource for my studies. The wealth of material in the files, built up over the last eighty-five years, has never ceased to amaze me. It has enabled me to look at Irish art in the broader framework of Europe and my thanks go to all who have assisted there.

A generous acknowledgement also has to go to Gillian Malpass, Yale University Press, who has brought her extensive knowledge and experience to the editing of this book; to Celia Jones for helping to guide this book from typescript to finished publication; and to Elizabeth McWilliams for all her help in structuring and designing

the final book. Working with this production team has been an experience and a pleasure.

My last acknowledgement must go to my family, and in particular my brothers Desmond, Kevin and James, who assisted in so many ways. Their encouragement and help can never be repayed but it is hoped that the publication of this work will act as an acknowledgement that their assistance was not in vain.

Preface

Other than in the area of architecture, Gothic is a word that has not been easily applied to late medieval Irish art. But exist it does, and has done so since it first reached Ireland's shores through the twin efforts of the Church reform movement and the Anglo-Normans in the late twelfth century. These two cataclysmic forces were to change the face of Ireland forever and create an infrastructure that still persists. These innovations brought the country into closer unity with mainland Europe and created links to England and Europe which have never been fully severed and for which, in such fields as art history, they have never been forgiven.

The political, social and racial composition of the country, with its twin *nationes* of Anglo-Norman conqueror and displaced Gael, was determined by the conflicting forces of Church and state for nearly three hundred years. This complexity is reflected in the art of the period, where the Insular and international styles, and combinations of the two vary over time and space. This was a style that was culturally alien, not only in the medieval period, and is one that has been little appreciated right up to the twenty-first century. Gothic Irish has always been considered to be the art of the outsider and, consequently, has not won a place in the native heart. Gothic Irish art is rarely pure and never simple. It has the complexity of a style that was introduced through conquest; culturally associated with Church and state, it merged, over time, with local idioms to reinvent itself into yet another indigenous variant. It is a style with multiple facets, and these, for a variety of reasons, have never received due attention. Discarded by scholars as representing a debased variant of either the Insular or the

international, Gothic Irish art has elements which are still culturally associated with a foreign power. And yet it contains untold treasures, many of which can compare favourably with the better known glories of Gothic art. It is a style which reflects the rapidly changing cultural and political dynamism of the late medieval period in Ireland and offers a unique historical insight into that period.

To cover the art of this entire period in one book would be well nigh impossible. While the seven chapters that make up this publication attempt as broad a coverage as possible of period, style and medium, they are largely iconographical essays and attempt to contextualize the subjects, not only in relation to the rest of Ireland, but also within the broader European framework. No study could cover all the media represented in medieval Ireland and in this present work much of the research deals with the neglected fields of architectural sculpture and metalwork. Every attempt is made, however, to relate these studies to the other media. These subjects, as well as the general characteristics of the style in Ireland are described against a briefly sketched historical background in the first chapter. The twin styles of Insular and international are outlined and some of the minutiae, which are examined in more detail in the succeeding chapters, are introduced.

The second chapter looks at the historiography of Gothic art in Ireland and attempts objectively to evaluate its relative neglect in relation to cultural associations. As such it provides a framework for the succeeding chapters and in many ways it attempts to justify its study as an art form. This is followed by the first ever

examination of the architectural sculpture at one of the most important cathedrals in Ireland, at Cashel, Co. Tipperary. It was a building which was started in the same year as the Anglo-Norman invasion of Ireland and, therefore provides a fitting start to the succeeding studies. Previously neglected, and providing an unrivalled model for sculptural motifs in thirteenth-century Ireland, this building must have been at the centre of artistic expression for the south of Ireland throughout the entire thirteenth century. Its influence can be seen throughout the country and this study provides the first comprehensive catalogue of its architectural sculpture. The tensions of location, patronage and administration are discussed in relation to date, and provide a revised framework for the construction of this building.

The Gothic portal is one of the most significant locations for sculptural embellishment anywhere, and Ireland is no exception. Although simpler in design, and iconography, than its international parallels, the Irish response to this feature is studied in the fourth chapter. The proposal is made that it too was a significant focus in the typical Irish monastery and that it was used for a variety of reasons, ranging from the commemorative to the didactic. The fifth chapter looks at a typical iconographical motif from the second phase of Gothic Irish art and discusses it in relation to a variety of media. The pelican was one of the most popular motifs in fifteenth-century Ireland and introduces – one of the most significant influences for this period – the bestiary. It was to provide medieval Ireland with one of its most important and widely used model books and was used in a distinctive way in a variety of media. This chapter cuts across the racial and religious boundaries to look at the same motif from both an English and Gaelic perspective.

It is only within the last twenty or thirty years that Gothic Irish metalwork has been studied and much remains to be researched. The sixth chapter examines the most significant corpus of metalwork objects from this period, which was the book shrine. In the past the book shrine was seen as a distinctly Irish invention, but recent studies have examined a number of international parallels. Nevertheless, its use in Ireland is unrivalled and it forms a fitting introduction to the art of metalwork for this period. The late medieval iconography of these shrines is examined, for the first time as a corpus, and whereas they were previously seen as iconographically insignificant and randomly decorated, this study will show that the subject matter was consciously selected and significantly displayed. These objects, like so many other areas of Gothic Irish art, are without cultural or racial boundaries and provide a background to the theme of the final chapter, which looks at the influence of the Gaelic Revival in Irish art of the late fourteenth to early fifteenth century.

These seven chapters are an introduction to the undiscovered field of Gothic Irish art and attempt to refute the negative reputation that it has unjustly gained over the centuries. Despite the numerous treasures that have disappeared over the centuries, the many monasteries and castles that still dominate the Irish landscape bear witness to the power and position that this style once had in Irish culture and which will hopefully be better understood with future research.

CHAPTER ONE

Gothic Art in Ireland

The origins of the Anglo-Norman conquest of Ireland in 1169 lie in the attempts made by Dermot MacMurrough, King of Leinster, to regain his wife Dervorgilla from his arch rival Tiernán O'Rourke, King of Breifne. The help which Dermot eventually received from the Anglo-Norman Richard FitzGilbert de Clare, Earl of Pembroke (Strongbow), on the beaches of Bannow Bay in May that year lead to the Norman invasion of Ireland and the cultural annexation of the country to England and Europe for the next seven hundred years. That episode has been seen as marking the end of Ireland's independence, it has also, with a certain justification, been claimed to be the single most dramatic event in the history of the country. Another, less dramatic but equally significant episode in Ireland's history was the introduction of church reform from Europe at the end of the twelfth century. The establishment of Cistercian and Benedictine foundations brought the new organizational structure and architectural styles gaining currency elsewhere.

These two events were to introduce into Ireland the Gothic style, which has been seen as ending the native spirit and creative powers of Irish art. Neither the Anglo-Norman invasion, however, nor church reform should be seen as solely responsible for introducing the new style into the country; it was a gradual process, and it would seem from the changes in architecture that the earliest manifestations of Gothic appear well after the arrival of the incoming forces, sometime at the start of the thirteenth century.

The term 'Gothic' has been ambiguously used: it can refer either to the period from the late twelfth to the sixteenth century or, alternatively, to the style of art and architecture produced within that period. Even though a series of basic and sometimes simplistic underlying principles and characteristics have been employed to define this style, the subject is far more complicated, given the huge area of coverage and the established cultures which interacted with the style. Gothic has been described as a genus with many species[1] – the result of constant interaction between different cultures and changing times. Such interaction has meant that this style, from its birth in the Ile-de-France, has had to adapt to survive, and nowhere is this process more evident than in late medieval Ireland, its most westerly European expression.

More than any other nation, the Irish have always adapted whatever style was introduced into the country – whether the art of the Vikings in the tenth century or the Romanesque style of the twelfth – fusing external ideas and concepts with the native to produce a uniquely expressive idiom. The Irish character appears to have had an intellectual and emotional need to create, rather than simply to accept, and this has produced some of the qualities that have characterized its rich artistic heritage.

Even within Ireland Gothic art has multiple personalities, ranging from the international to the Insular – and including a combination of the two. The international style is exemplified by alabasters, ivories, tiles and other smaller objects, some of which may have been imported, but all of which are similar to items found elsewhere in Europe (pls 1 and 2). Included in this division is the fine collection of fifteenth-century vestments from Christchurch cathedral, Waterford, which although known to have been used in medieval Ireland, was

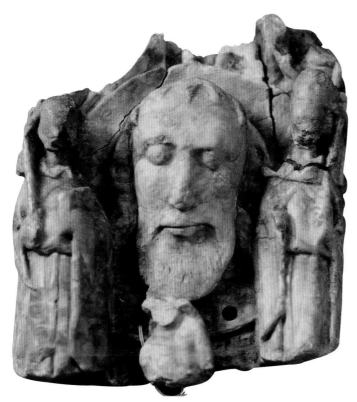

Plate 1 A fifteenth-century alabaster carving of the *Caput Johannes* possibly made in Nottingham, but imported into Ireland in the medieval period. It is typical of the trade in art objects that went on from the arrival of the Anglo-Normans in 1169 to the end of the fifteenth century. Alabasters provided a source of inspiration for stone sculpture throughout Ireland, especially in the fifteenth century. National Museum, Dublin.

Plate 2 Small portable objects such as this bronze pax were easily transported to Ireland from as far away as France and Italy and provided a model for Irish artists, especially in the thirteenth century. Length 9.7 cm, width 6.8 cm. National Museum, Dublin.

possibly made in either Italy or the Low Countries (pl. 3). The collection of Limoges enamels, on the other hand, does not have any medieval history in Ireland, although such objects must have been in wide circulation The Insular in Gothic art is exemplified by a shrine such as the Miosach (see pl. 150), with its unique iconography and design, or the mural paintings at Clare Island, Co. Mayo, with their extensive repertoire of animal and human motifs that defy understanding as a cohesive entity. The international and the Insular are merged in a work such as the altar cross from Donagh, where an international cross form is fused with a figure of Christ that is unparalleled outside Ireland (see, pl. 187). All of these three styles, controlled by social and political needs, are found unevenly in Ireland especially in the later period. In late medieval Ireland Gothic art was linked to two civilizations – the Anglo-Norman and the Gael – but merged between the two was the dominant presence of the Church, with which it was also inextricably linked.

For a variety of reasons – political, social, religious and cultural – this style of art and architecture, found in Ireland for nearly three hundred years, appeared during one of the most complicated periods in Irish history. Through a series of unfortunate and untimely coincidences, Gothic Irish art became inextricably linked to a political situation that was to identify and shape its character until the end of the Middle Ages, and has influenced our appreciation of the style right up to the present. Gothic art in Ireland was a political art; it was shaped and developed by the power of the Church and that of the state on either side of the political divide between the Anglo-Norman and the Gael.

Historical Background

Although the new monastic orders from continental Europe were responsible for changing the traditional

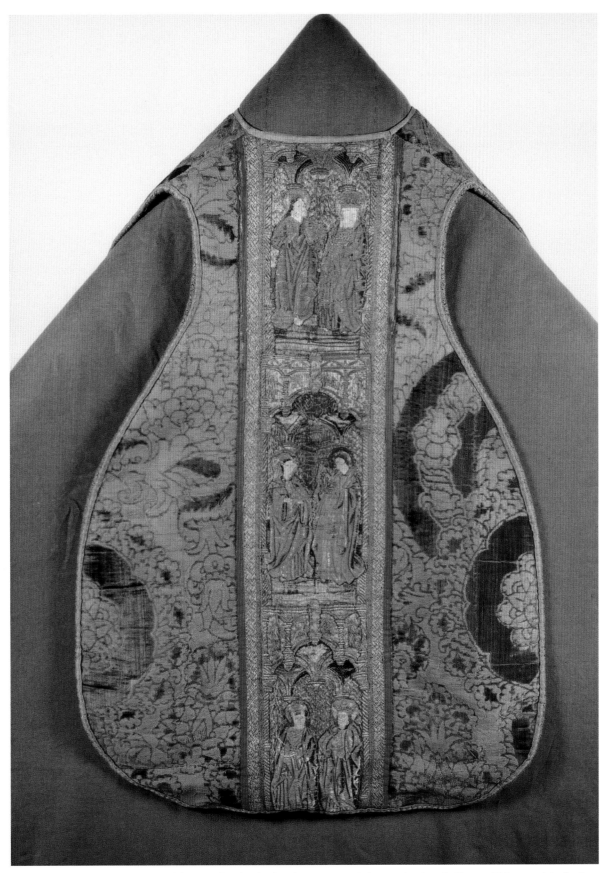

Plate 3 Vestments have not survived from medieval Ireland and are comparatively rare elsewhere in Europe. This set, originally from Christchurch cathedral, Waterford, was possibly imported into this thriving port in the mid-fifteenth century. Used for High Mass, it is of Italian or more likely Flemish origin. National Museum, Dublin.

design of the Celtic monastery into the more ordered structures developed by the Cistercians and Benedictines, their style was not yet Gothic. The large-scale introduction of Gothic was the result of the arrival of the Anglo-Normans in 1169, and it was not until the end of the twelfth century that elements of the new style began to appear, principally in architecture. This paved the way for its full-scale adoption in the first decades of the thirteenth century, which was, in turn, aided by the increased spread of the monastic orders.

In the thirty years after the invasion there was relatively little Anglo-Norman building and what does survive from this period tends to be more Romanesque than Gothic.[2] On the basis of what survives, architecture must have been the first public and large-scale manifestation of the style in Ireland, but it was probably not the earliest.[3]

The medieval period in Ireland was one of dynamic change. Although the rest of Europe was also repeatedly at war during this period, the situation in Ireland was more pronounced, given the size of the country, the fact that it had never before had to contend with alien occupation and the half-hearted nature of the Anglo-Norman conquest. Nevertheless, the whole country was not torn by warfare for the entire medieval period: there were long intervening and localized periods of peace. Ireland was conquered by the Anglo-Normans whose strong and influential links to England set them at odds with the Gaelic chieftains, who fought to reclaim both their lands and rights. The effects of this struggle, which resulted in temporary victories on each side across the island, are the reason for the complexity of the late medieval world in Ireland. The slow blending of the two cultures into what was to become yet a third element further complicates the situation.

The style of art associated with each of these powers or cultures and its influence on that of the others adds to the complexity. During the thirteenth century there were important advances in architecture – new castles, friaries, abbeys and cathedrals were constructed – while metalwork and the other arts were, on the evidence of what survives, either entirely absent or else poorly represented. The stylistic influences in architecture were far from constant, but the single most important was that of neighbouring England, which dominated Irish styles until the beginning of the fourteenth century, but became less significant thereafter. The second phase of Gothic art in Ireland is marked by a pronounced change in style. From the middle of the fourteenth century English influence

wained and the more indigenous spirit makes its presence felt. This combination of styles varied in the different media. The most constant medium for both periods is in the field of manuscripts, which have a stronger and less disjointed history than either metalwork or sculpture.[4]

The historian Francis Xavier Martin has stated that the tragedy of the Norman invasion was not the conquest of Ireland but the half conquest.[5] The Anglo-Normans never conquered all of the country and they were never there in sufficient numbers to enforce domination in the areas they had conquered. While the history of the country from the twelfth to the sixteenth century is one of considerable economic and social development – new towns were built and trade increased – this was overshadowed by intermittent fighting over land, kingship and ownership between the Anglo-Normans and the Gaelic chieftains throughout the period. This scene was further complicated by the fluctuating interest of the English Crown, and its intermittent interventions were subject to the demands of domestic policies and relations with mainland Europe. Towards the end of the thirteenth century the initial drive of the Anglo-Normans had slowed, and by the beginning of the next century there had been a considerable degree of assimilation between the Gaelic and the Anglo-Norman parties in areas such as marriage, language and literature.

A series of parliamentary enactments attempted to prevent integration by proscribing the Irish language, laws and customs, but these failed, although the Irish viewed the assimilated Anglo-Normans as a middle or third nation, neither fully English nor fully Irish.[6] By 1400 the Anglo-Norman and essentially English influence was restricted to the Pale, which surrounded Dublin. This period of Irish history, during which the Gaelic chiefs regained much of their power, is generally referred to as the Gaelic Revival. This revival was not simply manifest in the return of land or kingship to the Gael (in military terms, the Irish warrior now outnumbered his Anglo-Norman counterpart), but also in such areas as language, at least some of the third nation had now become so assimilated into Irish culture that they spoke the Irish language in preference to their own and older forms of poetry, scholarship and learning were revived (see chapter 7). If the start of the Middle Ages is marked by a period of drastic change, then the end, which is usually defined as the mid-sixteenth century, is characterized by equally dramatic events, such as the Tudor conquest and the Reformation. Although historians may

see these events as dramatic and dynamic it is clear that the cultural and stylistic results of such events were more gradual. Artistic output in the latter part of the fifteenth and at the start of the sixteenth century declined, and the stylization and repetition that are the hallmark of these late works indicate the end of artistic originality. It is clear that at this time the energies of the native chieftans went into consolidating control over their newly acquired land and the development of infrastructures to support daily life; art did not have a significant role to play. Very few monasteries were founded during this period and little restoration was undertaken on existing structures.

The Arts

Francis Grose in his *Antiquities of Ireland*, written in the late eighteenth century, was the first to recognize that in all probability the earliest surviving Anglo-Norman works in Ireland were made by English artists. This fact has been repeated in more recent scholarship[7] and has generally prompted the division of the medieval period into two. The art of the early period, from the invasion to the middle of the fourteenth century, is characterized by a close affinity with the contemporary English style. Indeed the buildings and works of art were probably made by artists and craftsmen from England. The early fourteenth century is seen as a watershed, after which the influence of the English, as a result of a series of economic and social upheavals, was on the decline and the fortunes of the Irish were on the incline, with a return to power and the control of previously conquered territories. The later period, from the middle of the fourteenth century onwards, was far more complex; the Gothic style was used by Anglo-Norman and Gaelic throughout the country, but with a freedom that, in some instances, places such works on the margins of what is generally accepted as belonging to this style. At the same time an indigenous use of the Gothic is merged with an older tradition, in a native revival of the arts that developed from the second half of the fourteenth century.

While modern understanding of events in Ireland from the thirteenth to the fifteenth century is coloured by our inability to grasp the complex social and political situation of the time, the arts are equally difficult to understand, especially in the early phase – where little or nothing is known of the identities of artists and patrons,

how the works were viewed or their role in society. This is in contrast to both the pre-invasion period and the fifteenth century, where far more is known about the patrons and artists. Identity was unimportant in the creative process of early Gothic Irish art and there are no inscriptions on any works of this period. The anonymity of the thirteenth century is indicative of the subjugation of the creative spirit and self to the power of the Church, and, in the case of Ireland, this is also complicated by the power of the invaders. What survives from the thirteenth century, such as sculptors' or masons' names, for example, is derived largely from administrative records. While, for example, the same sculptors can be traced working in the Tipperary and Kilkenny areas in the thirteenth century, nothing is known of their cultural background or training. The nearest we can come to identifying the makers of these works in the thirteenth century is to try and understand the personalities and working practices underlying the hundreds of masons' marks that are found on a building such as Cashel cathedral and to see the profound change in these simple signatures in the fifteenth century (see chapter 7).[8] The identities of these sculptors, masons and *imagours* in the thirteenth century is predominantly one of subservient humility – their marks are lightly incised and are usually composed of simple geometric designs placed in inconspicuous positions.

Because of the folk-art quality of a number of the better-known works, especially those of the later period, such as the sacristy wall in Kilcooly Abbey, Co. Tipperary (see pl. 116), the individuals responsible have been labelled with the slightly derogatory terms 'craftsmen' and 'artisans', and are very rarely described as artists. The simplicity of some of these works has been seen as reflecting a lack of professionalism, an assumption that is contradicted by what we know of the guild structure of medieval Ireland.[9] None of these anonymous Irish artists stands out from the others and neither is there any work that could, with any justification, be called a real masterpiece. Unlike the early Christian period – which produced such works as the Book of Kells, the Ardagh Chalice and the Tara Brooch – the Gothic period in Ireland is not an age of masterpieces. Nevertheless, there are some works, such as the owl in the nave at Holycross Abbey, Co. Tipperary, or the Ballylongford Cross, that are of outstanding beauty. There are no elaborate iconographic programmes in thirteenth-century Ireland such as those at Chartres, none of the classical beauty of Rheims or the simplicity of Wells – instead, the sculp-

tural output is distinguished by consistency that is missing from the more adventurous art of the fifteenth century. Gothic art in all its forms and guises, including architecture, sculpture (in wood, stone and alabaster), metalwork (both functional and decorative), manuscripts, frescoes, tiles, vestments and ivories, has survived from medieval Ireland in significant quantity. There is a relative uniformity and unity in these media in both execution and subject: as an examination of a simple motif, such as the pelican, shows (see chapter 5). Even though the arts are well represented from medieval Ireland there is a certain unevenness of output in the various media – a picture which is dependent on what survives. From the outset, architectural sculpture predominates throughout the entire span of nearly three hundred years but it is really in the fifteenth century that this medium flourished, as indeed did the other arts.

The comparative absence of art other than sculpture in the thirteenth century is understandable. Art in thirteenth- and early fourteenth-century Ireland is dominated by the decorative, the representational and the functional. Dog-tooth, nail-head and foliate motifs abound in sculpture. The motifs used are iconographically similar to those of England in the same period. Stone sculpture survives in considerable numbers, reflecting not only its durability, but also its widespread use in this period. The changes in both Church and society required an art that conveyed permanence and stability, whether in the body of a church or the interior of a castle. While there are very few surviving large carvings in Ireland from either this or the later period, that life-size figures did exist is suggested by the series of wooden figures which survive from the later period. The human head is the most common sculptural motif in both the earlier and later periods, whether in the form of a label stop, on a capital or embedded in walling. The majority of these heads, which must represent those from the upper levels of society, wear elaborate headdress, usually horned in the fifteenth century, and sometimes they have jewellery around their necks. These very representations are identical to those that were held up as symbols of evil and sin in a fifteenth-century Irish poem from the primatial register of John Swayne, Archbishop of Armagh (1418–39):

> Fleshly lust and fastings and furs of
> Divers kinds of beasts the devil of hell
> First invented. Whole garments cut to

Shreds and the pride of women's headdresses
Have destroyed this land.
May God, who wears the crown of thorns,
Destroy the pride of women's horns for
His precious Passion. And let their long
Trains, which are the flails of the
Devil of Hell, never be fur us the
Cause of our confusion.[10]

Carvings, such as those prominently displayed on the main doorway at Lorrha Priory, Co. Tipperary (see chapter 5), reveal that St Bernard's denunciation of such decoration several centuries earlier had, in fact, been ignored in Ireland.

Irish artists excelled in the production of manuscripts, sculpture and metalwork. However, this last is a craft that is sadly not found in Ireland between the arrival of the Anglo-Normans and the middle of the fourteenth century. Except for a corpus of seals, which are culturally and iconographically indistinguishable from those made in England, there are no other metalwork objects that can be dated to this one-hundred and fifty year period. The absence of such works is unusual and difficult to explain as we know that imported metalwork objects were in circulation at that time, and the craft cannot have suddenly died after the appearance of the corpus of Romanesque crucifix figures, the last assemblage of native metalwork objects that pre-date the invasion.[11]

In the second half of the period, from the mid-fourteenth century onwards, a greater number of objects in all media has survived and they are of a more complex nature. Typical of this period are the funerary monuments of the O'Tunney family,[12] the delicate, lace-like stone carving at Holycross Abbey (pl. 4) and the Ballylongford Cross (see pl. 134). To set beside objects of such outstanding beauty and skill produced in this period are the unevenness and incompetence found in the awkward and imbalanced proportions of several small altar crosses[13] or the naïve simplicity of a manuscript such as the Cistercian Ordinal from Monasterevin, Co. Kildare (Bodleian Library, Oxford, MS Rawlinson C32), with its inexpert modelling and lack of scale. The shift in the balance of power in favour of the native Irish directly followed the Black Death, which first entered the country in the winter of 1348–9 and killed over one third of the population, mostly in the larger urban centres, where there was a higher proportion of colonial inhabitants.[14] This was the first of a series of factors that paved the way

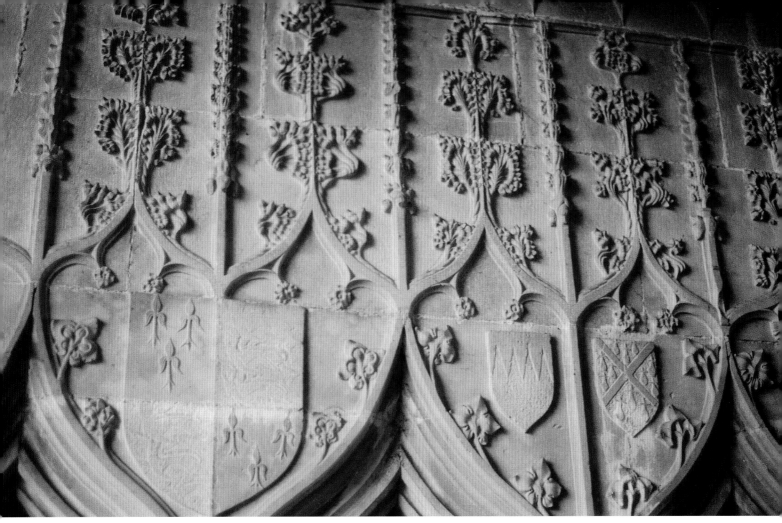

Plate 4 The fine workmanship on the canopy of the fifteenth-century sedilia at Holycross Abbey, Co. Tipperary, shows considerable skill in its handling of the locally quarried, hard grey limestone. There was a school of masons attached to the abbey in the fifteenth century and this work is typical of their output.

for the Gaelic revival, and for a number of years broke the direct artistic links between Ireland and England. These links were never fully restored, but at the same time they were never entirely severed.

If any single work heralds the second phase in Gothic Irish art it has to be the Fiacail Padraigh shrine, also known as the Shrine of Saint Patrick's Tooth. Although made in the twelfth century, it was remodelled in 1376 for Thomas de Bermingham, Lord of Athenry. Here, both artist and patron, in this case, an Anglo-Norman aristocrat, are identified and named. The work shows immediately the enormous jump in iconography from the preceding period: it combines the international with the Insular and presents a programme, albeit limited, the likes of which is not found elsewhere in the early phases of the Gothic period in Ireland. Irish saints, narrative elements and animals are present for the first time in the Gothic period. This piece also shows how the complex cultural situation could be used by different sides of the political divide, when a distinctively Irish shrine form and iconography could be reused and manipulated by an Anglo-Norman lord.

More significantly though, this shrine shows the dramatic change from a period of anonymity to an age of identity. The recording of identity at this time, whether that of patron or artist, had different functions, not least of which was an element of commemoration. Names of the artists and patrons as well as dates are frequently provided in inscriptions, as on the Fiacail Padraigh. This was a process that increased over time and is a characteristic of a number of the later metalwork shrines (see chapter 6). The fifteenth-century masons' marks, in contrast to those of the thirteenth century, use complex and intricately carved Celtic motifs and are carved in high relief and placed in conspicuous positions, reflecting the makers' pride in their work.

Not all the artists whose names are known from this later phase are identified by their marks only. In metal-work, in particular, several names can be attributed to well-known works. All the identifiable names known from this second phase are Irish. These artists were content to use an idiom that was culturally associated with the conqueror and to use an iconography that was an amalgam of the Insular and the international. Whereas at the start of this second phase Irish artists seem to be experimenting in objects such as the Fiacail Padraigh, it is clear that by the middle of the fifteenth century they had reached a level of professionalism and skill that could rival any international workmanship. With the Irish artists' wholehearted acceptance of Gothic in this later period the number of works increases significantly and there is a sense of experimentation: contemporary and antiquated, international and Insular – are all merged in a late fifteenth-century style.

*　　*　　*

If English Gothic is less complex than its French original, then the Irish handling of the same style at the start of the thirteenth century was even more diluted and certainly remained so until the start of the fifteenth century. Gothic Irish art has always been less ambitious than that of either England or Europe. The buildings of comparable foundations are smaller than elsewhere and less ornate. The art is, above all, direct and easy to understand, especially in the first phase: there are no elaborate iconographical programmes or extended narratives. This approach changed slightly in the fifteenth century, when a more ornate, but still relatively simple style became common in all the arts. Despite these changes there is a continued emphasis on the static, single image in most media, whether it be the sheela-na-gig in sculpture or a saint's portrait in metalwork. The sheela-na-gig, for example – those female exhibitionist figures in which the sexual organs are graphically represented – are nowadays seen as symbols of fecundity and evil, and their links with medieval religious buildings have caused eyebrows to be raised. In the fifteenth century, however, it is possible that they were perceived in differing ways, and could be symbols of fertility or fecundity, of life or temptation. These single images have a power that must have appealed to patron and viewer and are, to a certain extent, reliant on context to convey their full meaning. It is unfortunate that context

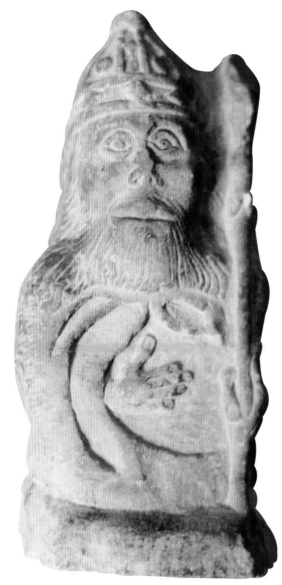

Plate 5 The original context of the small fifteenth-century carving (approximately 30 cm high) within St Patrick's cathedral, Dublin, is unknown. The mitred bishop holds a circular object and stands by a tree. National Museum, Dublin.

is now sadly missing for so much medieval Irish art – sculpture is displaced, metalwork is no longer associated with its owners and works are frequently damaged and incomplete. The fresco cycle in the northern transept at Holycross Abbey, Co. Tipperary (pl. 6 and fig. 1), for example, is incomplete – what this secular hunting scene, with its armed figures, dog, deer and beater was doing behind the backs of worshippers in such a location is a mystery.[15] Similarly, we know nothing of the context of a small carved stone figurine, now in the National

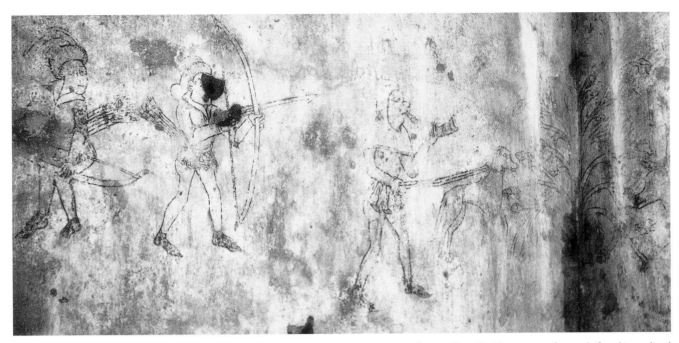

Plate 6 Hunting scenes, such as the late fifteenth-century example in the northern transept at Holycross Abbey, Co. Tipperary, are frequently found in medieval art. This wall painting has a limited palette in brown, green and pink, and is one of six or seven surviving from a religious context in late medieval Ireland.

Figure 1 The scene depicted in pl. 6 lacks any frame and is haphazardly arranged on the walls.

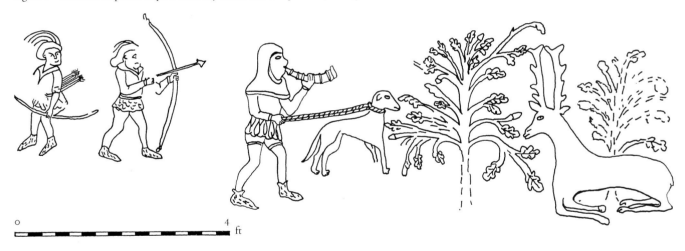

Museum, Dublin, but originally from St Patrick's cathedral Dublin (pl. 5).

Gothic Irish art is not an intellectual style, instead it is very much based on a popular approach, with its roots firmly anchored in society. It lacks the visual continuity of the Romanesque period; there is none of the fluidity in either handling or iconography that is one of the hallmarks of the pre-invasion period. This is a style which is rational and logical – it conforms to a set of rules that differ little from one location or medium to another.

There is less of an emphasis on the visual *continuum* in Ireland than there is elsewhere. An unusual representation of the close association between Gothic and Romanesque art is found on top of the Rock of Cashel. One of the human heads on the exterior of Cormac's Chapel (eastern wall), shows a human mask-head with tongue extended in the act of face pulling. This is an unusual motif for Gothic Ireland and is found only at the nearby cathedral (choir, southern side) where the same motif looks down at its earlier relative in an act

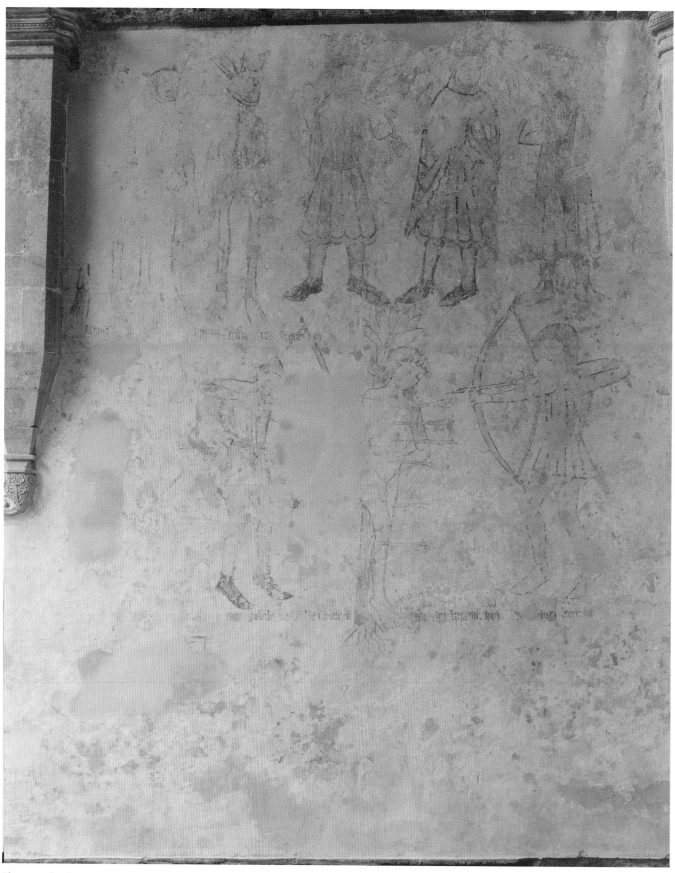

Plate 7 The three living and three dead kings and the martyrdom of St Sebastian in the chancel at Abbeyknockmoy, Co. Galway. This fifteenth-century *Vanitas* symbol would have faced the worshipper from behind the altar and been a constant reminder of the transience of life and the power of the eternal.

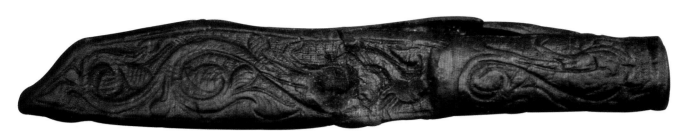

Plate 8 Decoration was used extensively in Gothic Ireland. Fifteenth-century leather scabbard, with curvilinear and foliate motifs – one of a number now in the National Museum, Dublin.

of homage. Both carvings recall St Bernard's admonition in a letter to the Romans that 'what affects the head cannot but affect the body – when the head is suffering, does not the tongue cry out for all the members that the head is in pain, and do not all the members confess by means of the tongue that the head is theirs and the pain too?'

The thirteenth and early fourteenth centuries were a period of consolidation during which the Anglo-Normans established an infrastructure of towns, cities, castles and churches, in which roads were built and trade developed, but for which there are no surviving written records. The scant documentary remains, in the form of masons' names or poems, shed little light on the culture or society that existed in either the Gaelic or conquering societies. Comparative studies for England have provided a parallel that has been used in most fields of research in Ireland, ranging from settlement patterns to artistic output. Any possible artistic chronology for this period has come from the scant inscriptions on metalwork objects (the names of artists or patrons or dates, are frequently given) from the late fourteenth to the fifteenth century, or the architectural styles of buildings that can be dated.

The style of the second phase was an all-pervasive force in medieval Ireland which reached into the most remote parts of the countryside – from the Cistercian foundation of Abbeyknockmoy in Galway,[16] with its surviving frescoes of the three living and three dead kings and St Sebastian (pl. 7) to its daughter house on Clare Island, Co. Mayo, with its encyclopedic repertoire of animals and humans. From the mid-fourteenth century onwards sculpture was made for easily visible publicly accessible areas, weapons were decorated with floral, geometric, stylized and representational motifs (pl. 8), pottery was enlivened with animal and human heads, shrines were displayed together with crosses on altars and frescoes were placed in prominent positions. All of these public images

were controlled either by the Church or by the landed classes. Little of the personal is found from medieval Ireland. It was a style which had, to quote Oscar Wilde, 'an enduring vitality'.[17] This was an art which was largely governed by the Church and much of what survives is religious in nature. It is only in this second phase that Gothic art was used in secular contexts. Surviving works include ring brooches or other pieces of jewellery and private devotional books of hours, such as the Bective Hours (Trinity College Dublin, MS 94).

Much of what survives is found in what was a largely rural economy and is therefore simpler than the contemporary urban style. The Middle Ages in Ireland were characterized by massive contrasts between the city and the country. There were few cities of any size and these were where the civilized sectors of society, in effect the Anglo-Norman conquerors, lived. Urban centres such as Kilkenny or Dublin were part of a feudalized world with social, moral and artistic connections to the wider world. The *gens silvestris*, or rural dweller, described by Gerald of Wales, was a less 'civilized' country dweller or Gael.[18] This classification of Irish society into two contrasting divisions remained unquestioned until the end of the Middle Ages and beyond, and it influenced the appreciation and cultural associations of the Gothic style in Ireland. Needless to say, it was the Irish who fared worst from this cultural classification and were seen as uneducated rural dwellers with little appreciation of the refinements of medieval society. Unlike the stronger English elements in the urban centres, Gaelic society lacked a central focus, and was undefined in terms of artistic output until the late fourteenth and early fifteenth century, at which stage it too began to produce its own distinct forms of Gothic art and architecture. Even then cultural and artistic values were certainly not uniform in Gaelic society, and this is evident until well into the seventeenth century.[19]

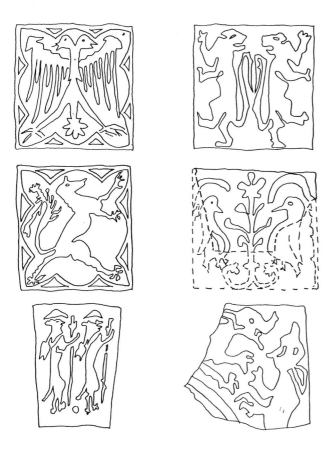

Society was culturally separated into distinct geographic areas, which must have affected what artistic influences were available, but the presence of the Church, especially in the more remote areas, probably acted as a bridge. The monastic structure of the Church, with its isolated buildings and localized nature hindered the dissemination of Irish Gothic. There is certainly a difference between the art used in the more urban areas and that of the more remote countryside. As is to be expected, buildings such as Christchurch cathedral, Dublin, in a thriving urban centre with close ties to England, would have been among the first buildings in Ireland to have employed new and contemporary styles. On the other hand, a Franciscan friary such as that in Bantry, Co. Cork, in a remote corner of the island could not be expected to have the same close ties. A lot of what remains from the Irish Gothic period was created in remote areas. Whether a distant friary or an equally rural castle, they were structures that were removed from the immediate circle of new ideas and concepts not only in Ireland but also internationally. Nevertheless, the style has been described as 'a visual statement of a whole social code of life and faith'.[20]

Nothing is known of the everyday reaction to art in medieval Ireland, although it was present at every level, from the church entrance to the castle wall. The fact that this art was very much based in local society is significant and suggests that the audience for which it was created as much as the actual person responsible for its creation came from the same society. Easily understood motifs predominate. As a general observation, decoration was used sparingly in the early medieval period, but there certainly seems to have been a lessening of the strict rules of poverty and simplicity over the centuries. By the start of the fifteenth century wealthy monasteries such as Holycross Abbey, Co. Tipperary, were lavishly adorned. Such a monastery would have had sculptural decoration inside and out, wall paintings, tiled floors, wooden sculpture, manuscripts and vestments, as well as metalwork in the form of church plate, seals, shrines and large crosses. Some of these objects, such as tiles (fig. 2), have been described as being distinctively English in iconography, style and distribution – their distribution, for example, is restricted to an Anglo-Norman background in Leinster, even though isolated examples have been found outside this area.[21]

The relationship of art and society changed drastically in Ireland over the period of three hundred years. Thirteenth-century sculpture is easy to understand but often physically distant from the viewer. However, by the fifteenth century the carvings have moved closer to the viewer and are present in greater numbers in the church or castle, but their iconography is increasingly complex, and drawn from a variety of sources, making it less understandable to the modern viewer and presumably also to the medieval eye. The decorative programme in the cloister at Jerpoint Abbey, Co. Kilkenny, which has over seventy carvings and hundreds of motifs, has still eluded satisfactory explanation (pl. 9).[22] We can look at individual piers and attempt to understand the many figures of saints, knights and ladies, but we are still puzzled at the semi-anthropomorphs who peer out from contorted bodies or the apes who sit patiently alongside human figures (pl. 10). We can also, for example look at the many frescoes or carvings in secular contexts, such as those at Ballinacarraiga, Co. Cork (pl. 11). These carvings in high relief on the window embrasures of the upper two floors of this sixteenth-century tower house neatly combine the secular and Christian. The Crucifixion, *Arma Christi* and angels are depicted here, as is an enigmatic female figure in secular dress sur-

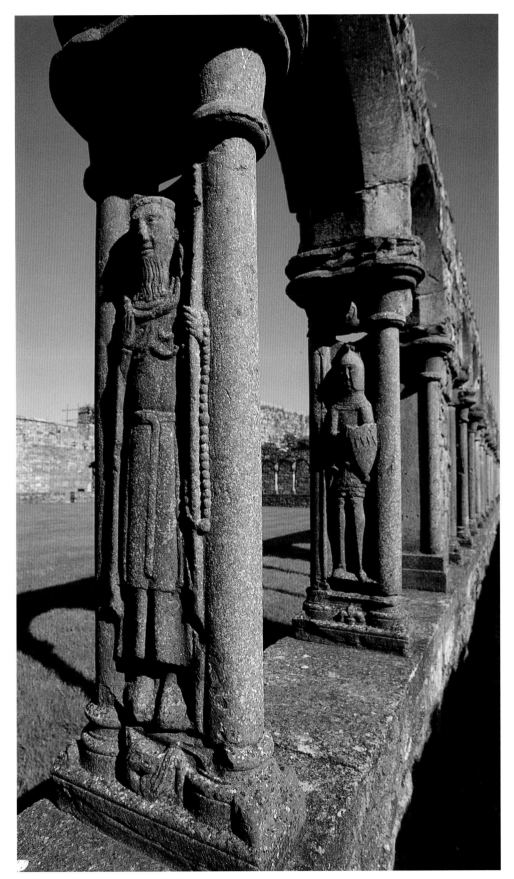

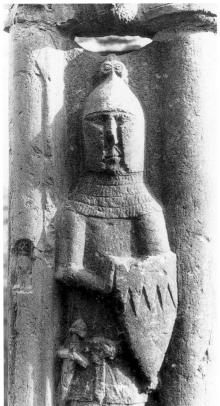

Plate 10 (*above*) Figure of a knight (*c.*1442), possibly a member of the Butler family, typical of the human representations at Jerpoint Abbey, Co. Kilkenny. The small seated monkey on his right-hand side may be a heraldic motif.

Figure 2 (*facing page*) Tiles with a range of decorative, heraldic and religious motifs have been found in considerable numbers in medieval Ireland. Clockwise from top right: addorsed lions, two birds regardant on tree, animal grotesques, pilgrim foxes and lion rampant (all Christchurch, Dublin), and double-headed eagle (Mellifont Abbey, Co. Louth).

Plate 9 (*left*) One of the largest iconographic programmes of fifteenth-century Ireland is in the cloisters of the Cistercian abbey at Jerpoint, Co. Kilkenny. The dumb-bell piers, capitals and bases are decorated with a combination of secular and sacred motifs.

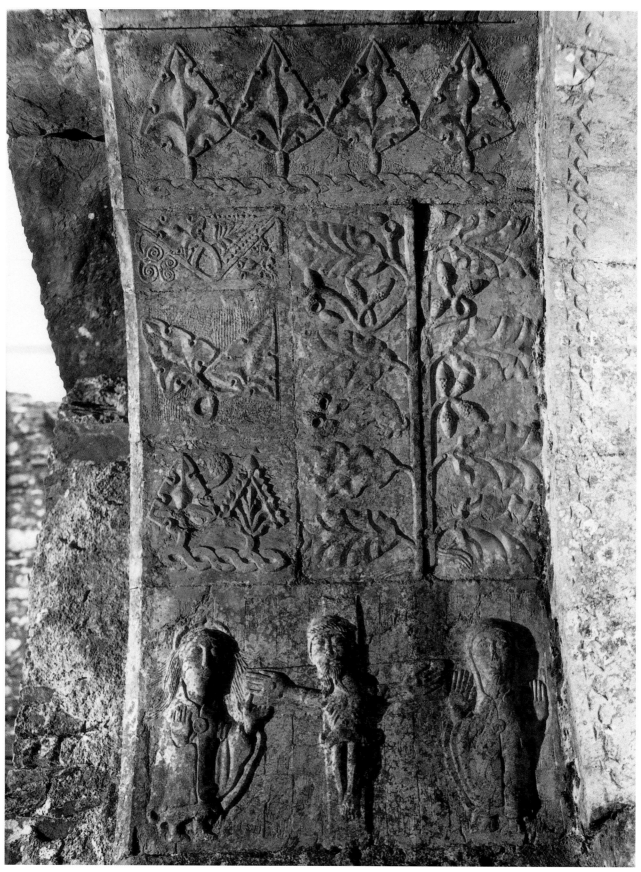

Plate 11 Wall paintings and sculpture are frequently found in tower houses, especially those built towards the end of the medieval period, as was the late sixteenth-century example at Ballynacarriga, Co. Cork. The crucifixion scene, dated by an inscription to 1585, is on the upper floor in a room that was used as a church as recently as 1815.

rounded by a series of six rosettes, the meaning of which probably relates to the patron and is unfortunately lost to us. As a general rule however, the introduction of this style into the secular world increased its accessibility and made it available on an unparalleled scale.

If the relationship of the artist to society is unknown, then that between artist and patron is equally enigmatic, and is complicated by the political alliances threading through the different sections of Irish society. The fact that three consecutive Irish archbishops were responsible for the thirteenth-century building of Cashel cathedral, Co. Tipperary, in the heart of Anglo-Norman territory, might lead us to expect a more indigenous expression in the style used. Nevertheless, it stands out as a high point in English Gothic for thirteenth-century Ireland. Similarly, the fact that shrines such as that for the Book of Dimma or the Domhnach Airgid were in Irish custodianship for the later medieval period did not impede their refurbishment by Gaelic artists in what was clearly a foreign style and using elements from an international iconography. The artistic boundaries between Gaelic and Anglo-Norman appear to have been blurred and not rigidly enforced. While the Anglo-Normans may at times have adhered to what could be called 'English' influences, the Gaels also showed an inclination towards what they perceived as a native idiom, but in both cases the underlying basis was Gothic. This relaxation in the boundaries of style may have been due to the influence of the Church, probably perceived by both sides as an impartial entity. The coarb of St Patrick, it is claimed, commanded the respect of both Gaelic and Anglo-Norman alike, and acted as a bridge between the two *nationes*.[23]

The earliest representations of the patron in Gothic Irish art are the many funerary effigies that are still found in the interiors of countless religious buildings (pl. 12). Anglo-Norman in origin, they record the posthumous presence of secular patrons and are unlike the more direct memorials to both Gaelic and Anglo-Norman munificence which first appear in the mid-fourteenth century. This new patronage comes to occupy an increasingly prominent position and is paralleled by closer links between the secular and religious worlds. More than that, it shows the place that such people had come to occupy in the organization of the Church. It is also at this stage, with such developments, that the iconography used by the Anglo-Norman and Gael becomes increasingly relaxed and more open in its approach to new ideas. The concept of visual commemoration, be it

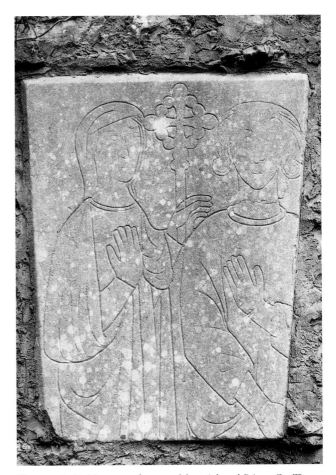

Plate 12 Incised limestone funerary slab at Athassel Priory, Co. Tipperary. The figures probably represent the type of secular patron frequently referred to in metalwork inscriptions. Early fourteenth century, possibly pre-dating the Black Death.

that of the secular patron, the important member of the religious community or the Crown, is introduced into the general repertoire of motifs for the first time (see chapter 4).

The Gothic period has been described as a period of 'new visions' in space, time, nature and God as well as the self, with the most obvious physical manifestation being a conspicuous increase in scale especially in the centre of worship itself.[24] If the cathedrals in the larger urban centres – Dublin, Cork, Waterford or Limerick – were expected to be imposing buildings, then the same could not be said of the more remote Cistercian foundations, which rival, if not surpass, the cathedrals in the use of art. This order was clearly the wealthiest in medieval Ireland and used art extensively, and on a scale that was not matched by any of the others, although even the smallest buildings of the various

orders, from the Dominicans to the Augustinian Canons Regular, attempted to include some element of ornamentation and embellishment. Different orders clearly had different needs and abilities for the provision of art in their foundations. A lot depended on the funds available, but it is clear that as time went by the use of decorative art increased. The monasteries lost their isolated positions within society, and art, with its popular appeal, increased. The Franciscans more than that of any other order, have a considerable number of images of their founder surviving, and objects that can be directly provenanced to their buildings, such as the Ballylongford Cross (see pl. 134), have a strong emphasis on elements of the Passion and suffering of Christ. Their art, more than that of any other order, relates directly to mainland Europe and is more international in its influence. Images of the founders of other religious orders are also known, including St Dominic (see chapter 4), and possibly even one of St Bernard (pl. 13). Much of this religious art was provided by patrons in the form of gifts or purchases and would have come from either the native workshop or the international market.

The Gothic style was shaped, above all, by the religious and intellectual conditions that prevailed in Ireland from the late fourteenth century onwards and the individual religious orders such as the Cistercians defined their own use. Art in the service of the Church clearly brought both elements of society together, if not on a political level, then certainly on a private and devotional level. The Anglo-Norman settlers, who had by then been living in the country for well over a century, appear to have participated fully alongside their Gaelic counterparts in commissioning works of art for the Church. It would be a futile task to attempt to distinguish between patronage at this stage, but if one single theme or subject reigns above all others and highlights this relative unity between Gael and Anglo-Norman it has to be the Crucifixion. This was a motif which the Irish had used distinctively and assiduously since the introduction of Christianity in the fifth century.[25] It is a motif which is both private and public, and allows the dual perspective of communal as well as personal worship and devotion (see chapter 6). The presence of crosses in prominent contexts (such as portals) and in such numbers indicates a significant power and purpose (pls 14 and 15). There is no obvious distinction in the handling of this motif between either sector of the community as there had been in the past.

Plate 13 Images of Saints Francis and Dominic are often found in fifteenth-century Ireland and are usually associated with foundations of their respective orders. No images of St Bernard, founder of the Cistercian order can be identified with certainty, although one possible example is the full-length, fifteenth-century limestone figure on a cloister pier at Bective Abbey, Co. Meath.

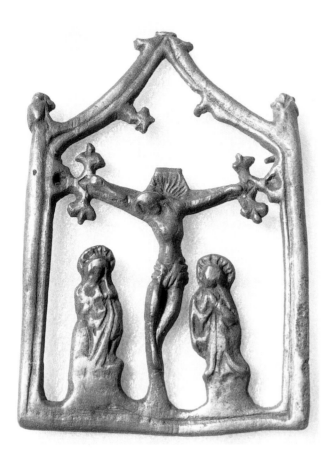

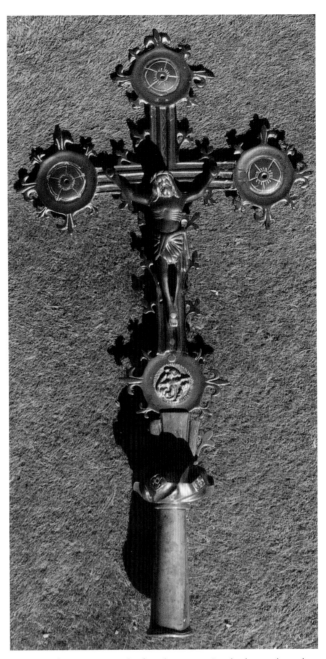

Formal and expected influences, such as the Bible and the Golden Legend, were ubiquitous, but a number of popular sources, such as the bestiaries, heraldry and history books, also influenced the choice of subject matter, especially with the expansion of the iconographical repertoire in the fifteenth century. As time progressed certain images appeared more frequently, and were drawn from sources that were very much based in a society that could understand them and with whom they were popular. Art becomes more literate in its visual content for a society that may have been largely illiterate, but such literary images were removed from their bibliographic contexts. Animals from the bestiary, for example, came to invade the general repertoire of both metalwork and sculpture. This increase in images and broadening of subject matter occurs relatively soon after the first stages of the Gaelic Revival. At the beginning of the fifteenth century, some fifty years after the more direct and large-scale English connections and influences ceased, new ideas began to filter in. Art had come to play an increasingly significant place once again in both the Church and society.

Plate 15 (*above*) Despite the fact that processional, altar and pendant crosses are found in considerable numbers in Gothic Ireland and Britain they have been neglected. This fine fifteenth-century processional example lacks any element of the Insular in its iconography and form. Private collection, Co. Waterford.

Plate 14 (*above left*) A small fifteenth-century openwork bronze pax, one of a number of such objects which may have been imported. It is typical of English work of the same period and could have been used for private as well as public worship. National Museum, Dublin.

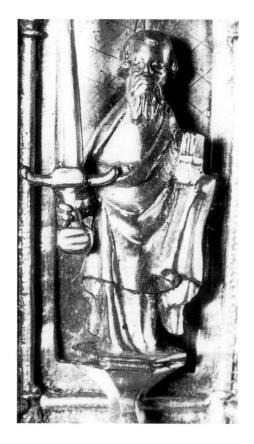

Plate 16 There is little of the Insular in the representation of St Patrick on the Limerick Crozier (late fifteenth century). The small cast figure is accompanied by other Irish and international saints, all of whom lack any element of local influence. Bishop of Limerick, on loan to the Hunt Museum, Limerick.

The early fifteenth century was a period of considerable linguistic change. For much of the medieval period several languages were used in Ireland, including Latin, Irish, French and English.[26] This certainly caused confusion: for example French continued to be used for administrative purposes until the end of the sixteenth century, but died out as a literary language in the second half of the fourteenth century.[27] There could be no such trouble in understanding the international language of the image and this explains their popularity. Even though the Gaelic Revival was gradually beginning to manifest itself in the visual arts from the middle of the fourteenth century, the English tradition never fully died out. The development of the Gaelic element did not mean the cessation of the international. The vernacular of the images used in Gothic Irish art, from whatever background, is largely international.

Much of the subject matter in Gothic Irish art does not have a history pre-dating the conquest, however

a number of motifs, such as the Crucifixion, the inter-lace animal and the saintly representation, often appear to draw on earlier Irish models for inspiration. Although Gothic was a fully-fledged style when it arrived in Ireland, older indigenous models were not completely discarded, especially in the second phase. Furthermore, where no pre-invasion models existed for particularly Insular subject matter, such as the Irish saints, an icono-graphy firmly based on the international repertoire was invented. Gothic images of St Patrick, for example, were unknown before the second phase, but when it came to representing him in the fifteenth century he was shown as a Gothic figure in conformity with the standards applied to foreign saints (pl. 16).

Apart from the rigours of modern life and the impact of visitors on many of these buildings, the greatest damage to the corpus of Gothic art in Ireland was undoubtedly the Reformation and the zeal with which the royal agents demolished many of the buildings and their contents. However, the early sixteenth century was a time of many other changes, such as the forced attempts to convert the country to Protestantism, the Tudor conquest, and the Flight of the Earls,[28] all of which were to play a major influence in ending the Gothic period. Between the reigns of Henry VII, the first of the Tudors, and Elizabeth I, the last, the political admin-istration and arts of the country changed beyond recog-nition. The accession of Elizabeth I marks a convenient terminus date for the end of the Gothic period in Ireland, but if any single object can be seen as marking the end of this style, it has to be the Miosach, which is dated 1536, just three years before the destruction of the monasteries. Created before these dramatic events, in many ways it heralds the end of Gothic creativity in its use of replica-tion and stylization and its poor workmanship.

It is nearly impossible to define the true nature of Gothic Irish art. Social, cultural, racial, political and reli-gious influences constantly interacted at different times, in an uneven pattern, over the entire country, to create a style of great complexity. Even when the style was no longer used, its cultural associations were to linger for the next four hundred years and influence its future appreci-ation and history.

An Art Forgotten:
The Historiography of Gothic Irish Art

As a discipline, art history is relatively new in Ireland and could really be said to start with the pioneering work undertaken by such scholars as Margaret Stokes in the late nineteenth century and, more significantly, Arthur Kingsley Porter[1] and Françoise Henry in the middle of the twentieth century. It is understandably difficult to distinguish the formal study of this subject from the many related disciplines, such as archaeology and architecture, which have had higher and more popular profiles. They also have a much older and more clearly defined history in Ireland, but one which in many ways overlaps with the lesser-known field of art history. Partly because of this multi-discipline approach, art history as a distinct area of research is less well defined and its origins are slightly muddled. Interestingly, its development is closely related to the national appreciation of the Gothic style from the Middle Ages to the present.

Much of the art historical material in Ireland consists of archaeological artefacts, and any study that was undertaken on these objects before the twentieth century was either by antiquarians, historians or archaeologists. Before the eighteenth century there was no well-defined Irish tradition in the graphic arts, which are popularly associated with the discipline.[2] For example, antiquarian drawings, which are among the earliest surviving graphic material, have rightly been viewed as documents that can be used in architectural studies but have rarely been treated as works of art in themselves (pl. 17). It is also not surprising to find that architecture is dealt with in more detail than the other arts – indeed, it was in this medium that the Gothic style was first recognized. On the surviving evidence, it appears that the style was introduced into Ireland through this medium, and the bulk of the material which can be used to chart the history and appreciation of this style in Ireland is indeed architectural. Not surprisingly therefore, even today the term Gothic is applied only to the architecture of this period in Ireland and never to the other arts, which have been left in a stylistic vacuum, usually referred to as the 'later medieval period' or the 'art of the Anglo-Normans'. Surprisingly little study has been undertaken to link all the arts of the period within the one stylistic movement.

The reasons for this avoidance of the study of Gothic Irish art are complex, not the least being the political associations of this style, first encountered in the thirteenth century and still persisting. For better or worse, Gothic art in Ireland has been seen as having political and cultural links to an English power that was responsible for a loss of national identity. The development of the political associations ascribed to Gothic Irish art is an interesting study and one that relates closely to the birth and development of art history in Ireland. Although Gothic art was the first area of art history to be documented and studied in Ireland, any modern evaluation of Irish art history usually begins with the nineteenth-century study of Celtic material; like the modern study of Gothic art in Ireland, the historiography of the subject has been equally neglected.[3]

Art in Ireland has been consciously used from the early medieval period to the present for a variety of reasons.[4] Apart from its more obvious decorative or didactic purposes, it appears also to have been used politically and has traditionally been seen as an expression of the presence,

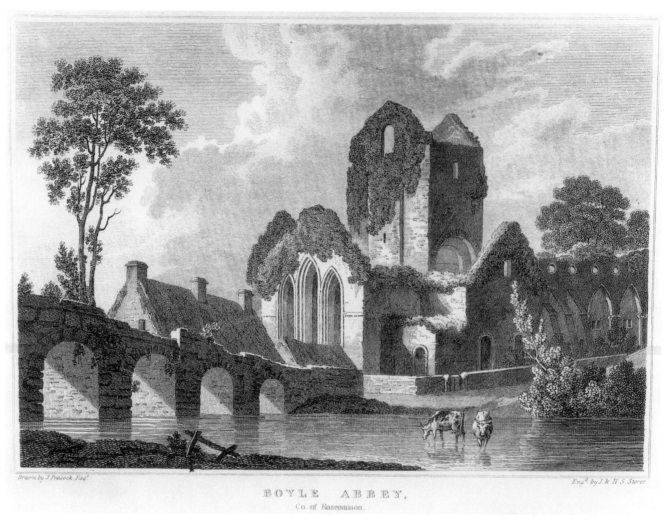

BOYLE ABBEY,
Co. of Roscommon.

Plate 17 View of the Cistercian foundation at Boyle, Co. Roscommon, typical of the approach to topographical illustration at the start of the nineteenth century in its combination of the pastoral and the architectural, the Irish rural cottage and the English Gothic building. From J. N. Brewer, *Beauties of Ireland, Being Original Delineations, Topographical, Historical, and Biographical of Each County* (London, 1825).

power and dominance of the invading force. More than this, however, Gothic was a style that was seen not only in the medieval period but also up to the present as heralding the end of the vernacular style. To appreciate fully its impact, it has to be remembered that throughout Europe Gothic was the style associated with the controlling powers of the medieval world – Church and state. Given the fact that these institutions were also perceived by the Irish as the means of control employed by a colonizing force, it is not surprising that the style was viewed negatively. The architecture and arts of Gothic Ireland were the products of a certain sector of the population – the wealthy and the powerful. They defined identity, especially in the post-medieval period, and were politicized to an extent not found elsewhere.[5] The association of Gothic

art with the Protestant faith has also not endeared the style to contemporary popular opinion, and again the complicated origins of this link lie in the later medieval period. The Church was the most important institution in Gaelic society. Before the Reformation the Roman Catholic Church was the principal exponent of the Gothic style, but of course the same style was culturally synonymous with England. The Reformation threatened to remove the Roman Catholic Church from its central role in Irish society.[6] Instead, the bonds between Irish society and Roman Catholicism were strengthened when the Church was forced to go underground. The churches and liturgical objects that had been central to Roman Catholicism came under English control, thus reinforcing their cultural ties with England. For a country that remained pre-

dominantly Catholic its religious buildings became synonymous with the Protestant faith.

These political associations attached to Gothic art in the medieval period persisted into the seventeenth-century and beyond. Irish Gothic was seen as an opposing force to the nationalist movement which developed in nineteenth century Ireland and found its own artistic expression.[7] During the first half of the nineteenth century Irish art and, in particular, the study of what was perceived as Celtic art became closely linked to the rise of the nationalist movement and the eventual creation of an independent state. The source of nationalism in Ireland is disputed. Some scholars see the Irish rejection of foreign dominance as part of the indigenous character and thus a pre-1700 movement, first developed as a response to the arrival of the Anglo-Normans. Others have seen it as developing from a series of eighteenth-century movements, in literature, theatre, drama and music, among which were the many art historical and antiquarian studies that will be discussed below.[8]

From the outset, it has to be said that biased and imbalanced argument is not the result of any lack of surviving material. Nearly all the studies and research on Gothic art and architecture, from the seventeenth century onwards, were undertaken by Protestants, a high proportion of whom also came from an Anglo-Irish background. Not only was Gothic art culturally associated with English dominance, but the study of this art in the post-medieval period was also undertaken by non-Gaelic scholars. The medieval Gaelic response to Gothic art has not been recorded, and we can only guess as to its nature, but the very absence of a response is, in itself, suggestive. The inability or refusal of many modern Irish scholars to characterize the art of this period as Gothic also shows a reticence which is not entirely due to its lack of associations with the international style. If the native tradition was used by the Gaelic Irish in their art from the mid-fourteenth century onwards to re-define what they felt was a lost national identity (see chapter 7), then the same could be said of the post-medieval colonist in Ireland. Gothic art and architecture was perceived by the Gaelic as part of the English culture. Barnabe Rich, writing at the start of the seventeenth century, records: 'from hence it proceedeth that, as they [the Irish] cannot be induced to love anything that doth come from the English: according to the proverb, "Love me, and love my dog"; so contrariwise, he that hateth me, hateth in like manner all that come from me.'[9]

Elizabethan writers – Edmund Campion, Philip Sidney, Edmund Spenser, Raphael Holinshed, Fynes Moryson and Luke Gernon – all focus on the cultural differences between Ireland and England in this period, and usually concentrate on the negative aspects of the Irish character. Such writers take up where Gerald of Wales had left off in the late twelfth century in his *Topographia Hiberniae* (*c*.1187) and *Expugnatio Hiberniae* (*c*.1189) in their negative evaluation of the people and culture.

> They are a wild and inhospitable people. They live on beasts only, and live like beasts. They have not progressed at all from the primitive habits of pastoral living.
>
> Moreover, above all other peoples they always practice treachery.[10]

Only one of these later writers, Luke Gernon, in *A Discourse of Ireland* (1620), was to write in any detail on the architecture of the cities and towns he visited. It is clear that the architectural style in cities such as Dublin, 'where the buildings are all timber and of the English form', or Waterford, where the buildings are once again 'of English form and well compact', differs from that of Cork. This last city, we are told, is located in a 'bog and unhealthy', and 'the building is of stone and built after the Irish form'.[11] Where such architecture is illustrated, and this is a rarity in the sixteenth century, it is very much a Gothic cityscape that is depicted (pl. 18). Even though it is illustrated, *Holinshed's Irish Chronicle* (1547) does not present us with any material that is of value, as the woodcuts are of a generic type that could relate to any European country except Ireland. The churches, for example, display a total lack of knowledge of the materials or styles used in medieval Ireland.[12]

The first large-scale, post-medieval manifestation of this cultural appropriation of the Gothic style by the colonists is in the early seventeenth century. A considerable number of histories and travelogues were written by colonists, in justification of their role in society and their continued presence in the country,[13] but also by visitors from England, who sought an excuse to promote and extend the power of the empire.[14] These volumes document Gothic art and architecture almost exclusively, where the opportunity arises, with little or no attention paid to the Gaelic monuments; prehistoric or early Christian Irish monuments are almost entirely absent.

Plate 18 (*right*) Limerick and the River Shannon at the start of the seventeenth century. The walled city and the architecture are predominantly English in style with little of the vernacular shown. From Sir Thomas Stafford, *Pacata Hibernia* (London, 1633).

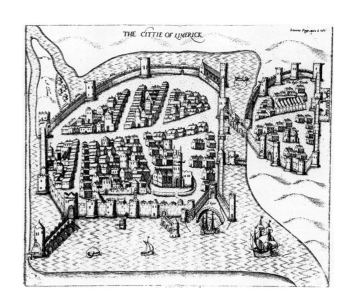

Plate 19 (*below*) Panoramic views of landscapes and stately homes such as Glenmore Castle, Co. Wicklow, 'Seat of Francis Synge, Esq.', reinforced the cultural associations between England and Ireland. From J. Carr, *The Stranger in Ireland or a Tour in the Southern and Western Parts of that Country in the year 1805* (London, 1805).

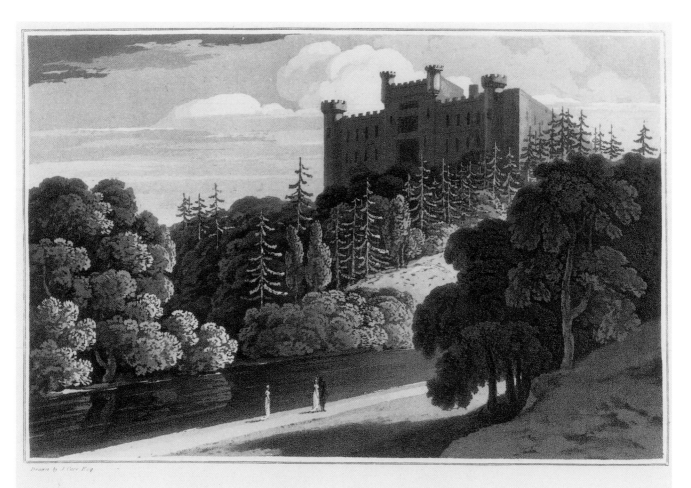

There is a noticeable vacuum in Ireland's artistic output between the end of the medieval period and the start of these seventeenth-century writings. The series of wars at the end of the sixteenth century has been seen as an explanation for this absence, but it is clear also that a decline in artistic output first began at the end of the fifteenth century, in advance of these battles. Little metalwork was being produced, few manuscripts were written and even fewer buildings were constructed by the middle of the sixteenth century. The Reformation, Tudor conquest, defeat of the Gaelic lords, colonization under Elizabeth I and the Flight of the Earls were not conducive either to continuing the existing tradition or to creating new works. There was thus no strong Gaelic tradition in the arts at the end of the Gothic period and it is therefore not surprising to find the more powerful 'English' perspective predominant in the seventeenth century. Such histories, more often than not, lack illustrations, but where they are included they understandably focus on those 'English' elements in the landscape that support the role of the colonial power (pl. 19). The landscapes illustrated in these early writings are virtually indistinguishable from English landscapes of the same period and can not yet be defined as 'Celtic'. Stately homes, castles and ruinous Anglo-Norman architecture predominate, and it is only occasionally that a 'native' appears, largely as staffage. At this stage it is the ignoble savage rather than the later romantic peasant that is represented, and such images must have reinforced the commonly held perception that the indigenous population and their art were an underclass beneath the refined world of English society. The term 'Celtic' became more widely used in the eighteenth century, when it was applied to monuments of the pre-invasion period.

These antiquarian illustrations are among the earliest art historical depictions of the Gothic tradition in Ireland, and they reinforce the association of this art with a non-indigenous culture. The writers and illustrators selected material that was culturally similar to their own and thus perpetuated the medieval belief that the Gothic style had political associations. These 'colonial' illustrations[15] usually present distant perspectives of ruined ecclesiastical sites, and are described by the writers not as Gothic but as 'Anglo-Norman' in style. They are of greater architectural than art historical interest; there is little, at this stage, of the sculptural and decorative details which were to appear later on in the eighteenth

century and which are of greater interest to the art historian.

From the end of the sixteenth century to the middle of the nineteenth century there is an absence of any evidence that might shed light on the Gaelic response to Gothic art and architecture. Although these seventeenth-century travelogues and histories inform us of the 'English' perspective on the indigenous population that was not their primary purpose. The writings and illustrations have also to be viewed in the context of the more widespread practice, at this time, of the Grand Tour and the discovery of the Classical worlds of Greece and Italy. Given its proximity to England, it is not surprising that Ireland as well as Wales and Scotland, came under the same scrutiny.[16] Considered less exotic than the Classical world, but nevertheless worthy of examination, Irish monuments, especially those of the post-medieval period, were described and illustrated for the first time as part of this larger tradition.

The cultural and political associations of the Gothic, and the considerable interest expressed by antiquarians in illustrating this style continued into the eighteenth century. Antiquarianism, especially an interest in the Gothic monuments that were illustrated, was very much based on a factual and realistic approach, in which every effort was made to reproduce architectural and sculptural details as accurately as possible. On the other hand, the eighteenth-century attitude to the 'Celtic' elements in these studies differs radically from that of the seventeenth century. There is an obvious increase in the number of 'Celtic' monuments illustrated and in the sentimentality and romanticism that was heaped on these studies (pls 20–22). The sense of the old and of otherworldliness evident in the approach of eighteenth-century writers is indicative of their perception that such 'Celtic' elements were separate from the colonial powers and distinct from the culturally assimilated Gothic material.

Various sub-divisions in the development of this movement have been defined,[17] but it is clear that a new awareness of this second, or Gaelic culture in Ireland, with a greater focus on the *minutiae* and detail of the material trappings, first developed towards the middle of the eighteenth century. One of the first real expressions of interest in 'Celtic' monuments was manifest in the literary world of the eighteenth century and is nearly coeval with the increasing focus on the archaeology and history of the country. It was a movement that heralded an even greater political consciousness of the negative

Drawn by Jo. Carr Esq. Engraved by T. Medland

Glendalogh, or the Seven Churches

Plate 20 Illustrations of such Celtic monuments as the round tower and seven churches at Glendalough, Co. Wicklow, were imbued with a romanticism that is typical of the interest in Ireland at the start of the nineteenth century. From J. Carr, *The Stranger in Ireland or a Tour in the Southern and Western Parts of that Country in the year 1805* (London, 1805).

associations of Gothic Irish art, and its place in the broader art historical picture. The eighteenth century was a period of consolidation in the differences of Gothic and Irish art, with their respective cultural associations. Antiquarian studies increased in number and their focus was once again on the most prominent architectural field monuments, which were nearly always Gothic in style. One of the best known of the antiquarians of this period was Gabriel Beranger, a French Huguenot, who arrived in Ireland from Holland around 1750.[18] Although born in Holland (of French origin), Beranger spent most of his life working in Ireland. He was a teacher and artist and the most prolific illustrator in late eighteenth- and early nineteenth-century Ireland. His particular focus was on

Irish antiquities and included large numbers of Gothic buildings.

A pivotal publication of this period is Francis Grose's *Antiquities of Ireland* (published in two volumes in 1791 and 1795), which serves to illustrate the distinct approaches to the handling of Celtic and Gothic material. More accurately described as Francis Ledwich's *Antiquities of Ireland*, the volumes were compiled largely by Ledwich, vicar of Aghaboe, Co. Kilkenny, and an antiquarian *par excellence*, who took over from Grose after his untimely death less than a month after arriving in Ireland to start his work. Capitalizing on Grose's *Antiquities of England and Wales* (1773–6) and his *Antiquities of Scotland* (1789–91), the work is pivotal in that it purports to

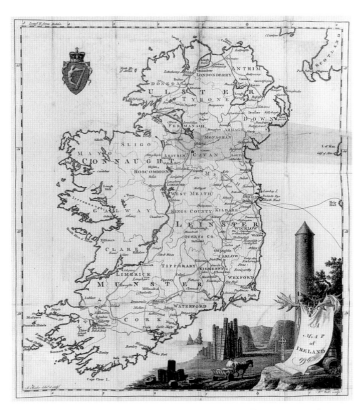

Plate 21 This map emphasizes Irish monuments and life, rather than the more usual focus on English elements. From R. Twiss, *A Tour in Ireland* (London, 1778).

Plate 22 The parish church of St Mary, Youghal, Co. Cork, offered an ideal opportunity to show the romantic approach favoured in the mid-nineteenth century. From L. Ritchie, *Ireland Picturesque and Romantic* (London, 1837), opposite p. 180.

cover all monuments equally. With such an expressed purpose, this work might be expected to include both Celtic and Gothic monuments, but this is found not to be the case when the volumes are examined in detail. Only the title-page of each volume of the *Antiquities of Ireland* illustrates a Gaelic monument (a round tower in vol. I, pl. 24; a high cross in vol. II, pl. 26), while the facing frontispiece in each volume illustrates a Gothic monument (Holycross Abbey, Co. Tipperary, in vol. I, pl. 23; the Hermitage, Slane, Co. Meath, vol. II, pl. 25). Although all four illustrations are of ruinous monuments, it is clear that two approaches are present from the start and that the focus of the work is not to be as general or all-encompassing as is suggested by the title or the inscription under the title-page, which records Grose's aim:

> Now be my Theme, Hibernias Ancient Glories, Druidic monuments and Danish Forts: Tall slender Conic Towers, whose date and use In vain have Antiquaries toil'd to find. Let us likewise her mouldering Abbies view Shrouded in ivy: her old gloomy Castles Fowning tremendous e'en in Ruins.

The two illustrations of the Gaelic monuments are fanciful capriccios, and are approximately one-third the size of the Gothic and provenanced illustrations on the opposite pages. If the scale of the illustrations is disparate, then the subject matter is equally biased: the high cross is cracked and covered in ivy while the Gothic remains fare slightly better and include human interest figures. If this front matter is indicative of a preferential approach towards the Gothic style then this is reinforced within the volumes themselves. Over two hundred monuments, arranged on a county basis, are described (vol. I, 102; vol. II, 113), and there are 266 plates – the bulk of which are of Gothic remains. The illustrations are also among the first to show details, and although the study is focused largely on architecture the two volumes provide us with the first serious treatment of Gothic Irish art. The justification for representing only 'English'-style monuments in a book on Ireland's antiquities again amounts to a perpetuation of the association of the Gothic style with a foreign country. As if to justify the choice of material and approach, but further reinforcing the stereotypical division of two cultures in the country, we are told that 'the

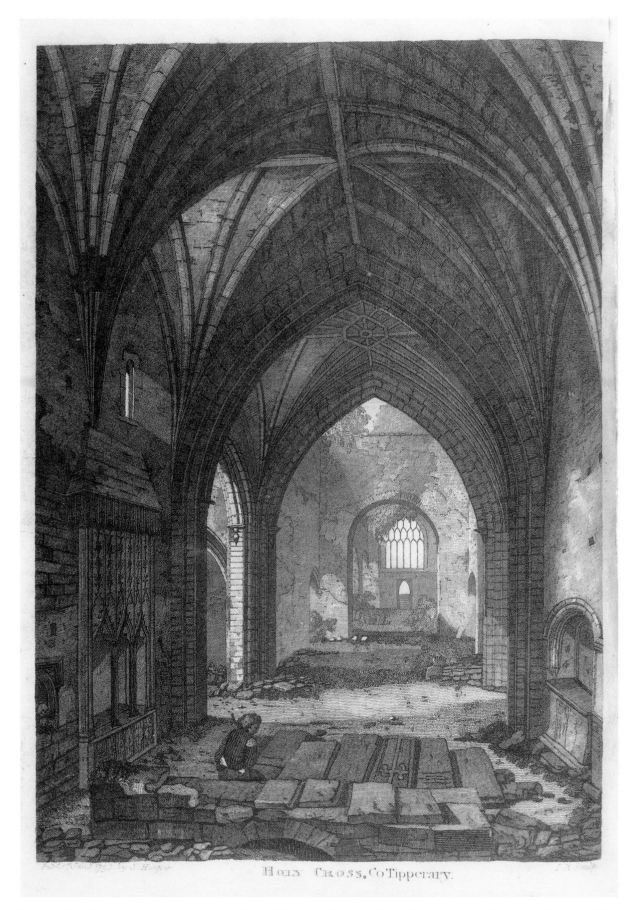

HOLY CROSS, Co Tipperary.

Plate 23 The full-page frontispiece to the first volume of Grose's *Antiquities of Ireland* (1791) shows a well-preserved Holycross Abbey, Co. Tipperary.

THE
Antiquities
OF
IRELAND
By Francis Grose Esqr. F.A.S.

THE FIRST VOLUME.

Now be my Theme Hibernia's Ancient Glories,
Druidic monuments and Danish forts;
Tall slender Cone-Towers, whose date and use
In vain have Antiquaries toil'd to find.

Let us likewise her mouldering Abbies view
Shrouded in Ivy; her old gloomy Castles
Frowning tremendous, e'en in Ruins.

LONDON, printed for S.HOOPER, No 212, HIGH HOLBORN.
MDCCXCI.

Plate 24 Title-page capriccio to the first volume of Francis Grose's *Antiquities of Ireland* (1791). It focuses on the ruinous state of 'Celtic' monuments in the panoramic landscape and is significantly smaller than the Gothic remains illustrated on the opposite page.

Pub Oct.ʳ 21 1793, by M. Hooper. 212. High Holborn.

HERMITAGE at SLANE. Co. Meath.

Plate 25 The Hermitage, Slane, Co. Meath, the frontispiece to the second volume of Grose's *Antiquities of Ireland* (1795).

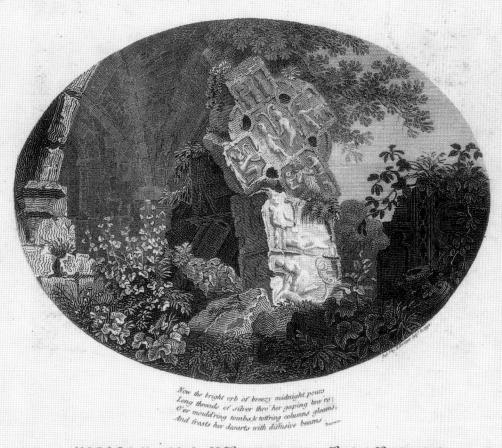

THE
Antiquities
OF
IRELAND

Francis Grose

THE SECOND VOLUME.

Now the bright orb of breezy midnight pours
Long threads of silver thro' her gaping tow'rs
O'er mould'ring tombs, & tott'ring columns gleams,
And frosts her desarts with diffusive beams.

LONDON, Printed for M. HOOPER N.º 212, HIGH HOLBORN.
MDCCXCV.

Plate 26 Another capriccio, the title-page of the second volume of Grose's *Antiquities of Ireland* (1795), again shows a Celtic monument – a high cross in a destroyed and perilous state.

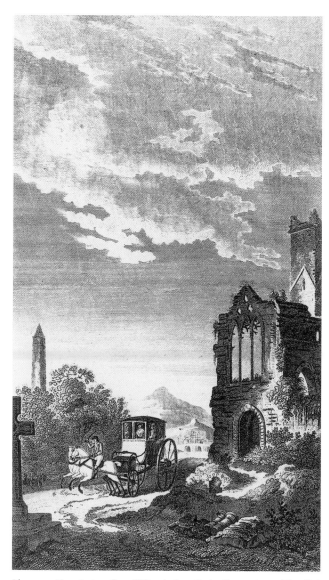

Plate 27 Frontispiece from Wilson's *Post Chaise Companion or Traveller's Directory through Ireland...* (1810), showing the same separation of monuments – the Celtic and the English – that was found in Grose's *Antiquities of Ireland.*

Irish' made no attempts in architecture, while 'the English were every where erecting beautiful churches and other religious structures [vol. II, p. xii], so that our ancient architecture as was observed of our castles, was planned and executed by English workers [vol. II, p. xii].'

While the 'firm footing' (vol. I, p. xv) or 'English invasion' (vol. II, p. xi) is seen as marking a crucial stage in Irish architecture, the work goes on to describe the style of later medieval monuments as 'Norman', but also includes one of the first occasions of the use of the word 'Gothic' in Ireland (vol. II, p. xiii). Grose was not alone in his separation of these monuments into two distinct types, as illustrations from other books show (pl. 27).

Although the term 'Gothic' had first been used in England in the late seventeenth century, it does not appear in common use in Ireland until the end of the eighteenth century – the same period that it became more widely used in England.[19] Whereas in England it was interchangeable, for a considerable time, with terms such as Perpendicular, Decorated, Pointed and English, few such subdivisions were used in Ireland, and the only terms that were applied derived largely from architectural studies, were 'early' and 'late'. The word 'Gothic appears to have been used ambiguously in Ireland from the eighteenth century onwards and with certain trepidation; it can refer either to the style or to the whole period of time from the arrival of the Anglo-Normans to the end of the fifteenth century. There is, for example, only one reference to the term in the indexes for the journal of the Society of Antiquaries of Ireland and that is for 1885–6, where the subject is 'Gothic Remains in County Waterford'.

In contrast to the emphasis on the Gothic in such eighteenth-century publications, the focus of the Royal Irish Academy, which was founded in 1795, the same year as the second volume of the *Antiquities of Ireland* was published, appears to have been mainly on the antiquities of the pre-invasion period. This was the first formal collection of artefacts to be established in the country and the first step in the creation of an art historical reference collection. Indeed, the catalogue of this collection, which was later incorporated into the National Museum, Dublin, is one of the first serious studies on 'Celtic' art. While it does include some of the best-known Gothic objects, such as the Domhnach Airgid and the Ballylongford Cross, it places these works outside the realm of the Gaelic in a separate art historical limbo.[20]

The nineteenth century was most significant for the scientific and methodological study of Celtic monuments, but it was also a time of increasing neglect of Gothic material. The relationship between national identity and Celtic art, the illustration of the romantic landscape in Gothic art and political independence and its influence on the arts are subjects that have previously been researched in the fields of archaeology, architecture and art history. There has been an emphasis on what have been perceived as distinctive symbols of Irish identity – the high cross, the round tower and the harp. On the

other hand, the subject of Gothic Irish art and the perception of its role in an English, Anglo-Norman, colonial or Irish society, which is equally interesting, has been totally neglected. A considerable amount of research has focused on the 'Irishness' of Irish art and not enough on the 'English' elements, as represented by the Gothic style, and how this entire period of almost three centuries has been relegated to the sidelines of art history in Ireland.

Antiquarian studies written largely by English visitors to Ireland and promoting the art of the Anglo-Normans continued to be produced into the nineteenth century, but with nothing like the vigour of the preceding two centuries.[21] In the early nineteenth century the increasing focus on Celtic art overshadowed the Gothic period, leading to its near total neglect. These studies on 'Celtic' material approached the subject in a more structured and organized way – one that was to establish the whole field of art history and archaeology in Ireland. Among the first and finest researchers in these fields were George Petrie,[22] Margaret Stokes,[23] John George Augustus Prim and James Graves,[24] whose work still appears, some two centuries later, significant and pioneering.

This focus on Irish art has been well documented elsewhere, especially in relation to the development of the Irish Antiquarian Society, the Dublin Society's Drawing School, the Ordnance Survey, the Geological Survey of Ireland, great exhibitions and many other separate strands that would eventually coalesce into the National Movement.[25] The most significant of these institutions, especially in the area of archaeology, but no less important for art history, was without doubt the Ordnance Survey. A group including some of the most important illustrators and antiquarians of the period systematically catalogued the field monuments of the entire country. Among those who worked on this project were George Petrie (1790–1866)[26] and his pupils George Du Noyer (1817–69),[27] William Wakeman (1822–1900) and Frederic William Burton (1816–1900). The impartial nature of the work makes it well nigh impossible to separate individual artists into groups of those who detailed only Irish monuments or those who documented only English monuments. The nearest we can come to any such division is between artists such as Petrie, whose primary interest was in the Celtic folk culture, and those such as Du Noyer, whose illustrations are among the most important for architectural historians of the Gothic

period in Ireland and whose output can be seen as less nationalistic in interest.

It is also clear that the Celtic or Gaelic Revival,[28] which started in the 1830s and lasted until the 1940s, would reinforce still further the foreign nature of the Gothic style in Ireland (see chapter 7). It was at this stage that Gothic objects began to be referred to as 'artefacts', were documented on paper and were separated from what were considered 'Irish' objects.[29] By the end of the nineteenth century studies on Gothic art and architecture had decreased to such an extent that they were almost non-existent. From being the centre of attention between the seventeenth and the early nineteenth centuries, Gothic art suddenly became a neglected field. In the battle between British colonialism and Irish nationalism that was fought on many levels in Ireland from the mid-nineteenth century onwards, one of the casualties was an interest in and appreciation of the Gothic period. On the other hand, if the study and appreciation of Gothic art suffered, then Irish art studies, especially those of the pre-invasion period, thrived. Art was just one of the component parts of the Gaelic Revival, alongside archaeology, architecture, literature and the many other cultural fields, all of which became politicized. The literature of the early nineteenth century also reinforces the pivotal role of the events at Bannow Strand in 1169. One of Ireland's most popular poets, indeed Ireland's national poet of this period, Thomas Moore, was to express a sentiment that clearly resonated on a national level in 'The Valley Lay Smiling Before Me' (*Irish Melodies*). In reference to Anglo-Norman invasion it states

> They come to divide – to dishonour
> And tyrants they long will remain
> But onward! – the green banner rearing
> Go, flesh every sword to the hilt
> On *our* side is Virtue and Erin
> On *theirs* is the Saxon and guilt.

One of the most significant reasons for this lack of interest in Gothic Irish art and architecture at the start of the last century was the overt belief, which was openly stated for the first time during the Gaelic Revival, that the art of the post-invasion period was foreign and not to be part of the revisionist programme. This stipulation, however, appears to have become blurred at times. An object such as the Fiacail Padraigh (pl. 28), which although made in the twelfth century and extensively remodelled in the fourteenth century for Thomas de

Bermingham, Lord of Athenry, became part of this revisionist programme in the belief that it was part of the Celtic heritage.[30] This was the period in which a considerable number of metalwork objects were replicated and motifs taken from others for jewellery designs. Despite the wish to promote only Celtic art in this revival, the process of separating the two styles proved difficult – in some cases impossible. Items such as the book shrines (see chapter 6) may derive from a pre-invasion period, but they were extensively remodelled in the late medieval period, and are now decidedly Gothic in appearance; however, they could not be selectively reproduced so as to exclude the later, Gothic, additions. The exhibition of such facsimiles at the Great Industrial Exhibition, held in Dublin in 1853,[31] and the Columbian Exposition in Chicago in 1893 would eventually bring this period of Irish art to the notice of the wider world.

In the mid-nineteenth century there was also, for the first time, public evidence of the Irish response to 'Celtic' art and a justification of its place and value in society. For example Henry O'Neill, the Irish nationalist, wrote in 1857 that 'the value of Irish art lies in its expression of a "national character". In all the remains of ancient Irish art there is a peculiar style, as truly national as that of Greece, of Assyria, of Egypt, or any other country that has been distinguished in art.'[32] Totally absent from all of these writings is any reference to the place of Gothic art or architecture in the national heritage. The creation of a national identity in art was ideally suited to the political needs of the time, and this identity was not to be linked in any possible way to a country that was held responsible for the original loss of cultural and political identity. The fact that what was perceived by the 'nationalist' illustrators and writers as being uniquely Irish in character was in fact a mixture of foreign cultures as diverse as the Viking or the Celtic was not discussed. Public perception was that the drastic break in style and suspected loss of national identity coincided with the Anglo-Norman conquest.

These political, cultural and religious associations have also been extended by the modern inclination to view Gothic art as inferior. As a style it has been criticized as rigid, flat and monotonous, and these, unfortunately, are qualities that have been associated with the art of both the medieval period in Ireland and the later Victorian Neo-Gothic period.[33] Even though the Gothic literature written in Ireland in the nineteenth century by Charles Maturin, Sheridan Le Fanu and Bram Stoker, all of whom were born in Ireland and came from an Anglo-Irish Protestant background, is now highly fashionable, it was not always so. The distinctions between medieval Gothic and Victorian Gothic appear to have been blurred, but it is clear that Victorian Gothic is also partly responsible for the negative profile of the medieval style after which it was called. The same negative cultural associations applied by the colonists to the Gaelic Irish in the sixteenth century are found in the Victorian period.[34] It was in the 1860s and 1870s that caricatures of the Irish as apes, suggesting an evolutionary inferiority, first appeared in magazines such as *Punch*. These publications, with their critical approach to the Irish, were yet again written from the perspective of a colonial and superior power. In the eyes of the Irish they perpetuated the negative associations of Gothic art with this force and did nothing to correct this image.

Not all the political or cultural reasons which have been used to justify the Irish inability or refusal to refer to the art of the later medieval period as Gothic can be related to the idiosyncratic qualities of the Insular style itself or its differences from the international style. Religious and art historical, as well as modern preferences, can all be seen to have had a major influence on the acceptance and rejection of the style in Ireland.

Unlike the appreciation of Gothic art in Britain, which has undergone periods of total neglect and extreme fashion,[35] the attitude in Ireland appears to have been consistently negative. The entrenched and deep-rooted antagonism towards the style is mainly the result of historical perceptions, but there is a certain amount of ignorance about the period because not enough is known of the extensive remains. It may seem overly optimistic to believe that the wheel of fortune has turned, but it is only within the last twenty or so years that any large-scale research has been undertaken into Gothic Irish art. The strong cultural and political associations have from its inception prevented any objective evaluation.

Despite the general focus on the Celtic in Irish art history, a number of scholars, mostly from an Anglo-Irish Protestant background, undertook research in Gothic Irish art and architecture. Much of this research understandably focused on architecture. The first study to include architecture of the later medieval period in a general survey of the country was published by Arthur Champneys in 1910.[36] It is still an invaluable source of information, and it was not until the middle of the

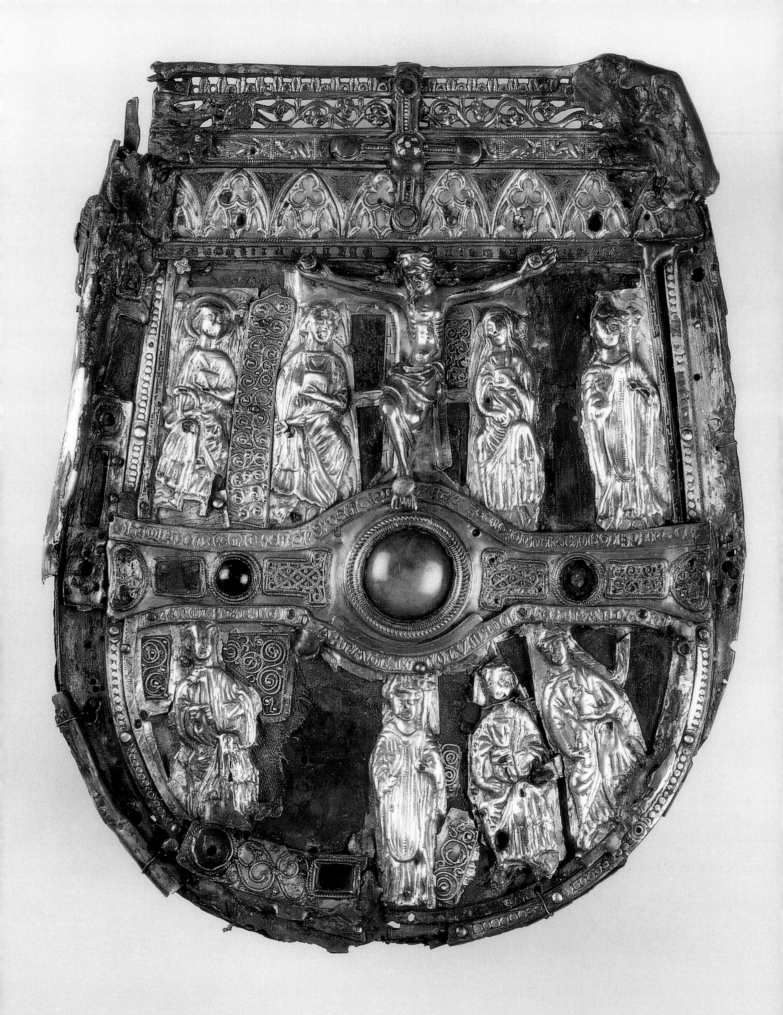

century that an equally systematic series of studies was made by Harold Leask.[37] As recently as 1925, in a significant study, the archaeologist the Reverend Patrick Power, expressed in uncompromising terms his belief that the introduction of Gothic art also marked the end of the 'Irish' in art: 'Cormac's Chapel marks the last stage in the growth of art. It is possible that Irish architecture would have grown to something higher still – to a beauty such as the world had not known since the halcyon days of Greece – had not the invader come on the scene. At any rate Irish architecture died when native independence ended. It had taken many centuries to grow; it died in half a century.'[38]

Before independence in 1921 a number of other publications on Gothic art appeared, including the pioneering work on seals by Armstrong.[39] By the mid-twentieth century isolated objects and buildings continued to be studied but there was no attempt to integrate the various strands into an overall picture.[40] The situation did not improve with the establishment of art history as a formal discipline in the mid-forties and an increasing interest by foreign scholars in Insular material. Even Françoise Henry, the doyenne of Irish art history who devoted much of her life to the study of Irish pre-invasion art failed, except for one foray into later medieval manuscripts, to study Gothic art in Ireland. Like so many others, she also saw the arrival of the Anglo-Normans as being a watershed: 'In many ways, the Norman invasion marks in Ireland the end of a world, and certainly the death of original artistic endeavour. For centuries after that, art in Ireland was almost completely dominated by foreign models, and the old fire of invention was nearly always lacking, though the great sense of proportion and the decorative feeling of the old style survived for a long time.'[41] Her successors also failed to research this area.[42] Three contemporaries of Henry did much to promote the arts of the period: Catriona McLeod, John Hunt and Helen Roe fought to integrate their research into the broader syllabus of art historical studies in Ireland and create an awareness of the riches of this period.[43]

Within the last twenty years studies on Gothic architecture have proliferated and have attempted to analyse systematically the origins, interrelationships and structure of the style for the secular and ecclesiastical remains that are still one of the most prominent and least understood groups of field monuments.[44] Urban development, with the consequent need to excavate, has had a significant impact on our understanding and knowledge of the medieval world. One scholar who has continued the tradition of both Champneys and Leask and who has done much to promote the unique nature of what survives in terms of Insular and English connections is Roger Stalley.[45] His studies focus on architecture rather than fine art, but have always attempted to evaluate the remains systematically against their European background. More recently, the studies of such scholars as Raighnall Ó Floinn and Peter Harbison have dealt with single works, groups of objects and media such as metalwork, and these are part of the increasing interest shown in this forgotten area of art history, which will gradually be restored to its rightful position.[46] In terms of study, the ecclesiastical remains fared better than did those of the secular world, which are only now being researched.[47]

Even in twenty-first-century Ireland the word Gothic still has associations and connotations that are difficult to overcome. The cultural ties that the Anglo-Normans brought with them linked Ireland irrevocably to its nearest neighbour, England, and many of these still remain. It is claimed that Gothic is now a term that is free of controversy. While this may be the case elsewhere in Europe, it is far from true in Ireland, and there is still much to learn of the mechanisms that were responsible for its rejection.[48] There is as yet no publication on Gothic art in Ireland and there is a difficulty in applying the word to either this timespan or style.[49] The creation, at the start of the new millennium, of the first gallery devoted to Gothic art (albeit called Late Medieval Art) within the National Museum of Ireland is a sign that old barriers are being broken down. This long neglected period may yet be valued for the riches it contains and be restored to its rightful place in Irish art history.

Cashel of the Cathedral

Throughout history man has been attracted to naturally elevated sites for the construction of important structures. This was clearly one of the main reasons why the limestone outcrop at Cashel, Co. Tipperary, over sixty metres above the surrounding fertile plains, was selected towards the end of the fourth century (*c.*370) as the royal seat for the kingdom of Munster (pl. 29).[1] The exact date at which the first church was built on this rock is unknown; during the late twelfth and early thirteenth centuries royal inauguration ceremonies seem to have been essentially secular in nature[2] and may not have required a separate religious building. It is clear, however, that at a slightly later date new kings were brought to the church which Cormac Mac Carthaig had built on this fortified site. Cormac's Chapel, as it is now known, the oldest and most studied of the surviving structures on the Rock, was built between 1127 and 1134. It not only marks the introduction of the Romanesque style into Ireland,[3] but is also the first evidence we have of a religious building on the Rock. In 1101 control of the Rock was transferred from the secular to the religious authorities, when Muirchertach O'Brien, King of Munster, granted 'Cashel of the kings to the religious, without any claim of layman or cleric upon it, but to the religious of Ireland in general'.[4]

The Rock of Cashel has occupied an important position in Irish history since the first and most important synod of the twelfth century was held there in 1101. This meeting introduced the first of many changes in canon law and ecclesiastical structure of the medieval period. Although bishops had existed before this time, they had little power, were not supported by any administrative

organization and had no real area of jurisdiction.[5] The first archbishop of Cashel to have a diocese was Mael Iosa O h-Ainmire, who was consecrated in 1106. He and over fifty other bishops who attended the nearby Synod of Rathbreasail in 1111 were signatories to the proposed division of the country into two archbishoprics: Cashel in the south and Armagh, with the primacy of all Ireland, in the north. The see of Cashel was to have twelve bishops.[6] In 1151, however, the number of archbishoprics was increased to four: Armagh, Cashel, Dublin and Tuam. The area over which Cashel had jurisdiction, although it covered the province of Munster, was drastically reduced by the exclusion of Dublin; this structure remained relatively unchanged, apart from modifications at the Council of Kells in 1152, until the end of the medieval period. The medieval dioceses of over half of the fifty-two medieval Irish cathedrals were established at the Synod of Rathbreasail with the majority of the remainder being set at the Synod of Kells in 1152.[7]

Apart from Cormac's Chapel, the first religious building on the Rock for which there are documentary records, scholars have proposed, and indeed the history, role and importance of the archbishopric would seem to have demanded, that there must have been an earlier church on the site.[8] Dates ranging from 1101 to 1111 (to link in with the synods that were held in Cashel) have been suggested as building dates for the first cathedral, but all traces of any structure, if any existed, have now disappeared. The positions of the other monuments on the Rock also support the possibility of another building lying between Cormac's Chapel, the round tower, the high cross and the other monuments on the site. It is also

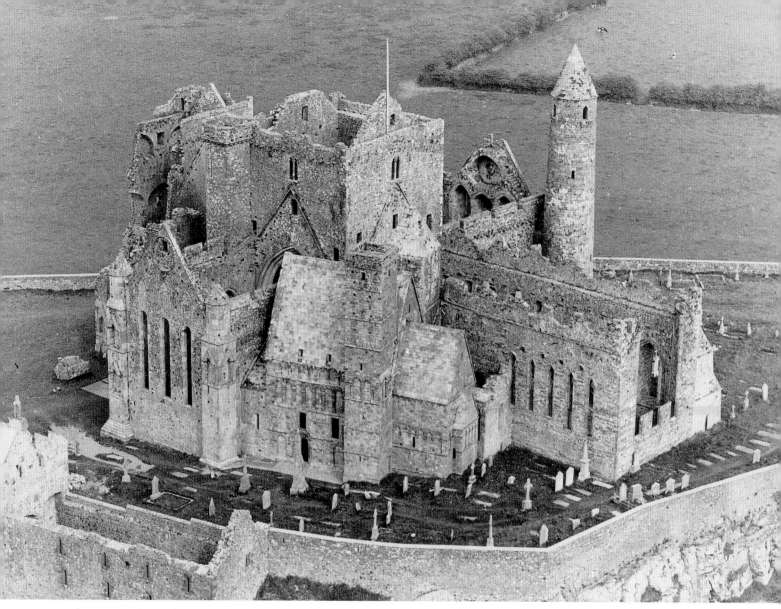

Plate 29 Aerial view of the Rock of Cashel, Co. Tipperary, from the south-east, with the unrestored Vicars Choral (left foreground), Cormac's Chapel (centre foreground), the cathedral (diagonally across centre) and the round tower (right background).

highly probable that Cormac's Chapel, despite its unique position and the obvious influence it had on Irish architecture of the period, would have been inadequate for the needs of such an important archbishopric between 1134 and 1169. This later date marks the earliest reference to a cathedral on the Rock, which we know was built by Domhnall Mór O'Brien, King of Thomond. This structure, begun in the year of the Anglo-Norman invasion, would almost certainly have been in a late Romanesque style, but little is known of its relationship or relative position to Cormac's Chapel, which must have been close. We know now that Cormac's Chapel was influenced, if not actually built by foreign craftsmen, and there seems little reason to doubt that the cathedral must

also have employed a foreign workforce and probably been even more lavish. The fact that a cathedral was either built or rebuilt thirty-five years after Cormac's Chapel was consecrated must indicate not only the inadequate nature of the existing structure, but also a growing need for an even more imposing church.

Had it survived, the cathedral, dedicated to St Patrick, would certainly have filled a gap in our knowledge of architectural styles for the period between the mid-twelfth century and the arrival of the Gothic style some forty years later. Neither the speed with which this cathedral was finished nor its size are known, but the fact that yet another synod was held in Cashel in 1172, three years after building began, suggests that at least part of it was

ready for this important meeting. O'Brien's cathedral was replaced in the early thirteenth century by the present building. The date at which the new cathedral was built is also conjectural.

Interestingly, none of the earlier structures was incorporated in any of the successive rebuildings undertaken on this site. The need to create buildings suited to the new organizational structures devised at the various synods must have been foremost in the minds of the church authorities in a period during which most of the important cathedrals of western Europe were built. In a number of instances existing buildings were used when new cathedrals were created, others were modified and altered, but, in a period during which most of the important cathedrals were built, only two were constructed anew: those at Killaloe and Cashel.[9] The Irish did not always construct large or grand cathedrals and indeed many medieval cathedrals started life as small early Christian churches. Even though Cashel cathedral has been criticized 'as grand in scale but lacking the sophistication of European Gothic architecture',[10] its fine architectural sculpture has been noted but never before studied.

After the Anglo-Norman invasion bishops could be Irish, English or from mainland Europe. Cashel is unusual in that it was administered throughout the entire medieval period by a succession of Gaelic archbishops. The preferences, allegiances and close relationships between these bishops, the Anglo-Norman administration and English Church makes this building a complex case study for medieval Ireland. The size of a cathedral does not appear to relate to the area of the see or archbishopric nor to its relative importance in the overall administrative structure; Christchurch cathedral, Dublin, and Armagh cathedral (which have equally large archbishoprics) are not comparable to the larger Cashel cathedral. The reasons behind a building as large and imposing as Cashel cathedral must lie in its status as a symbol of the English church in Ireland and of the power and strength of the invaders. It is a physical manifestation of the Irish bishops' submission to the Church of England at the Synod of Cashel in 1171, when it was declared that 'all divine offices shall henceforth be celebrated according to the observances of the Church of England'.[11] In many respects it is a religious parallel to the many imposing castles that reinforced the secular conquest. From the very beginning it is clear that the Rock of Cashel was singled out for a building that was

to reflect not only its role as head church of one of the four sees but also its older and more important religious and secular history, which now needed to be subsumed within the English dominance.

Cashel cathedral is a pivotal building in the history of early medieval Irish architecture and its influence certainly rivals that of Christchurch, Dublin. Lying as it does, at the centre of a significant area of influence,[12] Cashel shared not only a workforce but also the design and iconography of sculpture with a number of other buildings – those as distant as Youghal and as close as Athassel.[13] Together with the St Canice's cathedral, Kilkenny, Cashel lies in one of the most important areas of Anglo-Norman influence, astride the present-day border between Kilkenny and Tipperary. It was built in an English style with no concession whatsoever to native designs. There is, unusually, a similar lack of Gaelic influence in the fifteenth-century work, at a time when even minor elements were making their presence felt in such neighbouring buildings as Holycross Abbey, Kilcooly Abbey and St Mary's Priory, Caher. Considering the importance this building must have had in the surrounding area, the lack of distinctively Irish work of the later medieval period is unusual and is perhaps indicative of the fact that the cathedral was perceived as an English structure.

Cashel is one of the largest of the medieval Irish cathedrals to survive relatively intact – its only real rivals in terms of size or structure lie in the secular world of thirteenth-century castle architecture (pl. 29). It is also the most complete of the medieval cathedrals, despite the fact that it has been derelict since the middle of the eighteenth century and was among the first of the ancient monuments to be taken into state control in 1869. The cathedral is unusual for Irish medieval architecture in that it dates from one period, with only minor subsequent alterations from the fifteenth century. It is also one of the few Irish cathedrals to have been untouched in the Victorian era; little attempt at restoration has been made in modern times. Despite its importance, no documentary records exist for the cathedral and any interpretation of its style or date must come directly from its remains. There has been surprisingly little research undertaken on the cathedral, other than that by Leask,[14] who suggested that it was built under three successive archbishops, starting in either the third or fourth decade of the thirteenth century and ending towards the end of the same century (c.1270). The architectural sculpture that survives in the cathedral

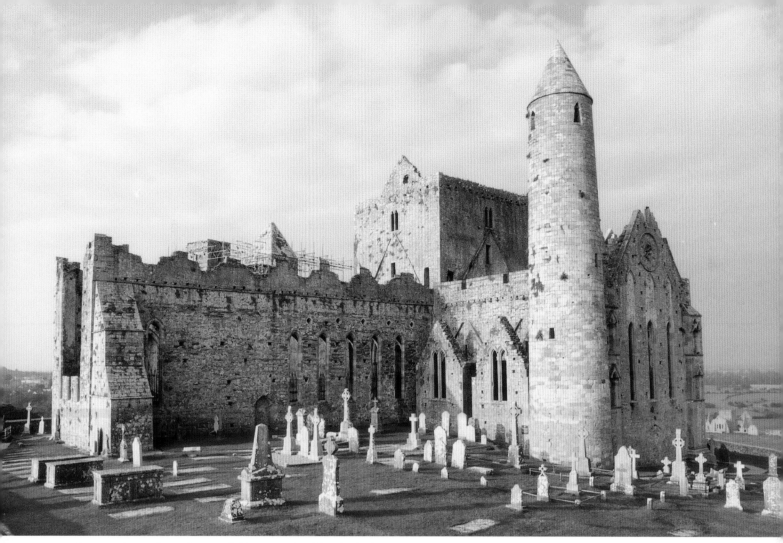

Plate 30 Now roofless and surrounded by post-medieval burials, the disproportionately long nave and round tower at Cashel cathedral are best seen from the north-east. The two chapels in the eastern wall of the northern transept are unique to this arm of the building.

is some of the most impressive Gothic work in Ireland. Leask made no use of this sculpture in his studies and no inventory exists of the entire assemblage; but it certainly provides valuable evidence for stylistic changes in the building. Leask's proposed dating remains unchallenged, and this study will suggest only minor changes to his dates.

Whereas the first Gothic cathedrals in England date from the last thirty years of the twelfth century, those in Ireland are much later and are certainly less ambitious than their English counterparts. Stalley proposed a date in the early years of the thirteenth century for the Gothic carvings from the nave at Christchurch cathedral, Dublin,[15] which have traditionally been seen as the inspiration and model for much of what remains in Ireland, including work at Cashel. It has been claimed that these Christchurch carvings, particularly the capital with human head and foliage – also one of the most common

motifs at Cashel – were the inspiration for all the later uses of this motif in the south of the country.[16] While this motif may have been derived from originals in the West of England, the examples at Cashel are considerably later and sufficiently different from those at Christchurch not to be directly based on the Dublin models. Nearly all the sculpture in the cathedral is decorative and in many ways reflects the introduction of secular elements into religious art in this period, as we shall see.[17]

Evil in the Choir

The cruciform building at Cashel is aisleless, has a disproportionately long choir in relation to the nave, equal-armed transepts and a central crossing tower (pl. 30). The oldest part of the structure is the long, rectangular choir, built entirely in sandstone. This part of the structure was

Plate 31 (*facing page*) The choir at Cashel cathedral, from the east, with the lancet windows in the northern and southern walls. The angle of the roof is visible on the central-crossing tower.

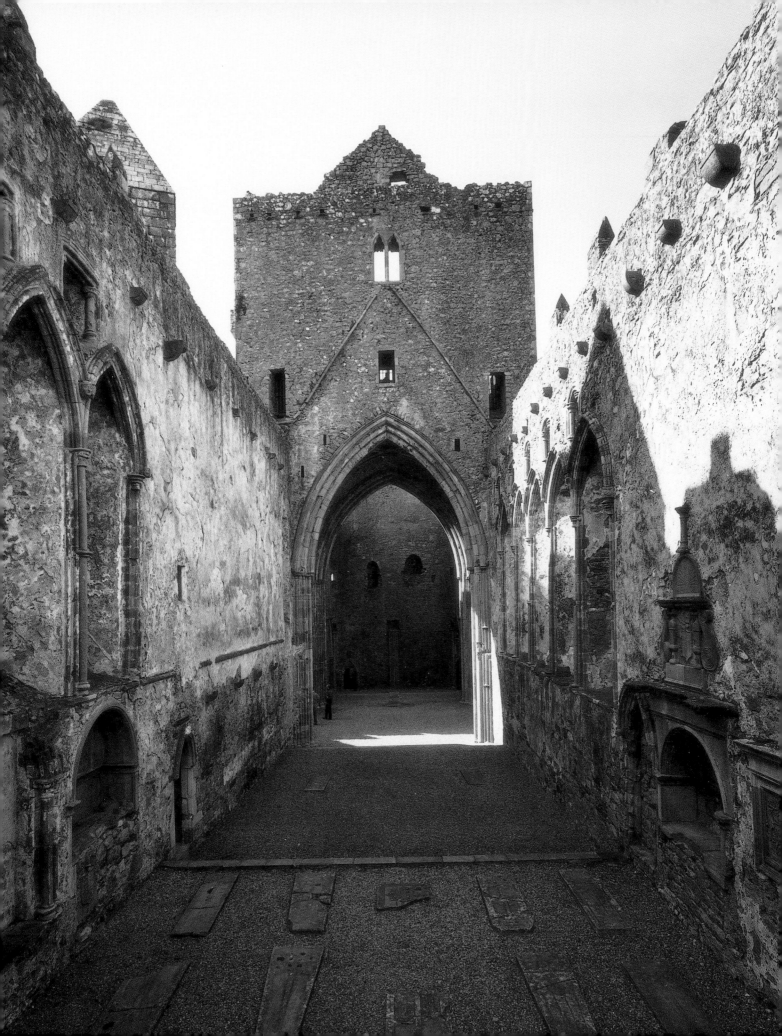

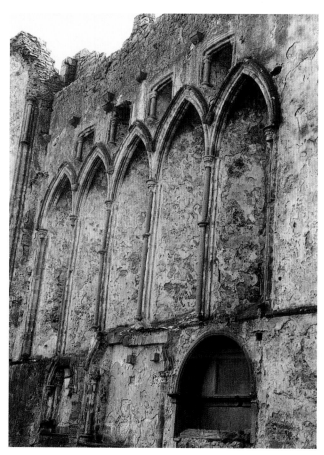

Plate 32 The group of five lancet windows in the interior of the southern wall of the choir in Cashel cathedral (*c.*1230–40) are typical of early thirteenth-century architecture in this area. The openings between the lights are quatrefoil on the exterior but rectangular on the interior and are similar to those found at the nearby Hore Abbey.

Plate 33 The introspective, inward-looking and badly weathered sandstone heads of the label stops on the exterior of the southern wall of the choir (*c.*1230–40), face each other and are not found elsewhere at Cashel cathedral.

dated by Leask to either the third[18] or fourth[19] decade of the thirteenth century (pl. 31), during the archbishopric of Marianus O Brien (1224–38), about whom comparatively little is known.[20] The northern and southern walls are broken by a series of five (originally six in the north wall) lancet windows; unusually, these are not opposite each other but are strategically placed to maximize their purpose. Those in the southern wall are positioned more to the east, so that they do not overlook the north wall of Cormac's Chapel, which would block out light (pl. 32). Two other single windows break each wall, but these are separate from the larger groups. Sculpture in the choir is used extensively, with every hood moulding, both inside and out, ending in either a human head or a stylized foliage ball. Considerable variation is introduced in this narrow repertoire of motifs, but all the heads are clearly of one period. They are characterized by a roundness and fullness, a pronounced tendency to look inwards towards a door or window, rather than out towards the viewer, as is almost universal elsewhere, and an all-pervasive evil expression (pl. 33). Those on the northern wall of the interior are particularly grim, with downturned mouths, while their parallels on the southern wall are positively grotesque (pl. 34).

Grotesqueness in Irish art of this and later periods has two characteristics: First, there is a tendency for such carvings to be banished to the higher areas of buildings, well out of the sight of any viewer (pls 35 and 38). This is the case at Ballybeg Priory, Co. Cork, where the faces peer down from under the crossing. The carvings at Ballybeg and those at the Monastery of the Holy Trinity, Adare, Co. Limerick (pl. 36), are among the closest in appearance to the grotesque carvings at Cashel. Those at Ballybeg date from the mid- to late-thirteenth century,[21] while the Adare examples are from the rebuilding of the monastery undertaken by Thomas Fitzgerald, Lord of Offaly, in 1272.

The second characteristic of Irish grotesques is the use of incised lines on both the body and head (pls 37–9).[22] Deep and finely incised lines follow the facial contours, adding fierceness to the image; additionally, some of the examples at Cashel have their tongues extended. That these lines were meant to reinforce grotesqueness and 'otherness' is nowhere more pronounced than on exhibitionist or sheela-na-gig figures, such as the one at nearby Fethard Friary, where the body and face are scored (pl. 40).[23] Not all such grotesque figures have these facial lines; in some cases they are used only to define the

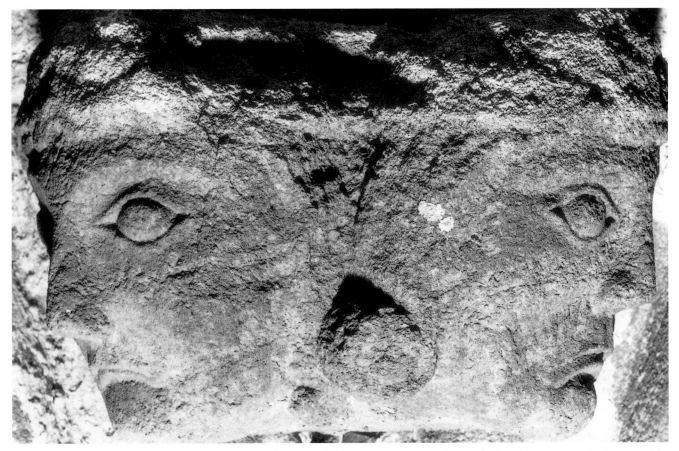

Plate 34 (*above*) Janiform heads with distinctively carved, finely modelled features characteristic of the predominantly grotesque and evil nature of the sculpture in the interior of the choir (*c.*1230–40) at Cashel cathedral.

Plate 35 (*below*) The grotesque and evil expression on these sandstone heads, high up on the interior of the choir at Cashel cathedral (*c.*1230–40) is achieved by their down-turned mouths and solemn expressions.

ribcage, but in a number of instances, such as the sheela-na-gig from Cavan they cover the entire body.[24] The use of lines to denote evil is also found outside Ireland; in the scene of the Last Judgement on the west tympanum at Saint-Foy, Conques, all the demons have lined bodies and faces, and on the capital from Autun by Gislebertus, which shows Judas hanging himself (now in the cathedral's Musée Lapidaire), the demonic figures waiting to take the body have these lines.

The extended tongue was also used to denote evil and is a characteristic of the devil, as in the twelfth-century mosaic from the cathedral of Otranto, where Satan has a long tongue that eventually bifurcates. Another example of the same motif appears on a twelfth-century capital in the Church of Saint-Julien, Brioude (south arcade, pier one, east side), where one of two horned devils has its tongue extended.[25] This can also be used to mock, as on a panel of the Crucifixion (Gemäldegalerie, Berlin; inv.

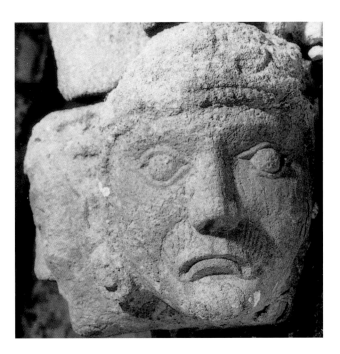

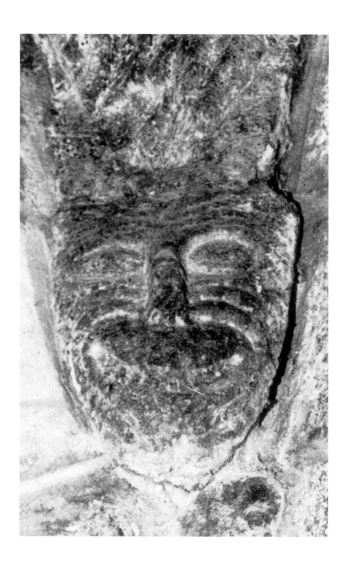

Plate 36 (*left*) It is frequently impossible to determine whether a grotesque head is animal or human, both display the same characteristic series of all-over lines. Monastery of the Holy Trinity, Adare, Co. Limerick, *c*.1272.

Plate 37 (*below*) This grotesque limestone head carved almost in the round is one of the few surviving thirteenth-century gargoyles at Athassel Priory, Co. Tipperary.

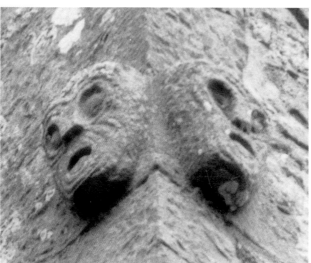

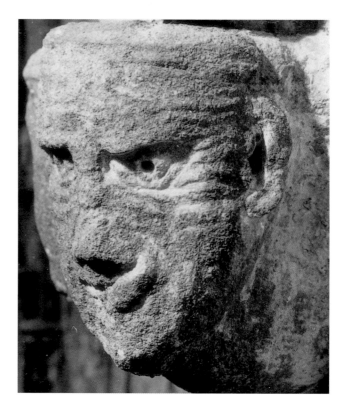

Plate 38 (*above*) An unusual pairing of two thirteenth-century grotesque heads is found on this gable at Duleek Priory, Co. Meath. The heads, each with an all-seeing eye, face in opposite directions.

Plate 39 (*right*) Label stop in the southern wall of the choir at Cashel cathedral combining the twin evil connotations of extended tongue and all-over facial grooving.

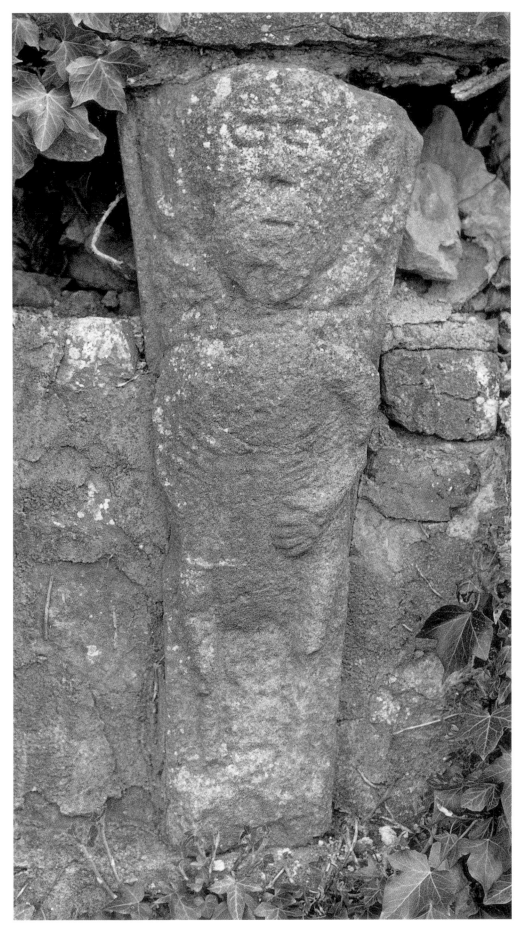

Plate 40 Sheela-na-gig at Fethard Priory, Co. Tipperary (*c.*1430). The distinctively modelled ears, oval face and facial grooving are also found on label stops in the northern transept at Cashel cathedral.

1219), which is dated to 1400–10 and shows the soldiers with extended tongues mocking Christ. The same gesture is found in a late thirteenth-century English manuscript in Cambridge (St John's College Library, K.21, fol. 51r.), where the soldiers who mock Christ at his crowning with thorns also extend their tongues. There can be little doubt that the early carvings at Cashel were intended to represent evil, but their inclusion on the interior rather than the exterior, of the building, and especially in the choir, is unusual (pls 34, 35, 39, 42).

While all the carvings in this part of the building appear to be the work of two or three sculptors, there are surprising variations, especially on the southern wall, where janiform heads are found as a single label stop. This motif is unique to Cashel in the Gothic period and includes male and female heads with contradictory expressions looking in opposite directions (in such cases the male head is normally grotesque and the female is naturalistically represented), as well as two male heads (with equally evil expressions). This motif can have a variety of meanings, including the commonly found symbolism in which the heads represent the dual nature of the Devil.[26] It is tempting to see these symbols of evil invading the interior of the church as paralleling the political situation of the time. The two heads, one looking forwards and one backwards, could be indicative of the political, social and religious changes that were under way. Perhaps they were intended as a reminder of the presence of the new power in both Church and society represented by the extensive Anglo-Norman colonization of the surrounding area, where they were building new monasteries – Hore Abbey (founded in 1272), Cashel Dominican priory (1243) and Cashel Franciscan friary (c.1265), some of which shared their workforce with Cashel cathedral. The single heads on the label stops in the choir have a more introspective stance, looking towards the body of the church rather than outwards to the colonized town of Cashel which lay beneath its walls. How overt a statement these sculptures were, and to whom they were addressed is entirely conjectural, but it is clear that as time went by and the building progressed towards the west, these heads changed direction and began look outwards towards the countryside, perhaps indicating greater acceptance of the political situation.

Compared to the relatively elaborate sculptural programme in the interior, that on the exterior of the choir is plain, and much of the work has been weathered beyond identification. There are no comparable heads on the exterior hood mouldings of these groups of lancet windows; instead, the four quatrefoil windows over the arches of these lancets have label stops on the southern side of the choir only. These small windows with deep embrasures are similar to those at Hore Abbey, where the same designs are found in the clerestory, but without the sculptural embellishments. The heads at Cashel are angled inwards to face each other and the window opening rather than the viewer.

Set high up in the interior of the choir on the southern side are some of the most interesting corbels surviving from the thirteenth century. Still surrounded by their original plaster, these are crudely carved abstractions of bestiary subjects, including the head of an owl, a ram and a man (pls 43 and 44). All are carved on the underside of the corbels and they are among the first uses of this manuscript source in Irish medieval art. Other examples of these motifs, including the ram and owl, are found elsewhere in the cathedral, but they date from the fifteenth century. These later corbels are now in the tower, and their original locations are unknown. All of these carvings, except for the label stop with the triton on the exterior of the northern transept (see pl. 126), reflect the popularity of this manuscript source, especially in fifteenth-century Irish art. Like the rest of the sculpture in this part of the building, the three corbels in the choir are set high up on the interior walls and are so small as to have been unnoticeable once the roof was in place. There are no parallel carvings on the north wall – a characteristic of the lack of symmetrical balance in Gothic art in Ireland.

While the ram is open to various symbolic interpretations, there can be little doubt as to the evil associations of the owl, particularly as most of the carvings in this part of the building are evil in nature. Furthermore, while they are not quite at the level of the medieval roof, these three corbels supported the original roof beams. Although crudely carved, the ram's head is the most accomplished carving of the three, with finely cut, back-turned horns and a flat face with little modelling.

The accompanying male head with its flat-featured, oval shape, and the owl, whose eyes alone are shown, are cruder work; indeed, the concentration on the most distinctive feature of the owl – its eyes – is reminiscent of prehistoric Irish art. In the bestiaries the ram was a symbol of war and it is frequently shown with its horns interlocked with those of another ram.[27] Comparatively

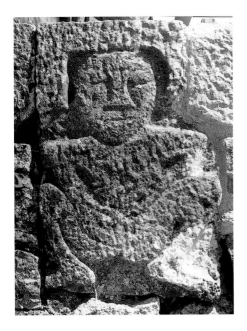

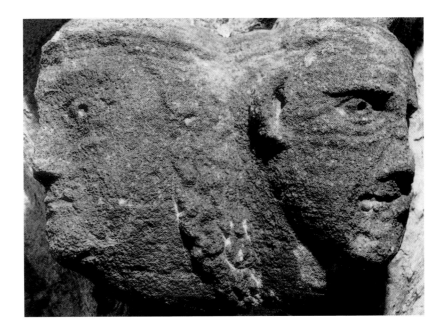

Plate 43 (*above*) Stylized ram's-head corbel of the thirteenth century in the southern interior wall of the choir at Cashel cathedral. (*c.*1230–40). It is similar to a fourteenth-century ram's head now in the tower, and was clearly influenced by this early work.

Plate 41 (*top left*) Squatting crouched exhibitionist figure, now embedded in one of the external walls of Cashel cathedral, which has been dated to the post-medieval period.

Plate 44 (*above*) Stylized owl's eyes on a corbel in the southern interior wall of the choir (*c.*1230–40) at Cashel cathedral.

Plate 42 (*top right*) Female and male janiform heads in the southern wall of the interior of the choir (*c.*1230–40) at Cashel cathedral.

little has been written on the symbolism of this animal, apart from its role in the sacrifice of Isaac.[28] Of the seven Irish examples, those in the naves at Cashel cathedral and Holycross Abbey are paired opposite the owl. As a symbol, the owl is found elsewhere, but at a later date, especially in this particular area of Co. Tipperary, where it became popular. One of the finest examples is less than

nine miles away at Holycross Abbey, where the life-sized but damaged carving is on the southern wall of the nave, directly opposite an owl in full flight (pl. 46). Another, similar owl is found under the tower at the Franciscan friary, Waterford, in an equally inaccessible location (pl. 45). While both these examples are higher than eye-level, they are certainly more visible than the Cashel owl, and

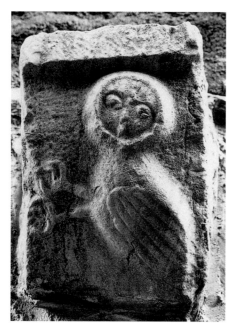

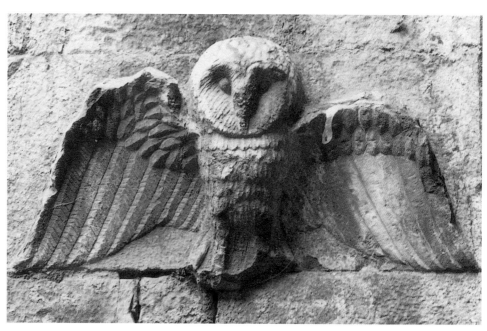

Plate 45 Naively carved owl on a corbel, similar in style and context to the fifteenth-century example at Cashel cathedral. Franciscan friary, Waterford.

Plate 46 An owl in flight, one of the finest carvings from fifteenth-century Ireland. Holycross Abbey, Co. Tipperary.

may play on the opposing symbolism of virtue (ram) and vice (owl). These mid-fifteenth-century carvings provided the inspiration, if not the actual sculptor, for the carving of the two rams' heads at the Franciscan friary at Ennis, Co. Clare, where they are found as corbels on the northern side under the tower (pl. 47).[29] Two other corbels directly opposite these, a bishop's head (flanked by angels) and a king, have been interpreted as representating Church and state. The ram's head at Kilkenny Friary, in its remote position high on the vaulting under the tower, is closely related to the other examples; the simply carved head with its prominent horns points away from the choir and dates from the fifteenth century.

The remaining two Irish examples of this symbolic animal come from Clonmacnoise cathedral, Co. Offaly, and the fourteenth-century tower at Cashel cathedral (pl. 71). The first of these is one of the smallest animal representations from fifteenth-century Ireland and is neatly fitted in between the orders of an arch in the southern wall of the chancel. Carved by a mason whose work can also be found at Clontuskert Priory, Co. Galway, this small animal head is the only example not to be related to another symbol, neither does it share the remote

context of the other carvings, but its small size would certainly have meant that it would have been difficult to see and, as such, would have had the same effect.

The iconography of the carvings in the choir at Cashel cathedral, with their particular focus on evil, is unique. There are no other decorative programmes that have such an all-pervasive emphasis on vice. The cathedral was, to use Camille's phrase, an edifice that looked out, not in, on society.[30] The evil in the choir, the most sacred area of the entire structure, is perplexing. Camille's suggestion that the distance of such figures from the worshipper puts them outside this spatial area and relegates them to the confines of the world and that their removal from society also puts them at the physical extremities of the building may be the reason why they are found in such a position at Cashel. They are symbols of evil, and evil always lurks at the extremeties of society. The iconography of this part of the cathedral, with its use of bestiary subjects and emphasis on the grotesque and evil, would seem to confirm the later of Leask's two proposed dates for this part of the building. Furthermore, the fact that bestiary subjects make their first appearance in English sculpture towards the mid–late thirteenth century also suggests that these carvings may be closer to the middle part of the

century than the third or fourth decade envisaged by Leask.

Although there are masons' marks on a fifteenth-century insertion in the southern wall of the choir at Cashel, there is only one feature in this part of the building, a door in the northern wall, which has thirteenth-century marks. This is unusual considering the liberal use of such marks elsewhere in the building.[31] None of these earlier marks on this part of the building can be linked to any of the nearby sites. The choir clearly had its own workforce and was built entirely in one phase with no overlap at all with the remainder of the cathedral. Indeed, it seems more than possible, considering its size, that when the western end of the choir was completed it could easily have acted as a cathedral in its own right.

Opulence at the Crossing and Transepts

A square tower supported by four massive piers, each of which is different, rises over the crossing. The pointed arches that rise from richly carved capitals are, like the piers, of several orders, all of differing profiles (pl. 49). The crossing space and the transepts on either side of the tower are 120 centimetres wider than the chancel, which creates a certain lack of balance in the cathedral's design.[32] The piers echo this imbalance, as they are not all of one period. Their capitals are among the most richly decorated areas of the cathedral and are varied in design. Despite the fact that they are well out of sight of the visitor, the small human and foliate designs on the capitals are worked in considerable detail (pls 50–52). There is little of the grotesque here and, instead, the carvings present us with a series of 'portraits', caricatures and semi-abstractions. Most of the twenty-two capitals on the two piers in the southern transept have small human heads and busts interspersed with foliate motifs. Predominantly male, these heads peer out from their foliate surrounds, hold the ball-shaped foliate divisions in their tiny hands and wear elaborate headdresses (pl. 53). One of the most interesting of these figures is a small anthropomorphic head with an ape-like jaw composed of a series of stylized lines rising to a peak (pl. 54). The closest parallels within the cathedral to these carvings are the capitals on the southern door of the nave, which are the work of the same sculptor and thus subtly link the two parts of the building.

Plate 47 One of a pair of mid-fifteenth-century ram's-head corbels under the crossing at Ennis Friary, Co. Clare.

Plate 48 Fifteenth-century miniature carving of a ram's head at Clontuskert Priory, Co. Galway.

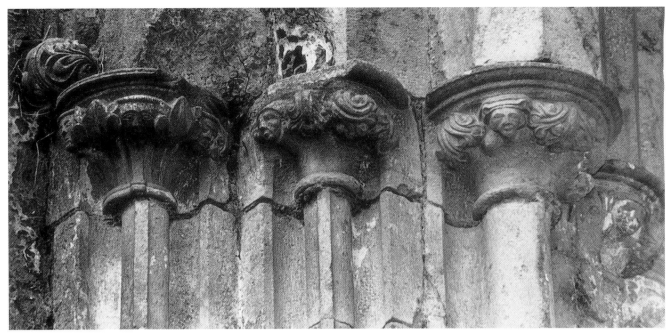

Plate 50 The capitals to piers under the crossing at Cashel cathedral have miniature human heads and foliate motifs (*c.*1240–50).

The capital with human head, a particularly popular motif in early medieval Ireland and the west of England, has been studied by Stalley,[33] who proposed that the examples in Christchurch cathedral, Dublin, are the earliest in the country and provide the prototype for the motif's dispersal throughout the country (pl. 55). Its introduction into Ireland may have been from Wells, via Worcestershire, to Dublin. The examples at Cashel have been criticized as crude,[34] which is true only when they are compared to those at Christchurch. The motif was adapted to Irish conditions and preferences and the generally smaller size of capital. The heads are consequently smaller than those in England, but to compensate for this they are far more detailed. Stalley noted a brooch on one of the examples at nearby Athassel Priory,[35] but those at Cashel cathedral are even more detailed. At Cashel the heads frequently develop into miniature busts with shoulders and hands included, and the rest of the body

Plate 49 (*facing page*) The south-eastern pier under the nave crossing at Cashel cathedral (*c.*1240–50). The capitals have human heads and label stops. The chapels in the southern transept are within the walls, unlike those in the northern arm, which are external.

Plate 51 (*below*) None of the capitals on the piers under the crossing at Cashel cathedral replicates the designs of another. Each expertly carved head is distinctive in headdress and pose.

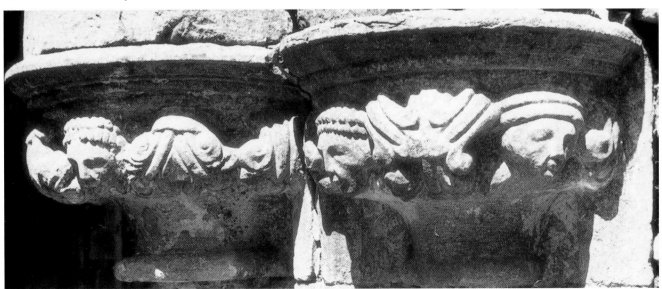

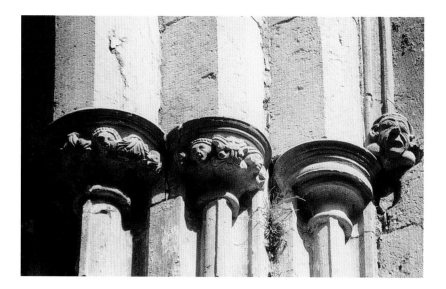

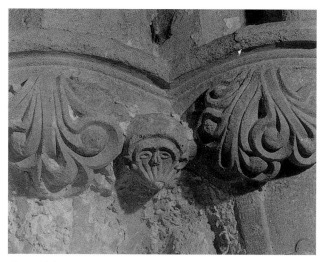

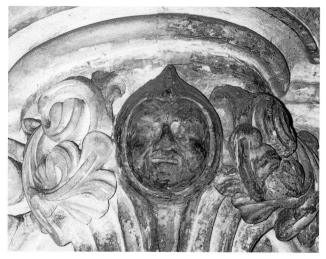

Plate 54 *(above)* Stylized ape-like miniature head in the southern transept at Cashel cathedral. The mouth replicates the foliate surrounds.

Plate 52 *(top left)* Label stop depicting a mitred cleric and capital under the crossing at Cashel cathedral. There are usually three to four heads on each capital with the bodies represented by fillet mouldings on the piers.

Plate 55 *(above)* One of a series of capitals with human heads at Christchurch cathedral, Dublin (*c*.1220). The characteristic pointed hood is also found on the southern transept at Cashel cathedral.

Plate 53 *(top right)* Capitals with human heads and label stop under the crossing at Cashel cathedral (*c*.1240–50). The use of limestone marks the change in building material from the sandstone used in the choir. This unusual grotesque head provides a continuity in motif between the choir and southern transept.

is implied by deeply cut linear designs where the fillet roll is normally found; some of these small carvings hold horns to their mouths and there is a considerable variety of headdresses, ranging from petal-shaped surrounds of the entire face to vertical leaf-like bands on either side of the face. The use of this motif continues into the fifteenth century, when it is found, for example, on the cloister piers at the Cistercian abbey at Jerpoint, Co. Kilkenny

(pl. 56).[36] In the fourteenth century the form changed considerably and the foliate motifs disappeared, leaving the focus on the actual head, as at Carrickbeg Priory, Co. Waterford. However the motif is most frequently found in thirteenth-century work in and around the Cashel and Kilkenny area.[37]

The label stops on the hood mouldings over the supporting arches to the tower at Cashel are even more

Plate 56 The capital with human head was a motif that continued to be used into the fifteenth century as in the cloister at Jerpoint Abbey, Co. Kilkenny.

Plate 57 Label stop at Cashel cathedral. The simple head reflects the paucity of decoration on the interior of the northern transept (*c.*1270–80), compared to the wealth in the southern arm of the crossing. Capitals with human heads have been replaced with less detailed foliate motifs.

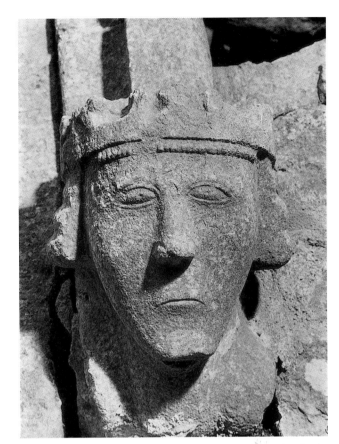

Plate 58 A label stop typical of the strong, angular style found under the crossing at Cashel cathedral. It is carved in the local hard grey limestone, unlike the work in the choir which is in a soft sandstone.

distinctive than the capitals. These life-size heads have an element of portraiture or at the very least give the impression of having been modelled from life; their detailed and naturalistic depiction differs considerably from the abstraction and symbolism of the human images in the choir (pl. 57).[38] The male and female heads under the tower wear contemporary headdress with hairnets, veils and crowns, and look either towards each other or else outwards from their lofty positions (pls 58–60). They are usually paired, with female and male found on each terminal; the only exception is on the south-eastern pier – a grotesque. The position of some of these label stops, in particular those on the southern side of the crossing, shows that the builders had miscalculated their designs. The carvings are squashed into spaces that are too small and the ribs of the hood moulding end abruptly. All the heads under the tower are stylistically similar, except for those in the northern transept, where they are more rotund in shape, heavier in design and lack the anatom-

ical detail of their parallels in the southern transept and nave. Indeed, the whole of the northern transept stands apart from the rest of the crossing and the nave. The capitals on the north-western pier beneath the tower have foliage motifs instead of human heads, and are more curvilinear and plastic in design than the other piers. Another distinguishing element of the northern transept is its overall plainness and lack of decoration; there is only one human head as a label stop on the windows compared to the many on the capitals and label stops in the southern transept.

If the interior of the crossing and southern transept are lavishly decorated, there are equally fine carvings on the exterior. Reflecting the wealth of the interior, this is the most embellished area of the whole building and the most prominent feature is the series of canopied niches in the corner piers of each transept. These piers, which are typical of many English cathedrals of the same period are crowned by octagonal turrets and pyramidal roofs

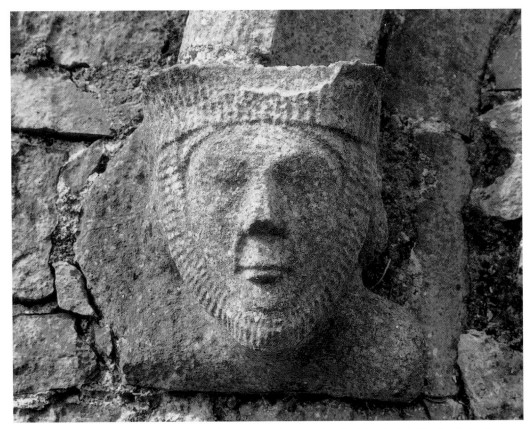

Plate 59 Label stop on the exterior of the southern transept (c.1240–50) at Cashel cathedral. The female head wears a characteristic flat-topped hat and simple veil.

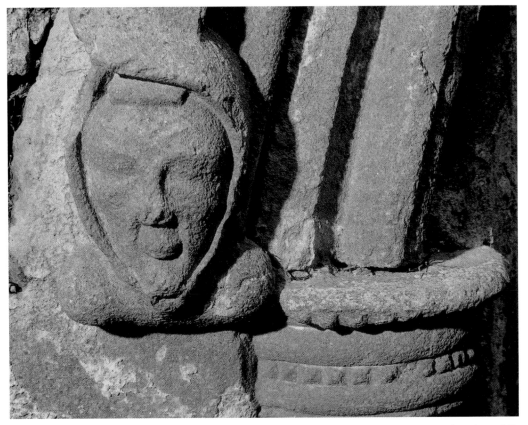

Plate 60 A number of the carvings at Cashel cathedral, such as this head (c.1240–50), may never have been fully finished. The lack of workmanship is typical of the exterior of the southern transept.

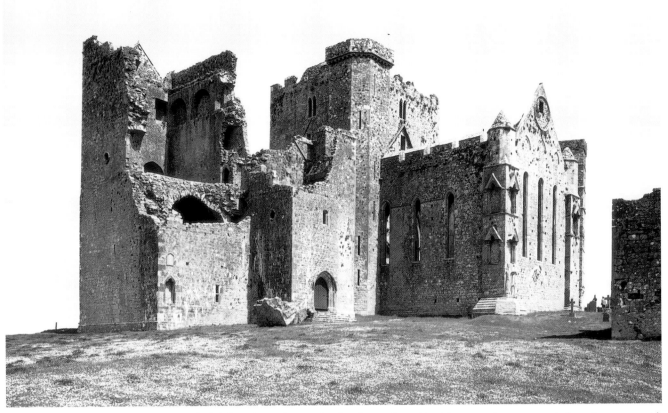

Plate 61 An early photograph of Cashel cathedral from the south west, showing the massive residential tower at the western end, the main entrance with porch in the southern wall and the niches in the southern transept. The high cross had not yet been moved to its present site in the foreground.

(there are no turrets on those in the northern transept). Niches with statuary are not uncommon in medieval Ireland, especially in the fifteenth century, but sadly anything they may originally have held has long since disappeared. The niches are unevenly distributed at Cashel (with four at the western end of the southern transept and two at the eastern end) reflecting the incline of the land (pl. 61). Each niche has a pointed gable over a trefoil-topped opening, with sculptural decoration in the form of labels stops at either end of the hood moulding and capitals to the pillars within. The capitals have human heads with little variety in either shape or gesture and are not as accomplished as those on the crossing in the interior (pl. 62). Interestingly, they are closely paralleled at Athassel Priory, where the work of the same sculptor can be traced.

However, the label stops to the hood mouldings closely intermingle fantasy and reality. With grotesque human heads, crowned busts, mitred bishops and women with smaller figures on their shoulders, all wearing some of the most exotic headdress imaginable, these carvings present a variety of gestures and styles unequalled in medieval Ireland (pls 63–5). All are competently carved, not with

the same realism as the heads under the crossing (on the interior), but nevertheless it is clear that they have also been modelled from nature. One of the few full-length figures to survive from the thirteenth century is the small child with arms folded on the left of its mother (pl. 64). These two figures, who make up a family group, again introduce the element of portraiture well beyond the sight of the viewer. Less reverential is another, smaller figure on the right-hand side of his or her parent, but in this instance, mimicking a gesture found in the choir – pulling a face and extending its tongue. However, not all of these carvings are virtuous in nature, and the presence of a triton with a lyre on the same label stop as an inverted female figure is yet another reminder of the presence of evil. Like the animal corbels in the choir, this is one of the earliest uses in Ireland of the bestiary as a source of inspiration.

The difference in architectural sculpture between the northern and southern transepts on the interior of the cathedral is repeated on the exterior, with neither label stops nor capitals found on the northern transept (pl. 66). It is also evident, however, that provision was made for such embellishments, but that these were never added.

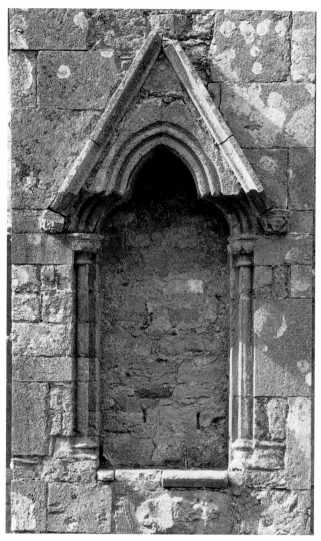

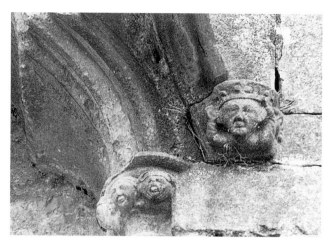

Plate 63 Label stop at Cashel cathedral (*c.*1240–50) depicting a bust of a king holding his crown. The capital with human heads is typical of the embellishment on the niches in the southern transept.

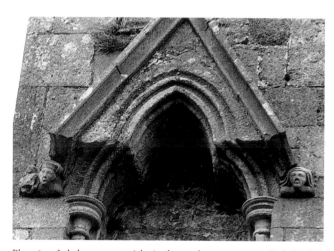

Plate 62 One of the six niches on the exterior of the southern transept at Cashel cathedral (*c.*1240–50). All are similar, with pointed canopies, label stops and capitals. The statues which they once held have now disappeared. One of the few carvings incorporated into the general walling of the building is visible under this niche.

Plate 64 Label stops on a niche in the southern transept at Cashel cathedral. A small figure rests on the shoulders of a female bust on the western end and there is another female bust on the eastern terminal (*c.*1240–50).

Plate 65 (*below*) Label stops depicting two grotesque male heads on the exterior of the southern transept at Cashel cathedral (*c.*1240–50). Both wear unusual headdress, that on the western end is the pointed hood found elsewhere at the site, but that on the eastern end is horned – with tongue extended, he looks down on the Franciscan friary in Cashel.

Plate 66 (*facing page*) The exterior of the northern transept at Cashel cathedral (*c.*1270–80) from the south west, showing the lack of embellishment on the southern arm.

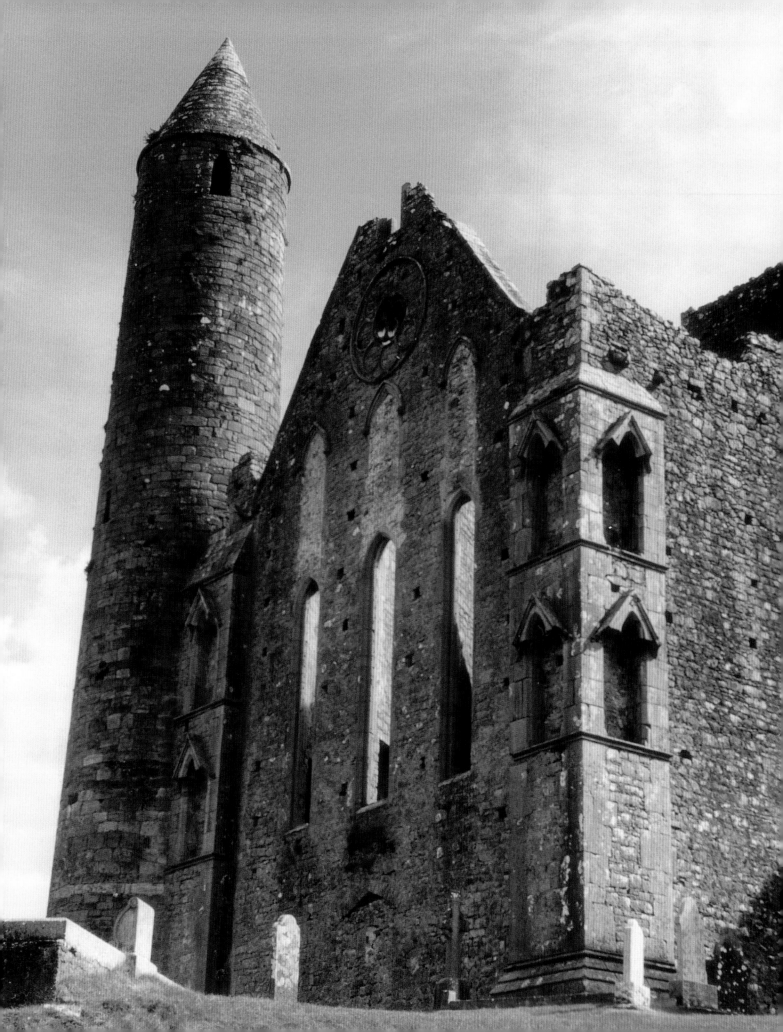

Plate 67 Label stop on the exterior of the northern transept at Cashel cathedral, with the same distinctive workmanship as that found on the exhibitionist figure from Fethard Priory and the window capitals at Caher Priory, both sites being close to the cathedral.

Plate 68 Fifteenth-century capitals on the interior of the northern windows in the choir at Caher Priory, Co. Tipperary. The same workmanship is also found at Cashel cathedral and Fethard Priory.

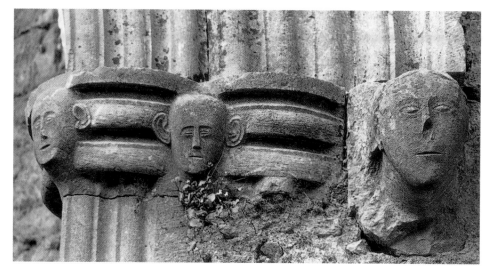

Plate 69 One of the few carved blocks at Cashel cathedral not associated with an architectural feature. A standing figure on the right holds a now defaced object from which a scroll extends to the left (c.1240–50).

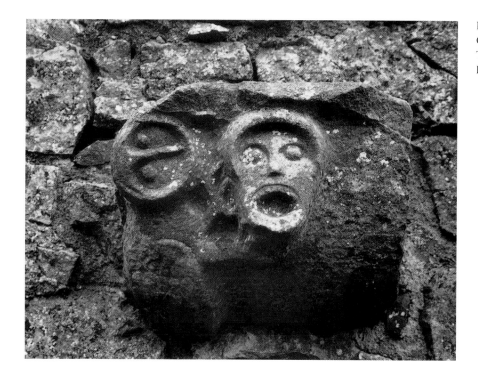

Plate 70 Gargoyle on the crossing tower at Cashel cathedral of an owl attacking a head. The naive carving is similar to that at the Franciscan friary, Waterford.

Alterations were made to the northern transept in the fifteenth century, when new windows and label stops were inserted in the second chapel from the end (pl. 67). These distinctive label stops (including one with a stylized ribbon motif) were carved by a sculptor whose hand can also be traced at the St Mary's Priory, Caher (pl. 68). With its unique modelling of the ears, eyes and nose, the single head is distinct from the other carvings in this area, but closely paralleled by the label stops to the east window at Caher, which dates from the early fifteenth century and must be contemporary with the work at Cashel. It is possible also, although less certain, that the same sculptor may also have been responsible for the sheela-na-gig from Fethard (pl. 40). Now badly weathered, this full-length figure has the characteristic ears, eyes and nose that were the trademark of this sculptor and if this is indeed the work of the same person it provides us with an unusual link between this exhibitionist figure and another carving, thus giving an 'identity' for the sculptor and possible date.

One final carving which deserves mention highlights the unusual and marginal quality of the sculpture in this building – a small panel in high relief found in the general walling under the lower of the two niches facing southwards in the southern transept (pl. 69). Although badly damaged and apparently purposely defaced, it originally had a full-length figure standing on the right-hand side and holding an unidentified object to the left. A scroll with Gothic black lettering extends upwards on the left-hand side. Such panels are not found elsewhere and this must have been related to the statue in the niche above, possibly being a commemorative carving. It is one of the few figurative scenes to survive from thirteenth-century Ireland.

The Tower

The cathedral has two towers, but it is the one over the crossing that gives the building its distinctive profile. It is of a later date than the crossing, and in the absence of any documentary evidence the date of its construction has to be deduced from the tower itself. It has been described in detail by Leask[39] and dated by him to the fourteenth century.[40] No architectural sculpture can be associated with certainty to this part of the building, but some of the cathedral's most interesting carvings are now embedded in the walls of the upper floors: a series of corbels with carvings of an owl, ram and human head on the underside. The first of these is also a gargoyle and is one of the few remaining examples of a gargoyle from the cathedral (pl. 70).

Gargoyles are not found in great numbers in medieval Ireland, although one of the most extensive assemblages

Plate 71 One of a series of corbels with animal carvings from Cashel cathedral, all of which were drawn from the bestiary. The ram's head is one of two from the cathedral and dates from the fifteenth century.

Plate 72 Female heads are rarely found as corbels and the original context of this example within Cashel cathedral is unknown. Although now accompanied by the owl and ram corbel, it does not seem to be part of the same series and may be post-medieval in date.

is at nearby Athassel Priory, where the same masons who worked at Cashel cathedral are known to have been employed.[41] The gargoyle in Ireland usually consists of a human bust or head, the most commonly found motif in the iconographic repertoire of medieval art in general. There are none of the wildly fantastic motifs found in Europe in the thirteenth century.[42] As a form, the gargoyle is first recorded in a building document dated to 1295,[43] and as Camille pointed out has a particular focus on the mouth, as in the carving at Cashel.[44] The gargoyle, again, is a marginal image, placed not only at the edge of the building but also on its external face, far removed from the centre of worship. Even more interesting is the large owl, its circular head facing the viewer, which stands and grasps the human face at the centre of the corbel. Why this symbol of evil should be depicted attacking the human face remains a mystery, but its position on the exterior of the building may illustrate a supposed wish of the forces of evil (the owl) to gain entry and confront the

virtuous interior (the human head). The other two corbel carvings on the tower are a finely carved ram's head and a female head. The first of these has the characteristic curved horns found on the other representations of this motif, but in this instance the animal is shown eating foliage (pl. 71). The female head borders on the grotesque, with large, bulbous eyes and an open, down-turned mouth, recalling Edmund Spenser's description of the Gaelic Irish at the start of the seventeenth century: 'sterne was their looke, like wild amazed steares, staring with hollow eies and stiffe upstanding heares.'[45] The cowled head is framed by a border with pellet decoration (pl. 72). Lacking the characteristic facial grooving found on other and earlier grotesque representations at this site, this carving nevertheless invokes feelings of terror and unease. The style and subjects of these three carvings are clearly late and can be dated to the fifteenth century, when the repertoire changed to include large numbers of animal motifs.

The Nave

Surprisingly little sculpture appears to have been designed for the nave at Cashel, which is in keeping with the stark architecture of this part of the building. Considering that this was the first part of the building to greet the visitor, visual impact does not appear to have been a consideration. The lack of windows combined with a low roof (there appears to have been an upper floor in the nave) must have meant that this was a comparatively dark area. The nave is only just over eleven metres in length and has a truncated feeling, it is shorter than the choir, culminating at the western end in a squat residential tower. The capitals with human heads on the southern portal are closely related to those found under the crossing (see chapter 4), although those on the southern entrance present a greater variety of forms, postures and gestures than their parallels under the crossing. The label stops on the hood mouldings of this entrance and those in the western and northern walls are typical of late thirteenth-century work (pls 73–7).

Although thirteenth-century architectural sculpture is poorly represented in the nave, there are some interesting sixteenth-century carvings, including a series of six corbels high up on the northern and southern walls – all with the coats of arms of various branches of the Butler and Fitzgerald families. The corbels originally supported the roof and, like so much of the sculpture found else-

where at this site, they would have been virtually impossible to see in their high, dark location. Interestingly, they are also the first obvious manifestation of the influence of a benefactor or patron in this building. In the thirteenth and fourteenth centuries evidence of the patron is rarely found in Irish architecture and it is only in the fourteenth century that any commemoration appears. The tower and second floor of the nave were being built in the early sixteenth century, during the archbishoprics of Maurice Fitzgerald (1504–23) and Edmund Butler (1524–50/1). The Butler family were the most important landowners in the Cashel area and are commemorated in numerous monuments throughout both Tipperary and Kilkenny, for example at nearby Kilcooly Abbey.[46] At Cashel the heraldic carvings include the Butler shield with an indented chief (southern wall), the shield quartered with crosses in the first and fourth quarters (southern wall) and two swords in saltire with four rosettes (northern wall).

There are some other carvings from this period embedded in the walls of the nave, but they are not in their original context. The unusual fifteenth-century (c.1442) composite corbel with a dragon eating a human hand may be a depiction of 'biting the hand that feeds',[47] but more importantly it provides the only evidence that one of the sculptors at Jerpoint Abbey, Co. Kilkenny, worked elsewhere (pl. 78). The most extensive sculptural programme from fifteenth-century Ireland is found on

Plate 73 Considerable variety in headdress is shown on the small heads on the capitals at Cashel cathedral (c.1260–70). This particular example is framed by a series of flower petals and is at eye level in the entrance porch.

Plate 74 Capital with human heads Cashel cathedral (c.1260–70). The small figures grasp the stylized foliate surrounds through which they peer.

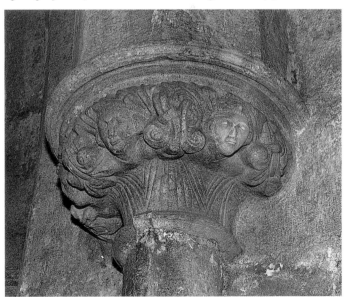

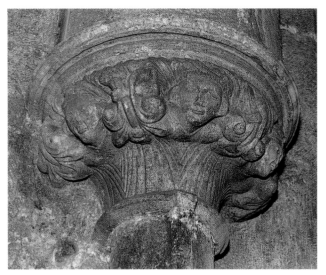

Plate 75　Capital with human heads at Cashel cathedral (c.1260–70). The small hands of these figures are shown in detail while the bodies are conveyed by the fillet ribs which extend downwards.

Plate 76　The central figure on this capital in the entrance porch at Cashel cathedral (c.1260–70) blows a trumpet, while the two other small bust are similar to the work on the exterior of the south transept.

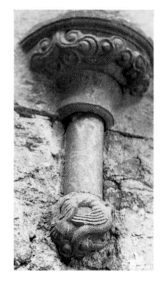

Plate 78 (*left*)　Dragon eating a human hand on a fifteenth-century capital in the nave at Cashel cathedral (c.1460–70), directly opposite a carving showing a bishop's head.

Plate 77 (*far left*)　These heads, on the western door to the nave at Cashel cathedral (c.1460–70), are larger and slightly later than those on the porch entrance, but carved in a similar style.

the lavishly decorated claustral ranges at the Cistercian abbey at Jerpoint. It is unique in that few of the motifs and no other examples of the workmanship can be found elsewhere.[48] There is evidence of a love of the fantastic and secular at Jerpoint, and it is clear that much of the iconography was localized. The unusual collection of motifs is drawn from both secular and sacred sources; as is the case with the thirteenth-century repertoire found at Cashel cathedral.

The Vicars Choral

The majority of the Irish cathedrals had secular chapters, and Cashel was no exception: a secular chapter with a

dean is recorded at the start of the thirteenth century.[49] In the fifteenth century Archbishop O'Hedian (1406–40) endowed a secular hall for a college of vicars choral on the Rock: it is now used as a museum for artefacts associated with the complex. A number of unprovenanced carvings are displayed in this building, which itself does not have any sculptural embellishments. Some of these carvings are clearly later than the medieval period, but they deserve mention, if only for their interesting iconography, which is soundly based on earlier sources. Although there is no record of repairs being undertaken in the cathedral in the post-medieval period, these carvings clearly date from this period. A medieval corbel of a cat-like animal in a standing position was originally part of the series of corbels from the tower (pl. 82). The long

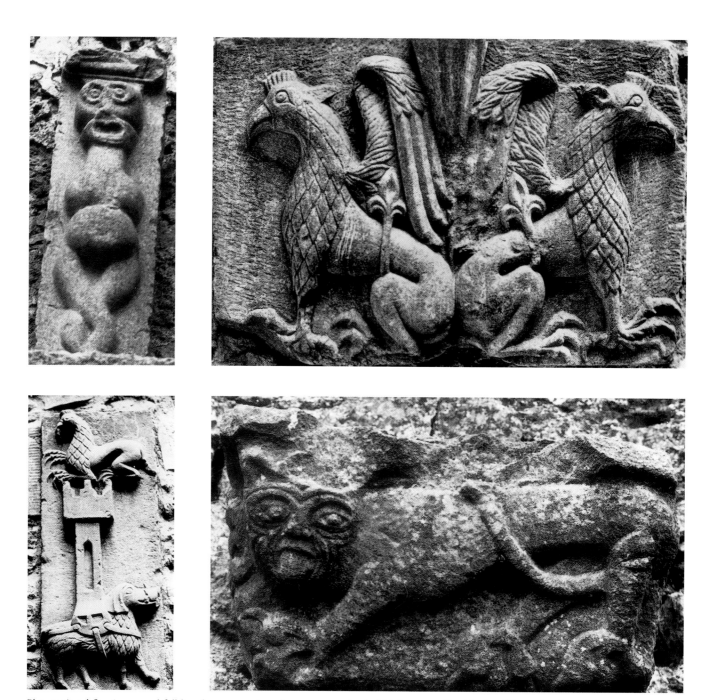

Plate 79 (*top left*) An unusual full-length representation of a grotesque animal which is post-medieval in date. Vicars Choral, Cashel.

Plate 80 (*top right*) The original context at Cashel of these two griffins is unknown, but they were probably heraldic and date from the seventeenth century. Vicars Choral, Cashel.

Plate 81 (*bottom left*) This unusual carving of an elephant and castle with a griffin dates from the post-medieval period and comes from an unknown context at Cashel cathedral. Vicars Choral, Cashel.

Plate 82 (*bottom right*) A small animal carving that may originally have been part of the series which included the ram and owl. Formerly Vicars Choral, Cashel.

animal has its tail curling over its body and its grotesque head has large bulbous eyes and an extended tongue. Traces remain of the broken cap overhead. Although the original context of this panel is unknown, it may date from the fifteenth century. Another grotesque cat-like animal with pendulous breasts, extended stomach and crossed legs dates from the seventeenth century (pl. 79). This carving is reminiscent of a similar, long necked, dragon-like animal from Kildare cathedral, and represents a movement towards the fantastic which occurred in the late fifteenth century in Ireland. This fanciful play of the imagination is seen at sites such as Jerpoint,

where the natural is interspersed with the fantastic. Such animals are part of a wider movement also found outside Ireland, and has a basis in popular religion.

More accomplished than either of these panels are two carvings of bestiary subjects, the griffin and the elephant, which originally came from the interior of the cathedral.[50] The griffin (pl. 80) was one of the most popular motifs from the entire medieval period in Ireland, especially in metalwork. Its usage is uniquely Insular, and it is usually paired with the dragon or lion, as for example at Clontuskert Priory (see chapter 4), or on the Domhnach Airgid Shrine. The two examples from Cashel, although seventeenth-century in date, do not differ significantly from earlier examples, and show the continuance of the medieval tradition well into the post-medieval period. Another unique representation of the griffin is found on the second bestiary carving at Cashel from this period, an elephant and castle surmounted by a griffin (pl. 81). The elephant itself is barely recognizable; the boar-like animal is covered in scales and has short, sharp, upturned tusks. On its back is a tall, tower-like castle surmounted by a crouching griffin.

The Building Programme: Date and Patronage

Leask does not specify the exact areas for which each of the three archbishops was responsible in the building process. Indeed, it is more likely that the entire building may have been constructed under two archbishops (David O'Kelly and his successor, David MacCarwell) rather than three. There is little doubt that the oldest, most distinctive and cohesive part of the building is the choir. The date at which it was started is open to conjecture and has in the past been seen as the work of the archbishopric of Marianus O Brien (1224–38). Little is known of this Cistercian monk and there is no evidence whatsoever that he was ever involved in the building of the cathedral.[51] Watt has noted that O Brien was translated from Cork at the expressed directions of Pope John, who was selecting an Irishman who had been the 'clerk and intimate' of King John,[52] thus ensuring that the good relations already established between the crown and Church would be maintained. Indeed, this seems to have been one of the overriding principles of the selection of archbishops for this see – that they be politically acceptable to both these forces and that, above all, they be able to keep the peace.

The style of architecture used in the early thirteenth century was similar to that in England at the same period, but this situation changed gradually towards the end of the century, as seen at Hore Abbey. Although this Cistercian foundation dates from 1272 and its abbey was built soon afterwards, the style of architecture is more compatible with a date of 1210.[53] There was no native workforce capable of constructing a building as complex as Cashel – this was a style that was largely alien to the country before the invasion. Indeed, the fact that the cut stone in the crossing and nave is almost completely covered with masons' marks shows that it must have been built by a professional group of masons and sculptors, most likely from abroad. There is nothing to contradict Leask's proposed date of the fourth decade of the thirteenth century for the choir of Cashel cathedral, especially when the work is compared to a number of other buildings under construction at the same time. Of these, Leask has related the window arrangement and general design of the choir at Cashel to the parish church of St Mary, New Ross, and Athassel Priory, Co. Tipperary, which date from the early thirteenth century (c.1207–20) and mid-thirteenth century (c.1240) respectively.[54] Leask initially suggested a date of around 1230 for this part of the cathedral,[55] but it is interesting that it is the only part of the structure which he later re-dated to c.1240.[56] This may reflect the difficulties he foresaw in trying to fit the slightly later work in the choir into the early framework of St Mary's, New Ross. Closer in date and design to the cathedral are nearer monastic buildings at which the same masons worked and in which the sculptural details at Cashel are closely paralleled. These include Athassel Priory, the Priory of St Dominic at Cashel and Hore Abbey. This last building shared a large number of masons with the cathedral (especially in its northern transept), and has details in common, for example the unique use of the quatrefoil motif, found high up in the choir (between the windows) of the cathedral and in a similar position at Hore Abbey, which we know was built soon after the foundation date of 1272. If Marianus O Brien was indeed responsible for the choir at Cashel it must have been relatively late in his administration. A more likely candidate was his successor David O'Kelly, who succeeded to the see in 1238 and died in 1252. Displaying the same reforming zeal and initiative as his successor, O'Kelly also founded the Priory of St Dominic in Cashel in 1243, and it is most likely that the cathedral choir was built under his administration.

If the building campaign started in the choir, the next part to be built must have been the southern transept. The use of label stops and capitals with heads, although not as lavishly employed as in the choir, attempts to replicate the style first used there. This part of the building dates from the middle of the thirteenth century and employed styles and motifs that were again current in England in this period. The crossing has been seen as playing a pivotal role in disentangling the architectural history of the building. Architecturally it dates from the mid-thirteenth century, and was built soon after the southern transept, where a considerable number of the same masons had worked. The crossing again attempted to continue the style of architectural sculpture used in the southern transept, and it is one of the most opulently decorated parts of the building; no expense seems to have been spared.

The records or 'snippets' that exist for the six thirteenth-century archbishops under whom the cathedral might have been built provide some insight as to who might have been responsible for the structure.[57] Three men can be ruled out immediately because of their dates; of the remaining three, the most interesting and pertinent by far is David MacCarwell (d. 1289), under whom much of the building must have taken place. An Irishman who became a Cistercian in 1269, MacCarwell is recorded as having been enmeshed in a series of personal antagonisms and points of principle relating to his archbishopric.[58] His succession to the see was neither immediate or unopposed and it is recorded that Henry III protested to the pope that MacCarwell, archbishop-elect of Cashel, was suspected of being bound by ties of friendship and kindred with men who had plotted against him.[59] An astute politician, MacCarwell was able to avoid trouble on a number of occasions, the majority of which centre on the debts he incurred while in Cashel and which must relate to the construction of this building. His spending appears, even by modern standards, to have been excessively high and probably covered his campaigns at the cathedral as well as his founding of the nearby Cistercian abbey at Hore in 1272. While this expenditure was noticed by the king in 1253, it increased after work started on Hore, when reference is found to the expenses incurred at the cathedral and the need to cut back.[60] The archbishop's wish was clearly to build the best that he could afford and in a style that was current in England, with whose architectural styles he must have been familiar, as he had spent extended periods there.[61]

If a terminus date of around 1240 can be ascribed to the choir, the southern transept must have been started by David O'Kelly soon after he became archbishop in 1238. The crossing, nave and northern transept, which appear to have been constructed in that order, was probably constructed by David MacCarwell from the middle to the end of the century (c.1250–80). After the expense of the crossing it would appear that funds had dwindled and such embellishments as architectural sculpture had to be restricted, which may explain the stark nature of this part of the building. There appears to have been considerable pressure to complete the building and every effort was made to do so in one style, even through funds may not have permitted a more lavish unity. The nave was clearly constructed after the crossing and slightly before the northern transept, which was even more affected by the cutbacks. As building progressed in a westerly direction it is clear that the opulence which characterized the first phases lessened and in many instances minor elements of the earlier phases were used to give the impression of continuing in the same tradition. The comparative lack of label stops, capitals with human heads and large sculptural niches from both the nave and northern transept are typical of these small breaks. The nave, however, does not differ significantly in terms of date from the crossing, as several of the masons worked in both areas and a date of around 1260–70 would not be out of keeping with the architectural evidence. Because it was on the other side of the crossing, the northern transept, had, at the least, to replicate some of the elements found in its southern equivalent. It is clear however that funds did not permit much ornamentation, and the capitals under the crossing on the northern side as well as the labels stops are largely undecorated. This part of the building, in particular, shared the same workforce as Hore Abbey, which we know from the presence of the same masons' marks, and as Hore was built around 1272–80 a similar date can be assigned to this part of the cathedral.

Cashel cathedral is unique in Irish architectural history in that it was constructed over a relatively short period, with only minor interruptions, so the style is nearly uniform.

There seems to have been little work undertaken in the fourteenth century apart from the construction of the central tower, but in the early fifteenth century there was once again new building activity on the site. It was at this stage, under the archbishopric of Richard O'Hedian (1406–40), that the castle at the western end of the nave

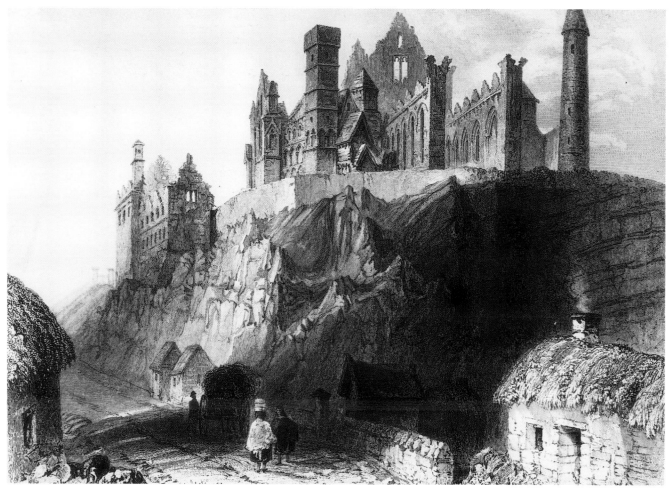

Plate 83 William Henry Bartlett, 'Rock of Cashel'. From J. S. Coyne, *The Scenery and Antiquities of Ireland . . .* , vol. II (London, 1842), opposite p. 139.

was built, together with the hall of the vicars choral and the southern door to the nave. Tradition has it that at the end of the fifteenth century the cathedral was burnt by Gerald, Earl of Kildare, but there is no evidence to support this belief. Various minor repairs were made during the seventeenth century, but these had little impact on the architectural sculpture. The church and, in particular, the choir remained in use until the middle of the eighteenth century and it was then that decay was first recorded.[62] In 1730 the cathedral moved from the Rock to the Church of St John in the town of Cashel,

after which the old building fell rapidly into disrepair.[63] The cathedral was unroofed by Archbishop Arthur Price (1744–52) and was consciously left to decay until it passed into the care of the state in 1869. Since then a number of repairs have been undertaken, especially between 1874 and 1876, but these have not damaged the medieval fabric of the building (pl. 83).

Although now roofless and visited by thousands of tourists every year, the cathedral still retains its dignity and stands high over the lowlands. It remains one of the most impressive monuments of medieval Ireland.

Decorated Irish Gothic Portals

The first architectural feature to greet any visitor to a medieval monastery was the western façade, the most important element of which was the doorway or portal.[1] As a consequence both were lavishly decorated and were used for a variety of purposes ranging from the functional to the didactic. The façade and the portal prepared the visitor for entry into the world of the sacred. That this passage from secular to sacred was no ordinary journey was made physically manifest by the use of elaborate iconographical and decorative programmes in a variety of media. The extensive sculptural programmes that survive on many of the Gothic façades and the scant remains of the painted scenes that once existed around the doors of iron, bronze and wood (also decorated with elaborate scenes), bear witness to the medieval focus on this part of the church.

Despite the scarcity of evidence surviving from pre-Romanesque Ireland, it seems that the doorways to the early Christian churches were the only parts of the structures to have any sculptural embellishment, there was nothing on the façade itself. The carving of a series of small crosses on the massive stone lintel slabs at the Church of St Fechin, Fore, Co. Westmeath, and the church at Clonamery, Co. Kilkenny, bear witness to this (pl. 84).[2] The lack of sculptural decoration in Ireland at this time is typical of mainland Europe as well, where façade decoration in the early Christian and Byzantine periods is equally sparse. At the start of the twelfth century, however, this changed drastically throughout the western world, and Ireland in particular: the façade, principally the doorway, began to be used with greater success for sculptural embellishment. O'Keeffe has shown how

popular this particular part of the building became for the carving of animal, human, floral, vegetal and geometric motifs, all widely believed to have been first introduced into Ireland on the main entrance of Cormac's Chapel, Cashel, which was consecrated in 1134.[3]

With one or two exceptions, Irish masons focused on the decoration of the portal rather than the façade. Reliefs are found on the jambs and arches of doorways, which are worked in a series of orders; capitals and tympana provided another location beneath tangent gables, such as the spectacular example at Clonfert cathedral (pls 85 and 86). Both Conleth Manning[4] and Peter Harbison[5] have recently shown that as time progressed the sculptural programmes of these façades moved from the portals along the façade, as at Kilteel, Co. Kildare. Employing an iconography which is consistent with that of the high crosses and largely derived from the Old Testament, these carvings stand outside, yet are subtly linked to mainstream façade decoration of this period on mainland Europe,[6] where the focus was initially on the Last Judgement and later in the Gothic period also included the Virgin and Child.[7]

Thirteenth-Century Portals

From the late twelfth to the early thirteenth century, church façades in the western world were the site of increasingly elaborate sculptural programmes, with large, full-length figures radiating from the openings and framed above and below by further figures and scenes. The archivolts and lintels provided yet another surface

Plate 84 Maltese cross with pedestal base over the massive lintel stone at Clonamery Church, Co. Kilkenny. Crosses such as this are the earliest portal ornamentation in Ireland and date from the pre-Romanesque period.

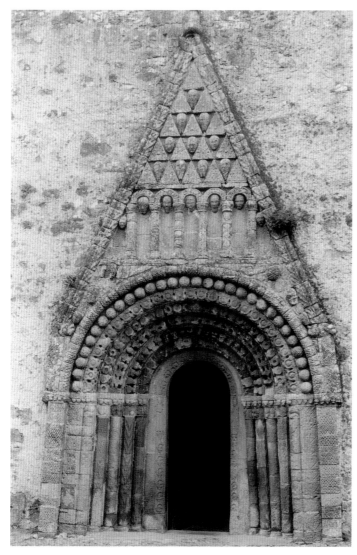

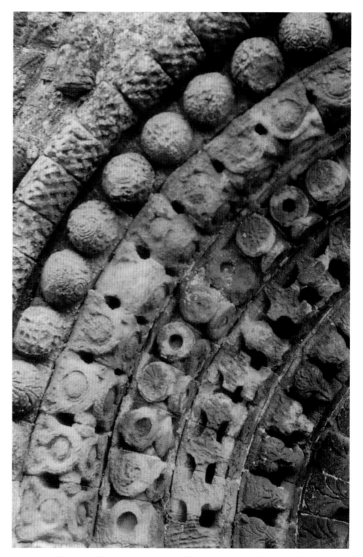

Plate 85 One of the finest of all medieval Irish portals is at Clonfert cathedral, Co. Galway. Originally dating from the twelfth century it was unsuccessfully remodelled in the late fifteenth century, when a limestone opening was inserted into the innermost order.

Plate 86 The twelfth-century portal at Clonfert cathedral is one of the highest achievements of the Hiberno-Romanesque period. Animal, vegetal and human motifs, worked in high relief, radiate from the opening in a series of decreasing arches.

for these carvings, as did niches dispersed along the façade, in which there are life-size statues. The iconography differs little from that of the preceding period, with the Last Judgement and the Virgin still occupying a central position, but this iconographical repertoire was extended by the addition of saintly effigies.[8]

Little attention has been given to the function, form or decoration of Gothic Irish façades or doorways. This neglect is probably due to the surviving remains which, although not extensive in the early period, are particularly interesting in the fifteenth century. The thirteenth-century portals, like so many architectural remains, are indistinguishable from English examples of the same period and it is not until the fifteenth century that any large-scale decorative use is made of this area. None of the doors has survived from medieval Ireland and any research is hindered by the paucity of the remains. It is unfortunate that many of the portals which must have once existed in Irish medieval monasteries, were probably destroyed in the Dissolution, as their absence has certainly hastened the speedy destruction of the fabric – the ultimate aim of the iconoclasts.

It has been noted that somewhere in the region of five or six doorways were needed to fulfill the demands,

routines and ceremonies in the typical Irish Cistercian monastery. This can be paralleled in other religious houses,[9] however, many smaller monasteries did not need as many doors and some of the larger foundations, for whatever reasons, seem also to have had fewer. In their studies of medieval Irish monasteries of the Franciscan, Cistercian and Augustinian Canons Regular Mooney, Stalley and O'Keeffe noted considerable variations in the ground plans of the various orders.[10] The ground plans of Irish monasteries vary enormously in such details as the placement of the main entrance portal, and no general conclusions can be drawn with regard to the individual monastic orders and their preferences. Variations in the positioning of such doorways may, in a number of instances, have been dependant on local topography.

Daily life in the monastic community was governed by regularity and continuity, and the routine had to be supported by the design of the building. Despite a seemingly relaxed and random approach to the placement of doorways, there is nevertheless a certain continuity as to where they are found in these buildings. The first portal to be discussed and the most significant in terms of location is the main point of secular access to the building. Traditionally located in the western façade of the church, this doorway was seen as crucial for conveying the essence of Christian beliefs and defining the sanctity of the enclosed area. This portal was used not only by the lay brothers and the secular world at large but also by the monastic community in their interaction with the outside world. The opening had to accommodate processions, including the transportation and veneration of reliquaries, as well as the many other demands of the monastic community, and had therefore to be on a scale not needed elsewhere. The decorative programmes on these façades and portals received special attention and are not replicated on either the interior of the western wall or the internal portals – a further signal that the audience for external iconographic programmes was the outside, or secular world. Even though there were areas of the interior, such as the refectory, to which the public may on occasion have had access, these lack the large-scale decorative programmes of the western façades.[11]

Although traditionally placed in a central position in the western wall of the nave, this main entrance in medieval Ireland is frequently positioned in the northern (and less frequently southern) wall of the nave, usually close to the western façade. Where the western end of the nave is without either a portal or a sculptural programme the wall is usually broken only by a window opening. The western façades in most medieval Irish churches are usually simple with only a single gable and one doorway. In a number of instances there may be a second or smaller doorway in the façade, such as that at Timoleague Franciscan friary, which is typical in that it allows access to the aisle. The presence of the main doorway in the western façade, similarly, does not preclude the construction of a second or smaller doorway in the northern or southern walls of the nave. Only one example of a triple gable arrangement is found in Ireland, at the parish church of St Nicholas of Myra, Galway, which was rebuilt in the late fifteenth century.[12] Two or sometimes three doorways are frequently found in the western façades of smaller monasteries in Britain, as at Dunstable Priory, Bedfordshire (two doorways) or Newstead Priory, Nottinghamshire (three doorways). The blank arcading traditionally used to unite these doorways, at Newstead and at Binham Priory, Norfolk, for example is not found in late medieval Ireland.

There are few surviving thirteenth-century western doorways in medieval Ireland. Those that remain are simple structures of the type which could be found anywhere in England at the same period, but with little of the elaborate sculptural decoration that appears there and mainland Europe. The western door to the nave at the Cistercian foundation at Grey Abbey, Co. Down (founded 1193), is generally believed to be among the first truly Gothic buildings in the country (pl. 87). The western façade was rebuilt in 1842 and the present doorway may have been moved there in 1626 or 1685 when the nave was being re-roofed.[13] This doorway has been dated to around 1220,[14] and is early English in style. It has a comparatively narrow opening of four orders, the innermost of which has the characteristic nail-head decoration of the period. The three engaged pillars are separated from each other by narrow vertical bands of the same decoration mirroring that of the hood moulding. The main entrance to another outstanding example of thirteenth-century architecture, Cashel cathedral, Co. Tipperary, was never in the western wall of the nave (see pl. 61). Even though a door is found in such a position (giving access to the castle) its small size shows clearly that it was never the main entrance to this important seat. That is found instead in the southern wall of the nave, close to the western end, and consists of a square porch with a fifteenth-century outer doorway. The interior of the

porch, however, dates from about 1252 to 1289 and is similar in style to the rest of the cathedral. The inner doorway, facing the nave, has three separate orders on either side of the opening. The central order projects beyond the other two and all three have semi-engaged columns with water-holding bases. A plain hood moulding, with only one label stop (on the eastern end) with a male head (now defaced), covers the opening. The most interesting feature of the portal has to be the series of capitals on either side: the two on the eastern jamb have a series of small busts and half-length figures in comic poses amidst stiff-leaf foliage, while the two on the western jamb have animals as well as human representations; similar capitals support the vaulting in the porch itself.

Capitals with human heads are limited in distribution in medieval Ireland[15] and the examples at Cashel cathedral are among the finest and earliest in Ireland, after those at Christchurch cathedral, Dublin (see chapter 3). The focus of most of the architectural sculpture associated with these doorways appears to be decorative. This is unlike the carvings found on the western door of St Canice's cathedral, Kilkenny, which has been described, yet again, as the finest of the early Gothic doorways to survive in Ireland (pl. 88).[16] The western façade here has the earliest use of the angel as guardian of the portal, a motif found on the outside of most of the great portals in both England and Europe and one that was to become popular in fifteenth-century Ireland.

Carved by a mason who has been identified as 'the Gowran Master', this doorway with its twin arches, centrally positioned quatrefoil and circular bosses in the tympanum, is believed to be an elaboration of the western doorway at Wells cathedral and dates to about 1260. Although the quatrefoil over the doorway is now empty, both Leask[17] and Stalley[18] believe that it may have once held a relief of the Virgin and Child, which would have been positioned between the two full-length angels in profile (pls 90 a and b). The only other carvings on this doorway are the label stops on either terminal of the hood moulding, one of the few features to be found both in thirteenth- and fifteenth-century styles.

Few of the other possible portals, such as the monk's doorway, the chapter-house doorway, the processional doorways or the door of the dead, that may once have existed within a typical monastery have survived from thirteenth-century Ireland. There must have been similar doorways to the screen door at the Priory of St Edmund,

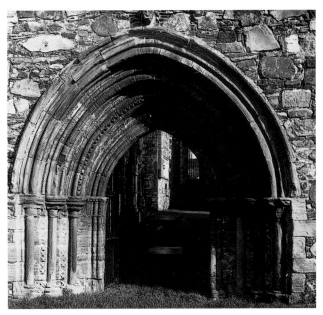

Plate 87 The Cistercian foundation of Grey Abbey, Co. Down. Although the western door may have been reconstructed in the post-medieval period, it is typical of early thirteenth-century designs.

Athassel, Co. Tipperary, which divides the choir from the nave (pl. 89). Although the area occupied by the nave must have been, more often than not, defined in Irish monasteries by a temporary structure, screen walls are not unknown, but they are generally less ornate in design with a simple segmented arched opening in the middle of a rubble wall, as at Bridgetown Priory, Co. Cork.[19] The doorway at Athassel is not unlike the western portal at Grey Abbey with its four orders, each of which has three rolls.[20] The outer and third orders have dogtooth ornament and the capitals have foliage decoration similar to that found at Cashel cathedral, where the same masons are known to have worked.[21]

The main entrance to a church from the cloister that was used by the monks was also in the southern wall of the nave, close to the east end, and has traditionally been called 'the monks' doorway'. This must have been one of the most used portals within a monastery, but with one or two exceptions is usually undecorated. The best known and most ornate example is that in Duiske Abbey, Graiguenamanagh, Co. Kilkenny. This has been dated to the early thirteenth century and is unique in its decoration: dog-tooth ornamentation, 'Islamic' looking cusps and expertly carved stiff-leaf capitals.[22] Fifteenth-century monks' doorways are also found in the Church of St Peter and Paul, Kilmallock, Co. Limerick,[23] and Drumacoo

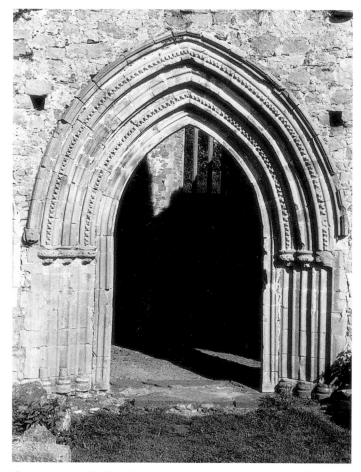

Plate 88 The western door of St Canice's cathedral, Kilkenny, was modelled on an original at Wells cathedral, which has also been seen as influential in providing the inspiration for the capital with human heads, first found in Ireland at Christchurch cathedral, Dublin.

Plate 89 Door dividing the nave from the choir at Athassel Priory, Co. Tipperary. It is typical of thirteenth-century Irish portals, in its combination of standard motifs: dog-tooth ornamentation, human heads and stiff-leaf foliage capitals.

Plates 90 a and b Western portal, St Canice's cathedral, Kilkenny. The angel was one of the most consistent motifs in portal decoration throughout the medieval period, in both Insular and international iconography.

Church, Co. Galway.[24] Like other doorways in Irish monasteries the monk's doorway could also be repositioned, and Stalley has noted how it was transferred to the southern transept at Grey Abbey, and Corcomroe Abbey, Co. Clare.[25]

The processional doorway, traditionally located in the southern wall of the nave, but close to the western end is also usually found in the southern transept in Ireland. The processions to which it refers left the choir on the side away from the cloister and proceeded around the building, through the transepts and nave to exit through the monks' doorway at the eastern end of the nave. The processions then went around the various claustral buildings to re-enter the church through this western processional doorway in the southern wall of the nave. Traces of such doorways are found at Mellifont Abbey, Co. Louth, Boyle Abbey, Co. Roscommon, Abbeyknockmoy, Co. Galway,[26] Kilmacduagh Abbey, Co. Galway, Clontuskert Priory, Co. Galway, Ballybeg Priory, Co. Cork, and Ballintober Priory, Co. Mayo,[27] but all lack any sign of ornamentation. The *porte des morts*, the doorway through which the deceased members of the religious community were transported from the church to the cemetery was traditionally undecorated, in keeping with the solemn nature of its function. Traces of such doorways survive at Boyle Abbey, Abbeyknockmoy, Dunbrody, Co. Wexford, Graiguenemanagh, Co. Kilkenny, Inch, Co. Down,[28] and Ballintober Priory, Co. Mayo,[29] but it is clear that they were not found in every monastery.

There is remarkably little architectural sculpture found on any other thirteenth-century doorway in the typical Irish monastery. Such doorways as those in the sacristy or the chapter house appear to have been undecorated until the fifteenth century. It would be interesting to know what styles were current with the waning of English influence in the fourteenth century and before native taste came to the fore in the fifteenth. Even though the Franciscan friary in Kilkenny was founded sometime between 1232 and 1240, construction of the buildings did not start until around 1245, and then continued well into the fifteenth century. The northern door to the nave, which can be stylistically dated to the mid-fourteenth century, gives us a tempting glance of what styles were current. The ogee-headed opening represents a transitional stage between the Early English style of the thirteenth century and the later Perpendicular of the fifteenth century. Two label stops, both consisting of male heads,

are in high relief on the recessed hood moulding, which has foliate crockets rising to a slight pinnacle over the apex of the door. Another doorway, which shows a particularly late handling of the capital with human heads, popular in the mid-thirteenth century, is found in the Franciscan friary at Carrickbeg, Co. Waterford; this mid-fourteenth century capital must be one of the last portals to be carved before the adoption of more elaborate designs in the fifteenth century.[30]

Fifteenth-Century Doorways

Architectural sculpture was used cautiously throughout the entire medieval period and nothing survives that is, in any way, comparable to the elaborate iconographic programmes found outside Ireland. The two most popular and well-used areas for architectural sculpture in fifteenth-century Ireland appear to have been the cloister and the western portal. In these two places in the typical monastery the visual needs of the monks within the building and those of the secular visitor would have been catered for. It was not until the fifteenth century that Irish sculptors began to use relatively large-scale iconographic programmes at sites such as Ennis Friary, Co. Clare, Holycross Abbey, Inistioge Priory, Co. Kilkenny, Jerpoint Abbey, Co. Kilkenny, and Kilcooly Abbey, Co. Tipperary. These, however, are exceptions rather than the rule and the general trend of small-scale embellishments found in the thirteenth century is continued in the later period.[31]

Unlike the thirteenth-century Irish portal, which was similar in design and decoration to that in England, and indeed may have been carved by English masons, it is clear that those of the fifteenth century adapted the slightly earlier English Decorated style and were probably carved by native masons. If the standard and limited design for these doorways tends to be multi-moulded with the same form being replicated, the iconography and its placement is more distinctively Insular and reflects a unique marriage of the Insular with the international. There is a focus on the vertical, often with pilasters and pinnacles, as at Clontuskert Priory, Co. Galway, Clonmacnoise cathedral, Co. Offaly, and Lorrha Priory, Co. Tipperary. Decoration is rarely found on the archivolts and no column figures or anything comparable are used. Capitals are rare and the doorway was generally used only as a focus for the placement of low-relief panels in the surrounding wall. In this respect it was similar to

the window ornamentation, where label stops are a nearly standard feature of monastic decoration. The arches on these doorways vary enormously, from the acutely pointed to the rounded, and lintels, instead of arches, were commonly used on internal doorways.

Clontuskert Priory

The most impressive western portal to survive is at Clontuskert, Co. Galway (pl. 91).[32] The Augustinian Canons' Priory of St Mary was probably founded by the O'Kelly family around 1140 and was burnt to the ground by lightning in 1413, but the records show that it had been rebuilt by 1443.[33] The priory was clearly a wealthy foundation from the beginning, as it is recorded that 'the books, jewels, ecclesiastical ornaments and other precious things', which would not have been found in any impoverished foundation, were also burnt in the fire.[34] Nearly all the present remains date to this 1443 rebuilding, but the western façade with its fine doorway can be dated to 1471. The site was excavated in 1971–2, when considerable foundations were unearthed, reinforcing the belief that this site was even more extensive than previously known.[35]

Although the western façade doorway has been reconstructed, it is clear that all the carvings are original to the structure, although the original sequence of the side panels is not certain and it is possible that there are missing panels. Asymmetry is an overriding characteristic of Gothic Irish art, but it is tempting to think that the entire wall area around the doorway was originally embellished. The four moulded orders of the limestone doorway rest on a massive lintel slab and end in a slightly pointed arch. Two pilasters (nearly half the height of the actual door) rise from the hood, each ending in two large crockets. This same hood moulding also decorates the top of the arch, between the pinnacles, but here it takes the form of a series of stylized vine leaves interspersed with bunches of grapes, linked together by an interwoven stem which rises in another centrally placed pinnacle only slightly lower than the two pilasters on either side. An inscribed cornice bar rests on top of the two pinnacles and extends slightly on either side of the door. The Gothic lettering records that 'Matthew, by the Grace of God, Bishop of Clonfert and Patrick O'Naughton, Canon of this house, caused me to be made. Ano Domini 1471' (Matheu: Dei:gra: eps: Clonfertens: et: Patre' oneacdavayn: canonie' ets: domine:fi'fecert:

Ano:do:mcccclxxi).[36] Bishop Matthew MacCragh died in 1507, but the identity of Patrick O'Naughtan is unknown.

In common with a number of other decorated doorways in Ireland, there are a number of carved panels on either side of the opening. These are asymmetrically arranged, with six on the southern (left) side and only three on the north. The low-relief panels vary slightly in size, but each has a narrow surrounding frame. All the panels appear to be randomly placed around the opening and, even though they are expertly cut, it is clear from the placement of the dragon away from the figure of 'St Patrick' (if it is indeed intended to relate to him) that it was not properly scaled before being put in place. The lowest panel to the left is a pelican in the act of piercing its breast over an open nest with three young chicks inside (see pl. 140). The second panel on the same side shows a griffin and lion, another familiar motif from the iconography of medieval Irish art (pl. 92). The two animals are shown in confrontation against a background of the same large vine leaves found on the hood moulding. The third and last panel on the left, at the springing point of the arch, is a finely wrought low-relief Tudor rose, enclosed within a square frame (pl. 93).

The lowest panel on the right-hand (northern) side is a bird, but clearly not a pelican, picking its breast alongside a quadruped biting its own tail (pl. 94). Although they face in opposite directions, their heads are turned back to confront each other. Unlike the other carvings, this is not rectangular and has a 'step' half way along its long axis. Immediately above this panel are two yales with interlocking necks (pl. 96). The third panel on the right is divided into two, with a mermaid on the left and a stylized version of the monogram IHC to the right (pl. 98). The mermaid faces forward, holding a star-shaped mirror in her left hand and bordered by fish on her right-hand side. Immediately above this panel is a rayed star-shaped motif within a shallow polygonal recess; simply interwoven bands surround a small central hole. The fifth panel is the IHC monogram ornately embellished with a floral tendril and geometric pattern. The last panel, near the top of the pinnacle, is a front-facing dragon's head with flowers and foliage emerging from either side of its mouth.

A number of unequally sized figurative carvings are placed over the opening and enclosed within the pinnacles and cornice bar (pls 97 a and b). There are two full-length figures on either side of the central pinnacle. From left to

Plate 91 Fifteenth-century portal decoration extends into the wall area surrounding the opening, as on the western doorway at Clontuskert Priory, Co. Galway. Fifteenth-century portal decoration in Ireland is largely based on the earlier Decorated style in England.

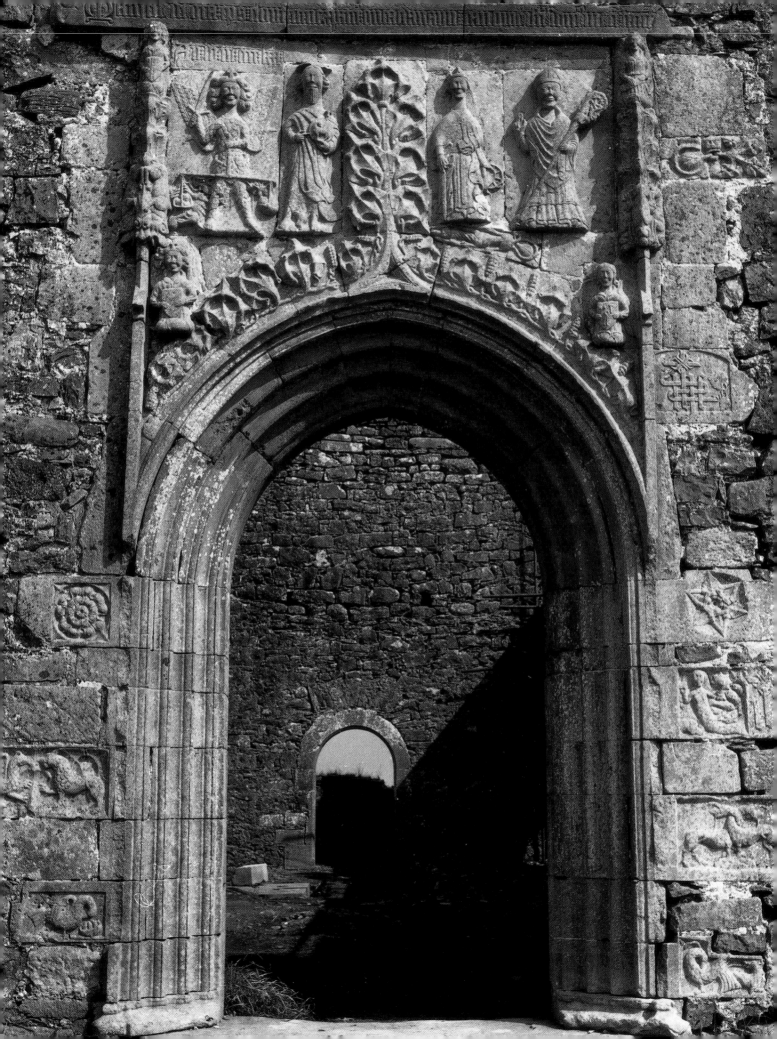

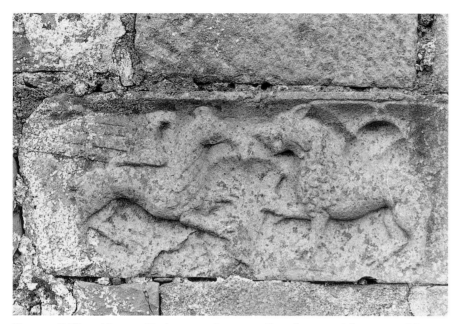

Plate 92 Griffin and lion panel in the western doorway at Clontuskert Priory. This was one of the most common decorative motifs in late medieval Ireland – particularly in such metalwork designs as the Fiacail Padraigh and Domhnach Airgid.

Plate 93 Heraldic motifs, such as the Tudor rose, swan and lion passant at Clontuskert Priory, are frequently found from the mid-fifteenth century onwards.

Plate 94 The bestiary was one of the most widely used motifs in sculptural decoration in fifteenth-century Ireland. The panel on the western doorway at Clontuskert Priory depicts an unidentified bird and animal, both with characteristic back-turned heads.

Plate 95 Placed at eye level this small panel must represent 'the sun in splendour' – the Yorkist heraldic motif that parallels the Tudor rose on the opposite side of the opening – an arrangement that is also found in metalwork in both Britain and Ireland.

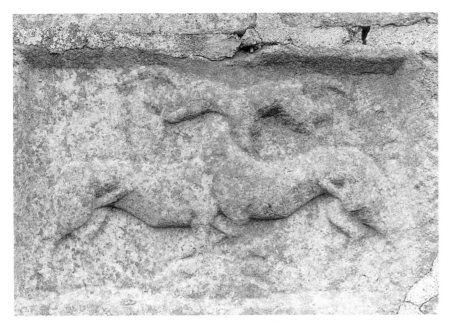

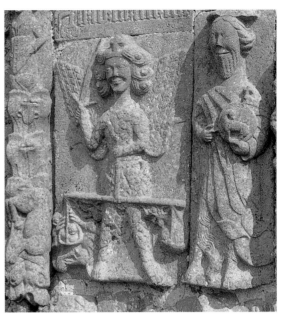

Plate 96 Animals with entwined necks can date from as early as 3000 BC. They are one of the hall-marks of Insular art and are frequently found in manuscript illumination of the Golden Age of Irish art, but are absent from the repertoire of the early Gothic period. Panel from the western doorway at Clontuskert Priory showing two yales with back-turned heads.

Plates 97 a and b (*above and below*) Framed by a cornice bar which carries an inscription, the four panels on the western door at Clontuskert Priory, are unequal in size but form the centre-piece of the composition.

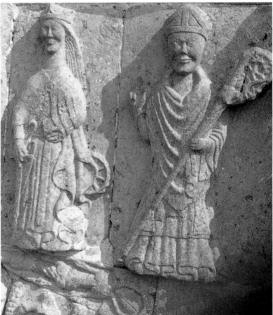

Plate 98 Virtue and vice are contrasted in a panel from the western doorway at Clontuskert Priory. The mermaid, holding her mirror and attended by fish, is separated from the IHC monogram.

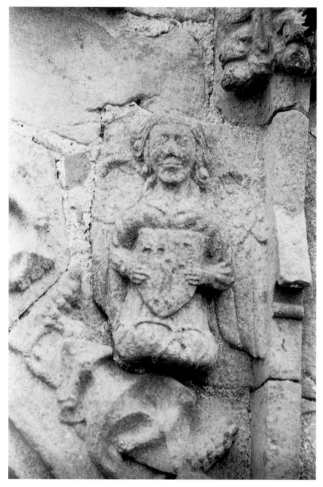

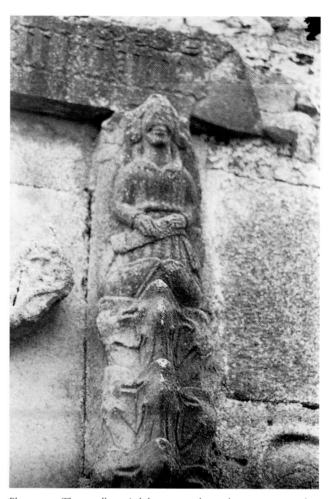

Plate 99 The *Arma Christi* first appear in Irish art in the middle of the fifteenth century and are usually associated with funerary monuments. The small carvings at Clontuskert Priory carry either shields with the instruments of the Passion or else blank scrolls.

Plate 100 The scroll carried by an angel on the western portal at Clontuskert Priory would originally have borne a painted inscription, but most of the polychrome which originally decorated these portals has disappeared.

right they are Saints Michael, John the Baptist and Catherine and an unidentified ecclesiastic, possibly St Patrick. Michael holds a sword in his right hand and scales in his left. The scales are perfectly balanced, despite the efforts of a long-eared demon under the bar on the left side grasping and tugging the basket in a downwards movement. Immediately to Michael's left, John the Baptist, one of the most popular patrons of the monastic orders, holds the cross-topped *Agnus Dei*. He points with his right hand to this disc as if to identify the presence of Christ on this panel. His flat, semicircular nimbus is unusual and rests comically, like a plate, on top of his head. The third figure in this sequence, Catherine of Alexandria, holds a book and purse in front of her wheel and stands on a dragon whose full-length body is viewed from above. The angle with

which this long-necked quadruped is shown is unusual and it probably relates to the figure of 'St Patrick', whose right hand is raised in blessing. His left hand holds a crozier in front of his vestments as if pointing towards the dragon.

In addition to these four figures there are four angels – one each on the terminals of the outer pinnacles and one at each of the lower corners formed by the outer pinnacles and the hood mouldings. Three hold shields while the fourth has an undecorated scroll (pls 99 and 100). The angel on the lower left side has an undecorated shield, while the other two have the *Arma Christi* in low relief (pincers, hammer and nails on the lower right shield; lance and ladder on the upper left shield). Arranged around either side of the lower end of the pinnacles is a group of three quadrupeds.

76

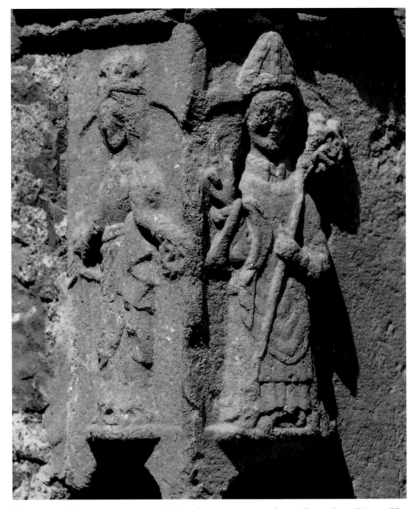

Plate 101 Unique water stoup inside the western portal at Clontuskert Priory. The iconography is similar to that of the outer portal and shows St Catherine and an unidentified ecclesiastic, possibly St Patrick.

Upon entering the church through this doorway the visitor would immediately see what is now a unique holy-water stoup built into the left-hand side of the same wall. The double-oped stoup is incorporated into the wall at the angle of the doorjamb on the interior (pl. 101). It bears another depiction of St Catherine on the southern face (and is perhaps carved by the same sculptor that executed the St Catherine above the doorway) and an unidentified religious figure on the western face; both stand under a simple moulding and over semicircular openings that allow access to the water.

Were it not for the decoration of this doorway, the rest of the priory would be unremarkable for its architectural sculpture with only isolated pieces surviving.

* * *

Clonmacnoise Cathedral

The iconography and designs used at Clontuskert relate closely to a number of other religious foundations at which the same masons worked, including Clonmacnoise cathedral, Co. Offaly, and the Cistercian monasteries at Kilcooly and Holycross, Co. Tipperary. The sculptural details on the rood screen at Clontuskert[37] were carved, for example, by the same masons who worked on the fifteenth-century sculptural embellishments of the chancel at Clonmacnoise.[38] The fine northern doorway at Clonmacnoise cathedral has, like the example from Clontuskert, been described as one of the landmarks in the story of Irish medieval architecture (pl. 102).[39] This doorway, identified in an early twentieth-century photograph as 'The Doorway of the Three Saints', is also

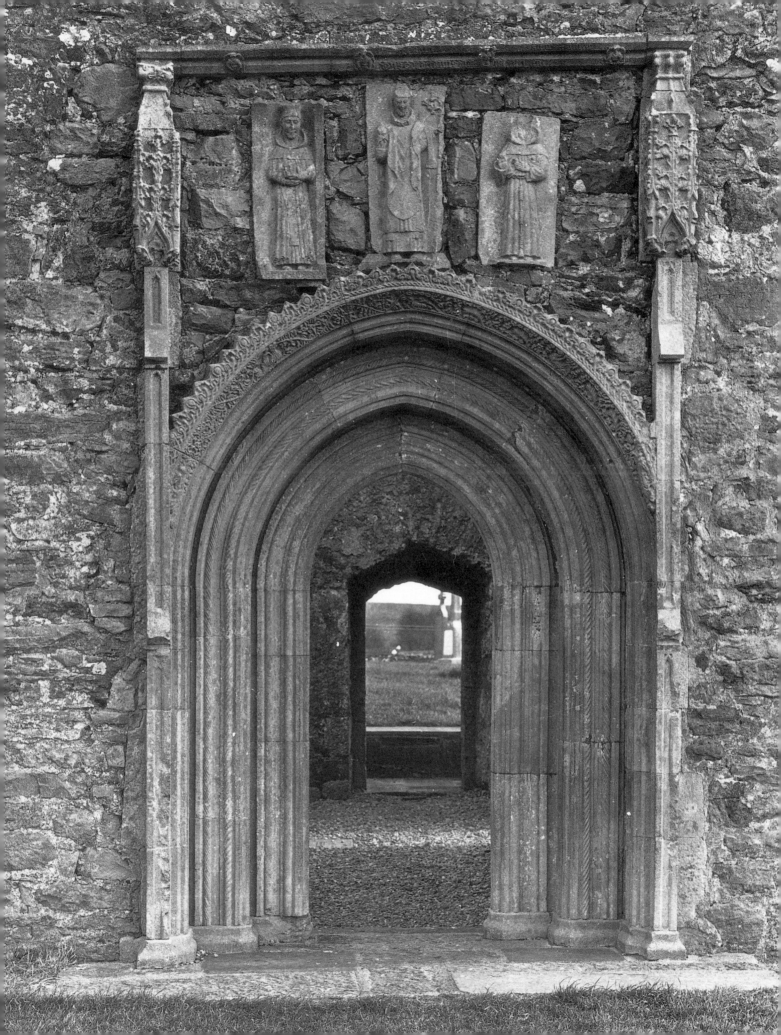

Plate 103 Although amphisbena-like animals are found in ninth-century Insular manuscripts, the motif first appears in sculpture in the fifteenth century, but was not widely used. The discreetly placed example amidst the lace-like foliate patterns on the hood moulding of the northern portal at Clonmacnoise cathedral can be dated to the middle of the fifteenth century.

known by the more modern title of Dean Odo's Doorway.[40] It must have been the main entrance to the cathedral in the later medieval period, despite the fact that there is an earlier and equally impressive doorway in the western wall; this earlier portal has been described as Transitional in style and dating from the twelfth century.[41] The northern doorway is close to the western end of the church and was inserted by Dean Odo, who died in 1461. The design differs from that at Clontuskert in that the door has three moulded orders and recedes steeply inwards. More original in design but less decorated than the Clontuskert doorway, the orders at Clonmacnoise have spiral rope-twist bands between hollows and rolls. The pilasters springing from ground level on either side of the jambs end in pinnacles with foliage and angel motifs. The hood moulding, which in turn springs from the pilasters, is the finest example to survive from medieval Ireland. Its curvilinear vine-scroll ornament is surmounted by a figure-of-eight interlace pattern from which spring crockets with foliate designs. The twisted-rope motif on the hood moulding is remarkably similar to that found on the base of the south side of the western door to the nave, which has been dated to the same period, and may have been an attempt to harmonize the decoration of the two portals.

The vine-leaf decoration on the crockets is beautifully cut and has been likened to lacework in the transparency of its design and execution. Hidden among the foliage of this moulding are four finely carved winged dragons which act as terminals to the decoration of the arch and crockets. The dragons are viewed from the side, devouring the foliage ends which spread along the moulding. They have distinctive backswept ears with ribbed wings. Although some of their unusual details, such as the twist in the tail and the scale-like coverings on the bodies are similar to examples from Clonfert cathedral and St Mary's Priory, Loughrea, Co. Galway, they were clearly not the work of the same hand but are part of an even more localized handling of this motif. Also hidden among the foliage motifs on the moulding is an amphisbena (or double-headed dragon), one of the more unusual motifs in medieval Ireland (pl. 103).[42] Accompanying this beast is a finely carved swan, another equally rare motif in the iconographical repertoire of Gothic Ireland. These two small creatures are surrounded by the detailed foliage and might easily go unnoticed by the casual visitor to the church. There are eight angels in all: four on the cornice bar and two on each side of the lower terminals of the pinnacles on either side of the apex. Each holds scrolls or shields in front of their bodies, in a pose reminiscent of the examples on the western doorway at Clontuskert Priory.

The most prominent features of this whole doorway are the three unequally sized panels set into the wall above the hood moulding. These in turn, are surmounted by a cornice bar with a two-line inscription, the upper of which identifies the three figures beneath as Saints Dominic, Patrick and Francis (pl. 104). The lower line of the inscription, in Gothic black-lettering, reads 'Dns Odo Decanus cluan me fieri fecit', which has been understood by Leask[43] and Manning[44] as referring to Dean Odo O Malone (or Molan), whose death at Clonmacnoise in 1461 is mentioned in the 'Annals of the Four Masters', where he is also referred to as the most learned man in all Ireland.[45] The doorway must date from this period. Although the three figures appear to be in their original grouping, it is clear that they were not originally made for such a location as they differ not only in size but also in design. The first from the left, St Dominic, is in a recess with a broad surround or frame on his left (arching forwards from the top) and beneath his feet. He wears the Dominican habit and cap and cups a book in both hands. St Patrick, the largest of the three figures, is

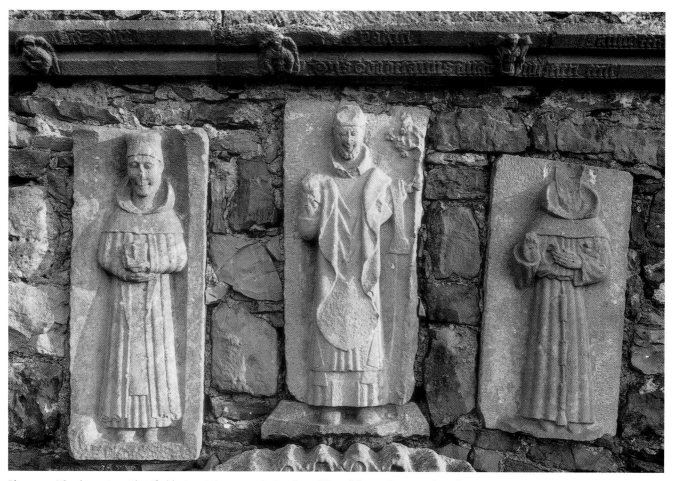

Plate 104 The three saints, identified by inscriptions, over the hood moulding of the northern portal at Clonmacnoise cathedral combine the international (Francis and Dominic) and the Insular (Patrick). Irish saints are largely absent from the repertoire of Gothic Irish art until the fifteenth century, and their appearance is indicative of the return to power of the Gaelic chieftains. One of the few representations of St Patrick to be identified by an inscription, his central and elevated position reflects his importance as primate of all Ireland. St Dominic is frequently found in late medieval Irish art in a claustral context.

Figure 3 Fifteenth-century carving of St Francis at Askeaton Friary, Co. Limerick. After Westropp, 'Notes on Askeaton, County Limerick, Part III', *JRSAI* (1903), 248.

Plate 105 A small figure from the Franciscan foundation at Dromahair, Co. Leitrim, which is identified by its inscription as St Francis.

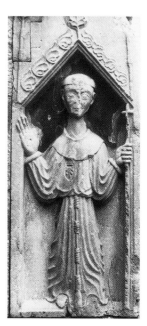

Plate 106 (*left*) The figure of St Francis, at Ennis Friary, Co. Clare, has the usual attributes of stigmata, crosstopped staff and habit. The niche, pose and canopy all suggest that it was carved by a hand more familiar with funerary monuments than architectural sculpture.

on a wedge-shaped panel made in two pieces. He, like the two other figures, is viewed from the front, with his right hand (now missing) raised in blessing and his left hand holding an ornately topped crozier. The third panel is the smallest and most damaged. St Francis's face is missing; his pose is reminiscent of a number of other representations of this saint, such as those from Adare Friary, Co. Limerick, Askeaton Friary, Co. Limerick (fig. 3), Dromahair Friary, Co. Leitrim (pl. 105), Ennis Friary, Co. Clare (pl. 106), and Meelick Friary, Co. Galway. All of these are Franciscan foundations where such figures are usually found in a cloister. Indeed, this may also have been the intended location for the Clonmacnoise panel, as the outward facing curve of the upper part of the carving indicates that it could have been placed on one of the cloister piers, directly under an arch.

Perpendicular Style Doorways

The western doorway in the Priory of Beatae Mariae Fontis Vivi, founded by the Augustinian Canons Regular at Lorrha, Co. Tipperary, is closely related in iconography and design to that at Clonmacnoise. Little is known of either the foundation date or history of this monastery,[46] and the western doorway is the only piece of architectural sculpture that survives from the relatively plain church. Like the previous examples, the simply moulded orders on the doorway have pilasters on either side ending in solid foliage terminals. The hood moulding springs from the pilasters and its centrally placed pinnacle rises to the same height as those on either side. The rectangular recesses on either side of this central pinnacle are unusual and may be a fifteenth-century version of the roundels and quatrefoil found in the thirteenth-century portal at the St Canice's cathedral, Kilkenny, in that they would have held statues or at the very least plaques like those at Dunmore, Co. Galway. Even though they are now empty, their rectangular shape would have been unusual for holding vertical figures.

The decoration at Lorrha is simple and iconographically related to the other doorways in this group. The one unique feature is the female head wearing a horned headdress with a veil falling to the shoulders which crowns the apex of the hollow sectioned hood moulding. This still preserves traces of the blue paint which once decorated the carving. The two angels at the junction of pilaster and hood moulding are similar to the examples at Clontuskert. Although less finely carved than other hood mouldings there is a series of fourteen paterae set at random intervals in the plain hollow section among which there is (second from the top of the arch, on the southern side) a naturalistic representation of a small bird probably a swan, but possibly a pelican. Otherwise the decoration of this doorway consists of a series of foliage crockets along the hood moulding as well as tapering horizontal and geometric bands on the terminals of the pinnacles. Although inspired by the examples at Clontuskert and Clonmacnoise, the style of clothing suggests that this portal could be as late as the third quarter of the fifteenth century. It is contemporary with the two-light window over the opening which, from its flamboyant tracery can be also dated to about 1475.

The practice of embellishing the western portal in the fifteenth century was not restricted to new insertions. At Clonfert cathedral, Co. Galway, for example, one of the finest Romanesque portals in Ireland was altered in the fifteenth century at the same time as other additions were made to the church (pl. 107).[47] The new inner order in hard grey limestone was inserted into the western doorway and decorated with two figurative panels. It is unmoulded and chamfered with a relatively wide band of large, stylized vine leaves running the length of the round-topped arch. Near the apex, hidden among the leaves, is a kneeling angel who, like a number of other figures in a similar position, could easily go unnoticed (pl. 108). The fully vested ecclesiastics, both of whom hold croziers, stand on corbels and face each other as well as the visitor to this cathedral (pls 109–10). In such a prominent position they may represent the founders of the monastery. They are the closest approximation in Irish portal decoration to the column figures so frequently found in thirteenth-century Europe. The merging of the Gothic and Romanesque styles is ultimately unsuccessful, and the differences in material, technique, style and iconography are too great to bridge the stylistic gap between the twelfth and fifteenth centuries. Far more successful are the carvings on the chancel arch in the interior. The humans, dragons, angels and a mermaid subtly link this building with Clonmacnoise cathedral, where the same iconography is found. Indeed, the facial details of the angels on the southern wall of the chancel arch at Clonfert indicate that they were carved by the same hand as the figure of St Dominic over the doorway at Clonmacnoise (see pl. 104). The dating of St Dominic to *circa* 1461 provides an approximate date for these alterations at Clonfert (pls 111–13). A similar

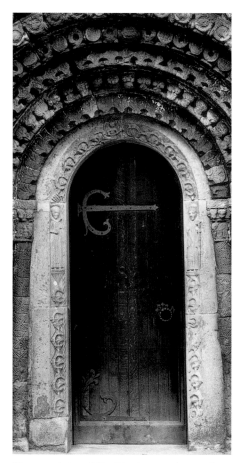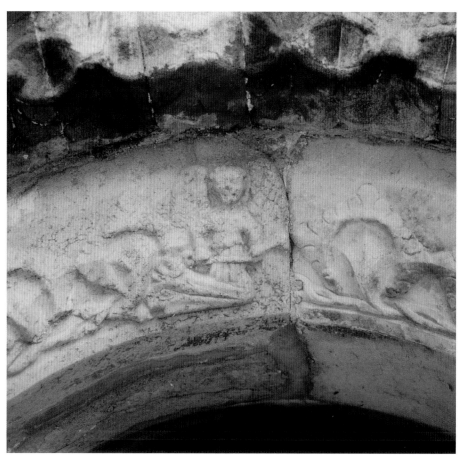

Plate 107 (*above left*) The inner order on the western portal at Clonfert cathedral, one of the masterpieces of Romanesque sculpture, was added in the fifteenth century. The unsuccessful merging of styles combines limestone with the softer sandstone of the earlier period.

Plate 108 (*above right*) A small angel on the hood moulding of the fifteenth-century order at Clonfert cathedral physically and metaphorically links the two portal figures of founder and bishop by uniting the vine scroll which extends from either side.

modernization of an older doorway took place in the southern wall of the nave at Lorrha parish church, Co. Tipperary, where a late fifteenth-century arch with carved paterae (including a pelican), similar in design to that in the nearby Augustinian priory, was inserted into the older opening (pl. 114).

Such additions attempt unsuccessfully to preserve the character and design of the old. The use of architectural sculpture was not a standard element of the western doorway and a number of undecorated examples are also to be found. Although Leask[48] has related the western doorway at the Franciscan friary at Ardnaree, Co. Mayo, to the examples at Clontuskert and Clonmacnoise, it is similar only in minor details. The friary was founded sometime before 1400 by the O'Dowdas, but was in need of repair by 1410 when an indulgence was granted for its restoration. The doorway is certainly later than this date and was possibly built about 1470. With its deeply set multi-moulded orders it is one of two such doorways to

have capitals. The relatively low door has two pilasters springing from capital level and ending in short foliate terminals. The lack of embellishments is unusual considering the overall design. Two label stops at capital level in the walling at the side of the pilasters are similar to those at Dunmore Friary, Co. Galway, which is slightly earlier in date and less complex in design (pl. 115). The headdress on these two label stops, tight-fitting skullcaps with vertical folds at one side only, can be dated to about 1470, and may provide a date for the doorway. The west door in the Franciscan friary at Dunmore, Co. Galway, is slightly earlier in date and was built sometime around the mid-fifteenth century. Like the other portals of this period it has three orders, separated from the arch by a plain band of capitals from which the hood moulding and pilasters spring. Unlike those of other doorways, this hood moulding lacks all decoration and rises to a central pilaster and terminal higher than those on either side. The only embellishments are the two heads set in the

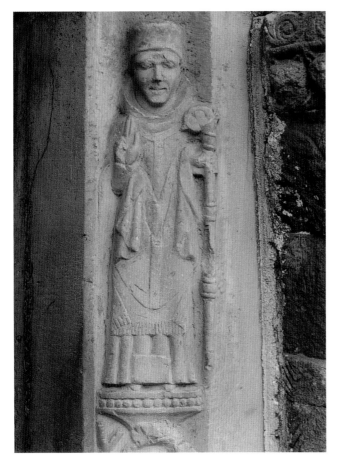

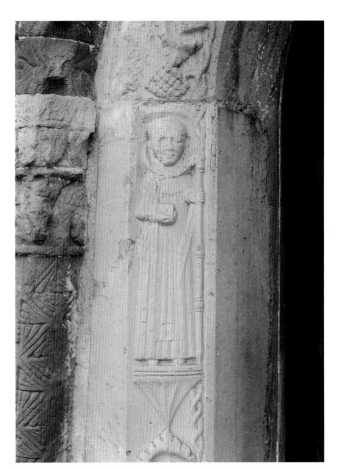

Plate 109 This figure, on the right-hand side of the portal at Clonfert cathedral, is perhaps either St Brendan, the founder of the earliest monastery at Clonfert, or St Patrick, the saint responsible for introducing Christianity into Ireland. This figure is the closest in Ireland to the full-length portal figure characteristic of the international Gothic.

Plate 110 The second portal figure at Clonfert cathedral represents Petrus O Mordha, the first Cistercian abbot of Boyle and later bishop of Clonfert. The vine that springs from his staff offers protection to the church.

wall on either side of the pilasters. Leask[49] has noted the framed memorial plaque to the right of this central pilaster (similar to the now empty recesses at Lorrha Priory, Co. Tipperary), which has an almost illegible inscription commemorating Gaulterius de Bremwycham, the friary's founder, who died in 1428.

One of the few surviving embellished doorways outside the predominantly western distribution so far discussed, is that at Callan Friary, Co. Kilkenny, which was founded in 1461 but may not have been built until later in the fifteenth century. Whereas the sedilia and piscina in the friary are noted for their rich ornamentation and design,[50] the western doorway to the nave, by comparison, is relatively simple but finely executed. A small opening, with multi-moulded splays of alternating rolls and hollows is broken only by the carving of an angel on one of the rolls of the southern jamb. Even though the carving at Callan is now damaged and the upper part of the small figure is missing, the work of this sculptor can

be recognised also at Holycross Abbey, Co. Tipperary, where there is a similar angel in exactly the same unusual position on the sedilia in the southern wall of the chancel. This may explain, in part, some of the overall similarities in architectural furnishings between the two sites.

Apart from these western doorways, a number of other decorated examples survive from fifteenth-century Ireland, including those in the sacristy walls at Kilcooly Abbey, Co. Tipperary, and St Mary's Priory, Devenish, Co. Fermanagh. Kilcooly has one of the finest and most unusual assemblages of relief carvings from the medieval period arranged around the sacristy doorway. Although the abbey, which adopted the Cistercian rule in 1184, is relatively wealthy in terms of surviving architectural sculpture, the visitor is not prepared for the unusual context of the relief carvings that surround the finely cut multi-moulded doorway of five orders in the southern transept. The narrow space surrounding the opening is lavishly decorated with nine panels of varying size, ran-

domly placed at various levels. The screen wall has been treated as a picture book, depicting what must have been significant motifs in the life of the community (pl. 116). The central panel, the Crucifixion, is placed over the apex of the hood moulding, but slightly off balance to the left (pl. 117). To the right of this and at the same level there is a vertical panel showing St Christopher with the infant Jesus on his shoulders (pl. 118). The third panel, on the right-hand side of the opening, is a full-length standing ecclesiastic, with a crozier in his right hand and a book in his left (pl. 119). The commemorative and funerary nature of this plaque is conveyed by the censing angel above the figure (pl. 120) and by the frame which surrounds him. This frame, with its pilasters, arched and recessed opening and crockets, is reminiscent of many fifteenth-century portals at sites such as Clontuskert and Clonmacnoise. Immediately above the central pinnacle there is a pelican in the act of piercing its breast over a chalice, a particularly apposite motif considering the location of the screen as the entrance to the sacristy (see pl. 138). The final panel on the right-hand side, near ground level, is one of the most charming from medieval

Plate 112 The facial details on the figures on the chancel arch at Clonfert cathedral are similar to those of the three saintly portraits over the northern portal at the nearby Clonmacnoise cathedral, where the same sculptor worked.

Plate 113 These figures on the chancel arch at Clonfert cathedral hold scrolls and a shield as do those on the western portal at Clontuskert Priory.

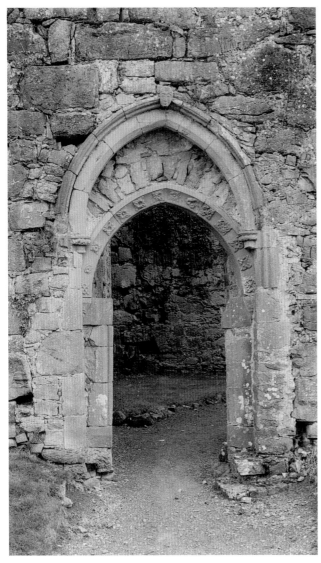

Plate 114 The paterae on the inserted arch at the parish church of St Ruadhan, Lorrha, Co. Tipperary, are similar in design to the nearby and larger fifteenth-century doorway at Lorrha Priory. The pelican appears in both decorative programmes.

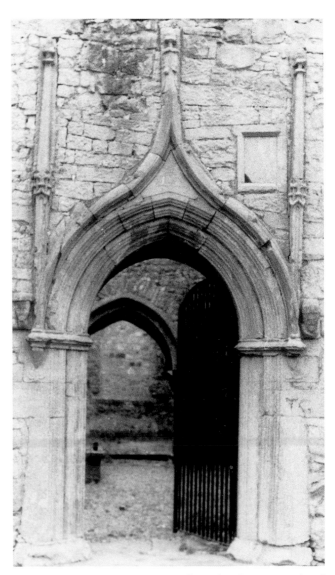

Plate 115 Doorway at Dunmore, Co. Galway. The pilasters, pinnacle and emphasis on the vertical are typical of fifteenth-century portals in the west of Ireland.

Ireland and shows a mermaid (pl. 121) similar to those at Clontuskert Priory and Clonfert cathedral (pl. 122). The left-hand side of the doorway is more sparsely decorated. Two shields charged with the Ormond arms are set above the hood moulding. The upper shield is supported by two pelicans piercing their breasts. The aumbry, at waist level, is surmounted by a floriate pinnacle and has a small male head neatly hidden in the moulding. The carvings on this portal vary in quality; the only panel that stands out from the general assemblage is the mermaid. Otherwise, despite their obvious charm they are similar to folk art and are disproportionately large and awkward.

The decorated doorway at Devenish Priory lacks even such naive embellishments. The finely moulded, pointed arch in the northern wall of the nave is typical of mid-fifteenth-century workmanship. The flanking pilasters spring from the hood moulding and end in heavy pinnacles. The hood moulding, surmounted by entwined stems with vine leaves on either side, rises to a central pinnacle with a bird pecking at grapes on the left hand side.

The southern door to the nave at Devenish was also used in the fifteenth century for sculptural embellishments.[51] The simple pointed arch is unremarkable except for the interesting little angel on the western side. He

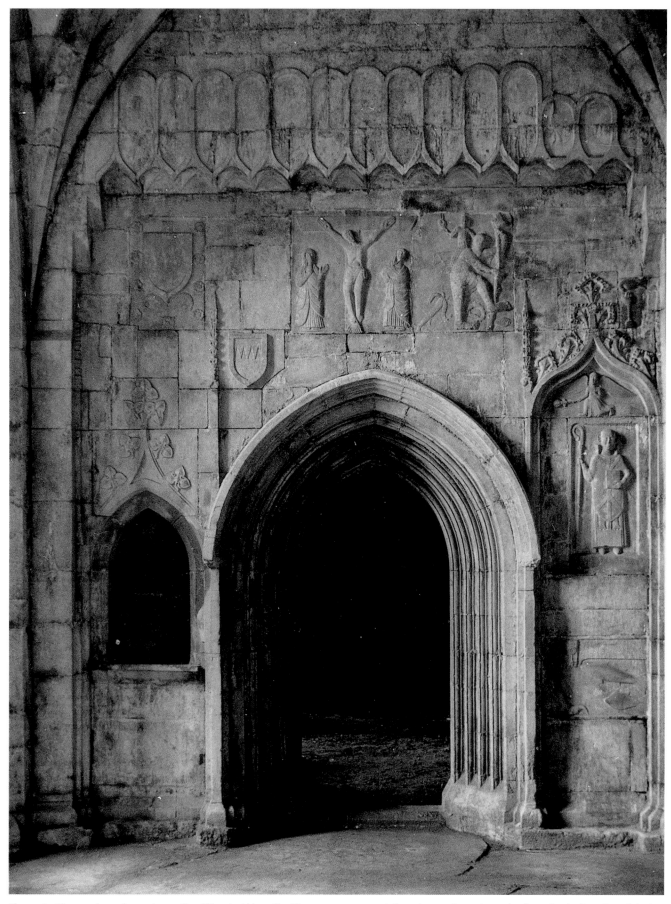

Plate 116 The panels on the sacristy wall at Kilcooly Abbey, Co. Tipperary, are removed from the actual opening and reflect a local adaptation of the late Gothic style.

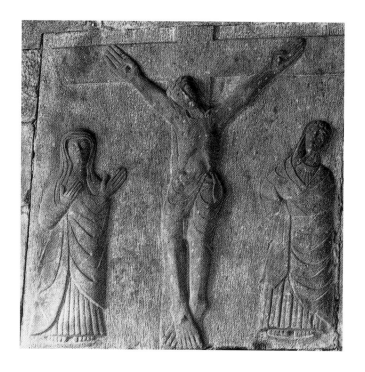

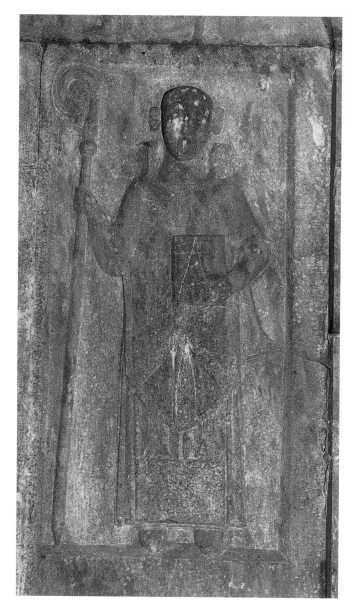

Plate 117 (*top left*) Despite the awkward proportions of the figures and the imbalance of the composition, the central motif on the sacristy wall at Kilcooly Abbey, Co. Tipperary, attempts to convey the humanity of the figures.

Plate 118 (*top right*) St Christopher, one of the most popular motifs in late medieval art, is rarely represented in Irish art and only three examples are known. He is usually shown, as in the example from Kilcooly Abbey, with the infant on his shoulders and surrounded by fish.

Plate 119 (*bottom left*) This figure at Kilcooly Abbey possibly commemorates Philip O' Molwanayn, who was responsible for the rebuilding of the abbey in the middle of the fifteenth century and is buried in the nearby chancel.

Plate 120 (*bottom right*) The angel with a censer – as if participating in a funeral rite – is directly above the carving of Abbot Philip (O' Molwanayn), and was probably intended to convey the fact that he was dead.

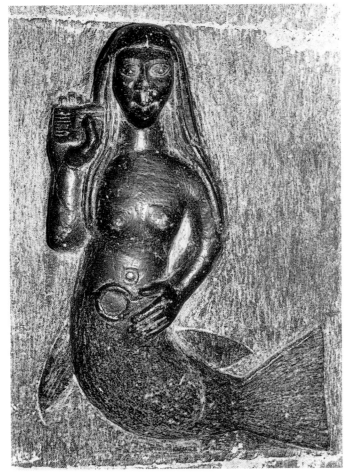

Plate 121 (*above*) This panel from Kilcooly Abbey, Co. Tipperary, is one of the best known carvings from Gothic Ireland. The mermaid, a symbol of vice, is accompanied by her traditional attriubutes of mirror and comb.

Plate 122 (*left*) This siren on the chancel arch at Clonfert cathedral is prominently displayed and would be one of the most visible images. The carving, similar in style to the nearby angels on this arch, was the work of the sculptor responsible for the saintly images over the northern portal at Clonmacnoise cathedral.

Plate 123 The chapter house doorway at Kilcooly Abbey, Co. Tipperary, is one of the most enigmatic decorative programmes in late fifteenth-century Ireland, and includes a cross of St Andrew and a tau cross among the motifs.

arch with a series of decorative, geometric, foliate and representational designs including a tau cross, male head, saltire cross and pear-shaped head with grapes extending from the top, as well as a number of curvilinear and geometric motifs.

All these fifteenth-century doorways are remarkably similar in design and are clearly based on English Perpendicular originals of a slightly earlier period. The use of such antiquated designs and their late appearance in fifteenth-century Ireland has been explained in terms of the native masons reverting to designs which were current before the mid-fourteenth century hiatus (see chapter 7).[52] Although they had been abandoned elsewhere, these were the designs with which the masons were familiar, and they chose to continue using. It is clear that by this time there was not the free exchange or travel between Ireland and England which had facilitated the transmission of styles and iconography in the thirteenth century.

The surviving doorways from the thirteenth and fifteenth centuries are remarkably localized, and it is clear that in terms of design and iconography, the presence of the same workforce played a significant role in the dissemination of ideas. The thirteenth-century doorways (both the plain and embellished examples) are found mainly in the east and south-east of the country, in those areas which were under more immediate Norman influence. On the other hand, the finest fifteenth-century examples are in the west of the country, in lands that were always considered outside the immediate sphere of influence.

Iconography

It is only in the thirteenth century that Gothic Irish sculpture is close in style to that found in England, and even then it is initially restricted to the few buildings which were under the direct influence of the Anglo-Normans. Christchurch cathedral, Dublin, and Cashel cathedral influenced a number of other religious foundations, but generally speaking the more distance there was from such centres the less their influence. The practice of using the wall area surround the doorway for displaying important sculptural programmes is similar to that of the Romanesque period on mainland Europe.[53] However, while such panels are also found in Romanesque Ireland, they differ slightly and are not as regularly placed as in Europe. It is unfortunate that most of the panels surrounding the fifteenth-century doorways in Ireland are reconstructions, and it is not possible to tell their

greets the visitor in a pose reminiscent of the thirteenth-century examples at the St Canice's cathedral, Kilkenny, and the later fifteenth-century example at Callan Friary, Co. Kilkenny. With his hands held in prayer in front of his body the angel acts as guardian for all who are about to enter this place of worship and is a gentle reminder of the sanctity of the site. As if to add dignity and importance to this small carving it is placed beneath a floriate canopy which is longer and more intricately cut than the figure.

Another unique series of carvings is found on the door to the chapter house at Kilcooly Abbey (pl. 123). Embellished chapter-house doorways are to be found in a number of Irish monasteries, including Holycross Abbey, where there is an all-over billet ornament, but there are no foliate or representational motifs other than those at Kilcooly. The ogee-headed limestone doorway, crudely set into the rubble walling, is decorated on the chamfered

original layout – whether they were regular or randomly placed. These panels are the most popular means of portal decoration in Ireland, and the Irish masons never used jambs, tympanums, archivolts or columns – unlike the English masons.

The iconography of these doorways is also a combination of the native and the imported, especially in the fifteenth century. Static single images could work on their own or, in some instances, relate to other motifs. There is very little of the narrative in these panels. It is interesting that of the three possible themes found in portal sculpture the Irish selected the one subject, the saint, which they could adapt with least difficulty to their preferred static portrait type. The emphasis on the saint in Irish portal sculpture belongs to the much wider tradition which includes the use of saintly effigies on mensa tombs and the many examples found in metalwork (see chapter 6).[53] A number of the saintly portraits found on these doorways are remarkably similar to funerary sculpture and were clearly the work of the same sculptors. The saintly portrait in Gothic Irish sculpture, on the basis of what survives first appears in the early fifteenth century and its incidence increases as the century progresses. The examples on some of these doorways, such as those at Clontuskert, Clonfert and Clonmacnoise, are among the finest and most interesting to be found in medieval Ireland.

While some motifs, such as the angel or saint, are common to more than one doorway, each portal deserves to be studied independently. The first and one of the most interesting of these great portals, which in many ways provides an introduction for the others, is the western doorway at Clontuskert Priory. The fairly broad range of subjects employed is remarkably similar to those on a number of other portals, but shows how limited the repertoire was. The first, bottom left-hand side panel on the wall surround, the pelican, is one of a number of motifs found in Gothic Irish art to be taken from the bestiary. It would have been understood by the visitor principally as a symbol of resurrection and is found on doorways at nearby Lorrha priory and Lorrha parish church. The pelican is opposite the first of several panels on this wall which are devoted to the struggle between virtue and vice. The small unidentifiable animal and bird in the right-hand panel are clearly in the middle of a confrontation. The use of contrast and comparison is much in evidence on this doorway, not only on the jambs but also within individual panels, especially where there is more than one animal. This is also the situation with the next panel above, in which two yales are shown with interlocking necks.[54] With their horse-like bodies and elephant tails, these two examples can also be identified by their goat-like beards, found in manuscripts but rarely in the other media. These animals are fighting and although their interlocked necks do not convey this aggression, it is reinforced by their front legs which, although now damaged, are raised against each other. Interlocking necks have been used in art from as early as 3000 BC,[55] but the stance and pose in this particular carving is reminiscent of manuscript illumination.[56] A number of examples of this subject are found elsewhere in Ireland. The first, also in architectural sculpture, is on the cornice table of the northern transept at Holycross Abbey (pl. 124). At Cloonshanville Priory, Co. Roscommon, the two animals are found in the spandrel of a window mould-

Plate 124 Two yales with interlocking necks on the cornice table at Holycross Abbey, Co. Tipperary, are similar to carvings at Clontuskert Priory and Limerick cathedral and date from the mid to late fifteenth century.

Plate 125 One of the surviving sets of misericords from medieval Ireland is at Limerick cathedral. The motifs are a mixture of the international and Insular and include two yales with interlocking necks.

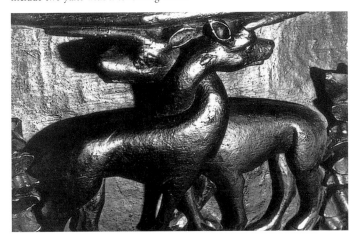

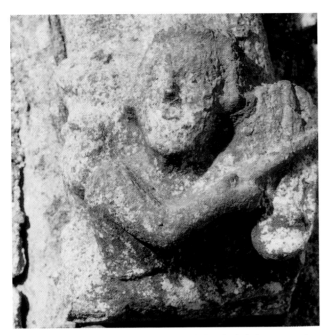

Plate 126 Label stop on a window at Cashel cathedral showing a triton (or siren) with a lyre as well as an unturned male figure. Its remote location is typical of the thirteenth century.

ing, and there is another example on the misericords at St Mary's cathedral, Limerick (pl. 125).[57] All of these date from the mid- or late fifteenth century.

Directly opposite the panel of the yales at Clontuskert there is a carving of a griffin and a lion, which combines two of the most popular motifs in medieval Ireland, a combination frequent to the country. This motif is particularly common in fifteenth-century metalwork and is found on a number of shrines, including the Cathach (see pl. 144) and the Domhnach Airgid (see pl. 158). Ó Floinn has pointed out that dies for this motif have been found in Ireland.[58] A similar scene, but with two griffins in confrontation, is usually found outside Ireland. More often than not there is an object, such as a chalice, between them,[59] a motif found in Ireland on the Fiacail Padraigh Shrine (National Museum of Ireland, Dublin, 2836). Two of the earliest occurrences of this motif may be on a seventh- or eighth-century bronze clasp from Switzerland[60] and an enamel vessel in the treasury of Saint-Maurice d'Agaune in Switzerland.[61] This was a popular motif in French Romanesque sculpture, especially in churches in the Auvergne region,[62] for example at the Church of St Pierre at Blesle,[63] which dates from the twelfth century, and on an archivolt originally from

France but now in the Cloisters Museum, New York (inv. no. 22.58.1A).[64] The same motif is found in ninth- and tenth-century Italy, for example two reliefs which may have also come from a portal, one from Sorrento cathedral[65] and the other from Salerno.[66]

The love of contrast, so obvious on the reliefs around the doorway at Clontuskert, is nowhere more clearly shown than in the carving of the mermaid and IHC monogram. No other subject allowed the medieval artist the freedom to depict beauty, vanity, lust and nakedness in all its forms.[67] Derived from the bestiary, the mermaid is also commonly represented in Romanesque sculpture throughout Europe. In the later medieval period the motif is not usually found in architectural sculpture but, instead, is one of the most familiar subjects on choir stalls, misericords and in manuscripts. Even though it was recorded that sirens were caught off the Irish coast on three separate occasions,[68] they do not appear in Irish art before the thirteenth century, and are comparatively rare after that. The earliest example is high on the exterior of Cashel cathedral (away from the eyes of the public), as a label stop to the hood moulding on a thirteenth-century window (pl. 126); a male triton with the characteristic lyre and fishtail faces the viewer, while to his side, and turned upside down, there is a female figure.

In such a remote and inaccessible part of a building the influence of the siren as either symbol or motif, must have been minimal and may partly explain its infrequent appearance, particularly in Ireland, until the fifteenth century, at which point it forsakes its lofty and remote location and comes down to eye level in prominent positions. What is unusual about the use of the siren in Ireland is that at this time it is still found in the more remote and inaccessible areas.[69] Only five such examples are recorded,[70] and of those datable to the fifteenth century all but one come from buildings with embellished portals. All five examples show a mermaid, with her mirror in her left hand and a comb in her right, and with fish on her right-hand side. An anthropomorphic fish appears in the Monasterevin Ordinal (Bodleian Library, Oxford, MS Rawlinson C32, fol. 47r; fig. 4), but it is not a mermaid and is typical of the marginalia in that Cistercian manuscript. An even older example, and closely related to the Monasterevin anthropomorph, is found in the tenth-century Book of Kells (f. 213r; fig. 5). The finest and best preserved Irish mermaid is at Kilcooly Abbey (pl. 121), on the southern side of the sacristy doorway; that at Clonfert cathedral is on the southern

wall of the chancel arch. The example at Clontuskert Priory must originally have been one of the most detailed; she holds a monstrance or ciborium-shaped mirror. The rayed, star-like surround and flat base to this mirror is unusual and closer in design to a liturgical object than any of the other simple, circular mirrors. In such a prominent position on this doorway it is difficult to gauge what the reaction would have been to a naked female who greeted visitors on each occasion they entered the doorway. The associated emotions and connotations of this motif have been extensively studied and can range from prostitution to sexual lust and evil.[71] In English medieval churches she is usually relegated to a position far removed from such immediate interaction (for example on misericords or cornice tables), but at Clontuskert the figure could not be more forcibly placed or stated. Placed at the entrance to either the chancel or the body of the church these symbols must have warned the worshipper of the evils of sin and the need to resist temptation (especially of the flesh) in all its forms.

The eye-level position of the two panels opposite each other at Clontuskert, beneath the springing point of the pilasters suggests their importance in the design of the doorway. Of all the panels on the surround, these two most clearly parallel each other. The panels must represent the heraldic motifs of Edward IV, in whose reign this portal was carved. These two motifs, the white rose and sun in splendour, are also found on metalwork in both Britain and Ireland, their most common occurrence being on the backs of the roundels of late fifteenth-century processional crosses. Here, at Clontuskert, their forceful presence was an immediate sign of allegiance for this quiet monastery in the west of Ireland. Directly above the panels is the finely carved IHC monogram, which, with its floriate tendrils is clearly based on a manuscript original. It contrasts with the last panel, directly above, of a small dragon's head. The placing of this motif, away from eye level and the other symbols of temptation, resurrection and the struggle of virtue over vice, surely suggest both aloofness and fecundity. Moreover, the deep undercutting in the area of the mouth reinforces the evil nature of this subject and the horror that it was intended to inspire. This same undercutting in the area of the mouth is found in the carving of the grotesque animal head which looks down from beneath the tower at Ballybeg priory, Co. Cork (see chapter 3).

The choice of the four saintly figures over the arch at Clontuskert is unusual and closer to the iconography of

Figure 4 (*top*) Anthropomorph resembling a siren from the Monasterevin Ordinal (*c.*1501), which replicates a design from the Book of Kells. Bodleian Library, Oxford, MS Rawlinson C. 32 f. 47r.

Figure 5 (*bottom*) Anthropomorph from the tenth-century Book of Kells. Trinity College Library, Dublin, MS 58 (A. I.6) f. 213r.

funerary sculpture than to the general repertoire of architectural motifs. Indeed, it is clear that the sculptor responsible for this entire doorway was more familiar with funerary carving than portal decoration. The panels on either side of the opening, with their frames and recesses, are similar to the workmanship on many later medieval Irish tombs, such as that at Mothel, Co. Waterford.[72] Similarly, the four saints – with their bell-shaped outlines, unique drapery folds and portrait-like quality – are more akin to figures on mensa tombs than to any other piece of Irish architectural sculpture. All four figures were carved by the sculptor responsible for the figure of an archbishop on the western end of the Creagh Tomb in Ennis Friary, which has been dated to around 1470.[73] Particularly characteristic of this sculptor's work are the strong modelling of the jaw, the deeply and regularly cut folds of the chasuble drapery and the pose of the figures, especially the placing of their hands. In fact, there is a remarkable similarity between these doorways and the general design of some late fifteenth-century tombs (for example, the Joyce Tomb, Galway, and the canopied tomb in Kilconnell Friary, Co. Galway, are remarkably similar to portal designs).[74] Their pinnacles, foliate crockets, multi-

moulded jambs, iconography and overall decoration are all part of the same stylistic movement.

All four of the saints at Clontuskert were venerated in medieval Ireland and are represented elsewhere in a variety of media. The two inner figures, nearest the crocket, St John the Baptist and St Catherine, may have been intended to relate directly to each other. What is unusual on this portal is that there is no image of the Virgin, to whom the priory is dedicated. However, it may be her son whose presence is subtly hinted at by St John: usually seen as Christ's representative, the allusion here is made even more emphatic by his pointing to the *Agnus Dei* in his hand. In such a position St John would be aptly located next to his mystical bride, St Catherine. While Christ may not be represented in figurative form on this doorway his presence is certainly indicated by the double use of the IHC monogram and the symbols of the Passion which the angels display on their shields.

There are not many examples of St Michael weighing the souls and even fewer where the demon is tugging the scales, but in such a position he is linked to the pelican and its meaning as a symbol of resurrection.[75] From the early Christian period in Ireland St Michael is symbolically associated with the Last Judgement. If this was the symbolism attached to the saint in the later medieval period, then as a motif it is closely related to one of the general themes of portal sculpture outside Ireland. The fact that the saint is here associated with three other saintly portraits may however mean that it has a different meaning. St Patrick also appears at Clonmacnoise cathedral, and his presence there has been explained as reflecting the primacy of Armagh and the fact that the cathedral falls within its province.[76]

Above all, however, St Patrick is an example of the increasing appearance in the iconography of this period of the local indigenous saints, unrepresented in Irish art during the previous two centuries. Irish saints such as Brigit, Columba and Munchin are found in metalwork and sculpture for the first time in the art of this period, and in a monastery such as this, in the west of Ireland, where he was known and venerated, it would be perfectly usual for both St Michael and St Patrick to be included in the repertoire of saintly effigies. At Clonmacnoise the identity of the three saints over the doorway is provided by an inscription which must have been undertaken not for the medieval viewer, as it is totally illegible from ground level, but with a view to preserving

their identity for future generations and as a commemoration.

The Clontuskert doorway is the highest achievement in portal sculpture for the later Middle Ages in Ireland, but it also provides a key to the motifs on the other contemporary doorways, all of which are similar but simpler in design and iconography. While the saintly figures at both Clontuskert and Clonmacnoise are identifiable, those at Clonfert and Kilcooly are not. There can be little doubt, however, that they were significant not only in the life of the community but throughout Ireland. It is tempting to see the two figures facing each other at Clonfert as representing the actual and spiritual founders of the monastery. The early Christian monastery was founded by St Brendan the Navigator in the sixth century, while the foundation of the first stone cathedral is generally credited to Petrus O Mordha, Bishop of Clonfert and first Cistercian abbot of Boyle, who was drowned on his way to the Synod of Cashel in 1172.[77] The figures differ in their clothing and posture, with that of highest authority on the side of greatest importance (the right or southern jamb). If the fully vested bishop with his inturned crozier may represent St Brendan or alternatively St Patrick,[78] there can be little doubt that the other figure with a flowering staff and habit is intended to represent a member of the later monastic community and may be a commemorative representation of Petrus O Mordha. Stalley suggested that the figure of the fully vested cleric at Kilcooly Abbey, who stands under an elaborate canopy to the right of the sacristy door, may represent Abbot Philip O'Molwanayn, the cleric responsible for rebuilding that abbey after its destruction in 1445.[79]

Although the iconography of the sacristy wall at Kilcooly Abbey relates in isolated elements to other portals, it is unusual in its choice of subjects. This is undoubtedly because it is a portal within the monastery and not one in the western façade. The sacristy was the room in which sacred vestments and vessels were stored and was one of the most important rooms inside the church. The largest panel on this wall is the Crucifixion, with the traditional pairing of the Virgin and St John. Despite the unequal sizes of the figures and the general awkwardness of the composition, there is an attempt to convey movement and narrative in the gestures of the hands and in the bodies. The flatness of the drapery and figures is typical of this whole wall which, despite the location of the abbey in the heart of the

Plate 127 The abbot's seat in the southern wall of the nave at Kilcooly Abbey, Co. Tipperary, is unique. It is carved by a single mason and includes Butler family heraldry over the opening.

Plate 128 Most carvings of the *Arma Christi* from medieval Ireland include three or four of the instruments of the passion. This fine shield with a larger than usual complement is carved on the eastern wall within the abbot's seat at Kilcooly Abbey.

Ormond territories, is particularly localized. Christ's relatively large, flattened feet and hands are close in style to those of a group of late fifteenth-century processional and altar-cross figures which are particularly Insular in origin.[80] Although the peculiarities of this panel may be the result of incompetence (the nearby figure of St Christopher has even larger feet) it is tempting to see a definite iconographic stress at Kilcooly on the Passion, as in the nearby shield (on the southern stall, or abbot's seat, in the nave), which has one of the finest sequences of the *Arma Christi* in medieval Ireland (pls 127 and 128).

Immediately to the right of the Crucifixion and iconographically linked is an equally large panel showing St Christopher carrying the infant Christ on his shoulders. From its imbalanced design it is clear that this panel was the work of the same sculptor; the fish and eels which surround the saint's legs must have been drawn from a manuscript source. Given the cult of this saint in popular religion and art during the Middle Ages, it is unusual to find only three surviving examples in Ireland;[82] the other

two are at the Cistercian abbey at Jerpoint, Co. Kilkenny (pls 129 and 130). Far more competent in design and execution, the Jerpoint figures forsake the element of narrative and focus instead on the moment of delivery.

One of the most interesting panels at Kilcooly is the small pelican immediately above the hood moulding of the niche on the right-hand side of the doorway. The replacement of the bird's nest with a chalice is particularly apposite in a context such as this and there can be little misinterpretation of the intended Eucharistic reference to Christ's salvation. Together with the panel of the mermaid, this is one of only two subjects on the wall to be drawn from the bestiary.

The pilaster of the main door at Kilcooly acts also as one of the pilasters of the niche over the fourth panel on the wall, which encloses an ecclesiastical portrait. Within his own miniature portal the cleric stands with outturned crozier in one hand and book in the other. There can be little doubt that this is Philip O'Molwanayn, the abbot responsible for rebuilding the monastery, whose tomb

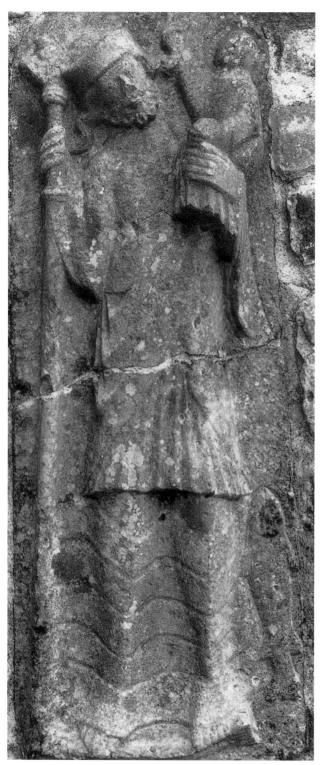

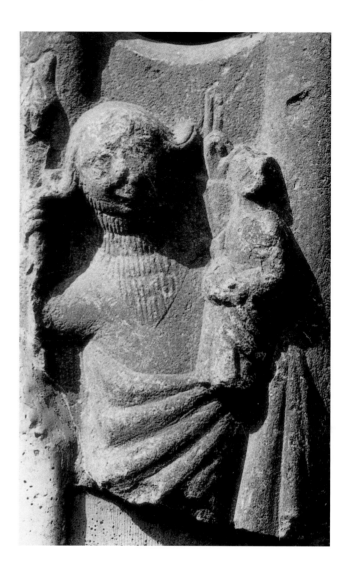

Plate 129 (*above*) St Christopher is traditionally associated with travellers and those in need of help on a journey. The carving at Jerpoint Abbey, Co. Kilkenny, may originally have met visitors to the abbey but is now in the cloister.

Plate 130 (*above right*) This St Christopher, also in Jerpoint Abbey cloister, is part of the most elaborate iconographical programme in late medieval Irish sculpture. The emphasis on the large size of the infant's hands is typical of other carvings of the period, including those on the Domhnach Airgid.

slab is in the nearby chancel. Given its context and design, this carving must be considered a portrait, albeit a death image, and is thus one of the first in Ireland – other than funerary effigies. The censing figure over the abbot is not the typical acolyte who usually holds such an implement, but an angel – an indication that the abbot has left this world and is in the Kingdom of the Lord.[83] This is, in effect, a commemorative plaque, the primary aim of which was to celebrate the life and memory of the abbot. Allowing for the inadequacies of the sculptor responsible for this whole wall (even the figure of Abbot Philip is not centrally placed under the niche), it is possible that the niches on either side of the opening may have been intended to balance one another.

The two Butler shields on the left side of the sacristy wall represent the patronage of this family throughout the history of the abbey, nevertheless there is remarkably little

evidence of any patron's influence on these doorways, although the choice of saints on the portals may reflect the patrons' wishes. In general, it is not until relatively late in the fifteenth century that the more obvious presence of the secular input is evident. The inscribed plaques at Dunmore and Lorrha are the first examples of secular influence. With an iconography drawn from scripture, heraldry and the bestiary, the unifying themes of all the motifs on the Kilcooly doorway appear to be salvation and resurrection. In the light of the disasters that had beset the abbey in the mid-century, its subsequent rebuilding was a suitable event for visual celebration.

Influences and Sources

The chapter house was one of the most significant meeting rooms for the monastic community, a place where prayers and chapters of either the order's rule or the Scriptures would be read. It was a room to which only the monks had access. The doorway at Kilcooly is iconographically enigmatic and made up for the most part of non-representational symbols, the meanings of which are difficult to unravel. There are two heads, one on either end of the decorated chamfer that links a range of geometric, foliate and curvilinear motifs and only one or two identifiable symbols, including a St Andrew's cross and a tau cross.

Apart from these unique elements, two of the more traditional motifs are also repeatedly found on portals: the vine (and grape) and the angel. The first of these, symbolizing the strength of the Church, appears on the hood moulding of most doorways.[84] A minor variation, showing birds picking the grapes, is found at Devenish Priory; vine leaves are found in Gothic Irish art as a decorative motif, but the inclusion of grapes is unusual and reinforces the symbolism of the doorway as offering salvation to all who enter. The angel, which surpasses even the vine and grape motif in use, also offers protection to the visitor entering the sanctified space beyond.

Despite the fact that these symbols were used internationally, the Irish carvings have a strong Romanesque element in their sense of design and are closer to twelfth-century carvings than those of the fifteenth century. This may be explained by the fact that even though they were introduced into Ireland in the fifteenth century the only prototypes on which workmen could base their designs were those of the earlier period. However, much of the sculptors' creative spirit had been lost in the intervening two centuries and it was difficult to recapture the unique

style of much of the Hiberno-Romanesque designs. Similarly, the workmanship at most of these sites falls short of the earlier periods.

All the animal subjects on the Clontuskert portal derive from the bestiary and were used in a position where their meaning would have been easily understood by a visitor, but the route by which these motifs reached the west of Ireland may not have been so direct. Unlike England, where the bestiary first appeared in the late thirteenth century, the earliest use of the subjects in Ireland (apart from the isolated surviving carving at Cashel cathedral) appears to have been in the fifteenth century, when they are either direct borrowings from manuscript sources, as in the case of the pelican, or motifs adapted to the Insular Gothic taste, such as the griffin or the yale. The use and adaptation of these motifs must depend on the audience for which they were created, one which, by and large, was probably illiterate and ignorant of the original manuscript sources. This audience would have understood the images as symbolic representations. Their appearance in Irish architectural sculpture coincides with their transfer into the more widespread and accessible arts of church furniture and decoration such as misericords and bosses. However, while in England such motifs are found in secondary locations, their position in Irish sculpture is forceful and dominant (as at Clontuskert), indicating their popular appeal.

It is interesting to see the close relationship between the yales at Clontuskert Priory and the swans at Clonmacnoise cathedral (pl. 131) and Lorrha Priory, with the same subjects on Ireland's only surviving medieval misericords at the St Mary's cathedral, Limerick (pl. 132). Such motifs may be drawn from the bestiary, as undoubtedly the yales are, but, in the case of the swans, they may be derived from a different source. The swan was a royal emblem, used first by Henry V, who reigned from 1413 to 1431, the approximate period at which the portals at Clonmacnoise and Lorrha were carved. In much the same way as the Tudor rose at Clontuskert Priory proclaimed allegiance to a later king, so too these discreetly placed emblems might also have been a subtle declaration of royal allegiance. The frequency with which a number of royal emblems – the Tudor rose, the swan, the lion passant (see chapter 6) – are found in Ireland is more than accidental and is part of the programme of commemoration which is a focus of such portals.

As a general rule, however, by the time most of these animals reached Ireland they had long become disassociated from their textual sources – sources which

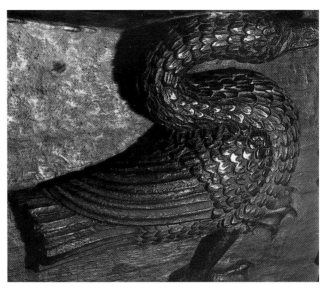

Plate 131 A small heraldic swan is discretely hidden in the hood moulding of the northern portal at Clonmacnoise cathedral, Co. Offaly, where it is paired against the amphisbena (pl. 103).

Plate 132 Swan carved in dark oak on a misericord at Limerick cathedral. This is an example of one of the least used motifs in Gothic Ireland; only two others are known.

would have been useless for an audience that could not read. Images were more easily understood on their own, but this severing of links could also mean that the animals may have taken on a life of their own. Without a textual correlate, there is every possibility of reinterpretation or misinterpretation by an uneducated audience, and indeed some of the panels for which there are no known parallels outside Ireland, such as the yale, the griffin and dragon, may have been created in such a manner.

These animals may have been removed from their original contexts, but there can be little doubt that they were still used to convey a moral lesson. As self-contained symbolic lessons on Christian behaviour, they would have been an easily understood and effective teaching aid. There could be no better way of repeatedly raising public awareness than to have such symbols visible on a daily basis at the entrance to a church. Why some animals were selected in Ireland and others were not remains a mystery. There does not appear to be any cohesive pattern in the underlying choice, or even the avoidance of some animals. The use of familiar everyday animals to which moral values could be applied, would, no doubt, have

made them more attractive as subjects for moralizing, but everyday animals are found only rarely in Irish art of this period.

The portal, with the cloister, was the most significant area for the placement of sculpture in Gothic Ireland. It provided an unparalleled location for the interaction of message and audience. The sculptural programmes found on these doorways are simple when compared to the more elaborate Gothic portals of thirteenth-century France, and it was not until the fifteenth century that they were properly exploited in Ireland. Thirteenth-century portals are more international in style and make limited use of sculpture. In the fifteenth century, however, it is clear that they are part of a revisionist programme, either consciously or accidentally. The forms replicate English designs of nearly half a century earlier, but are combined, uniquely, with even older Romanesque models, in which a series of panels surrounds the opening. Their iconography is limited, but specific, and combines the Insular with the international. In selecting decorative motifs from the bestiary, heraldry and history, these portals work as visual lessons and areas of commemoration, uniting form and function.

The Virtuous Pelican in Medieval Irish Art

Although the study of Gothic Irish art has been largely neglected, its iconography at least has been the subject of some scholarly attention. Studies such as those by Helen Roe[1] attempted to redress the general neglect and, by looking at the continuity in iconography between the pre- and post-invasion periods, dispel the notion that the creative spirit in Irish art ended at the time of the conquest.

As in so many other areas of Gothic art, the Irish did not simply replicate they also invented. Animals, in particular, abound in all the decorative arts from the ninth century onwards, but those of the Gothic period have been dismissed as merely interesting details, lacking the complexity of those of the Golden Age. The pelican, which is not found in art of the pre-invasion period, is one animal so stigmatized. It is found in a variety of media in Gothic Ireland – metalwork, wall painting, sculpture – and is an example of how a simple motif is used in an Insular context. Examination of this motif against its European background reinforces the notion that close ties existed between Ireland and the rest of western Europe in the fifteenth century, and shows how the Irish art of this time maintains the creative force of preceding periods.

Despite the fact that the pelican is one of the most popular motifs in the history of art, and one whose symbolism is widely known, no single study in English has dealt fully with its origins and meaning. No such study will be attempted here; rather, what follows is a brief review of early textual references for this motif before the discussion of its Irish representations.

Origins

Unlike the owl or the ram, whose antiquity and origins as symbols can be traced to the Classical period, no ancient links can be found for the pelican in either Classical or orthodox sources. Classical writings earlier than the *Physiologus*, other than the commentaries on the Bible, appear to have contributed little to the legend of the pelican. Pliny (*c.* AD 79), for example, gives only a brief description of the bird and its feeding habits, saying that it lives in northern Gaul and resembles a swan, but has two stomachs like a ruminant.[2] Aelian (*c.* AD 220), similarly, gives an account that focuses on the natural history of the pelican, particularly its diet.[3]

The description by Horapollo (*c.* AD 500), on the other hand, attaches some symbolic importance to the pelican, but adds little to our understanding of the medieval occurrences of the symbol. In fact, as George Boas points out, this is one of the few emblems in Horapollo which contradicts the descriptions in the *Physiologus*.[4] Horapollo's account, which essentially agrees with that of Artemidorus (*c.* AD 2), gives foolishness as the pelican's main characteristic:

A Fool: When they draw a pelican they indicate foolishness or imprudence. Though, like other birds, it can lay its eggs in the highest places, it does not. But rather it hollows out a place in the ground, and there places its young. When men observe this, they surround the spot with dry cow-dung to which they set fire. When the pelican sees the smoke, it wishes to put the fire out with its wings, but on the contrary only fans the flames

with its motion. When its wings are burned, it is very easily caught by the hunters. For this reason priests are not supposed to eat of it, since it died solely to save its children. But the other Egyptians eat it, saying that the pelican does not do this because of intelligence, as the vulpanser, but from heedlessness.[5]

The essential characteristic of the pelican in the medieval period, however, was that it fed its young with its own blood, which differs considerably from the characterization of Horapollo. Wellman argues that this discrepancy may have arisen through a misapplication of the vulture's traits to the pelican.[6] Horapollo's description of the vulture is as follows: 'When it is at a loss to find food to prepare for its young, it cuts open its own thighs and allows its young to drink its blood, so that it may not lack food to give them.'[7] Wellman further believes that the name 'crooked beak', which Hermes Koiraniden (3:39) gives to the pelican, was also used to refer to the vulture and this may explain the confusion that seems to have occurred. It has been argued that it was in fact the theme of resurrection through self-sacrifice that prompted Christian writers, eager to use the nature and behaviour of animals for didactic purposes, to see in the pelican a parallel to the sacrifice and Passion of Christ, and readily to accept this account of the bird.[8] This characteristic of the pelican was, according to Percy Robin,[9] elaborated during the first three Christian centuries by commentators on the Septuagint.

The Septuagint makes reference to the pelican (Psalm 102:6), but does not offer any solid foundation for viewing the bird as a symbol of self-sacrifice. The origin of this symbolism must therefore have occurred between the date of the Septuagint, the third century BC, and its earliest definite usage in the original Greek version of the *Physiologus*, which may have been written as early as AD 200,[10] but was probably not in wide circulation until the end of the fourth century AD.

It is clear that the origins of the pelican motif are as complex and numerous as was its symbolism in the Middle Ages. The *Physiologus* provides the first definite and the clearest description of the medieval symbolism of the bird: 'David says in Psalm 101, "I am like the pelican in the wilderness".'[11] The *Physiologus* also says of the pelican that it is an exceeding lover of its young:

If it brings forth young and the little ones grow, they take to striking their parents in the face. The parents, however, hitting back, kill their young ones and then,

moved by compassion, they weep over them for three days, lamenting over those whom they killed.

On the third day, their mother strikes her side and spills her own blood over their dead bodies [that is, of the chicks] and the blood itself awakens them from death. Thus did our Lord speaking through Isaiah say 'I have brought forth sons and have lifted them up, but they have scorned me' [Isiah 1:2]. The maker of every creature brought us forth and we struck him. How did we strike him? Because we served the creature rather than the creator. The Lord ascended the height of the cross and the impious one struck his side and opened it, and blood and water came forth for eternal life, blood because it was said 'Taking the chalice he gave thanks' [Matthew 26:26; Luke 22:17] and water because of the baptism of repentance [Mark 1:4; Luke 3:3]. The Lord says 'They have forsaken me, the fountain of living water and so on' [Jeremiah 2:13].[12]

This essentially favourable account in the *Physiologus* is the most widely accepted version of the legend of the pelican and is referred to in another *Physiologus* quoted by Vincent of Beauvais.[13] Slightly earlier Greek versions of the *Physiologus*, however, report that the young birds are killed not by their mother, but by a snake which blows venom toward them on the wind. Similarly, in the *Physiologus* ascribed to Epiphanius[14] there is no reference to the young hitting their mother or vice versa – it is simply through excessive caressing of her young that she smothers them.

Different versions of the *Physiologus*, as well as the later bestiaries, record that it is the male bird and not the female, which sheds its blood. This last detail emphasized the allegory of Christ's suffering by equating the sex of the bird with that of Christ. The accounts of the pelican in the bestiaries contain variations similar to those found in the *Physiologus*. Many of these accounts may have been drawn from earlier writers of natural history and then expanded.

Medieval theologians invested the symbol with a variety of meanings. The moral commentary in the *Physiologus* draws a parallel between the wound of Christ and that of the pelican. This characteristic remains constant throughout the life of the legend: God is always directly equated with the pelican, 'God who is the true pelican'.[15]

The popularity of the pelican as a symbol with the Fathers of the Church may have been because of the

many aspects of Christ's life which it incorporated, which were extended with the passage of time. The pelican was used not only as a symbol of resurrection but also to depict the entire Passion and sacrifice of Christ. Schiller has pointed out the late medieval usage of the pelican as a symbol referring specifically to the holy blood, and as a symbol of Longinus, the soldier who thrust his lance into the crucified Christ.[16] The pelican also appears as a symbol of charity from the sixteenth century onwards.[17]

As a general rule the pelican is shown piercing its breast, with its blood nourishing the young beneath. The minor variations that occur may be the result of the differing details which were originally recorded in the *Physiologus* and found their way into the later English and French bestiaries. One such depiction of a pelican, in a Latin prose bestiary of the twelfth century (Cambridge University Library, MS II.4.26), attempts to illustrate the entire legend, showing the young pecking at their mother, the mother in turn biting her young and finally the rebirth of the young birds. The resurrection in this instance is not brought about by the opening of the pelican's breast, but by what appears to be regurgitation from the mouth of the mother into that of the young. This depiction shows a certain influence from Pliny's original description of the bird.

The pelican also appears as a motif in manuscripts ranging from psalters to books of hours, and Lilian Randall alone has catalogued some twenty-eight marginalia examples between the late thirteenth and the mid-fourteenth centuries.[18] Some of these illustrations are similar to the late Irish examples in that they do not depict the nest or the young but identify the bird only by its action of pecking its breast. The pelican was also a most popular bestiary subject with the medieval wood-carver in England, as Anderson has shown.[19] The pelican motif was also a common subject for roof-bosses in the late medieval period,[20] and it figures prominently as a subject for architectural sculpture (see below).

Ireland

Whatever the origins of this symbol, its popularity in Irish medieval art is unquestionable. Motifs such as the pelican, fox and rabbit, to name just a few, are first found in Irish art of the Gothic period. No such animals have been identified in the extensive repertoire of animal

motifs from the early Christian period. Although Gerhardt recognized only two Irish examples of this motif in his survey of its usage in Europe,[21] there are at least sixteen representations to be found in Ireland, fifteen of which are medieval. In every example the pelican retains the full force of its symbolic meaning. While other animal motifs in Irish art, for example the dragon and the fox, may have been used in specific locations or periods in ways that are entirely decorative and without any symbolic purpose, this cannot be said of the pelican. Only one late example, on the seventeenth-century Sexton Tomb in St Mary's cathedral, Limerick, differs in meaning from the other examples.

The following discussion of medieval Irish depictions of the pelican is arranged by medium: metalwork, architectural sculpture and fresco. Within each medium the representations are grouped by monastic affiliation.

The Limerick Crozier

The earliest dated medieval Irish representation of the pelican is that found on the Limerick Crozier, one of the treasures of the later medieval period in Irish art, which has an inscription on the lowest moulding of the head section recording the year of manufacture as 1418.[22] The animated depiction is found on the end of the volute directly below the platform (pl. 133): 'which is also supported by a pelican in her piety, with wings displayed "vulning herself". The young pelicans which she is feeding with her blood thrust their heads upward from a nest made of the cast vine leaves.'[23] The pelican's beak is shown piercing its breast, while the eager heads and open mouths of the three chicks extend from the nest to the wound. The curve of the pelican's neck exaggerates its grief. Unlike the other figures on the crozier, which were cast from one mould with additional and distinguishing features added before gilding, the pelican appears to have been cast as one piece.

This representation is one of the most accomplished in Irish metalwork and also one of the most graphic, adhering rigidly to the original bestiary description. The rough yet expertly cast pelican's wings tower above its body as if in flight and contrast with the smooth vine leaves of the nest. The Annunciation is shown in the crook of the crozier, with the seated and surprised Virgin facing the standing angel. This scene is linked to that of the pelican by the curved crook of the crozier, which sur-

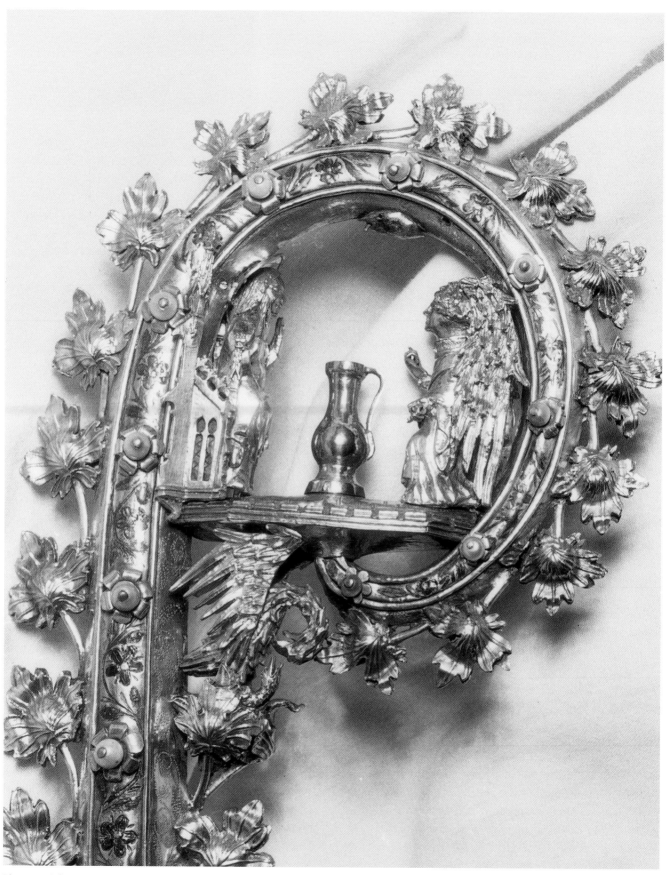

Plate 133 The Limerick Crozier, 1418. Silver gilt, length of staff 137 cm, length of head 60 cm. Irish croziers of the pre-invasion period survive in considerable numbers but there is only one from the Gothic period. Although an angel most commonly supports the platform on Gothic croziers outside Ireland, here the pelican uniquely links the Annunciation with the Resurrection. Bishop of Limerick, on loan to the Hunt Museum, Limerick.

rounds the Annunciation and ends at the pelican's head. The two contrasting styles in these scenes, the tranquility of the Virgin in marked opposition to the power and movement of the bird's and the angel's wings, emphasize the linkage of a symbol of Christ's suffering and resurrection with a scene foretelling his birth. This work shows a skilful and unique handling of composition and technique.

This only surviving example of a Gothic Irish crozier was made, according to its inscription, by an Irish craftsman, Thomas O'Carryd, for an Irish patron, Conor O'Dea, Bishop of Limerick (the mitre also survives). The iconography of the crozier combines Insular and European motifs, and is one of the earliest examples of such a combination from the late medieval period in Ireland. The juxtaposition of the two Saints Brigit – one from Sweden, the other from Ireland – may have been an intentional play on their names, but the appearance of local figures, such as Munchin and Patrick, side by side with Saints Margaret of Antioch and Catherine of Alexandria indicates the creative powers displayed in this work. This is the same combination of Insular and international found on the portal at Clonmacnoise (see pl. 104). Irish and European elements are found again in the association of the Annunciation (which appears on other croziers) and the pelican (which is not recorded elsewhere) in the crook of the crozier. Several Continental croziers of the late thirteenth and early fourteenth century also have an Annunciation in the crook, for example those in the Musée du Louvre, Paris,[24] and the cathedral in Sulmona,[25] where the two figures are shown standing facing each other. Compositionally, however, these European examples are far removed from the Limerick depiction. Much more frequent in such a position, and closer to the Limerick Crozier scene, is the adoration of the Virgin and Child, usually by the donor, as on croziers in Cologne[26] and Haarlem.[27] In almost all of these examples the Virgin is seated on a throne similar to that found on the Limerick example and holds the Christ Child on her knees. The full-length figure of a donor either stands or kneels facing her, a composition that is also closer to the example from Limerick, where the angel would originally have represented Conor O'Dea. The dove and vase are not found in scenes of the Annunciation, but appear in representations of the Adoration. It is possible that Conor O'Dea drew on more frequent formal Adoration scenes in creating this unusual depiction of the Annunciation. Overall, the Limerick

Crozier is closer in style and iconography to examples from mainland Europe than to the better-known crozier of William Wyckham (c.1367) now in New College, Oxford, which is the only surviving English example.[28]

There are no known parallels for the pelican in this position on a crozier, and the Limerick example may represent a local or Insular adoption of the more common figure of an angel with his broadly sweeping wings, which is similar in composition. There can be little doubt, however, that the bird was chosen not for its form but for its symbolic meaning. Great care seems to have been lavished on this scene, and the standardization found elsewhere on the crozier is not in evidence here. The expression of surprise on the Virgin's face, details of the throne, the vase with its now missing lily and the Holy Ghost (also now missing) add to the power and force of this scene.

The Ballylongford Cross

Processional, altar and pendant crosses survive in considerable numbers from medieval Ireland, but the most outstanding example has to be that found in 1871 in a field in the townland of Ballymacasey, near Ballylongford, approximately two miles from the Franciscan friary of Lislaughtin, Co. Kerry (pl. 134).[29] According to an inscription on its arms, the cross was made in 1479 by an Irish craftsman, William O'Connor, for an Irish patron, Cornelius, 'son of John O'Connor, head of his sept [or tribe], and Eibhlin, daughter of the knight'. It comes, in all probability, from the friary at Lislaughtin. The cross was damaged and has been reassembled, but it appears that the arms are in their original positions. The arms are divided into registers, as they are in the majority of processional crosses of this period.[30] These registers usually have lightly incised angular motifs, and the Ballylongford Cross is the only known example to have both an inscription and animal representations. The inscription, in Gothic lettering, is on the left and right transoms and the upper shaft of the cross, and interspersed with four animals, simple interlace patterns, knots and foliage motifs. It reads: 'ACORNELIUS FILIUS JOHANNIS Y CONCHYR SUE NACONIS CAPITANUS ET AVILINA [rabbit] [fox] FILIA MILITIS ME FIERI FECERUT PER MANU [bird] UILLIAMI CORNELI M. XXI CCCCC [pelican] ANNO DI.'

The only creature on the vertical shaft is the pelican; the other three are on the right-hand transom (pl. 135).

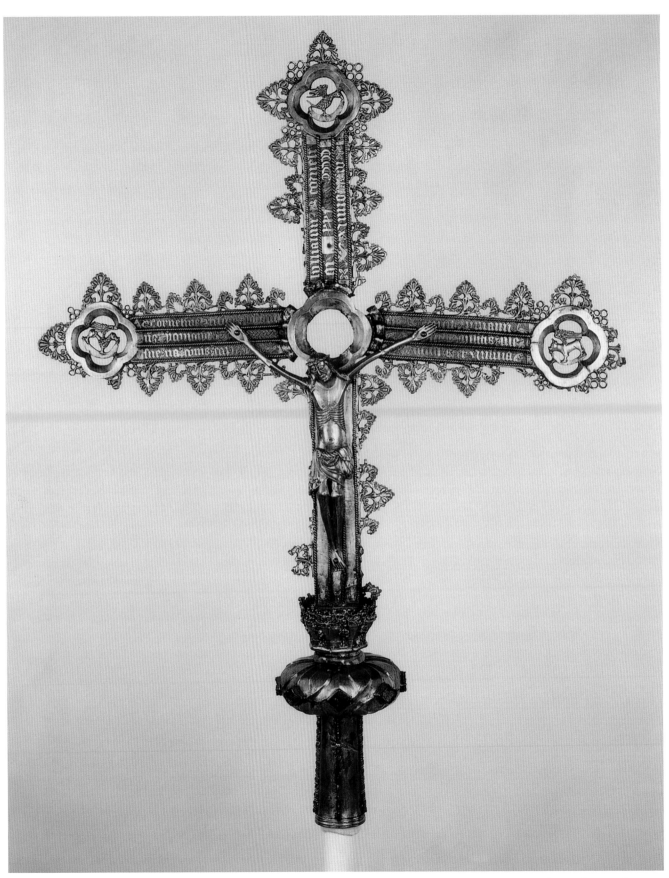

Plate 134 The Ballylongford Cross, *c.*1479. Silver gilt, height 67.2 cm, width 51.2 cm. This processional cross, made by an Irish artist for an Irish patron, combines the Insular and the international styles. National Museum, Dublin.

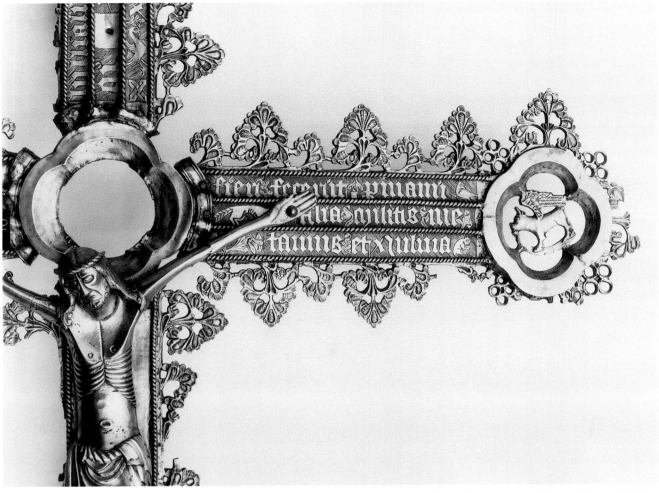

Plate 135 The stylized and suffering figure of Christ on the Ballylongford Cross may have been influenced by Franciscan ideologies. The cross has been reconstructed, but remains one of the finest examples of fifteenth-century Irish metalwork.

These animals may be interpreted as independent symbols, but it is more likely that their significance is based on opposing groups of twos. The pelican (virtue) is opposed to the woodpecker-like bird (vice), while the fox (vice) is opposed to the rabbit/hare (virtue). The association of the pelican with these three other animals is closely paralleled in an early sixteenth-century manuscript from Germany (Hessische Landes- und Hochschulbibliothek, Darmstadt, MS 1944, Cologne, c.1525, f. 188v), where a rabbit, bird and pelican are found together. The representation of the pelican on the Ballylongford Cross is naturalistic, unlike the figure of Christ, which shows elements of stylization in its depiction of suffering. No nest is shown, and the young birds are not depicted. Instead, the pelican is in an almost vertical position, as if in upward flight, with its long beak about

to pierce its breast. The foliage motif, directly over the bird's head, does not appear to have any relevance to the symbol.

This processional cross, which is considered to be one of the masterpieces of metalworking of the Gothic period, is the only example that can be assigned to an Irish artist and patron with total certainty. Although a number of other processional crosses conform to the mainstream English style of this period, the Ballylongford Cross is unique in its iconography. It has been noted that 'small animals such as the fox or the pelican' on metalwork are 'typical of Irish art of this period, and similar incidental animals are a feature of Irish friary architecture of the fifteenth and sixteenth centuries'.[31] The pelican on the Ballylongford Cross is not a unique occurrence, pelicans are frequently found on European metal-

work crosses of this period, usually processional or altar crosses,[32] and they are always directly above the head of the crucified Christ. On an object such as a cross, the pelican is used to reinforce the general Eucharistic nature of the symbolism, and in this position, rising above the head of the dead Christ, it immediately brings to mind the Resurrection. The blood shed by Christ on the Ballylongford Cross is thus symbolically echoed by the pelican. The drama and tension in the figure of Christ on this cross are subtly paralleled in the two opposing pairs of animal symbols, but not by the individual representations, which are merely static depictions. It would have been possible for the artist to have used the pelican simply as an isolated symbol, but by linking it to a symbol of vice he has created a dramatic tension which is also manifest in Christ's body. The association of this cross with the Franciscans in Lislaughtin Friary would have been particularly apposite, considering the devotion that order had for representing Christ's Passion.[33]

A Seal Matrix in the National Museum of Ireland

The legend on this small seal matrix reads '+ SIC PELICAN * FITM [.] I S'S ANG [. . .]'. The roughly circular seal is pierced by three holes and shows the bird in profile over its three young in the nest. Like those in Kilcooly Abbey and Thomastown (below), the nest appears to be a chalicelike cup, the stem of which has no base. There are slight traces of a scroll pattern on either side of the stem. The original provenance or association of this seal is unknown, but it is likely to have been used by a member of the religious community.

Figure 6 This seal is simpler in design than most of those that survive from medieval Ireland. National Museum, Dublin.

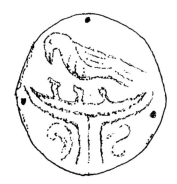

Shrine Reliefs, Holycross Abbey, Co. Tipperary

The rebuilding of Holycross Abbey may have begun as early as 1430, when protection was granted to the abbot and convent for clergy begging alms 'for the works of the aforesaid monastery'.[34] Reconstruction was certainly under way by 1431, and the earliest reference to Holycross as a place of pilgrimage was in 1488.[35] Stalley has discussed the unusual presence of two shrines in this abbey.[36] One of these is in the south transept and forms part of the structure of the building, while the second has been damaged, and its parts are now housed in a storeroom at the site. Stalley records the temporary reassembly of this second shrine in the early 1970s and notes that its vaulted canopy was three bays long and one bay wide.[37] He also mentions the possibility that it was a tomb rather than a shrine. It is decorated in a manner similar to that of the intact shrine; of the three complete arches that remain, two have carvings in their spandrels. Even though both works come from the same shrine, they are not similar in style and are the work of two different hands.

The first of these two examples, which is carved in low relief, shows the pelican facing towards the left in the spandrel of an arch fragment (pl. 136). The bird is shown with its curved neck forming a nearly perfect circle, and with its beak piercing its breast. Under the breast is a nest holding unshapely chicks. There is no attempt to depict the bird in flight. This carving betrays the hand of an experienced and skilled craftsman who was capable of judging his proportions exactly and was not content merely with simple execution but employed distinctive details such as the rough finish on the nest and the angle of the parent bird's head. It is interesting to note that this pelican, the more accomplished of the two examples at Holycross, is balanced against a fox in the adjacent spandrel, apparently another example of the pairing of animal symbols of virtue and vice in Ireland.

Although the pelican as a symbol of resurrection is found in a post-medieval context in Irish funerary carvings (see the Sexton Tomb below), it is not used with this meaning on any funerary monuments before the sixteenth century. Stalley has also noted that it is a more appropriate motif for a shrine than for a tomb.[38] The presence of two examples of this symbol on a single shrine is unusual and may have been necessitated by the fact that pilgrims could approach the monument only from one side or the other, thereby creating the need to replicate the decoration on both sides.

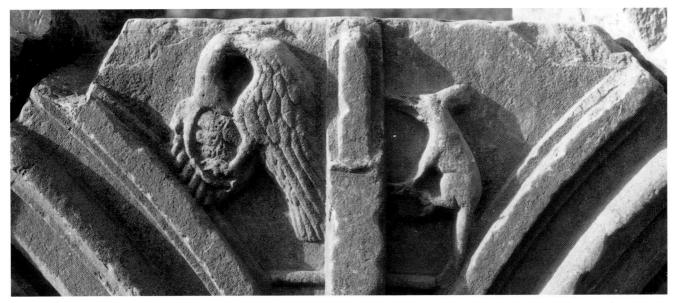

Plate 136 This pelican, originally from a shrine that displayed a relic of the True Cross would have been accompanied by another animal motif; mid-fifteenth century. Holycross Abbey, Co. Tipperary.

The second panel (pl. 137), which is the less accomplished of the two examples from this shrine, shows the bird facing towards the right. The pelican is placed in the spandrel of the arch fragment and is again carved in low relief. Although it is similar to the other example, it does not have the same level of detail. The tail feathers of the bird are all that remains of any detail that might have been on the carving. The bird's neck curves over its young, which are facing its breast. In this example the nest is not separated from the bird's breast but appears to be part of the bird itself. This panel exhibits a certain lack of judgement in proportion and balance: the bird is awkwardly placed in the spandrel and even the finer details lack balance.

Portal Reliefs at Kilcooly Abbey, Co. Tipperary

Three examples of the pelican symbol are found in the Cistercian abbey of Kilcooly (see pl. 116). A considerable number of the workforce employed in the rebuilding of Holycross Abbey were re-employed in the rebuilding of nearby Kilcooly Abbey,[39] but it is unfortunately impossible to detect any similarities between the pelican carvings at these two sites. The carvings at Kilcooly are slightly later than those at Holycross, and date from around 1464, when the rebuilding took place, or shortly thereafter.

Plate 137 Coming from either the cloister or another shrine this carving is similar to the other pelican from Holycross Abbey, Co. Tipperary (mid-fifteenth century).

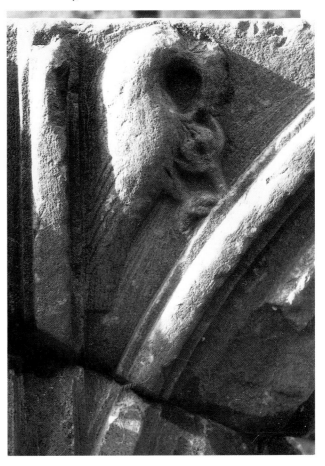

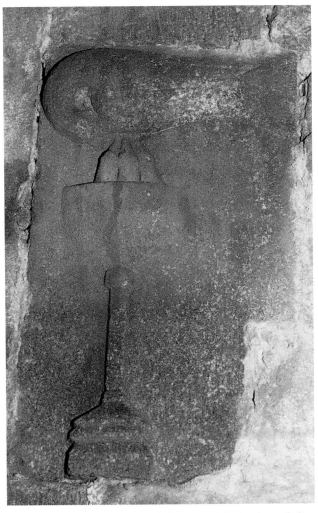

Plate 138 Pelican with young in a chalice nest, reinforcing the symbolism of resurrection (*c.*1464). Kilcooly Abbey, Co. Tipperary.

Plate 139 Life-size carving of a pelican at Strade Priory, Co. Mayo, directly opposite an eagle with snake. Both carvings are at eye level and on the chancel arch (*c.*1440–50).

The pelicans are part of a larger programme of single motifs, all of which seem to act independently. The first bird is to the right of the crowning pinnacle and is shown feeding her young. The other two pelicans are on a panel to the left of the crucifixion scene, the most important motif in the wall in a central position over the opening. Here there are two small birds, with their beaks piercing their breasts, supporting the larger of two Butler shields which is charged with a chief indented within a border of eight roses.[40] The Ormond shields commemorate the patrons in whose territories the abbey is located (see chapter 4). All the work is inexpertly cut, but unlike the other carvings on the wall, which are awkward and disproportionate, both pelicans are competently executed. Healey describes the panel with two pelicans as 'two pelicans adorsed and tails united with beaks in breast, emblematic of their unbroken union and in themselves of the undivided eternity which awaits those who are nurtured on the most precious blood. . . .'[41] No nests are shown, and it is only the characteristic position of the neck on the breast that identifies the birds.

The single pelican on this wall (pl. 138) is shown piercing its breast over the three long-necked chicks whose nest is a chalice. This overt equation of the blood of the pelican with the blood of Christ is found on one other fifteenth-century carving in Ireland (the Thomastown font, below), but given the situation of the carving on the sacristy wall this is a perfectly apt linkage of symbol and location. The two pelican panels at Kilcooly are in low relief, and may be the work of the same sculptor.

Plate 140 Panel on the left-hand side of the western portal at Clontuskert Priory, Co. Galway. Part of an extended programme in which virtue opposes vice (c.1471).

Chancel Relief, Priory of the Holy Cross, Strade, Co. Mayo

A relief carving of a pelican appears on the north pier of the chancel arch at the Dominican Priory of the Holy Cross (pl. 139). Like a number of the other examples here, it dates from the mid-fifteenth century. Documentary sources relate that an indulgence for the restoration of the priory at Strade was granted in 1434,[42] and it is likely that work would have started soon after this date. It is probable that this carving is contemporary with the rebuilding, around 1440–50, the period in which the same mason may have been working at Holycross Abbey.

The pelican, which is seen in profile and facing towards the right, is about to pierce its breast, and its neck is curved into a nearly circular form. Neither the nest nor the young birds are shown. This carving is one of a pair, the other being an eagle and snake on the opposite, or south pier of the chancel arch. Both reliefs are clearly the work of the same sculptor and are of a high standard: the pelican's plumage is well cut, and the lozenge-shaped feathers are similar to the more accomplished examples from Holycross Abbey (see above). If the Holy Cross Priory pelican is not the work of the same sculptor, it was at the least influenced by it. The position of the eagle's head at Strade, for example, is exactly the same as that of the pelican at Holycross. Although the body is shown in profile, the head is depicted as if from the front.

The location of this motif at the entrance to the chancel would have reminded the worshipper of Christ's sacrifice and its recreation in the Mass. The eagle and snake show the victory of Christ over his adversary and, like the pelican, would have offered hope.

Relief Fragment, Abbey of St Mary de Pertu Patrum, Annaghdown, Co. Galway

Only a fragment of this carving now remains. The lozenge-shaped panel is on the left of a simple moulding and depicts a bird standing over a nest with the young inside. The stylized bird is shown in profile, with finely lined wings and tail feathers, while the young are placed regularly within the basket-like nest.

Portal Relief, Priory of St Mary, Clontuskert, Co. Galway

One of the most charming of all the medieval Irish depictions of pelicans is found in the Augustinian Priory of St Mary, Clontuskert (pl. 140). The group of

Plate 141 Pelican carving in the parish church of St Ruadhan, Lorrha, Co. Tipperary. Although more forceful than the small patera showing a swan, on the nearby priory of the Augustinian Canons Regular, this pelican, less than fifty yards away, is similar in location, style and date (mid–late fifteenth century).

carvings surrounding the west or main doorway into the nave is one of the largest sculptural programmes of the period to have survived, and would have formed an impressive entrance into the church (see pl. 91). The carvings are contemporary with the door, which is dated to 1471 in an inscription on its horizontal crown moulding.[43]

As at Kilcooly Abbey (above) and Clonmacnoise cathedral, the nine panels at Clontuskert are grouped around the opening. The pelican is the lowest panel on the north (left) side of the doorway. The carving shows the bird standing above the basket-like nest, with its beak at its breast, feeding the three young chicks. Its wing is curved upwards and falls in a fanlike shape over the rear part of the body. It is interesting to note the similarities between this carving and the other panels. The pelican was originally worked in great detail; traces of its plumage still remain, and they show skilful cutting. The wing of the bird is unusually modelled and resembles the wings of many of the dragons executed in this period, for example, those on the misericords in St Mary's cathedral, Limerick.[44]

Hood Moulding, Lorrha Parish Church, Co. Tipperary

This example (pl. 141) is carved in relief on the outer face of the door moulding in the south wall of the nave. This arch was inserted, at some unknown date, but clearly in the fifteenth century, into an earlier and larger thirteenth-century doorway (see pl. 114).

Crawford records 'fourteen small ornaments in relief, most of which take the form of square rosettes' on the arch ring.[45] One of these 'ornaments', however, the sixth from the east end, is a pelican. The small carving shows the pelican with its neck curved, beak on breast, over its nest, which appears to be made of twigs and shows the young birds within. The thirteenth-century doorway had stiff leaf capitals on either side, but the late insertion ends in a simple twist motif. Even though other pelicans, such as those on the Ballylongford Cross (see above) and the Dunsany Font (see below), are associated with depictions of foliage, this particular example is unusual in that all the other rosettes have foliate motifs except for the single example with the pelican.

Font Relief, Church of St Nicholas, Dunsany, Co. Meath

The decoration of the medieval font in the church of St Nicholas, Dunsany, includes a representation of a pelican. The carving, which is found on the under-stone of the bowl, displays a certain influence from needlework.[46] The panel shows the pelican with its neck curved in a slightly exaggerated circle, piercing its breast and feeding three young chicks in the plain basket-like nest beneath. The bird is shown in great detail, with its beak and claws portrayed naturalistically. Similarly, the depiction of the three young chicks is highly detailed. The subject is surrounded by 'palm-like sprays of foliage', which highlight the central subject.[47] The font dates from the late fifteenth century.

Font Relief, Thomastown Parish Church, Co. Kilkenny

The final medieval example in stone is a font, now in the baptistery of the parish church at Thomastown. The small carving is on the south face of the font, the decoration of which is divided into three parts. The pelican, which appears to the left of an architectural motif, is in profile with its neck curved and its beak on its breast. Its plumage is depicted by a series of deeply cut parallel lines. Three long-beaked chicks are shown in the nest, which resembles that of the example at Kilcooly Abbey (above). The nest is chalice-shaped, with a long stem that appears to have no base. The cup of the chalice is decorated in an all-over chevron pattern. This work seems to have been influenced by the example at Kilcooly Abbey; not only are the distinctive nests similar, but the use of architectural designs on the other sides of this font are also paralleled on the font in the northern transept at Kilcooly. The use of vaulting as a design element on such pieces of architectural furnishing dates from the late fifteenth and early sixteenth centuries in Ireland, and it is not widely found there. The heraldic arms of the Butler and Fitzgerald families on the east side of the Thomastown font are again related to those on the sacristy walls at Kilcooly. McGarry detected a mason's mark on the bottom right-hand corner of this panel,[48] but unfortunately no other example of this mark has yet been recorded.[49] On the basis of its heraldic iconography, this font has been dated to around 1516–46. The associ-ation of the pelican with the sacrament of baptism is unusual and appears to have been introduced towards the end of the fifteenth or the beginning of the sixteenth century.

Fresco, Clare Island, Co. Mayo

Among the many subjects depicted on the ceiling of the small Cistercian cell on Clare Island, off the coast of Co. Mayo, is a possible representation of a pelican.[50] These paintings, some of which are still visible, are distributed over the four bays of the chancel vault. They include a variety of subjects including St Michael, hunting scenes, the Tree of Life, dragons and other mythical animals. Stalley detailed the many colours used in this work and the cleverly executed *trompe l'oeil* of rib vaulting in this remote cell.[51]

This small pelican is found on the south side of the decorated ceiling in area L, according to Westropp's classification.[52] The painting shows a 'large yellow conventional bird outlined in red. It has a curved neck, serrated wings, triangular tail, with a curved red object and some red lines below. It is very probably a pelican.'[53] Westropp's sketch of this painting, which now provides the best evidence of what the original looked like, is very similar to the examples in stone discussed above, and reinforces the belief that the number of examples in the present catalogue may represent only a small proportion of those that once existed. Its position, directly over the chancel arch, would have been particularly suitable for such a symbol.

Few frescoes have survived from medieval Ireland. The largest cycle is to be found at Abbeyknockmoy, which was the parent house of the cell on Clare Island, and this may explain the presence of these paintings in such a remote location. The architectural remains have been dated to the fifteenth century and Stalley was willing to believe that Luckombe's assertion of a foundation date of around 1460 is correct.

Sexton Tomb, St Mary's cathedral, Limerick

The popularity of the pelican as a symbol appears to have continued beyond the medieval period. A detailed carving of a pelican is found on the Sexton tomb at St Mary's cathedral, Limerick, but here it forms part of

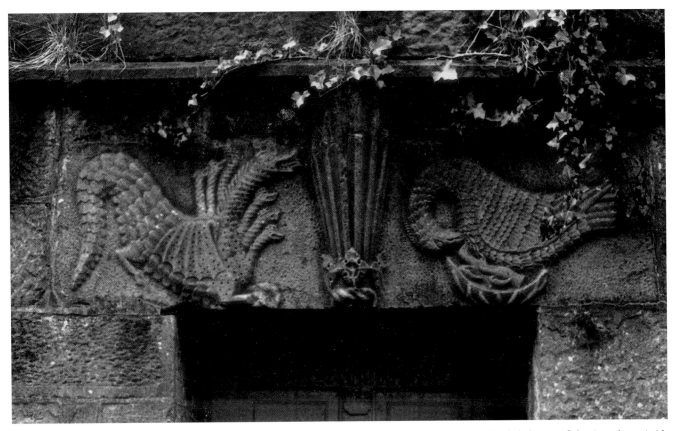

Plate 142 The pelican on a tomb at Limerick cathedral is heraldic in intent and is paired with the seven-headed dragon of the Apocalypse (mid-seventeenth century).

the crest of the Stacpole family (pl. 142).[54] The bird is found over the entrance to the tomb and faces the seven-headed dragon of the Apocalypse. All the work appears to be in one style and dates from the mid-seventeenth century.

*　　*　　*

It is clear from this brief study that the pelican attained great popularity during the Gothic period in Ireland. Its appearances there are not significantly later than in the rest of Europe, where it is found as early as the sixth century but was widely used only from the thirteenth century onwards. In the early Gothic period in Ireland the majority of animal motifs, where they are found, are purely decorative in nature, and it was not until the late fourteenth and early fifteenth centuries that symbolic animals appear on a large scale. This period coincided with rebuilding campaigns undertaken in a number of the monastic houses, which allowed the sculptors and metalworkers to introduce new motifs.

The relative importance of the pelican in relation to other symbolic animals in Irish art cannot be judged accurately, as the purpose of some of the others seems not to have been consistent: the dragon, for instance, appears in great numbers and in a variety of media, but the didactic element is clearly lacking in some of these depictions. Klingender believed that the bestiary subjects in general appear more often and later in carvings than in manuscript illuminations.[55]

While no bestiary texts have survived from Ireland, it is clear that such manuscripts exerted great influence on the choice of subject matter in church decoration. The pelican is one motif that was taken from this source (see chapters 3 and 4). Many of the English and European carvings of the pelican, such as the examples on a misericord at Winchester College[56] and on a roof boss at Sherborne Abbey, are similar to the Irish examples in that the bird is shown in profile only. However, the English sculptors as a general rule employed a greater variety of poses, as in the carving on a roof boss in the nave at Winchester cathedral, where the

pelican forms the central element and is viewed as if from above, surrounded on all sides by the young chicks.[57]

When the nest is shown in Continental manuscripts, sculpture, tapestry and painting, there are usually three young chicks. Examples of this common representation include the Aberdeen Bestiary (University Library, Aberdeen, MS 24, f.35r), the Northumberland Bestiary (formerly Alnwick Castle, MS 447, f.41r),[58] the Brussels *Physiologus* (Bibliothèque Royale, Brussels, MS 10066–77, f.143v), the Nuremberg Triptych (Germanisches Nationalmuseum, Nuremberg, KG 1)[59] and the fifteenth-century printed bestiary known as the *Libellus de Natura Animalium*.[60] However, the number of young shown does not appear to have been either significant or standardized in Britain or Ireland. In some instances only one chick is shown (Cambridge University Library, MS 11.4.26, f.38r), in others two (Gonville and Caius Library, Cambridge, MS 384, f.191r; silk altar cloth, Städtisches Museum, Brunswick, B no. 56).[61] As we have seen, one Irish representation of the subject, that from Holycross Abbey, may have five young in the nest. Another example with five chicks is found on a mid-fourteenth-century Italian painted cross (Staatsgalerie, Stuttgart).[62] Irish sculptors employed a greater variety of nest forms than is found elsewhere; in Britain and on the Continent the most common shape of nest is the simple basket-like one, best seen in Ireland on the carving from the Church of St Nicholas, Dunsany. The form of the nest, however, does appear to have been significant in the examples where it takes the shape of a chalice, reinforcing the Eucharistic symbolism of the bird's sacrifice. Several examples do not show any nest, and it is the recognizable

pose of the bird alone that would have made it immediately identifiable.

The contexts of Irish pelican depictions appear to have been important to its meaning as a symbol. Unlike the European examples, which are generally found in the chancel or above the crucifix, the Irish pelicans occur in a wide variety of conspicuous locations. Their positions – on a chancel arch, a sacristy wall and around doorways – all normally at eye level, must have been chosen for visual and associative impact, not only within the monastic community but also for lay visitors. These prominent locations reinforce the Eucharistic symbolism of the bird, which is also significant on the shaft of the processional cross from Ballymacasey. This is again contrary to English practice, 'where from the late thirteenth century animal subjects tend to disappear from the more visible parts of the masonry in the interior to lead a secret life on the remote bosses high on the vaults'.[63]

Like most other animal carvings in late medieval Ireland, the pelican is found with greatest frequency in Cistercian houses. It is one of the few animal symbols to be used both independently and in programmes linking and contrasting symbols of virtue and vice. There are few depictions of the Passion in Ireland at this period, but a number of symbolic representations of the cycle, for example the *Arma Christi*, are found (see chapter 4). Similarly, there are very few representations of the Resurrection in Gothic Irish art, but that subject is shown symbolically in images of the pelican. This reliance on symbolism and on small-scale representations, whose meaning must have been recognized by laity and clergy alike, implies a relatively sophisticated and learned audience in the remote areas where these Irish pelicans are found.

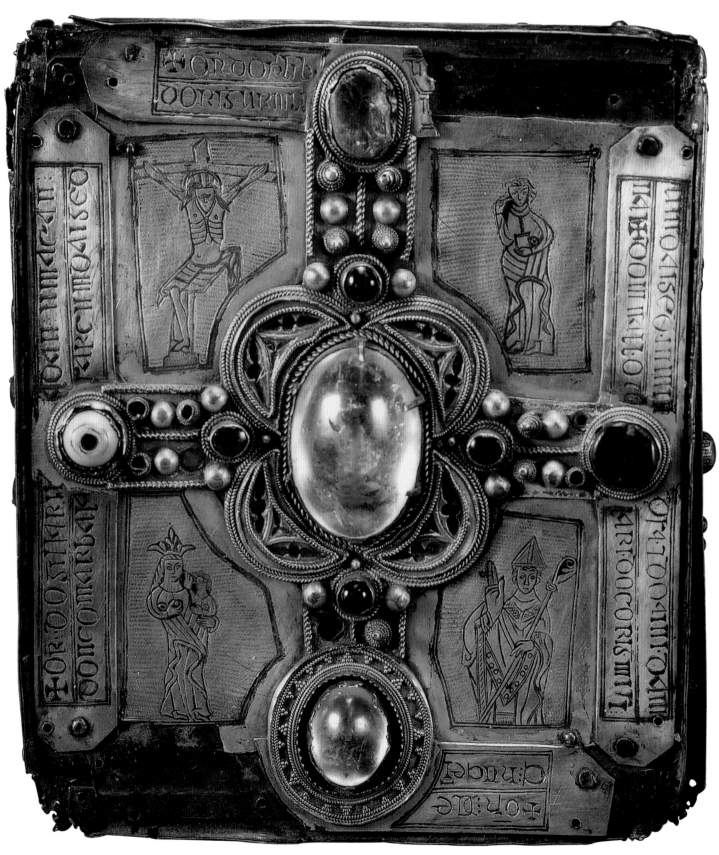

Plate 143 The main faces of the small shrine of the Stowe Missal have elaborate superimposed crosses that were added in the fourteenth century. Silver, gilt bronze and gold foil on a wooden core, height 18.5 cm, width 15.5 cm, depth 5.6 cm. National Museum, Dublin.

Gothic Metalworking and the Art of the Book Shrine

Compared to Gothic architectural sculpture, which is found in a fairly logical if, at times, uneven *continuum* from the arrival of the Anglo-Normans to the end of the fifteenth century, the other arts are less strongly represented. An exception is certainly the manuscript tradition, which has been shown to have a long, but comparatively stable history throughout this period[1] there is a claim to be made also for the metalwork from this time. Like the manuscripts, the many chalices, brooches, croziers, crosses and shrines have not only been held in special esteem outside Ireland, and the Irish have always regarded them as being of the greatest importance in defining their own identity, political situation and culture.[2] This despite the fact that the forms, styles and iconography of metalworking in Ireland have at times been a combination of the Insular and the international.

Metalworking was a tradition which, for various reasons, appears to have declined towards the middle of the twelfth century.[3] If any single object can be seen as marking the end of this early tradition it has to be the Cross of Cong (National Museum of Ireland, R 2833), which has been dated to around 1123–6[4] and heralds the end of a particularly fertile period characterized by a number of shrines, including St Lachtin's Arm (National Museum of Ireland, Dublin, 1884:690) and the Shrine of St Patrick's Bell (National Museum of Ireland R 4001). It is in metalwork particularly that the Anglo-Norman invasion has been held to be responsible for ending the native tradition. Metalworking in the Gothic period in Ireland is unevenly represented with, for example, nothing secular surviving until the fifteenth century. Apart from a fine collections of

seals[5] and jewellery,[6] which are representative of the entire period, and a particularly impressive corpus of processional, altar and pendant crosses, which can be dated, once again, to the end of the medieval period,[7] there are very few objects which belong entirely to the Gothic period. Among the better known are the Shrine of St Patrick's Hand (Ulster Museum, Belfast), the Shrine of St Brigit's Shoe (National Museum of Ireland, Dublin, P 1023) and the Cross of Clogher (Monaghan County Museum). Isolated objects, mainly of liturgical use, such as church plate, pyxes and chalices also exist, and indeed it is clear also that there was a sizeable corpus of imported objects used in Ireland in the later medieval period.

Otherwise, the series of repairs and alterations to pre-invasion shrines constitutes the greatest and most interesting part of Gothic metalworking in Ireland. Without doubt the largest part of the entire assemblage of metal objects, either from the pre- or post-invasion periods consists of reliquaries and shrines. These objects were held in veneration and were usually in the custodianship of native Irish families. We know that a number of them at least were made by Irish craftsmen for Irish patrons and, as such, offer another interesting channel through which the tastes of the native Irish can be gauged in relation to the invading forces. The reasons underlying their alteration in the fourteenth and fifteenth centuries have never been studied and it is impossible to say if these changes were deemed necessary or indeed if they were undertaken voluntarily. It may have been that their use over the preceding centuries had caused damage and that repairs were necessary, or it may have been that these alterations were an attempt to incorporate current styles and iconography.

Most significant, however, may be the Gaelic Revival, which began in the second half of the fourteenth century (see chapter 7).

Studies of the shrine or reliquary in late medieval Ireland have been sparse and most have been from an archaeological or technological perspective.[8] Only one study has even included the later medieval additions to these objects and that has been from an archaeological perspective.[9] The iconography of the later additions has never been considered as a single study and no attempt has been made to evaluate the relationship, if any, between the patron, keeper and saint commemorated and the subjects represented. A limited but representative sample of most of the major shrine types found outside Ireland is also to be found in an Insular context and includes the body part or corporal type reliquary (arm, hand, jaw and tooth) and the associative type of reliquary, such as the bell, cross or crozier and manuscript. The largest group of shrines from Ireland is the second type and within that general grouping the greatest number are devoted to the preservation and enshrinement of the book, which neatly links the two dominant arts of the later medieval period in Ireland in a single object.

The whole practice of enshrining books or manuscripts has been claimed in the past to have been particularly insular in origin and restricted to Britain and Ireland. By and large, such objects were encased elsewhere in lavishly decorated covers, sometimes made of wood but more frequently made of metal. Close German parallels for book shrines have been examined by Steenbock[10] and it may be that future research into this whole subject will add to the understanding of the practice. Among the book 'shrines' or containers which are close in structure, design and iconography to the Irish examples is one from the Guelph Treasury, (Cleveland Museum of Art, CMA 30.741), which has a wooden core, is lavishly decorated with stones and has an ivory relief in the centre. A group of saints, including Blaise, John the Baptist and Thomas of Canterbury, are found on the back face.[11] According to literary sources, the practice of making such shrines first started in Ireland as early as the late eighth and early ninth centuries;[12] however, the surviving book shrines or *cumhdachs*, of which there are some eight, date largely from the eleventh and twelfth centuries and are all similar in construction. Several precious books, including the Book of Durrow and Book of Kells, are known to have had shrines but these are now missing and it is to be expected that what has

survived may only be a fraction of what was originally made.[13]

Book shrines are almost all small rectangular wooden boxes with exterior metal casing, sometimes decorated with semi-precious stones or rock crystal. The Soiscéal Molaise and Shrine of the Book of Dimma never had a wooden core and are made from plates of sheet metal. Because they come from different periods the styles between faces and sides can vary enormously on any single shrine. The motifs may be embossed in high relief or finely incised, and it is usual to find both these techniques on a single face. The eight surviving book shrines, in an approximate chronological order, are the Book Shrine of Lough Kinale (Dublin, National Museum of Ireland), which may date from the late eighth or early ninth centuries:[14] the Soiscéal Molaise or Gospel of St Molaise (Dublin, National Museum of Ireland, R 4006),[15] which although altered in the fifteenth century by the addition of embossed silver plates (most of which have disappeared), does not have any surviving Gothic embellishment; the Shrine of the Stowe Missal (National Museum of Ireland, Dublin, 1883:6614a); the Cathach (National Museum of Ireland, Dublin, R 2835); the Miosach (National Museum of Ireland, Dublin); the Shrine of the Book of Dimma (Trinity College, Dublin); and the Shrine of the Book of Moling (private collection, Borris, Co. Carlow), which although dated to the fifteenth century does not have representational subjects on the shrine.[16] The last example is the Shrine of St Caillin of Fenagh (St Mel's Diocesan Museum, Longford). Five of these shrines were altered in the later medieval period and the assemblage constitutes one of the largest and most cohesive groups of Gothic metalworking from Ireland. Also included in this survey is the Domhnach Airgid Shrine (National Museum of Ireland, Dublin, R 2834), which although excluded from other surveys of these objects, should, I believe be included.

The Shrine of the Stowe Missal

Various efforts have been made to rename this shrine, which was traditionally called the Shrine of St Maelruan's Gospels, but was renamed the Shrine of the Stowe Missal after it came into the possession of the Duke of Buckingham sometime before 1815, and was housed in the library at Stowe in Buckinghamshire.[17] The original

shrine was made in the early eleventh century but was refurbished in the late fourteenth century, when both the front and back faces were altered.[18] This is one of the few shrines from medieval Ireland to have the same motif on both faces. The main face was altered sometime before 1381, when a large silver mount and central setting were superimposed on to an existing inscribed cross with little regard for the eleventh-century decoration or inscription underneath. This is one of the few alterations known to have been the result of taste rather than repair, and reflects the fourteenth-century *horror vacuui*. Without this central addition the main face is one of the least decorated of all the book shrines. The decoration of the older parts – a series of stylized human and animal figures – is now visible only on the sides. The entire back face of the shrine was also altered in the late medieval period, but in a more adventurous manner, with the addition of another large central jewelled cross that extends across the face (pl. 143). The four silver-gilt plates incorporated into the corners of the face are engraved with scenes of the crucifixion, the Madonna and Child, St John and a saintly bishop.

The fourteenth-century embellishment of what was originally the back face of the shrine may mean that from this time onwards it became the main face. The iconography is certainly in keeping with that of a main face, with the Crucifixion once again occupying an important place. An inscription along the edges of this face records the patron and his wife: '+OR DO PILIB DO RIG URMU[MAND] / CUMDAIGED · IN MINDSA · DO AINI DO MNAI / +DOMHNALL O TOLARI DO CORIG MISI + / OR DO GILLA RUDAN ·U MANAC ··DON COMARBA LASAR CUMDAIGED' (A prayer for Pilib, King of Ormond [who] covered this shrine and for Aine his wife/ Domhnall Ua Tolari arranged me/ A prayer for Giolla Ruadhan Ua Mecain the successor by whom this was enshrined).[19]

The style of the four figures is inexpert – they do not fit into the corners for which they were obviously made and although three are full-length, the fourth, in the lower right-hand corner, is three-quarter length and disproportionate to the others. The Crucifixion is logically placed in the upper left-hand side – the most significant in visual terms. The pronounced twist to the lower part of Christ's body, the long loincloth and the focus on suffering so evident in the contorted angle of the body are typical of late fourteenth-century crucifixions. Directly beneath the crucifixion is the crowned standing figure of the Madonna holding the Child. This is an

unusually early representation of this type for medieval Ireland in that she is normally shown seated. Her floriated crown is also unparalleled and the rigid drapery folds and lack of facial expression suggest that the whole would appear to have been unsuccessfully modelled on a manuscript original. The object which the Virgin holds has been identified by Mullarkey as an apple,[20] but it may also be interpreted as a pomegranate, which is used with equal frequency in such compositions. However, in this instance, with the focus on salvation it is most likely the apple that was intended and used in reference to her son's role as Saviour and to the Tree of Knowledge.

The two other figures pose problems as regards identity. Even though it has been accepted that the upper right-hand figure represents St John, who would logically complete the Crucifixion grouping, this inetrpretation is not convincing. Moreover, a Virgin and Child would never appear at the foot of the cross – unless conflation was intended and both the birth and death could be conveyed through positioning the Virgin alongside her dead son. This third figure must therefore represent an unidentified saint, as does the last figure beneath it. There is less difficulty here as the mitred and fully vested cleric is similar to representations of St Patrick elsewhere, such as the Domhnach Airgid. With his crozier and hand raised in blessing the figure adopts the typical pose of the patron saint of Ireland. If this figure is accepted as St Patrick, it is likely that the figure above may also be Irish in origin. A possible identification may be St Ruadhan, the patron saint and founder of the monastery at Lorrha, Co. Tipperary, where the shrine was kept.

The Shrine of the Stowe Missal does not present any innovative iconographic programmes. The cross and all that it stood for is the main motif, in keeping with the manuscript that was originally held in the container.[21] The Crucifixion is typical of such shrines and, indeed, the only common element on every book shrine from medieval Ireland.

The Cathach

One of the most accurately dated of these book shrines is that which was previously called by the saint traditionally associated with the work – the book shrine of St Columba's Psalter,[22] – but is now referred to as the Cathach (pl. 144).[23] The change in name (Cathach means 'battler') refers to the role the shrine had as a 'battler' or

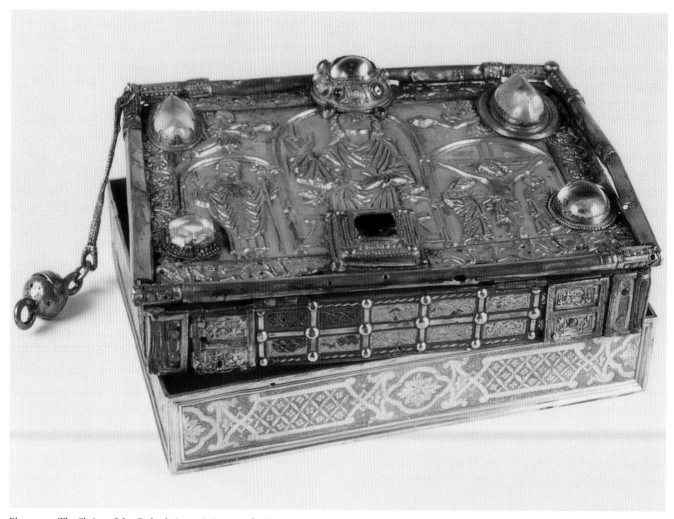

Plate 144 The Shrine of the Cathach (*c*.1470). Its main face has one of the most iconographically structured programmes in Gothic Irish metalwork. Used as a battle talisman, the shrine focuses on the twin aspects of St Columba and victory. Gilt bronze and silver on a wooden core, length 24.3 cm, width 19 cm, depth 5.5 cm. National Museum, Dublin.

battle talisman for the O'Donnells of Tyrconnell, Co. Donegal. The association of St Columba with this shrine can be traced back to the Book of Fenagh, which records that St Columcille gave the Ceathar Leabhar (the Gospels) as well as the Cathach, which was written by him to St Caillin, with a promise 'that these relics would be ensigns of victory and triumph to the monks and people of Caillin under doom'.[24] The book of psalms which this shrine originally held (Royal Irish Academy, Dublin, MS 12R.33) was the most popular book for both private and liturgical devotions from the ninth to the thirteenth centuries until the emergence of books of hours. It is possible that the main face of the original shrine could have had an image of King David, the author of many of the psalms.

The original shrine was made, according to the inscription on the base, between 1062 and 1098 by Sitric to the order of Cathbarr O'Donnell. Domhnall Mac Robertach (d.1098), one of the hereditary keepers, is also referred to in the inscription. The main face is the most clearly delineated of all, with the decoration neatly defined in three arched frames. The shrine may have been carried aloft into battle, with the main face directed towards the enemy to protect the troops and ensure their victory. It is recorded in the sixteenth century that the shrine 'was carried righthandwise three times around the armies of the Cinél Conaill to bring them to victory'.[25] Not only did the shrine and its iconography have to instil fear into the enemy, but, more importantly, it had to instil confidence into the army of the O'Donnells following it. How well known the secondary subject matter on this main face would have been to either enemy or victor is unknown. It is clear, that in common with most Christian shrines which had a public function, the power of the

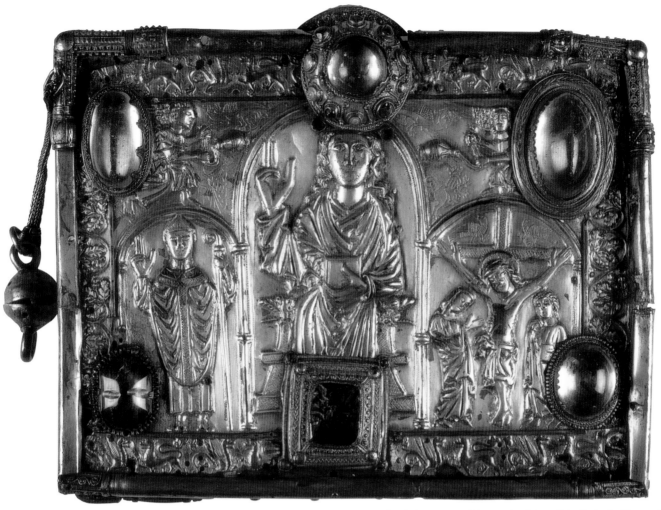

Plate 145 Christ in majesty, with his emphasis on blessing and victory, occupies a central and dominant position on the shrine of the Cathach. The small figure of St Columba also has a large and imbalanced hand raised in blessing.

shrine was not entirely dependent on seeing or understanding the subjects depicted on it, but partly on the foreknowledge or association that this shrine had as a saintly symbol of power. When these shrines were not in use, in either a battle, processional or other such public context, they must have been venerated in more accessible and permanent settings, their iconography and symbolism understood and their fame spread by word of mouth. The power of the shrine was thus transferred into the public setting, possibly without any direct or real visual appreciation but through the power of association.[26]

The role of the shrine as a talisman had clearly been assumed between its creation in the eleventh century and its subsequent alteration in the fifteenth century. Ó Floinn has shown that the term 'Cathach' may not have been applied to the shrine before the thirteenth

century and its association with Colmcille cannot be conclusively proven.[27] The iconography on the main face, the only part to have been remodelled in the later medieval period, would be expected therefore to reflect its role as a battle talisman rather than as the shrine of a manuscript written by St Columcille. In this, it does not disappoint. The focus on the shrine as a bringer of 'victory' was first referred to in the Book of Fenagh. The most important figure, Christ in majesty, occupies the central position and largest of the three frames on the main face (pl. 145). Byzantine in style, the victorious Christ is shown in a seated position on a dragon-headed throne. The use of the dragon in this subservient position, unparalleled elsewhere in medieval Ireland, is symbolic of the place of the defeated beneath the victorious Christ. The book which Christ holds in his hands would have been immediately recognizable as the Gospels, but it was also a reminder

Plate 146 The two birds on the transom of the cross in this crucifixion scene on the Shrine of the Cathach, which are not found elsewhere, are probably a visual play on the literal meaning of St Columba's name.

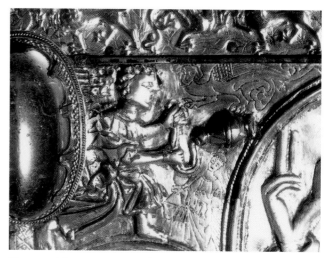

Plate 147 The two censing angels, to the right and left of the crucifixion scene on the main face of the Cathach are thematically linked to it in their adoration but also to the personifications of evil, found in the same frames.

Plate 148 Differing in technique to the angels which are in repoussé work, the small incised anthropomorphs on the main face of the Cathach, National Museum, Dublin, are similar to the marginalia found in medieval manuscripts.

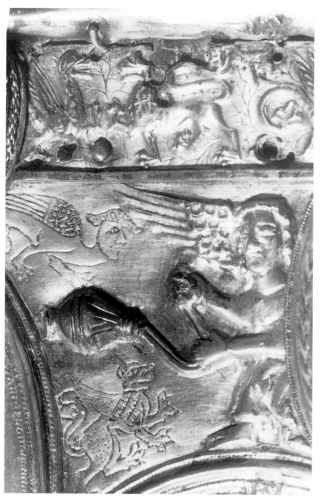

of the psalter manuscript which the shrine would have held. This powerful and tranquil image is dominated by Christ's disproportionately large right hand, raised in both blessing and admonition against those who would engage in battle – a warning to those who faced the power of this shrine. In focusing on Christ in majesty the emphasis is placed on what even today is recognized as one of the most potent symbols of victory, one that must have held the same message for the medieval Irish viewer.

The two smaller arched frames on either side of Christ also reinforce this message of victory to the holder. St Columcille, in the left-hand arch, here dressed as a fully vested cleric, is first and foremost a public reflection of the associative elements of this shrine and links this Gothic alteration with the reason for its creation in the first place. The image is remarkably similar in pose to another representation of this saint in an early sixteenth-century 'Life of St Columba' (Bodleian Library, Oxford, Rawlinson MS B 514), in which the fully vested saint is shown under an arch, holding his crozier in his left hand and with his right hand raised in blessing. On the shrine Columcille also holds his crozier in his left hand, but the viewer is immediately drawn to his disproportionately large right hand, which mirrors that of Christ in majesty. Beneath the third arch is the Crucifixion – Christ victorious over death, attended by the Virgin and St John (pl. 146). It is tempting to see the two birds (probably doves) above the transom as reflecting the Columban associations yet again, in much the same way as the similarly placed bird on the Domhnach Airgid. Birds, especially doves, are frequently found in such a position

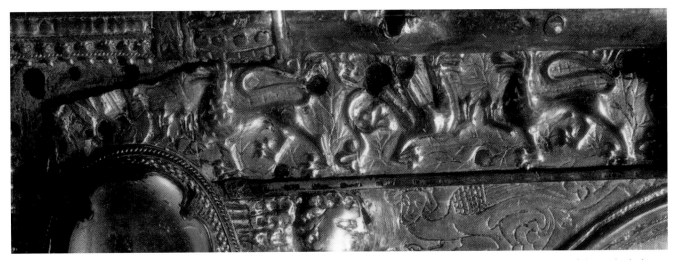

Plate 149 Die stamping was a technique favoured by late medieval metalsmiths in Ireland. The upper border of the main face of the Cathach depicts diestamped dragons and griffins in confrontation.

from the late Antique period onwards, but are unusually absent from the repertoire of Gothic Irish art.

The message of victory is reinforced yet again in the spandrels above the two side arches. Here, two censing angels face Christ in majesty; both are embossed in high relief and have lightly incised evil-looking anthropomorphs and dragons in the background, another example of the victory of good over evil (pls 147 and 148). Among these anthropomorphs is the small figure of a kneeling, tonsured and fully vested cleric holding a chalice and facing the left-hand angel. There is yet another cleric, almost obliterated by the rock crystal on the bottom left-hand side of this face. This cleric points towards a bird on the tree directly over his head and is particularly reminiscent of other representations of St Francis preaching to the birds. This tiny figure may provide a tentative link between the shrine and the Franciscan friary in Donegal, which was the only Franciscan monastery founded by Aodh Rua O'Donnell, chief of Tyrconnell, and his mother Nuala O'Conor in 1474 thus suggesting a date at which this shrine may have been refurbished.[28] Indeed, it could be that as founders of this monastery they left the shrine there for safekeeping. It is also clear that when the main face of the shrine was refurbished the choice of iconography must have been that of a religious community. The subject matter – tonsured clerics and Franciscan friar – apart from the more orthodox motifs, does not point to the tastes of a secular keeper. For a religious body victory would be achieved through the religious life, not a battle, even though both were clearly suggested in the iconographic programme of the shrine.

The four borders of the main face of the shrine are decorated with dragons and griffins on the top and bottom (pl. 149) and foliate patterns on the sides. It would be tempting to view the confrontational stances of the animals as yet another symbol of virtue versus vice, but this is one of the most frequently found motifs in Irish Gothic art, and its use here may have been decorative rather than symbolic. The foliate patterns on the vertical borders are not typical of other contemporary metalwork. The naturalistic oak leaves, which curve around in imitation of vine-scroll designs, have parallels in architectural sculpture of the same date.[29] Another metalwork example of these leaves is found on the Bearnan Conaill Bell-Shrine (British Museum, 89/9/2.22). Thus, even the oak, traditionally the leaf from which the victor's crown is made, reinforces the concept of victory. Five of the six large settings on the main face of the shrine still have their crystal insets, but the most important one, square in shape, has lost its stone. This setting, beneath the figure of Christ in majesty, would almost certainly have held a fragment of the True Cross and as such is another reason for the inclusion of the crucifixion in the design.

The iconography of this face is particularly unified, not only in composition, but also in origin, and execution. With the concept of victory personified by well-known *exempla*, the focus is primarily on the victorious and majestic Christ and his ultimate victory, his Crucifixion. From this *exemplum par excellence* the composition moves to the local saint, whose power and fame would be viewed in the same light. Even the smaller compositional

elements, the angels, the anthropomorphs and the animal and foliate friezes, unite in this all-consuming theme. The iconography is unusual; some motifs, such as Christ in majesty, were not widely used in medieval Ireland, even though the motif is found, but in not quite so prominent a position, on another book shrine from medieval Ireland, the Domhnach Airgid. Although the motif was widely used in the Romanesque as well as the Gothic periods, some of the unusual elements in this representation, such as the dragon-headed throne and the rendition of Christ's hair, are particularly reminiscent of manuscript sources and give an antiquated, almost Merovingian, feel to the overall composition. The Christ in majesty was often used in Europe for shrine decoration and indeed dominates a number of such works.[30] The two small birds, which sit on each arm of the cross are also reminiscent of earlier sources, in this case manuscript originals, and may be part of a revisionist programme.[31] They are certainly outside the mainstream of Gothic art of this period both in Ireland and elsewhere. The incised anthrompomorphs are typical of the marginalia found in numerous contemporary manuscript sources, including the Bective Hours (Trinity College, Dublin, MS 94), where similar creatures appear on folios 5v. and 6v. Even the incised foliate patterns that are used as a background to the animal borders are typical of scrollwork in manuscripts. It is impossible to specify any single source from which these subjects were derived, but it is clear that they are typical of fifteenth-century manuscripts. Unlike a number of other shrines, where some of the most important themes are incised and merge into the background, in this shrine there seems to have been a decision to place the most significant images in repoussé, while secondary elements, such as the anthropomorphs, are incised and visually less striking.

The only unsuccessful notes in the overall composition are rock crystals and the effect that they have on the subject matter. Given such prominent positions, they are clearly intended to add to the preciousness and visual appeal of the shrine for the medieval viewer. In a world where such stones were difficult to come by they would have added a lustre to a shrine such as this, and certainly have been more visible when the shrine was held aloft on a battlefield.

The iconography and the techniques of the Cathach are particularly indicative of a mid- to late fifteenth century date; the face clearly dates from the fifteenth century and must have been undertaken before the capture of the shrine in 1497. Lawlor[32] was the first to date this shrine to the fourteenth century and his opinion has been followed,[33] but the work is clearly later than previously suggested. The Crucifixion and portrait of St Columcille are the two most revealing motifs on the entire shrine. The former is typical of the growing interest in the depiction of Irish saints, absent from the repertoire for several hundred years before their large-scale reappearance in the fifteenth century. While Irish saints first appear in metalwork in the mid-fourteenth century, as on the Shrine of St Patrick's Tooth, they are then not found again until the fifteenth century. Even though the relics of St Columcille were 'found' twice in Ireland and there was obviously a growing interest in his cult in the later medieval period, he is not widely represented. A second example, interestingly, is on another late medieval book shrine in a tripartite grouping with St Patrick and St Brigit – the three most important native saints at this period. His depiction, on this shrine, is typical of saintly representations and is, again, the static portrait-type image typical of the mid-fifteenth century. The style of the Crucifixion also dates the work to this period: the hollow of Christ's stomach, the widely arching V shape of his arms and baggy loincloth make this representation typical of Irish representations of around 1470.[34] This shrine, like so many others, came to represent the power and authority of the individual saint on earth. The iconography is not revisionist and there is no attempt to replicate the original face, whatever that may have been. Instead, an intelligent and contemporary language is used to reinforce the function of the shrine at this period. In the shrine of the Cathach purpose and decoration are perfectly linked.

The Miosach

This shrine is one of the last to have been refurbished at the end of the medieval period. It was originally made in the twelfth century, but extensively altered in both the sixteenth and nineteenth centuries and it is now nearly impossible to disentangle the work of the different periods.[35] Its name is believed to come from the Irish word $m\bar{\imath}$, meaning month, and this has lead scholars to believe that it may originally have held a calendar of saints' lives,[36] although all traces of any manuscript have now disappeared. Its suggested associations with either St Columba or St Cairnech have also caused problems, and

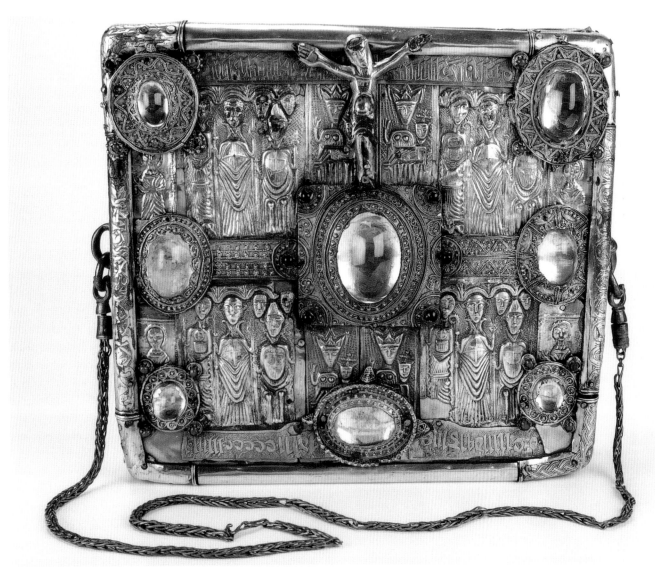

Plate 150 The twelfth-century Shrine of the Miosach was extensively altered in 1534. The main face consists of the same panel repeated four times. Silver, bronze and enamel with crystals and glass beads on a wooden core, length 26.2 cm, width 23.2 cm, depth 6.4 cm. National Museum, Dublin.

the most recent research on this aspect of the shrine has attempted to disentangle its history.[37] It is clear that it was an important relic of the Church in the twelfth century, when it was known as the Misach Cairnigh and associated with St Cairnech of Dulane, Co. Meath, but it transferred to St Columba at a relatively late date. Like the Cathach, the Miosach was a battle talisman for the Cenél Conaill and Cenél Eōgain and, like the Cathach, it too has a surviving chain from which it must have been suspended. It is interesting that none of the other chains or attachments for carrying such shrines has survived. It is probable that although the back face may date from the nineteenth century, the openwork cross motifs prob-

ably replicate the twelfth-century original. The main face is late Gothic in style and, according to an inscription which runs along the top and bottom, 'BRIAN MAC BRI(AIN) UI MUIRGIUSSA D/O CUMDAIG ME A D MCCCCC.XXX IIII.' (Brian son of Brian Ua Muirgiussan covered me AD 1534).

The description of the Miosach as a 'most beautiful specimen of ancient art'[38] may exaggerate a little. Like most of the book shrines the main face is decorated, with crystals in silver settings which partly occlude the decoration. Like all the shrines, the main face is dominated by a large cross with a central crystal setting above which the figure of Christ is placed (pl. 150). There is no shaft

to this cross, but this is cleverly implied by positioning the figure of Christ near to the centre of the face. The two panels beneath the central setting do not meet, which may indicate that there was once a vertical shaft which is now missing.

The decoration on this main face consists of the same panel repeated four times. Raftery has recorded the fact that three of the panels are original but that the fourth has been cast in brass from the one directly opposite.[39] Each panel has three stylized figures, presumably in imitation of a twelfth-century original. Although each figure has either an attribute or some identifying element it is nearly impossible to identify them with any certainty. The figure on the left-hand side may be St Catherine as she holds a wheel or circle over her book and does not have a staff. That she stands on a dragon has lead Mullarkey to believe that the figure is instead St Margaret of Antioch.[40] The central figure, the most imposing of the three, is fully vested and may be tonsured. He holds a crozier and has his left hand raised in blessing, in a pose similar to other depictions of St Patrick. The third figure, on the right-hand side, also fully vested in the robes of a bishop, holds a cross-topped staff. He has been interpreted as representing St Columba.[41] The two heads behind this last have been identified as Saints Patrick and Brigit. A Madonna and Child are shown in the four panels above and below the central boss. Extremely stylized and wearing a crown, with the infant Jesus on her lap in a pose similar to the pietá, this small panel again reinforces the role of the Virgin as mother of Christ, whose crucified body is framed by the panel. The four smaller figures in the 'borders' may be the patron of the shrine, Brian, son of Brian Ua Muirgiussan. It would not be unusual at this period to have a secular figure represented on a shrine.

The whole face of this shrine is stylized, not just the inexpertly modelled and cast, but contemporary figure of Christ, as is common elsewhere. It has been argued that this element of stylization was an attempt to continue the tradition that is first found in ninth-century Ireland and that appears again in the twelfth century.[42] It must have been perceived as a distinctly Insular rendition of the figure and the all-over use of this style on the Miosach may have been a conscious late attempt to use this native style again. There are no parallels for this style elsewhere and the fact that it dates to 1534 – the year in which Henry VII declared himself head of the Church of England – the beginning of the Reformation, may be sig-

nificant. Like all the other shrines, this too uses the Crucifixion as the main motif and the gallery of saints, all of whom may be Irish (with the exception of St Catherine, if indeed it is she), as *exempla*. The Miosach does not, like the other talisman, the Cathach, focus on the element of 'victory', and indeed there is nothing in its iconographical programme to indicate such a function.

The Shrine of the Book of Dimma

Another simpler shrine is that of the Book of Dimma, which has an equally interesting history in terms of refurbishment. The shrine was originally associated with the monastic community founded by St Crónán at Roscrea, Co. Tipperary, and its history and recent provenance have been published.[43] Scholars have differed as regards the structure of this shrine (particularly over which is the main face), but all agree that the original work dates from the mid-twelfth century.[44] Of more significance, however, have been the dates proposed for the Gothic repairs – which have extended from the thirteenth[45] or fourteenth to the fifteenth centuries.[46] Paralleling these uncertainties have been differing opinions as to which is the front and which the back of the work. Indeed, while this may in fact have varied over time, there can be no doubt that the refurbishment in the later Middle Ages created (or repaired) what from then on became the front or main face.[47] This refurbishment, recorded in an inscription on the borders of the same face, reads: 'TATHEVS O KEARBVILL REI DE ELV MEIPSVM DEAVRAVIT: DOMINVS DOMNALDVS O CVANAIN CONVERBIVS VLTIMO MEIPSVM RESTAVRAVIT: TOMAS CEARD DACHORIG: INMINDSA +' (Tadhg Ua Cearbhall, king of Ely had me gilt:/the Lord Domhnall Ua Cuanain, coarb, was the last to restore me:/ Tomas the goldsmith fashioned this shrine).[48]

The main face is dominated by a large equal-armed cross raised over a background of two designs occupying diagonal quadrants (pl. 151): double-stranded circular motifs (upper-left and lower-right quadrants) and square shaped motifs pierced by openwork crosses (upper-right and lower-left quadrants). Four glass beads are placed at the four corners of the face, over the inscription, and four more are set near the end of the four arms of the cross. The only representational motif on this face is the small crucifixion scene that is superimposed on the main cross and has generally been dated to the fifteenth century on the basis of a monogram in Gothic lettering on the upper

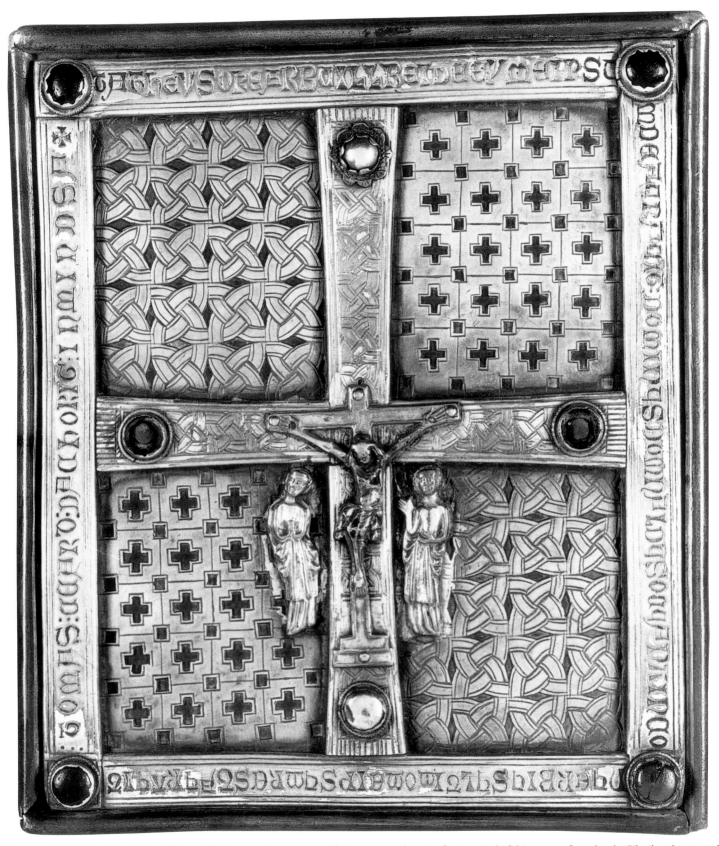

Plate 151 The Shrine of the Book of Dimma. The fourteenth-century crucifixion scene on the main face is typical of this corpus of metalwork. Gilt silver, bronze and glass beads on a wooden core, length 19 cm, width 16 cm, depth 4.4 cm. National Museum, Dublin.

Plate 152 The lions rampant on the sides of the Shrine of the Book of Dimma were all cast from the same die and are typical of a number of other royal emblems, such as the Tudor rose, Yorkist sun and the swan, that are found in Gothic Irish art.

part of the shaft.[49] The inexpertly cast figure of Christ is typical of such fourteenth-century figures as those on the Fiacail Padraigh (National Museum of Ireland, Dublin, R 2836; see pl. 28), which has the same pronounced twist to the lower part of the body and long loincloth. Similarly, the gestures and poses of the Virgin and St John point to this period. It is likely that this scene was added to the main face at the same time in the fourteenth century as that proposed in the most recent study on this shrine by Ó Floinn.[50] A central cross on the main face is typical of a number of reliquaries outside Ireland.[51] Indeed the cross, as is to be expected, dominates most reliquaries of the Gothic period and Ireland does not differ here. In such a position it would logically relate to the manuscript for which the shrine was created, which in this case was a Gospel book of the second half of the eighth century.[52] It is interesting that in the later medieval period in particular the Crucifixion came to be used in Ireland as the main motif associated with the Gospels in preference to the four Evangelist symbols which normally cover such manuscripts elsewhere.

The top end panel of the shrine and the left-hand side panel both have traces of animals, also dated to the later medieval period. The top originally had three quatrefoils (two of which survive) with embossed lions rampant, with a rectangular panel at either end on which are a griffin (right-hand side) and an unidentifiable animal (left). The left-hand side panel had three lions rampant (although the central panel, which originally held the third lion, is now empty (pl. 152)). The triple lions on this shrine, cannot be coincidental: the number is the same as on the English royal arms, first adopted by Richard I in the late twelfth century.

The griffins and unicorns may also have had a heraldic significance but they are also typical of the decorative bands found on such shrines as the Domhnach Airgid and the Shrine of St Patrick's Tooth, and were mass-produced from dies. The difficulty with many of these animals is that while in a number of instances they were used with specific symbolism and meaning, in other contexts, such as on this shrine, they can be decorative, and it is frequently difficult to distinguish their purpose. These animals have been dated to the same period as the Crucifixion on the main face,[53] but they may be from the fifteenth century. It is probable that what remains of the later work on this shrine comes from two periods, with the Crucifixion being the earliest (late fourteenth century) and animals (early–mid-fifteenth century). Their use as heraldic motifs is perfectly in keeping with the increased use of secular representations at this time, particularly royal emblems such as the swan and Tudor rose (see chapter 4).

The Shrine of St Caillin of Fenagh

Like its other late medieval companion, the Miosach, the Shrine of St Caillin of Fenagh, is one of the last surviving metalwork objects to have been made before the Reformation (pl. 153). It is not certain if it ever held a book, or if indeed it was made for that purpose, although its shape is similar to the other examples. Various attempts have been made to fit the existing manuscripts of the life of St Caillin into this shrine without success.[54] The life of St Caillin[55] records that on his return from Rome the saint brought with him unspecified relics of the

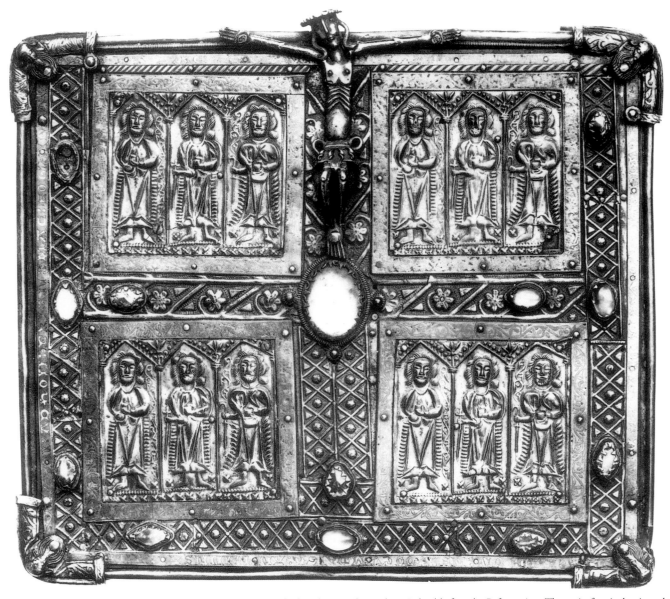

Plate 153 The Shrine of St Caillin of Fenagh (1536). This was the last shrine to be made in Ireland before the Reformation. The main face is dominated by a stylized crucifixion scene with the same panel repeated in the four quadrants. Gilt bronze, silver and enamel glass studs on a wooden core, length 27 cm, width 23.2 cm, depth 3.8 cm. Diocesan Museum, Longford.

Apostles Martin, Lawrence and Stephen Martyr and ordered that they be enclosed in a shrine. This is clearly the present shrine, but it may not have originally held books. An inscription recording the patron and year of its making runs along the upper and lower borders of the back face: 'ORAID: DON: MFIR: DO CVMDAIGH: AN MINNSA: CAIL/LIN: ADHON: BRIAN: MAC: EOGAIN: /RVAIRC: AGVS: MAIGREITE: INGIN/HBRIAN: AGVS: DO: BI: AOIS: AN/ TIGEARNA: AN: TAN: /SOIN: SE: BLIANA/DEG: AR: XX: AR: M: AR/CCCCCAIBH: A: MARIA.' (Pray for the man who

covered the shrine of Caillin, that is, Brian, son of Owen Ruark, and for Margaret, daughter of O'Brien, and the year of our Lord was 1536. A Hail Mary).[56]

Raftery was the first to point out the frequently published error of adding an additional, or fifth 'C' to the date in this inscription, making it 1536 instead of 1436, however, more recent study has shown that there are five Cs, and that a reading of 1536 is correct (pl. 154).[57] The main face is the only one to have representational motifs. It is divided into four quadrants by a large and

Plate 154 The back face of the Shrine of St Caillin of Fenagh replicates the openwork cruciform design of twelfth-century examples.

ornate cross with thirteen settings for semi-precious stones. The cast figure of the crucified Christ is placed in the most prominent position on the face, directly above the largest, central, stone. This stylized figure, with his long arms outstretched along the top, is easily the most prominent of all the crucifixion scenes on these shrines. The figure is part of a group of such representations of the fifteenth and early sixteenth centuries in which an Insular stylization comes to the fore, and may have been an attempt to replicate earlier stylized figures in Irish art.[58]

The panel of three standing figures, each under a pointed niche, is replicated in each of the four corners of the main face (pl. 155). The low-relief panel was struck from the same die and inexpertly superimposed on the niello figures of the old face, which can be seen as a background. There is little difficulty in identifying the styl-

Plate 155 The subtle balance of international (Saints Martin, Lawrence and Stephen) and Insular styles (the figures on the right- and left-hand borders) in the Shrine of St Caillin of Fenagh is also reflected in the choice of technique, with the larger figures in repoussé and the smaller in enamel.

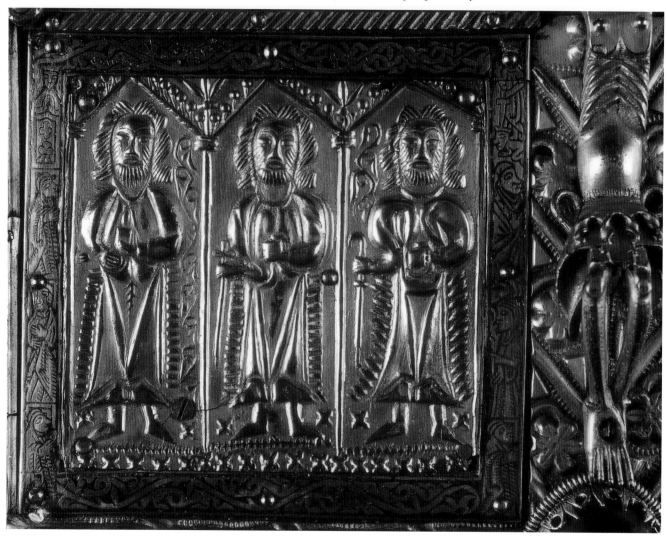

ized saintly effigies, two of whose faces were also cast from the same die (the two figures on the outside have the same hair, facial details and vine scroll on the side). They are Saints Martin, Lawrence and Stephen, all of whom are similarly attired, probably in deacons' vestments (although St Martin should never be shown so vested). All hold a book in their left hand and St Lawrence, in the middle, holds a cross-topped staff, while St Martin, to the left, holds a crozier. These three saints were worshipped throughout Christendom and were sometimes represented together, but more often than not the triple grouping consisted of Lawrence, Stephen and Vincent.[59] They do not figure prominently in late medieval Ireland and their iconography may not have been known by the artist responsible for this shrine, which may explain the lack of certain attributes and the errors in others.[60] St Lawrence, for example, does not have the usual dalmatic,

while St Martin always has a mitre if he has a crozier and St Stephen never has a beard.

As with the Domhnach Airgid the decoration of this shrine also has a secular element: a narrow strip of figures in niello which borders the upper left-hand panel of saints (pls 156 a and b). All the other panels are bordered by narrow strips of curvilinear and stylized vine-leaf motifs but that in the right-hand corner has a series of stylized figures showing four small full-length figures on either side. That on the upper left had side must be Margaret, daughter of the O'Brien commemorated in the inscription on the main face, while the first figure from the top, on the left-hand side is Brian, son of Owen Ruark, also mentioned in the inscription. Both of these were responsible for the making of the shrine and are shown crowned and in the act of veneration: she stands with her hands joined in prayer while he holds his downturned sword

Plates 156 a and b (*below left*) The small stylized figures in the border of the upper left quadrant on the main face of the Shrine of St Caillin of Fenagh represent the secular patrons – usually given a secondary position at this time.

Plates 157 a–d (*below right*) The rivet covers on the four corners of the casing on the main face of the Shrine of St Caillin of Fenagh consist of four bearded and stylized heads similar to those on the Domhnach Airgid.

over a kneeling and nude figure, who is also crowned and bowing towards the three saints. Beneath these figures, from top to bottom there are three other full-length figures, alternately male and female and pointing in opposite directions to the one directly above. All are clad in the shawls and simple robes typical of fifteenth-century dress and must represent the rest of the O'Ruark dynasty. In many ways they are similar to the Maguires on the Domhnach Airgid, but unlike those small horseback riders, who really represent little more than a heraldic motif, there is an element of personalization found on this shrine which is absent from the Domhnach Airgid. Even though the figures on the shrine of St Caillin are stylized and could not be said to have any element of portraiture it is clear that motifs such as the crown, the position of the figures in relation to one another and their overall hierarchy was drawn from history and reflected the family structure.

The final element on the main face of this shrine is a decorative feature also found on the Domhnach Airgid and the Miosach – on each of the four corners a bearded male head with a central rivet hole holds the casing to the plate underneath (pls 157 a–d). Such features have been worn beyond recognition on the other examples, but they are well preserved on this shrine. These heads are in imitation of such earlier and more accomplished originals as the eleventh-century examples on the back face of the Soiscéal Molaise.

The back face of the Shrine of St Caillin represents an attempt to replicate the openwork panels found on earlier twelfth-century shrines, and is part of the revival which occurred at this time (see chapter 7).

Less interesting and complicated than other contemporary shrines, the shrine of St Caillin is an example of metalworking at the end of the medieval period in Ireland. Although the iconography is mainly international in origin, an effort was made to use older techniques to replicate style and form, but this is not successful. At this stage in the late medieval period unsuccessful replication rather than innovation is the dominant theme in metalworking.

The Domhnach Airgid

Easily the most complex and interesting of all the late medieval shrines in Ireland, this work originally came from Clones, Co. Monaghan, and was once called St Patrick's Gospels.[61] It is also the shrine with the longest history of refurbishment – originally made in either the seventh[62] or more likely in the late eighth to early ninth century[63] and altered in the fourteenth and fifteenth centuries.

Doubts have been expressed as to the original purpose of this shrine and it has been suggested that it was not a book shrine but a general repository for relics.[64] Nevertheless, because of its shape, and its iconography it has been included in this study. The scene where a book is being presented to an ecclesiastic (main face, lower left panel) is usually directly related to book shrines outside Ireland and its unique context on this face also points to such a purpose.

The main face of the shrine has two inscriptions, and these link the work to John O'Carbry of Clones, who died in 1353: 'IOHS: O KARBRI: COMORBANVS: S: TIGNACI: PMSIT; + IOHANES: O BARDAN: FABRICAVIT + +'[65] (John O'Carbry, successor of St Tighearnach /John O'Barradain made me).

This main face is dominated by a centrally placed Crucifixion with the figure of Christ in high relief on a cross which divides the face into two registers, both of which have a series of full-length figures under pointed arches (pl. 158). This whole face is remarkably well structured, and the two cohesive divisions are easy to read once the central grouping of the Crucifixion is isolated. The crucifixion scene, which also includes the figures of the Virgin and St John who frame the body of Christ, should be viewed as a discrete unit, but one that relates to all the other subjects. It is then possible to divide the remaining representations into two registers. All the figures in the upper register are international in origin and are, from left to right, St Michael, the Madonna and Child, Saints James, Peter and Paul. These were particularly important figures whose cults were significant in Ireland. Those figures in the lower register are all Insular, Irish in origin and distinctly separate from the upper group. From left to right they have been interpreted as St Patrick giving the Domhnach Airgid to St Mac Cairthinn, St Brigit and St Columcille.

The second possible way of 'reading' the main face is vertically rather than horizontally, with the figures in the upper and lower right-hand niches as static portraits. The six figures, be they international or Insular in composition, are all viewed frontally holding their respective attributes, and they act as commemorative symbols. The figures in the upper and lower left-hand niches are not

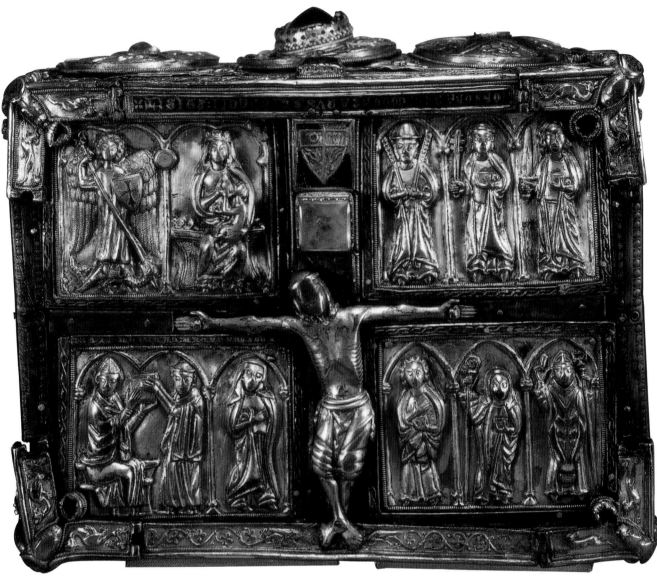

Plate 158 The main face of the fifteenth-century Domhnach Airgid is neatly separated into iconographical divisions and the style is a fine balance between the international and the Insular. Tin, bronze, silver gilt and enamel on a wooden core, length 23 cm, width 16.5, depth 9.8 cm. National Museum, Dublin.

static, they contain an element of narrative and are shown in action; whether it is the act of slaying the dragon, suckling the infant or presenting the book, all convey movement. Such a twofold division to the structure of this face is not accidental but revolves around the overall theme of the work, which centres on the Crucifixion, and it must also relate thematically to the original purpose of the shrine.

Each of the four quadrants of the main face consists of a separate unit and all four relate to the main theme. In the first, upper left, quadrant, St Michael and the Madonna and Child are compositionally linked and need

to be viewed, as with all of these quadrants, from the Crucifixion outwards rather than, as traditionally, from left to right. Both of these figures link thematically to the central Crucifixion in showing the infancy and power of Christ. The first unit in this quarter is therefore the Madonna and Child, who represent the infancy of the Saviour and the maternal role of the Virgin, rather than her later suffering at the side of the cross, which is shown in the lower left-hand quadrant. This was one of the most popular motifs in medieval Ireland and is found in a variety of media.[66] Next to this panel is St Michael, who in Irish literature is interpreted as 'like unto God'. Helen

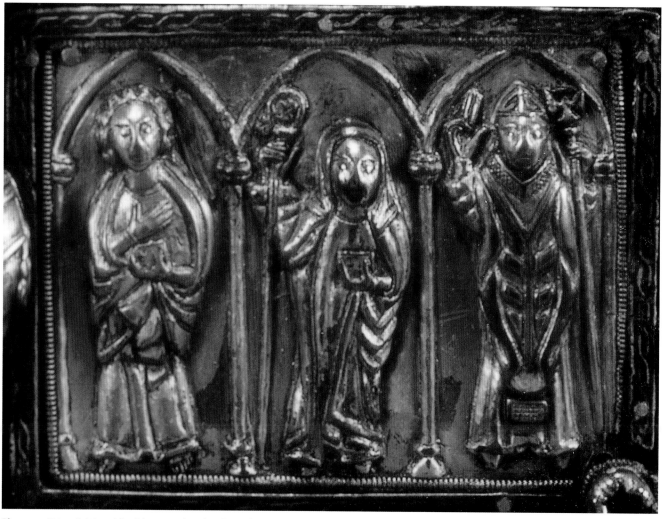

Plate 159 Saints Brigit and Patrick are combined with St John in the lower register on the main face of the Domhnach Airgid and reflect the Insular presence. St John, like the Virgin in the lower left register, is part of the central crucifixion scene.

Roe has shown how the cult of St Michael has a long history in Ireland and reached a peak in the later medieval period when there were numerous representations of the saint.[67] The example on the Domhnach Airgid focuses not, as on the portal from St Mary's Abbey, Clontuskert, Co. Galway, on the saint's weighing of the souls, but on his role as conqueror of Satan and evil in much the same way as the suckling Christ Child was the ultimate conqueror.

The upper right panel is also compositionally linked to this first panel in its choice of saintly subjects. The association of St Michael with other saintly effigies in Irish art of this period, and in particular, with Saints Peter and Paul has already been noted (see pls 91 and 97).[68] These saints were chosen for their eschatological significance and, as Roe has noted, as the Apostles were chosen for their role as Christ's assessors on the Day of Judge-

ment. The Domhnach Airgid does not present any novel selection in its full-length figures of Saints James, Peter and Paul, all of whom stand motionless under niches with their attributes in poses reminiscent of figures on the sides of funerary monuments. These figures were models and symbols for the viewer and were also significant in that the Augustinian canons abbey in Clones,[69] where John O'Carbry was abbot, was dedicated to Saints Peter and Paul, which must account for their presence here. St James, on the other hand, with his pilgrim's hat, would have paralleled Columba's own life of pilgrimage.[70] If these saints represent the international aspect of saintly powers and models of exaltation, they are paralleled by the Insular and Irish versions in the lower right quadrant (pl. 159). Here, Saints Brigit and Patrick mirror those figures in the register above. St Patrick, in particular, stands as a fully vested bishop in a pose of victory and

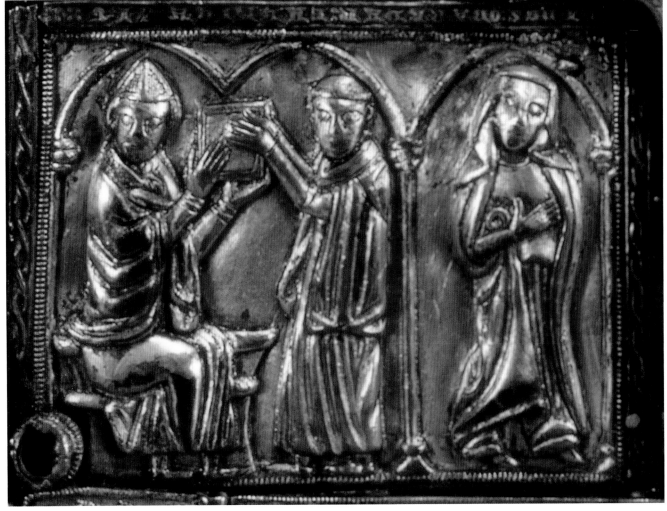

Plate 160 The Virgin in the lower left-hand register on the main face of the Domhnach Airgid is part of the crucifixion grouping. She is accompanied by two unidentified figures, possibly representing a scene from the life of St Columba.

blessing with his right hand raised; St Brigit carries her staff and book. Both Brigit and Patrick form two thirds of the saintly triumvirate in Irish life whose relics were found in 1185 and 1293.[71] The fact that all visual references to Columba after 1185 also include Saints Bridgit and Patrick has reinforced the belief that the identification of these two figures is correct.[72]

There can be little doubt that the figure in the remaining quadrant (lower left) must represent the saint who has given his name to the shrine – St Columba. This scene has in the past been interpreted as the handing of the Domhnach Airgid or Gospels by St Patrick to St Mac Cairthinn, but it must relate more directly to St Columba himself, and may possibly depict an episode from his life or the historical act of giving this shrine to some ecclesiastic (pl. 160). In either case the significance of representing what is clearly the handing over of a book on the

main face of this shrine reinforces the belief that it was originally a book shrine. The significance of books in the Columban tradition has already been noted.[73] Two of the eight surviving book shrines as well as a number of manuscripts can be linked with the Columban tradition. This scene links the subject of the Gospels – the life of Christ and his crucifixion – with the actual manuscript and its container. The representation of books and manuscripts is typical of other non-Insular shrines. The majority of these shrines do not show the saint who is associated with the shrine, but rather Christ or God the Father holding the Gospels in his hands.

Unlike the other depictions of the Crucifixion from fourteenth- or fifteenth-century Ireland,[74] there is a particular emphasis in the Domhnach Airgid on the Passion and on salvation, both popular subjects at the time of the refurbishment in the fourteenth century.[75] The central

Plate 161 The small bird directly over the crucified Christ on the main face of the Domhnach Airgid is similar to the examples on the other Columban shrine, the Cathach, and must represent a visual play on the dove of St Columba.

Plate 162 The *Arma Christi* was one of the most popular motifs in fifteenth-century Ireland. This small example, on the main face of the Domhnach Airgid, must relate to the relic of the True Cross, which would have been placed under the large crystal directly below this shield and above the head of Christ.

theme of the main face is the Crucifixion; the figure of Christ, with long outstretched arms, is not only larger than any other figure but also in high relief. Immediately above, and slightly to the right of Christ's head is a small bird (pl. 161). Even though the bird is in the background it is one of the few enamelled details on the main face. This bird represents the dove of salvation, who returned to Noah after the Flood, announcing the delivery of the world from evil in much the same way as St Michael is represented banishing evil in the form of a dragon. However, this salvation has been bought at an expensive price, as represented by the figure of Christ, the symbols of the Passion (nails, flails, crown of thorns), which are also enamelled in red and blue at the top of the cross, above a crystal which must once have held a relic of the True Cross (pl. 162). The unparalleled position of this bird in relation to Christ is another play on Columba's name and it also has a hidden association with the depiction of the Holy Ghost. The opening and main theme of the *Vita Columbae*[76] is the association of Columba in 'Christ's universal role of redemption', which is visually represented in this scene, where the dove of St Columba flies towards the greatest symbol of redemption the world has known – the crucifix. The position of the bird, in direct communication with the suffering Christ,

indicates the role of Columba as intermediary and successor to the Redeemer in much the same way as the saints in the niches do. The emphasis on the Passion and suffering (Christ, the symbols of the Passion, the Virgin and St John) combines strongly with symbols representing the power of salvation and redemption (the dove, St Michael, the Madonna and Child, the saints and the power of prayer through the word of the Gospels) on this main face. The eschatology of the figures and their interrelationship have been purposely structured in divisions that all relate to the theme of salvation.

At each corner of the main face are two right-angled borders each divided by a head. The short corner panels are decorated with dragons and hunting scenes arranged diagonally. The dragons face each other separated by the head (upper left and lower right corners), but the two hounds or hares chase after each other (lower right and upper left corners). These contemporary motifs are found elsewhere and, like the dragon and griffin motifs found more widely in this later medieval period, they were probably cast from standard dies.

Recent research has proposed that the two long side panels of the shrine are not in their original position and that they may have originally been on the back face.[77] When these panels were repositioned is unknown. In

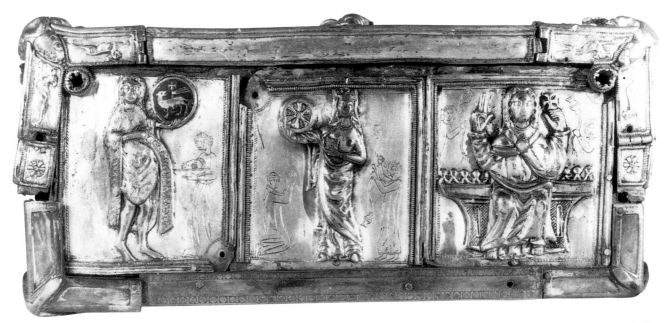

Plate 163 The side panels on the Domhnach Airgid are now out of sequence and it is possible that the figure of Christ in majesty may originally have occupied a central position between St John the Baptist and St Catherine.

their present state they are clearly incorrectly placed, but even combined they would not convincingly make a full back face (pl. 163). One of these sides, that with St John the Baptist, St Catherine and Christ in majesty, is clearly out of place and some of its three sections have been repositioned. The now right-hand panel of Christ in majesty may originally have been in a central position. It is clear from the base line incised under all three figures (which rises and falls unevenly) that St Catherine was on the left-hand side of Christ and St John the Baptist on the right-hand side. The rivet hole in the upper left-hand corner of the St Catherine panel also reinforces this belief. When these panels were repositioned is unknown. The division of Insular and international found on the main face is also apparent in the two side panels of the shrine. The figures of Christ in majesty and the two saints are international in style, while on the other side panel a series of hunting figures on horseback, could easily be derived from fourteenth-century Ireland.

The elements of the static portrait and narrative scene so carefully separated on the front face, are skilfully combined on both these side panels. On the side with the three figures, for example, all the main subjects are in high relief against a background of incised figures which add the element of narrative to the main subject. The narrative elements in these panels are a combination of scenes from the life of each saint – in the case of John the Baptist Salome is shown with a charger and the head of the saint – or monks and acolytes venerating the saints (as in the other two scenes). The combination of St John the Baptist and St Catherine is found frequently in later medieval Ireland, as on the portal at St Mary's Priory, Clontuskert, Co. Galway (see chapter 4). Their presence here, and the emphasis on the instruments of torture (St Catherine proudly holds her wheel aloft) and sacrifice (John the Baptist, while holding the enamelled *agnus dei*, faces his persecutor and his own head), reinforces the whole theme of salvation and redemption found on the main face. The correct position of these two figures on either side of Christ in majesty is a visual statement of the power of such models for the monastic community and, indeed, it is these same monks and friars who are shown here in poses of veneration and adoration. The tonsured monk to the left of St Catherine kneels and prays towards her with his arms upraised, while an acolyte to the right raises two censers. Two more acolytes, each with a censer, are found on either side of Christ in majesty. These are visual statements of the power of salvation and the need to emulate the saints' behaviour as promoted by St Columba.

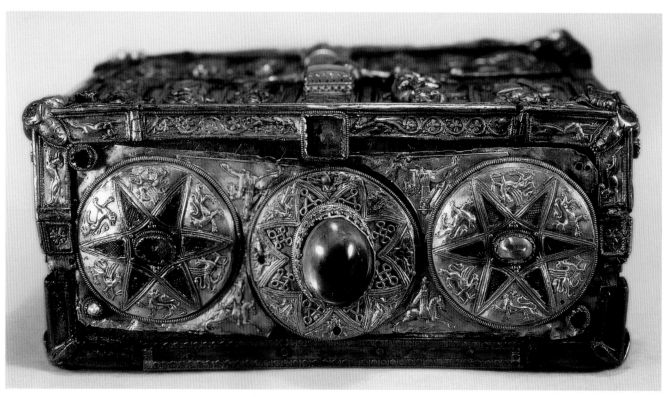

Plate 164 The triple arrangement of the bosses on the Domhnach Airgid is symbolic of the Trinity, as are the interlaced triquetras on the central boss. These symbols of the eternal are guarded not only by the mounted horsemen with their swords held aloft, but also by the defiant griffins. The increasing importance of secular patronage in late-medieval Ireland is shown by the inclusion of mounted knights, who represent the Maguires, Lords of Fermanagh and keepers of the shrine, in what is otherwise an entirely religious iconographic programme.

The other side panel is one of the enigmas of the shrine, as it seems unusually out of place in relation to the rest of the iconographical programme (pl. 164). The three large bosses, each of which has a central crystal, are decorated with a series of smaller motifs in the spandrels surrounding the star-shaped designs. The central boss has eight pairs of birds facing each other with their beaks pecking the grapes which hang between them. An early Christian motif symbolizing the nourishment of the soul through the word of the Lord, this subject is found elsewhere in late medieval Ireland: sculpted on the base of the shrine in the southern transept at Holycross Abbey, Co. Tipperary, under the tower at Ennis Friary and on the entrance to Grey Abbey, Co. Down.

Interlaced triquetras (three interlaced arcs) and four-looped interlace patterns are found in the inner spandrels of this boss. The spandrels on the other two bosses are decorated with griffins and lions all struck from the same two dies, while four horsemen with upraised swords and dressed in full armour are in the spaces between the central and outer bosses. These horsemen have been interpreted as representing the Maguires, Lords of Fermanagh, keepers of the shrine, whose arms consisted of a 'plumed knight, mounted sword in hand'.[78] The border, here as elsewhere on the shrine, is decorated with long-tailed dragons and rabbits or hares. The programme on this side panel is unparalleled and any interpretation has to be based on general assumptions. The central boss, from which the vine grows, may be interpreted as God the Father, the first person of the Holy Trinity from which the nourishment comes, while the bosses on either side may complete the Trinity. This Trinity and the shrine itself are protected by the mounted knights – the Maguires – while the griffins and dragons who stand menacingly on the rims of the bosses also act as a deterrent to any potential danger. If the knights do represent the Maguires, this is one of the earliest representations of the secular world in late medieval Irish metalwork. This panel, like all the other fourteenth-century work on the shrine, emphasizes the triple grouping, and the back face has a fifteenth-century cross inscribed in Gothic lettering with the names of the three Magi – Caspar, Melchior and Balthazar.

At a glance the Domhnach Airgid appears less unified in theme and execution than some other shrines. When examined in more detail, however, the unifying principles and composition become apparent – the general theme of salvation as promoted and embodied in the life of St Columba. It attempts to represent the teachings and practices of this saint as they apply to the monastic community, and in so doing includes references to the patron saints of the foundation and hereditary keepers of the shrine. In many ways the iconography of this shrine breaks with the more formalized structure of the other shrines and introduces the secular and the monastic for the first time.

*　　*　　*

While the primary function of the book shrines was to protect their precious contents, it is clear that their decoration goes far beyond such functional needs and that relatively elaborate iconographical programmes, by Irish standards, were used with intent. The more elaborate the workmanship the more ornate the materials used, and the more arresting the iconography the more successful would be the shrine. It may have been an indirect route, but both responses had to lead to the saint and the powers that he incorporated. This external covering had first to evoke a variety of responses in relation to the saint with whom it was associated and the manuscript it contained and, on a second level, the purpose for which it may have been used. As Van Os has recently demonstrated, the power of memory was at its most potent and compelling in the veneration of holy relics.[79] The enshrinement of objects such as fragments of wood, even if they were from the True Cross, demanded an elaborate casing to emphasize the sanctity of the relic and, more importantly, to meet the expectations of the believer. This display is, in all of the book shrines from Ireland, reinforced by the lack of any internal ornamentation. It was the external display that was significant. It would be logical therefore to find that the subjects used would have been determined by these needs, but this is not the case. Saintly representations, where they are found on these shrines, are normally in a secondary position and are usually smaller that the main motifs. Indeed, there is little

evidence that any saintly relics were ever added to these shrines. At the outset it has to be said that there is little unity in the iconography of these shrines. The Cathach, for example, is directly related to its role in society, but shrines such as those of the Book of Dimma or the Stowe Missal are not easy to relate to any of the above themes.

Despite their unity of purpose each shrine is also relatively independent, and factors such as history, provenance, custodianship, religious associations and contents can be used to extend our understanding of their decorative programmes. Sadly, this information is lacking in most cases, consequently the iconography is the strongest evidence we have of their purpose. The only subject common to all shrines is the Crucifixion. Whether it is the large semi-abstract division of the main face of a number of these shrines by an equal armed cross, the smaller openwork cross-shaped motifs on the back faces or the smaller and sometimes later addition of second crucifixion scenes on top of a number of these shrines as well as on top of larger crosses, it is clearly the most significant motif. In a few instances, such as the Cathach or the Domhnach Airgid, the Crucifixion was used to relate the saint to the saviour, but by and large it stands independent of such narratives. In a number of instances the Crucifixion relates to the manuscripts that were protected and could be taken as a visual substitution of the Evangelists and a rendition of the Gospels, but even allowing for such instances there are a number of shrines where it must simply stand as the most powerful Christian symbol, understood by all. Indeed, it is this last element – the universality of the symbol of the Crucifixion and what must have been the popularity of the motif that may have determined its presence on these objects. Visually this is also linked, in a number of instances, to the relics of the True Cross, which may have been held under settings on the main faces of a number of shrines and may have been the impetus behind the selection of this subject. There is nothing new in either the subjects used or the techniques employed. It is interesting that elements from the secular world as well as heraldic and royal emblems are included in the iconographical repertoires of these saintly shrines. There is little of the casual here – all are structured both in the choice of subjects and the visual representation.

Plate 165 The 'Book of UíMhaine', written sometime before 1394 by Fáelán Mac a' Ghabhann na Scéal, is a particularly fine example of fourteenth-century penmanship. More refined in quality than the 'Book of Ballymote', it is closer in style to twelfth-century illumination than other manuscripts of this period. Royal Irish Academy, Dublin, MS d. ii. 1.

Two Traditions? The Gaelic Revival in Gothic Irish Art of the Fifteenth Century

Towards the end of the thirteenth century the initial drive of the Anglo-Normans had slowed and by the start of the fourteenth century a considerable degree of assimilation between the native Irish and the Anglo-Norman had taken place in areas such as marriage, language and literature. Irish opposition to the Anglo-Norman power frequently manifested itself in battles, such as that at Callan in 1261 which lead to the entire south-west corner of the country being reclaimed by the Gaelic chieftains. A series of parliamentary enactments, which attempted to keep the 'races' apart by proscribing the Irish language, laws and customs and to prevent this integration, failed. The racial and cultural composition of the country was, to say the least, complex. We have scant information as to how these social groups saw each other; the most famous comment, and one that is still in use in modern Ireland, is the one suggesting that those Anglo-Normans who had become assimilated into Irish life were now 'more Irish than the Irish themselves'. In reality, the native Irish viewed this group as a middle or third nation, neither fully English nor fully Irish.[1] These racial and social boundaries were prone to dramatic and far-reaching change. Shifting land boundaries could significantly affect social position. By 1400 the Anglo-Norman, and essentially English, influence was restricted to the Pale, which surrounded Dublin. With the diminution of English influence and power there was a consequent and parallel upturn in the fortunes of the native Irish. The Irish soldier now outnumbered his Anglo-Norman opposite and the English forces that remained in the country saw their area of jurisdiction rapidly decrease. This period in Irish history, one in which there was a renewal of

power for the Gaelic chiefs, is known in literature as the Gaelic Revival. This revival has traditionally been seen as relating to political control, land distribution and military activities, however its impact went way beyond these administrative areas and we can see its influence on the more cultural aspects of Irish life; some at least of the third nation had now become so assimilated into Irish culture that they were conversant with the Irish language. Institutionally and socially, older forms of poetry, scholarship and learning were also revived, but the impact of this revival on the arts has never before been evaluated.

The concept of revival, be it that of the late fourteenth to early fifteenth century or the more frequently studied Celtic Revival of the nineteenth century, which was predominantly based in the arts,[2] is predicated on an appreciation of antiquity and the value of past history. The very concept of a revival suggests the renewal or regeneration of elements from the past that has been lost but which was at one time prized and valued. This appreciation of what has gone is the first stage in recreating or reviving, either in part or in whole, that which has disappeared. It is true that in Ireland in the second half of the fourteenth century, as is still the case in the twenty-first century, the artistic past was highly visible and easily accessible and must have been particularly evocative of a glorious era, a time when the country was not under foreign occupation. Not one of the many struggles of the Anglo-Normans in Ireland ever appears to have been over what were significant elements in the pre-invasion artistic heritage. The many surviving round towers, high crosses, early Christian churches and prehistoric monuments

scattered throughout the countryside, bear witness to a considerable presence from the pre-invasion period. By the middle of the fourteenth century this significant native culture was co-existing with that of the Anglo-Normans. The control of these monuments, however, had now reverted to the native Irish, as had the land, and as such could be used as the starting point for a revival. It is probable that there was an element of celebration in the return of this culture, with a consequent wish to see it continue. Continue, it certainly could not, as there had been no native *continuum* in the Irish arts since the arrival of the Anglo-Normans – what was needed was a revival and renewal of this tradition. There can be little doubt that it was a valued aspect of Irish identity and was but one element in a cultural reorganization that gained momentum in late fourteenth-century Ireland.

Not all revivals need necessarily involve national identity or be politically driven, but the situation in Ireland in the later Middle Ages is certainly comparable to that of the 1830s in that the underlying reason was a wish to restate and restore a cultural identity through political freedom. The revival in the nineteenth century culminated in war and, eventually, political independence, whereas in the fifteenth century the revival was born out of a calm after a period of struggle. This period of peace was particularly important, as artistic revivals are usually not of the greatest importance in times of struggle. Both revivals were linked to the Celtic past and, as such, were perceived as being essentially nationalistic. The art resulting from both revivals was politically imbued with the wish to create or revive a cultural identity that had been lost through colonization. Interestingly, in the later revival, where documentary evidence suggests reasons for the choice of sources or models, it specifically states that these were to be drawn from Irish culture prior to the arrival of the Anglo-Normans. Like the late medieval revival, that of the later Gothic period also rejected the art of the thirteenth and fourteenth centuries as being insufficiently Gaelic or Irish to form the basis of a revival of national identity. Both revivals were instigated by those in power and not from popular demand, as the recreation of an artistic culture could not be undertaken without considerable investment.

Unlike the later revival, however, which consciously attempted to replicate the art of the earlier period with little innovation, that of the late Middle Ages was clearly more difficult to achieve and was more a merging of the past, or elements from the past, with the present, than a

complete replication. Throughout history, one of the closest parallels for Ireland in terms of art, culture and politics has been Scotland, where a similar political situation arose after the Normans arrived. There, the art of the Gothic period can be more easily divided into that of the western Highlands, with its Celtic influences, and that of the Lowlands, with its stronger links to England.[3] The situation in Ireland has meant that it is more difficult to disentangle the artistic output of the later medieval period into neat divisions, for example that produced by the Gaelic chieftain and that produced by the assimilated Anglo-Normans. After all, this second group had been living in the country for several hundred years and had come to see themselves as another element in the national tradition. Consequently, the patronage of the 'third nation' for Irish manuscripts in Insular script or alterations to shrines and religious objects was perfectly natural.

To attempt to divide the Gaelic Revival neatly in terms of art historical output is thus a complex and perhaps not entirely valid task. The control of land in medieval Ireland was synonymous with authority, power and freedom of choice, but that authority did not necessarily manifest itself in the selection of an artistic style that can be definitively described as either Gaelic or Anglo-Norman. Cashel cathedral, for example, one of the most important medieval buildings in Ireland, was controlled throughout the thirteenth century by native Irish archbishops and yet it is built entirely in an 'English' style. Similarly, the rapid development of the friary movement in the fifteenth century under both Gaelic and Anglo-Norman patronage does not appear to have had a decisive effect on the architectural styles used in these particular buildings.[4] The role of the private patrons, whether of Gaelic or Anglo-Norman origin, and their relationship to the Church was clearly complex – as was that of the workforce. As we have seen elsewhere, by the fifteenth century the workforce was drawn largely from Ireland, whereas in the thirteenth century they had been English.[5] Although from the beginning of the fifteenth century most of the Irish attempted to separate themselves from England both politically and culturally, the composition of the 'third nation' and the Church itself would have acted as a filter through which these links would never be entirely severed.

For a revival to succeed it is necessary for it to develop out of a strong and continuous heritage in the visual arts, something that, unfortunately, was lacking in Ireland in

this period. Although the evidence of what survives may present a biased picture, it is clear that the art, more than the architecture, of the later Gothic period in Ireland is a series of important works with little in the intervening *lacunae*. Even though the Gaelic Revival is generally agreed by historians to begin sometime around 1350, it does not appear as a significant movement in the arts (with the exception of manuscripts) until later in the fifteenth century and appears, even so, to have developed unevenly. The native artist who wanted to revive a past heritage at the start of the fifteenth century had to accept that contemporary styles could not be completely abandoned. For a revival to be successful it has not only to replicate forms and motifs but has also to have the technical skills needed to recreate these. It is impossible to see how the technical skills of the pre-invasion period could have been revived by a workforce that had not used them for over two hundred years, and it is obvious that much had either been lost or else was forgotten.

In her study of the nineteenth century Celtic Revival Jeanne Sheehy[6] has remarked, with a certain justification, the fact that 'the Irish do not naturally express themselves in art' and that 'their natural means of expression it is maintained is language in which they are highly gifted'. The predominance of the written word in the arts of the Gothic period and the Insular or Celtic nature of the manuscripts would appear to support this opinion and may lie behind the large-scale absence of this revival in other media. Except for a hiatus in the thirteenth century, Gaelic scribes continued to use the native Insular script for both Latin and Irish manuscripts from the eighth and ninth centuries until the eighteenth century. The absence of manuscripts in the thirteenth and early fourteenth centuries has been blamed on the ecclesiastical reform and the Anglo-Norman invasion;[7] what does survive from the thirteenth century is in the form of entries in older manuscripts and was executed by clerics whose native language was Irish but who had been trained to write Latin in the Gothic script.

The desire to understand the past is a characteristic of all revivals and the greatest source of such knowledge is, understandably, either the oral or written tradition. It is not without justification that Lydon believes that 'many of the greatest books in Irish date from this period', that is the late fourteenth to early fifteenth century.[8] These books were essentially compilations and traditional in content and style (pl. 165), and included collections of stories and verse commissioned by the leading Gaelic

Plate 166 The 'Book of Ballymote', written mostly in Irish by Robert MacSíthigh, contains genealogical, topographical and biblical as well as hagiographical material and was produced under the patronage of Donnchaid of Corann of Ballymote, Co. Sligo. Royal Irish Academy, Dublin MS 23 p 12.

families. Law tracts, and medical and astronomical treatises were produced, as were extensive genealogies. The revival in this manuscript tradition starts in earnest in the fourteenth century after a gap of some one hundred years, and from then onwards there is an increasing number of manuscripts produced with illumnations that attempt to replicate earlier ninth-century models.

This revival in the manuscript tradition culminated in the fifteenth century with the addition of new material mainly in the traditional style. It was only after the traditional material had been dealt with that artists and scribes then looked to material that was outside their own culture. Patronage for these manuscripts came from both the Gaelic and Anglo-Norman lords (pls 166 and 167). The

most powerful expression of national identity for these scribes was the imitation of older and intrinsically Irish models, even if they were old fashioned by contemporary standards. The scribes and patrons were almost certainly familiar with the many Anglo-Norman manuscripts, such as the Bective Hours (Trinity College Library, Dublin, MS. 94), in circulation at this time.[9] As in a number of other areas of Gothic art in Ireland there appears to have been two traditions in manuscript studies, one of which was native and the other international. One manuscript which combines both of these traditions is a genealogical tract on the Burke family (Dublin, Trinity College Library, MS F. 4.13, *c*.1578–84). This reflects the patronage of a Gaelicized family originally of Norman origin. The manuscript, written in Irish and Latin, is one of the last books from the medieval period and its thirteen illustrations show how the iconography inspired by mainland Europe has been imported and merged with the native textual tradition. The scene of Christ carrying the cross in the Bective Hours (pl. 168) is an international depiction

Plate 168 (*right*) *Christ Carrying the Cross* (English, possibly made at Cambridge, *c*.1340). One of thirteen miniatures in the book of hours made for the Cistercian foundation at Bective. Trinity College Library, Dublin, MS 94 (F. 5.21), f. 61v.

Plate 169 (*facing page*) *Christ Carrying the Cross* (early sixteenth century). The illustrations in this manuscript written for the De Burgo family of Mayo combine elements of the Insular and international styles. Trinity College Library, Dublin, MS d. ii. 1.

Plate 167 (*below*) The illuminations in the 'Book of Ballymote' have been criticized as debased and lacking the spirit of the original tenth-century tradition. Written around 1391, it nevertheless shows how the Insular tradition was perpetuated well into the Gothic period. Royal Irish Academy, Dublin, MS. 23 p 12.

Plate 170 Panels from the Cistercian foundation at Abbeyknockmoy, Co. Galway, the typical fifteenth-century workmanship attempts to replicate in stone the intricacies of interlace found some three centuries earlier in manuscripts and metalwork.

of the subject and was made in England. On the other hand, by including members of the Burkes dressed as knights the same scene in the Book of the Burkes (pl. 169) merges the Insular and the international. The Cistercian Ordinal from Monasterevin (Bodleian Library, Oxford, Rawlinson MS C. 32, *c*.1509) is another manuscript which combines the native and the imported in terms of its iconography and execution. The native piper (f. 31v), bird (f. 10v), fish (f. 47r) and the many interlace patterns reflect the indigenous style, while the armoured knight (f. 58v), cleric (53r) and king (54v) are within the mainstream of imported imagery. The subject matter is largely Irish in the early phases of this development, but changes slightly once the tradition is established to include a shared but limited iconography with the English tradition.[10]

The other arts in this Gaelic revival are less cohesive and continuous because there was not the same firm basis for development. In architecture, for example, the impact that a hiatus of some fifty years had on the styles of the later fourteenth century was significant.[11] After a century and a half of development closely aligned to English styles and dependant on a workforce from abroad, a break occurred in the mid-fourteenth century. This was the result of political and economic downtrends as well as the devastating influence of the Black Death.

The workforce that attempted to revive architectural styles at the end of the fourteenth century was Irish and the same interchange between England and Ireland no longer existed. Thereafter, Gothic architecture has an archaic quality, the result of using older models from before the hiatus, which are still Anglo-Norman in style. Fifteenth-century Irish church architecture is a compendium of older large-scale forms, up-to-date smaller features, such as window designs, and localized developments. Although Rae believes that the use of older cloister forms and the frequent use of the round arch in these later Gothic buildings was ultimately inspired by earlier Romanesque and transitional styles, they do not constitute a large-scale revival in architecture.[12] While the styles and techniques were Anglo-Norman there is evidence of the Gaelic Revival in architecture: this may be minor, small in scale and not widely distributed, but taken together it constitutes evidence of a significant attempt to impose an Irish identity on the architecture of this period.

The first such example is a group of architectural carvings of interlace panels, found in isolated sites throughout the country and dating from the fifteenth century (pl. 170). They are neither consistently located in buildings with Gaelic or Anglo-Norman patrons nor within the

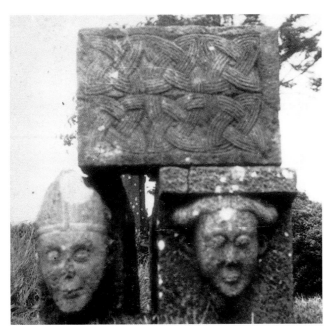

Plate 171 Interlace panel (originally from Kilnanare Friary, Co. Kerry). Possibly work of the fifteenth-century sculptor responsible for similar panels at Caher Priory, Co. Tipperary.

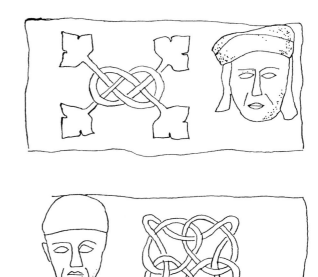

Figure 7 The human head was the most popular label stop in Irish architectural sculpture from the thirteenth to the fifteenth century. Two typical fifteenth-century carvings are at Bonamargy Friary, Co. Antrim, and are accompanied by interlace motifs.

buildings themselves, but are usually positioned relatively prominently as an obvious statement of identity. Some examples are found in the fifteenth-century remains of the Augustinian canons' priory of St Mary, Caher, Co. Tipperary, where three large panels, all with distinctively Celtic motifs are prominently positioned. Entirely decorative in purpose, they are on the east window and at eye level by the northern entrance under the tower. Interlace designs are found in Irish art only in manuscripts after the late twelfth century. Before that they were commonplace and their use in architecture and in the other media at the start of the fifteenth century cannot have been accidental. Compared to the entire corpus of architectural sculpture from this period the number of interlace carvings that survive is not substantial, but they stand outside the general repertoire of motifs and designs. Such designs may go back as far as the ninth century for inspiration and include large panels from Kilnanare, Co. Kerry (pl. 171); Bonamargy, Co. Antrim (fig. 7); Bective Abbey, Co. Meath; Mellifont, Co. Louth; Abbeyknockmoy, Co. Galway; Carlingford Mint, Co. Louth (pls 174 and 175) and Caher Abbey, Co. Tipperary (pls 172, 173 and 176).

Another minor, yet telling display of national identity is the number and character of masons' marks used by the workforce. Thirteenth-century marks are virtually indistinguishable from those used on mainland England and indeed probably came from there, they are lightly incised, placed in relatively discreet positions on the cut stone and nearly always based on angular and linear designs. In the fifteenth century they were placed in prominent positions on the native hard grey limestone and are carved in high relief. A considerable number are based on Celtic interlace motifs such as those found on trial pieces from nearly three hundred years earlier (fig. 8).[13] The masons went to considerable lengths to replicate detailed interlace panels, derived not from the period preceding the hiatus, as in the case of architectural designs, but from a period of over two hundred years earlier. Ironically, considering that they proclaimed both an individual as well as a national identity, the Irish craftsman must have used such marks in ignorance of their English origin (pls 177 and 178). Marks were first used in Ireland after the Anglo-Norman conquest as a declaration of personal identity by a foreign workforce.

Although there is little evidence that a significant Gaelic revival took place in church architecture in the fifteenth century, the development of lordships lead to the large-scale building of tower houses. The arguments for the origins of these structures in early Anglo-Norman castles, their relationship with similar structures in

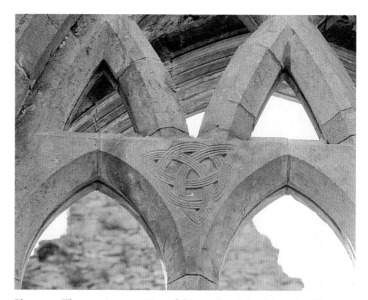

Plate 172 Caher Priory, Co. Tipperary, founded by Galfrid de Camvill, is decorated throughout with small carvings in unusual locations. The five-stranded interlace design on the exterior of the east window is typical of this work.

Plate 173 The prominent position of this panel at Caher Priory, Co. Tipperary, is unusual and must have been carved with the aid of a compass. Found on the exterior, it is not balanced on the other light and would have gone unnoticed from ground level. Nevertheless it proclaims the Irish identity of the mason responsible for this window.

Plate 174 Windows in the small fifteenth-century tower house at Carlingford Mint, Co. Louth. Three stories in height, this building acted as a mint from 1467.

Plate 175 Carlingford Mint, Co. Louth, combines revisionist with contemporary iconography. The spandrels in these small ogee-headed windows reflect the fifteenth-century preference for interlace motifs in small yet conspicuous locations.

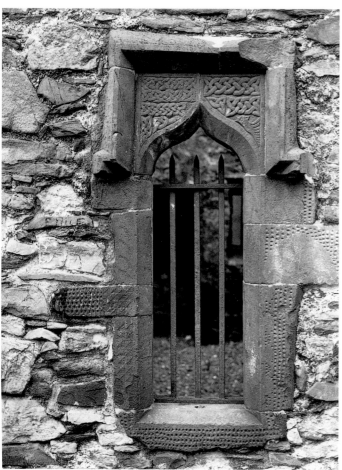

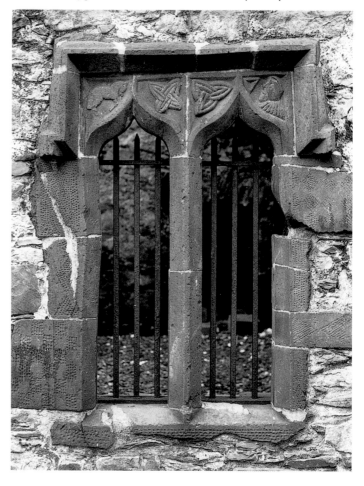

Plate 176 Most fifteenth-century architectural carvings in Ireland are either functional or attached to functional elements. However, the single interlace panel in the wall under the tower at Caher Priory, Co. Tipperary, lacks such context and is one of the few carvings from this period which does not relate to any architectural feature.

Plate 177 Small interlace motif in relief carved as a mason's mark at Holycross Abbey, Co. Tipperary. It is typical of the complex patterns used by Irish masons in the fifteenth century.

Figure 8 These examples of fifteenth-century masons' marks replicate interlace patterns of the pre-Romanesque period. They are usually less than ten centimetres in height and carved in high relief in the hard grey limestone.

Plate 178 The simple triquetra, used as a mason's mark at Holycross Abbey, Co. Tipperary, is also found in fifteenth-century Irish metalwork and manuscripts.

Plate 179 Leather satchel for the Book of Armagh combining roundels, interlace panels and animal motifs (fifteenth century). Length 32 cm, width 27 cm. National Museum, Dublin.

Northumberland and Scotland and their dating to as early as 1300 have been studied elsewhere.[14] It is clear, however, that they were built in great numbers with over three and a half thousand possible houses constructed over two centuries. Tower houses have been described as 'an aggressive statement of the Gaelic Revival', which may refer to their function in controlling land rather than their architectural elements.[15] They are found in greatest numbers in Counties Galway, Clare and Limerick, which, interestingly, were all territories under Gaelic control. The tower house was also a form which was built in considerable numbers by the Anglo-Irish lord and indeed was encouraged by a subsidy from Henry VI in

1430, when a grant of ten pounds was given for every tower house that was constructed.[16] Whether or not they were derived from earlier Anglo-Norman castles, certain features of the general design and, in particular, those of the fifteenth century including the battered walls, battlements with double steps and machicolated galleries at the corners are all essentially Irish in origin. Barry has also noted documentary evidence of tower houses built out of native material – wattled walls or even out of sods or hedges.[17]

The evidence for the Gaelic Revival in other media is similar to that in architecture and manuscripts in that it is sporadic and has to be evaluated on what has survived.

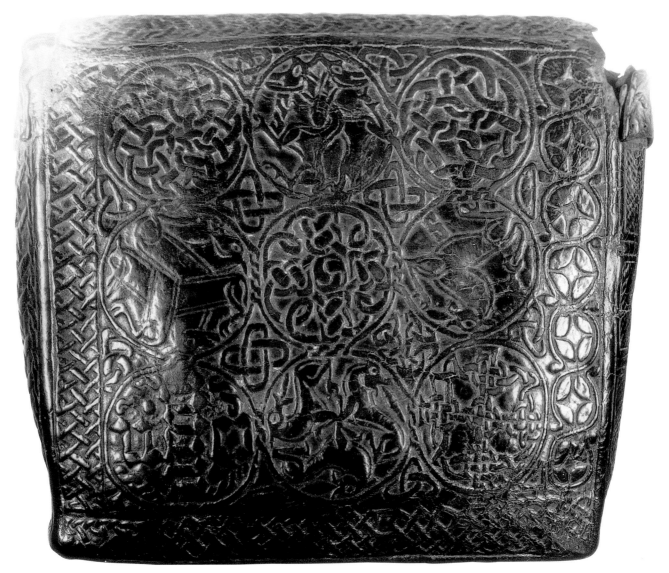

Plate 180 The decoration on the back of the satchel for the Book of Armagh is more structured in design than on the front and consists of ten interlocking roundels. The lower left corner roundel has an inscription in Gothic lettering.

Isolated objects, such as the leather satchel for the Book of Armagh (Trinity College Library, Dublin, pls 179 and 180), which throughout its history has been ascribed to different periods, is now accepted as fifteenth century.[18] Its interlaced animals, curvilinear designs, Gothic inscription and repertoire of motifs, including triquetras and links, would not be out of context in the ninth century. It is one of the few objects which has not been criticized as having lost the spirit of the earlier period. It is closely linked to the leather satchel for the shrine of the Breac Mhaedogh (pl. 181) in style and decoration. The ornamentation on this oblong piece of leather is not as intricate as that on the satchel for the Book of Armagh and consists of two rows of four interlocking circles bordered by a plain frame on one side. The other side has four interlocking squares with double stranded radial lines extending from a circle in the centre of each square. A simple interlace pattern joins the two sets of squares while the sides of the satchel have interlocking tendrils on one side and interlaced links on the other. Like the other satchel it was probably not made for the shrine with which it is now associated. There seems little reason to doubt its fifteenth-century date. A close sculptural parallel for one of the panels on this satchel is to be found in County Tipperary and also dates from the fifteenth century. This carved panel is an isolated but prominent

149

Plate 181 (*above*) Now associated with the Breac Mhaedogh, this fifteenth-century leather satchel may originally have been made for another shrine or manuscript. It is one of three surviving satchels from medieval Ireland. Length 21.25 cm, width 25.93 cm. National Museum, Dublin.

Plate 182 (*right*) The triple-stranded interlace design found at ground level under the tower at Caher Priory, Co. Tipperary, replicates in stone the design found in leather on the fifteenth-century satchel for the Breac Mhaedogh (Pl. 181).

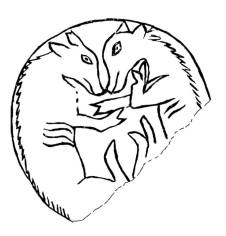

Plate 183 (*above*) The design and workmanship of this harp, known as 'Brian Boru's Harp', are closer to Scottish than Irish examples. Each series of roundels (see figs 9–12) has pairs of animals drawn from a bestiary source. They are substantially different from the interlace animals used elsewhere in Gaelic Revival art. Willow and oak, height 86 cm. Trinity College, Dublin.

Figure 3 (*right, top*) Most of the animals enclosed in roundels on 'Brian Boru's Harp' show pairs of the same species facing or looking away from each other, and this example is the only one depicting a struggle. The lion-like animal stands victorious over the dragon beneath.

Figure 4 (*right, second from top*) Two animals in a roundel on 'Brian Boru's Harp', display a symmetry not found elsewhere in Gothic Irish art and have the characteristic double-stranded outline found in manuscript illumination.

Figure 5 (*right, second from bottom*) Most of the animals depicted on 'Brian Boru's Harp' are now unidentifiable. The roundels are randomly incized on the forepillar.

Figure 6 (*right, bottom*) These two-boar like animals are found on the lower flank of the forepillar and are typical of other roundels on 'Brian Boru's Harp' in their incomplete and unfinished nature.

motif immediately inside the western doorway under the fifteenth-century tower of St Mary's Priory, Caher, Co. Tipperary (pl. 182). The recognizably Celtic design was one of the first motifs that would have greeted the visitor who used this doorway and is nearly forty-five centimetres in length. There is no doubt about the date of this panel, but it is clear that further research has to be undertaken on the collection of Irish satchels.[19] The wooden harp, generally known as Brian Boru's Harp (pl. 183) is another object which has traditionally been referred to as evidence of a large-scale revival in the arts of the fifteenth century. Iconographically (figs 9–12) and stylistically it is closer to harps which are Scottish in origin than to those produced during the Gaelic Revival in Ireland.[20]

Metalwork

Comparatively little attention has been given to Gothic metalwork. The corpus of remaining objects is not large and consists mostly of repairs to older shrines, a small number of new shrines, liturgical objects and seals. The country has a long and illustrious history in the production of metalwork and this did not cease with the arrival of the Anglo-Normans. However, with the exception of seals, nothing remains from the thirteenth and early fourteenth centuries. Some of the technical expertise is sadly missing in this later work, but what remains compares more than favorably with work produced in England. The cult of relics and shrines had political aspects in the later Middle Ages in Ireland: such highly venerated objects could be manipulated by the Anglo-Normans as well as the native Irish chieftains to maintain control of the populace, and was therefore of significance to both *nationes*.[21] The artistic heritage and control of many early Christian objects was vested in the native Irish, who occupied the western and northern areas of the country and many of these objects were not in immediate circulation; their worship and veneration, even after several hundred years, cannot have been widespread, nevertheless their history was known in the Gothic period.

As a form, the processional cross has a long but interrupted history in Irish art. The earliest example, which dates from the twelfth century, is known as the Cross of Cong, and is an Irish adaptation of the European processional cross. Except for a group of Romanesque crucifix figures[22] no other examples of processional, altar or

pendant crosses are to be found until the mid-fourteenth century, by which time both the style of the cross and its iconography are within the mainstream of the English tradition.[23] In the mid-fourteenth century the altar cross, with its twisted representation of the suffering Christ, is virtually indistinguishable from English examples and indeed it is likely that some of these pieces may have been imported (pl. 184). There is little of the native or Insular in most of these objects. Several examples of the same workmanship in both altar and processional form which date from the early to mid-fifteenth century are presently to be found on both sides of the Irish sea and may have been in such a context since the medieval period. The long-held belief that such crosses were imported into Ireland must be revised. From the corpus of such crosses, most of which date from the fifteenth century, it is clear that some display close links with English originals, but a number are outside this tradition and have no parallels on mainland Europe (pl. 185). These pieces date mostly from the end of the fifteenth century, and they represent the first significant manifestation of the Gaelic Revival outside the manuscript tradition.

The focus in all of these objects is not the form of the cross itself, which is 'English', but the actual figure of the crucified Christ.[24] The best-known Irish representation of the crucified Christ from this period is the large processional cross from the Franciscan friary at Ballylongford, Co. Kerry (see pls 134 and 135). According to an inscription on the cross, it was made in 1479 by an Irish metalsmith for an Irish chieftain, and it represents one of the highpoints of the entire Gothic period in Ireland.[25] The style and iconography, however, are not sufficiently native to warrant its inclusion as part of this Gaelic Revival. Nevertheless, the slight element of stylization in the suffering figure, which contrasts with other metalwork depictions of the crucified Christ, prepares us for a group of other representations which are distinctly Insular in style. This group of six crosses and figures are contemporary and, on stylistic evidence, date from the third quarter of the fifteenth century (pl. 186). Neither the crosses nor the figures can be provenanced with certainty, but they are clearly of Irish origin.

This group of figures is characterized by a conscious stylization, which contrasts sharply with the naturalistic representations found elsewhere (pl. 187 a). In these examples the human element is generally abstracted and the head and limbs stylized. Christ's head may range from the ape-like in some examples, with a pendulous jaw

and large oval eyes, to a smooth triangular form entirely lacking in musculature. The monumental, and usually flat-topped heads have, in general, two strands of hair falling on either side of the face (pl. 187 b). A series of parallel hatched lines on either side of the body, again pattern-like in their depiction indicate a high ribcage, which is significant in tracing a possible origin for these figures. It is virtually impossible to distinguish whether Christ is dead or alive.

The origins of this sense of stylization can be traced back to pre-invasion models in which the early Christian metalwork has a similar sense of abstraction in depicting the human figure and in particular the head. Ironically, the sources of this type of figure have been traced, variously, to Spain, Denmark, Germany and, more recently, to the west of England, where Ó Floinn has shown the significance of the high ribcage.[26] Close parallels for the Gothic representations include the twelfth-century bronze figure of an ecclesiastic (National Museum of Ireland, Dublin, R 2940) and the figures on St Manchan's Shrine, Boher, Co. Offaly, which are again dated to the twelfth century (pl. 188). Although now worn and lacking detail, the same stylization and shape is found on several of the bronze crucifixion plaques from the same period. The relationship between the Irish Romanesque crucifixion figures and the even earlier metalwork figures discussed above has already been noted by Ó Floinn,[27] but this present group extends the tradition into the sixteenth century. Apart from the similarities in body shape, the loincloths on the Gothic examples are also unusual and differ from those found elsewhere in this period. The drapery is flattened and had the characteristic cross-hatching used to indicate depth common to Romanesque representations of the crucified Christ. An early Irish origin is also proposed for the disproportionately long limbs and flattened hands, which are similar to representations of the crucified Christ on the high crosses. It is suggested that the large panels in the transom may have dictated the emphasis given to the hands in a number of carvings and may thereby have inadvertently provided a stylistic model for the later period.

A similar facial and body abstraction appears in isolated examples of Gothic Irish sculpture, and one unprovenanced stone head, now in the National Museum, Dublin (pl. 189), with its characteristically high cheek bones and lines dividing the facial features, is reminiscent of some of the metalwork examples in this group. Similarly, some of the panels on funerary monuments, in

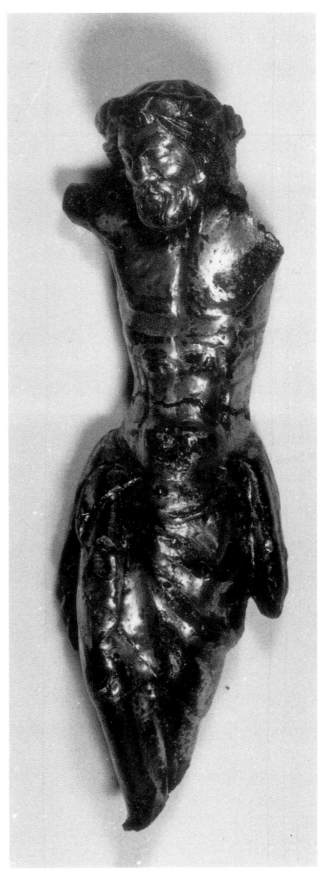

Plate 184 The medieval provenance of a number of objects can not be proven. It is most likely that they, like this small crucifix figure possibly of French origin, were imported in the Gothic period. Gilt bronze, height 10 cm, width 2.7 cm. National Museum, Dublin.

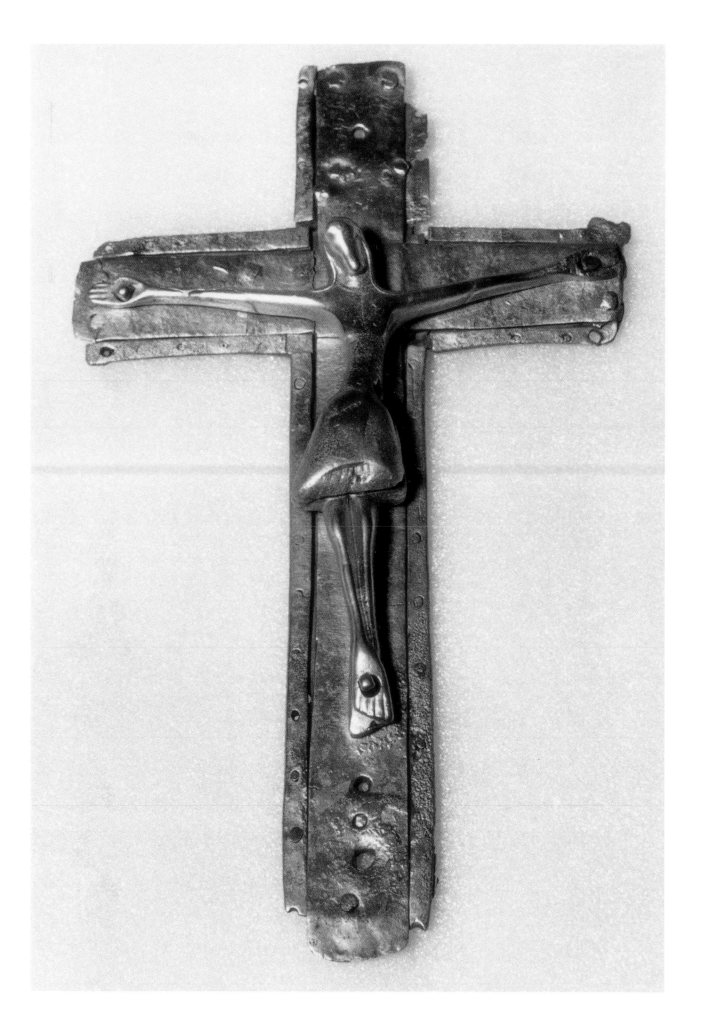

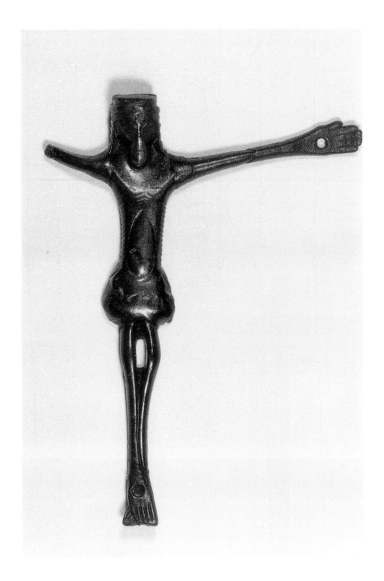

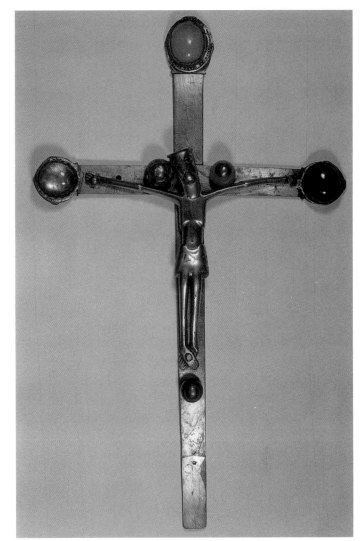

Plate 186 Small, fifteenth-century corpus. The stylization of the figure of Christ, found on a number of late fifteenth-century representations, was an attempt to continue a tradition first found in twelfth-century Ireland, but which is lacking in the thirteenth and fourteenth centuries. Various origins, from Spain to the west of Britain have been proposed as a source for this motif. Bronze, height 14.2 cm, width 10.5 cm. National Museum, Dublin.

Plate 187 a (*top right*) Fifteenth-century cross from Donagh, Co. Monaghan. Gilt bronze, height 35.7 cm, width 22.3 cm.

Plate 187 b (*right*) Detail of pl. 187 a.

Plate 185 (*facing page*) Processional, altar and pendant crosses survive in considerable numbers from medieval Ireland. An unusual group, including this altar cross from Clonaheen, Co. Offaly (*c.*1470), display a stylized approach in representing the crucified Christ which is not found elsewhere. Bronze, height 22.3 cm, width 13.7 cm. National Museum, Dublin.

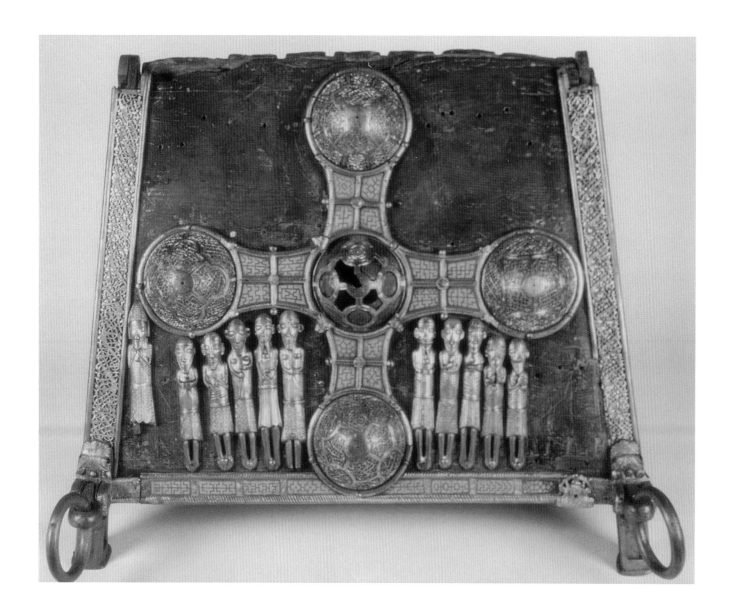

Plate 188 (*above*) The house-shaped Shrine of St Manchan, originally associated with the monastery at Lemanaghan, Co. Offaly, dates from the twelfth century. The eleven stylized figures on the front are typical of the semi-abstract approach to human representations of the Romanesque period in Ireland. Private collection, Boher, Co. Offaly.

Plate 190 (*facing page*) Small bell shrine, known as the Corp Naomh Bell Shrine, tenth century, remodelled in the late fifteenth century. The figure of Christ, with its symmetrical and linear body, is typical of the stylized approach to representing the crucifixion in fifteenth-century Ireland. Height 23 cm. National Museum, Dublin.

Plate 189 (*left*) Although the stylization of the human figure and face is mainly found in metalwork it is occasionally represented in sculpture, as in this fifteenth-century unprovenanced carving. National Museum, Dublin.

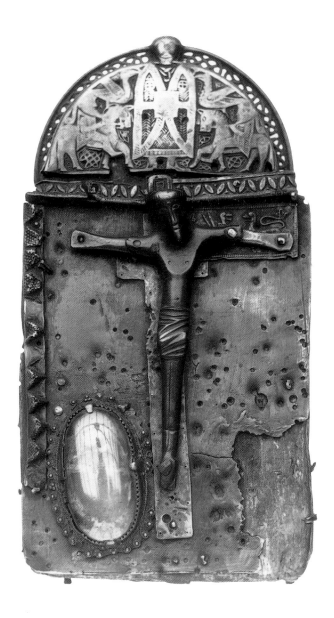

particular those in the west of Ireland (O Craian Tomb, Sligo), exhibit the same sense of abstraction. The remote location of these monuments in areas under Gaelic control may have provided the initiative for the revival, which was clearly not widely adopted.

Objects such as the high crosses, for example, with their dominant theme, frequency and distribution throughout Ireland, must have been part of the national consciousness by the late medieval period and have been seen as at the core of national identity. The elements of abstraction and stylization that appear are not accidental. The Irish have always adapted the iconography of the Crucifixion to their own needs and this is clearly a tradition that continued in the fifteenth century. Where the rest of Europe had a compositional grouping of the

Virgin, St John and other ancillary figures from the sixth century onwards, Ireland appears, with a few possible exceptions, to have preferred a more limited compositional grouping of the angels, Stephaton and Longinus until the end of the twelfth century. With the arrival of the Anglo-Normans and the increasing devotion to the Virgin Mary the iconography changed and the older grouping never again appears. It was, however, replaced by the equally selective composition of the Virgin and St John. If there was a conscious revival of the theme of the Crucifixion, in metalwork of this period, the origins must lie in what was perceived as a native or pre-invasion model.

This group of figures is not the only evidence of a Gaelic revival in metalwork (see also chapter 6). The stylization and abstraction found on these figures extends also to other contemporary representations of the Crucifixion. The same sense of stylization is found on the figure of the crucified Christ on the Corp Naomh Bell Shrine (pl. 190). Although now damaged and missing his hands, Christ's facial details and his head are similar to those on the crosses, and also outside the mainstream of representations of this period. It is tempting to speculate that this late fifteenth-century figure was made specifically in imitation of a now lost original and was executed in what was thought to be the late tenth-century style of the original shrine. The figure on the bell shrine of St Conall can also be included in this group (pl. 191). In this example Christ has the same disproportionately large hands and feet and unnaturally extend limbs. Although less stylized in facial features it stands outside the more naturalistic representations, but is similar in treatment to many of the twelfth-century Romanesque figures.[28] The modelling of the drapery on this shrine, with its flattened and regular folds, is also reminiscent of an earlier period. Even though the iconography is from the fifteenth century, the execution is in imitation of earlier models and subtly links to another group of shrines where this same feature is found. This is similar to the corpus of book shrines (chapter 6), where earlier, twelfth-century designs are recreated in the fifteenth century (see pl. 145). This group of early sixteenth-century shrines represents the final stages of the Gaelic Revival in metalwork. The first of these is the Miosach, which, as already discussed, is a twelfth-century shrine altered in 1534, just nine years before the Reformation. It also rather sadly represents the nadir of Irish metalworking – the same panel is found on each of the four corners of the main face. On the Miosach (see pl. 150) pattern has replaced individualization and

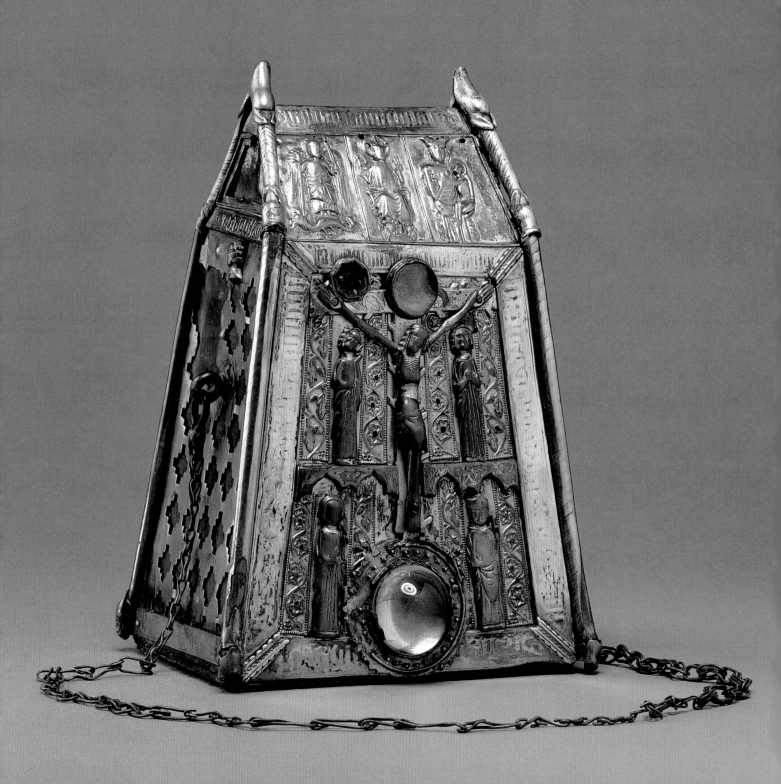

the use of empty space and balance apparent on other fifteenth-century shrines is also absent. Instead, there seems to be a conscious need to decorate every available space, a characteristic of a number of pre-invasion shrines, including the Breac Mhaedogh and the Stowe Missal (see pl. 143). Stylistically, the flat modelling of the drapery is reminiscent of pre-invasion originals, such as the Breac Mhaedhogh, which dates from the first decades of the twelfth century. The iconography of the Miosach is also more Insular in quality; details such as the croziers, a crowned Madonna and vestments worn by the figures are not paralleled elsewhere in Gothic Irish metalwork. The Crucifixion on this shrine is less detailed but has the same flattened and enlarged hands as well as a poorly modelled corpus.

The shrine of St Caillin of Fenagh (see pls 153 and 154) is slightly earlier in date and was made, according to an inscription, in 1526. This is similar to the Miosach in that the same panel is repeated four times on the front and has the same flattened modelling of the drapery. The crucified Christ on this shrine, however, shows a further stage in abstraction: the body now appears to be a stylized depiction of Christ made in the sixteenth century, not an imitation of what a fifteenth-century Gaelic chieftain and artist perceived as an earlier insular model. The ability to replicate an earlier style would appear to have been been lost by this date, and the artist used his own expertise not in imitation but in creation. Both the Miosach and the shrine of St Caillin of Fenagh are structurally similar to eighth-century book shrines, which they imitate, and differ in form from other Gothic Irish shrines, such as the Fiacail Padraigh (see pl. 12). Interestingly, the absence of narrative in these two shrines and their emphasis on the static portrait is also representative of twelfth-century Irish metalwork and unlike some of the later fifteenth-century examples. A more obvious example of the Gaelic Revival in metalwork of this period is the early sixteenth-century reliquary known as the Cross of Clogher; its eight interlace panels at the junction of transom and shaft and the openwork panels on the back are in an earlier style (figs 13 and 14). It is similar to the other objects in that it attempts to merge a current style and iconography with pre-invasion elements. It is probably one of the last objects to have been made in Ireland before the Reformation.

The revival of metalwork in this period appears to have been selective in the elements it tried to imitate and was modelled on what must have been perceived as pre-

Figures 13 and 14 The two bosses on the early sixteenth-century Cross of Clogher at St Macarthan's Seminary, Monaghan, are among the most successful attempts at using interlace in metalwork of the Gothic period in Ireland. The stylized animals on each boss spell the words 'Amen' and 'Deaus'.

Plate 191 (*facing page*) The main face of the fifteenth-century Bell Shrine of St Conall combines an iconography drawn from the international and the Insular. Dominating the entire programme is the stylized figure of Christ, with unusually long arms and flattened hands. Gilt bronze, height 21.6 cm, width 15.2 cm. British Museum, London.

invasion examples. There is an attempt to replicate the stylized nature of the figure, the use of pattern, an all-over application of design and the avoidance of blank or undecorated areas as well as an absence of narrative and a focus on the static. This corpus has to be viewed against the broader background of Gothic art in Ireland. The objects stand apart in their attempts to rekindle the spirit and tradition of an earlier, pre-invasion period. In using this sense of stylization in the fifteenth century and merging it with the later medieval cross form, the artists were uniting the past and the present and the Gaelic and Anglo-Norman traditions. It is not however a simple act of replication but a subtle linking of the art of the two periods. However, the manuscript tradition lacks the power, technical competence and beauty of the earlier examples. With the exception of manuscripts, all the works date from the mid- to late fifteenth century and could be seen as either an early or transitional stage of what might have been achieved had the dramatic events of the Reformation not stopped the movement and lead to complete abandonment. On the other hand it is possible that the English style was too firmly entrenched in public acceptance to have been seriously affected by a revival and that that the objects here were all that was created. The exact nature of this revival may never be fully understood; it is clearly complex, and extends beyond the medieval period. It is interesting that after the Emancipation Act of 1829 most of the Catholic churches built in Ireland were constructed in a Gothic style which could be seen as refuting a strong and popularly held cultural association; on the other hand it may have been the only style known to the architects and masons of that period, and could be seen as continuing the medieval tradition.

Historical studies have looked at this revival from different perspectives, and there has been considerable discussion as to its true nature. Most historians agree that a revival did indeed take place and that this revival was not restricted to political events but that it was also manifest in socio-cultural elements such as literature and music. The revival has hitherto been seen as a politically motivated nationalist movement, but more recent studies have questioned this. The essence and interpretation of nationalism lies at the core of both views. Leerssen, for example, has shown how political poetry of the later Middle Ages, with its many instructions as to how to resist English encroachment, suddenly ceases after the Flight of the Earls.[29] This has lead a number of scholars to question the 'national' aspect to this revival and instead to have seen it in terms of a smaller scale and more focused movement that relates solely to the Gaelic aristocracy. This may well be the case at the start of the seventeenth century and even more so when the literary evidence is examined, but it does not fit the artistic evidence for the second phase of the Gothic period. The revisionist programme in the arts of the second phase is very much based in Church and society and is at a level that does not indicate any exclusiveness. The uneven revival in the different arts has to be viewed against the nature of Irish society at this time. Lacking the centrality of English settlement in the larger urban areas, it would have been difficult to accomplish a uniform revival. Whatever its basis in society, or its strengths in the art of late medieval Ireland, the Gaelic Revival was ultimately destined to fail. The events that enveloped Ireland at the start of the sixteenth century also heralded the end of any attempt at recreating Ireland's Golden Age.

Inventory of Sculpture in Cashel Cathedral

Interior

Choir

1 Label stop (eastern end) to the hood moulding of the group of five windows in the northern wall: female head. Parallel head on the western end now missing.

2 Label stop (eastern end) to the hood moulding of the eastern window in the northern wall: male head. Foliate motif on western end.

3 Label stop to the hood moulding of the door in the northern wall: human head.

4 Two label stops to the hood moulding of the group of five windows in the southern wall: human heads.

5 Four label stops on the hood moulding of the group of five windows in the southern wall: from east to west, (a) two male heads; (b) male head and grotesque male head;, (c) male head and a grotesque male head; (d) two male heads.

6 Corbel in the southern wall: an owl's eyes.

7 Corbel in the southern wall: male head.

8 Corbel in the southern wall: ram's head.

9 One carving in the southern wall: male head.

Southern Transept

10 Three label stops to the hood moulding of the southern windows: two male heads and one female head.

11 Two label stops to the hood moulding of the western windows: two male heads.

12 Two capitals on the western windows: series of heads and foliage.

Nave

13 Corbel in the southern wall: male head.

14 Label stop (eastern end) to the hood moulding of the southern door, depicting a male head.

15 Two capitals on the eastern jamb of the southern door: from east to west, (a) two male heads and foliage; (b) three male heads and foliage.

16 Capital to the vaulting of the entrance porch (western wall): one male head and foliage.

17 Two capitals on the western jamb of the southern door: from south to north, (a) three male heads and foliage and an animal; (b) one head and foliage.

18 One capital on the northern jamb of the western door: three male heads and foliage.

19 One corbel in the northern wall: dragon and human hand.

20 One carving presently incorporated in the northern wall: male head.

Northern Transept

21 One label stop (eastern end) to the hood moulding of the northern windows: male head.

Crossing

22 One label stop (northern end) to the hood moulding of the arch under the tower (in the choir): male head.

23 Series of ten capitals on the south-eastern pier under the tower: from east to west, (a) three male heads and foliage; (b) one head and foliage; (c) two heads and foliage; (d) one head and foliage; (e) two heads and foliage; (f) one head and foliage; (g) two heads and foliage; (h) two heads and foliage; (i) two heads and foliage; (j) plain capital.

24 Two label stops to the hood moulding of the arch under the tower (in the southern transept): female head (western end), grotesque male head (eastern end).

25 Series of eleven capitals on the south-western pier under the tower: fom south to west, (a) one head and foliage; (b) two heads and foliage; (c) stiff-leaf foliage only; (d) two heads and foliage; (e) one head and foliage; (f) one head and foliage; (g) one head and foliage; (h) one head and foliage; (i) three heads and foliage; (j) two heads and foliage; (k) two heads and foliage.

26 Two label stops to the hood moulding of the arch under the tower (in the nave): female head (northern end) and male head (southern end).

27 One label stop to the hood moulding of the arch under the tower (in the northern transept): male head (northern end).

28 One carving on the north-eastern pier under the tower: human head.

29 Two labels stops to the arch under the tower (eastern side): female head (southern end) and male head (northern end).

30 Two label stops to the arch moulding under the tower (south-western pier): two male heads.

Exterior

Choir

31 Series of label stops on the quatrefoil windows in the southern wall: from east to west, (a) weathered beyond identification; (b) male head (western end); (c) two label stops depicting two male heads; (d) two label stops, now weathered beyond identification.

32 Three carvings presently incorporated in the southern wall: all weathered beyond identification.

33 One label stop presently incorporated in the eastern wall: male head.

Southern Transept

34 Two label stops to the hood moulding of the niche in the eastern wall: male head (southern end) and female head and smaller figure (northern end).

35 Two gargoyles in the southern wall: lower portions of angels.

36 Two labels stops to the hood moulding of the eastern window (now blocked up) in the southern wall: female head (eastern end) and male head (western end).

37 Two label stops to the hood moulding of the central window (now blocked up) in the southern wall: female head (western end) and male head (eastern end).

38 Two label stops to the hood moulding of the western window (now blocked up) in the southern wall: two grotesque male heads.

39 Two label stops to the hood moulding of the eastern niche in the southern wall of the southern transept: two male heads.

40 Two labels stops to the hood moulding of the western niche (upper example) in the southern wall: male head (eastern end) and female head and smaller figure (eastern end).

41 Two labels stops to the hood moulding of the western niche (lower example) in the southern wall: male head (eastern end) and grotesque male head (western end).

42 One capital (eastern side) to the lower niche in the southern wall: three male heads.

43 One carving in the southern wall: human figure and inscription.

44 Two labels stops to the hood moulding of the upper niche in the western wall of the southern transept: female head and smaller figure (northern end) and male head and smaller figure (southern end).

45 Two label stops to the hood moulding of the lower niche in the western wall of the southern transept: female head (northern end) and male head (southern end).

46 One label stop to the hood moulding of the group of three windows: female head.

47 One capital to the lower niche in the western wall (northern side): three heads.

Nave

48 One label stop to the northern entrance (western side): human head.

Northern Transept

49 Two label stops to the hood moulding of the western window (now blocked up) in the northern wall: male head (western end) and foliage motif (eastern end).

50 Two label stops to the hood moulding of the centre window (now blocked up) in the northern wall: triton and female figure (western end) and female head (eastern end).

51 One gargoyle on the northern wall: lower portion of an angel.

52 One label stop to the hood moulding of the northern window of the northern chapel (southern end): double head.

53 One label stop to the hood moulding of the southern window, in the southern chapel (southern end): male head.

Tower

54 One gargoyle: owl and human head.

55 One corbel: ram's head.

56 One corbel: grotesque female head.

Vicars Choral

57 One panel: two griffins.

58 One panel: elephant and griffin.

59 One panel: grotesque cat-like animal.

60 One panel: grotesque cat-like animal.

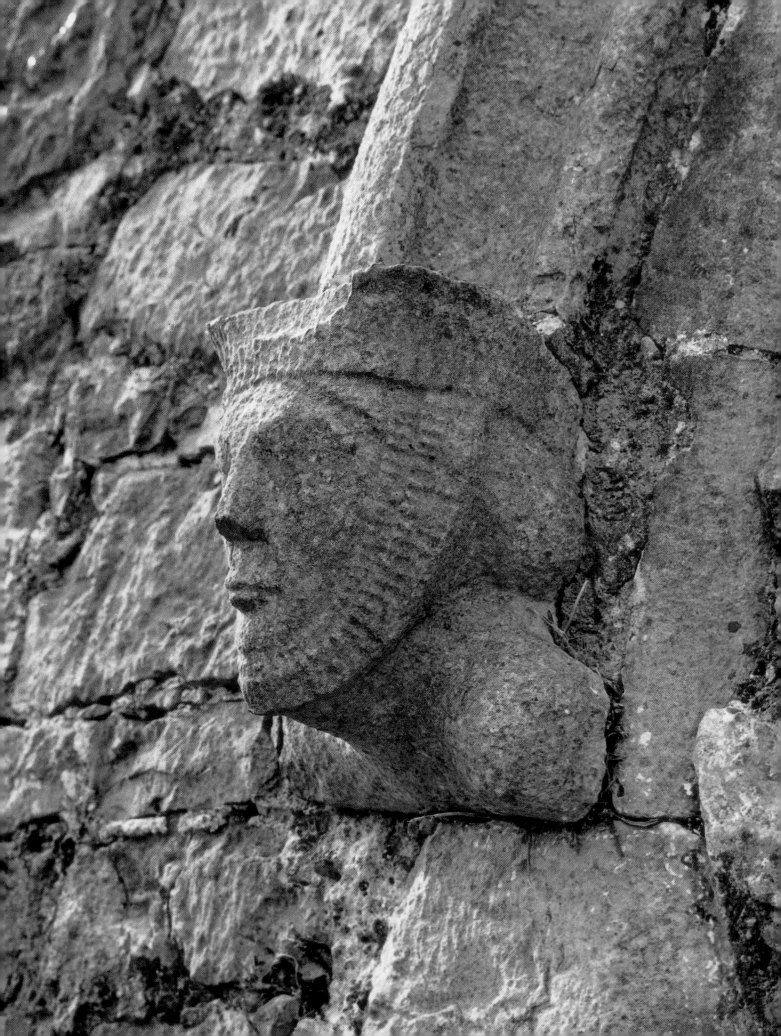

Notes

Chapter One

1 Henderson 1978, 11.
2 Stalley 1994b.
3 O'Neill 1987.
4 Apart from the study undertaken in Henry and Marsh-Micheli 1984, one of the most useful studies on the continuity of this tradition is O'Neill 1984. Other studies which deal with the tradition of later manuscripts, either in whole or in part, include O Dougan 1955; Byrne 1979; Mac Niocaill 1986; Carney 1987.
5 Martin 1995.
6 Cosgrove 1979.
7 Stalley 1994b.
8 Hourihane 2000a.
9 The most recent study on Irish guilds is Clark and Refaussé 1993. Older studies on individual guilds include Berry 1905 and Stubbs 1919.
10 Seymour 1933.
11 Ó Floinn 1987 and Hourihane 2000b.
12 Hunt 1950 and Rae 1971.
13 Hourihane 2000b, pl. XXII.
14 The most recent study on this disease in Ireland is Kelly 2001. Other works on the subject include Shrewsbury 1970 and Platte 1996.
15 See Crawford 1915.
16 Crawford 1919.
17 Wilde 1999, chap. 11, 147.
18 Gerald of Wales 1982, book III, chap. 10. This same subject has also been studied in Leerssen 1986, 33–9, and Leerssen 1995, 25–39.
19 Leersen 1995, 36.
20 Roe 1966, 108.
21 Eames and Fanning 1988, 61–78.
22 Rae 1966 and Hourihane 1984.
23 Walsh 1988. *Coarb* is an Irish word, meaning heirs or successors. It is used to refer to a distinct and structured, but always religious, group or organization. *Nationes* was the word used in medieval Ireland to refer to the two distinct cultural and national groups – the Irish (Gael) and the English (Anglo-Normans).
24 Camille 1996.

25 The most comprehensive bibliography on the theme of the Crucifixion in Irish art is that given in Harbison 1992, 273. More recent studies on this subject include Hourihane 2000b and Harbison 2000.
26 Mullally 1988.
27 Mullally 1998, 339.
28 In September 1607 the earls of Ulster (the Earl of Tyrone and the Earl of Tryconnell) left Ireland with their families to live in Spain and France. Their emigration marks the end of the struggle by the native chieftains to retain their way of life and it paved the way for the plantation of Ireland under Elizabeth I.

Chapter Two

1 Among the most recent articles on Kingsley Porter are Richardson 1993 and De Vegvar 2001.
2 Ó Ciosain 1997.
3 Among the most recent studies of these symbols of national identity are Stalley 2001 and Williams 2001.
4 MacDonagh, Mandle and Travers 1983; Leerssen 1996; McBride 1999.
5 See Canny 1987.
6 Ronan 1930; Canny 1987; Ford 1997.
7 Such a role in art history is not unique – the same approach for archaeological material in Ireland has been recently studied in Cooney 1996.
8 The various opposing views on this subject are clearly synopsized in Smith 1998.
9 Myers 1983, 131. This subject is also dealt with in Faulkiner 1904. The historical background is admirably sketched in Canny 1976.
10 Gerald of Wales 1982, pt II.
11 Myers 1983, 243–5.
12 *Holinshed* 1979.
13 Cunningham 1986.
14 Lenox-Conygham 1998.
15 De Paor 1993, 119–20.
16 An interesting study focusing on royal visitors to Ireland is Cappock 2000.
17 Hutchinson 1987.

18 See Harbison 1991 and 1998.

19 The origins of the term Gothic have been discussed in detail by several scholars including De Beer 143–62; Dynes 1973, 366–74; Cocke 1987.

20 Coffey 1910.

21 Some of the best known studies of the late eighteenth and nineteenth centuries are Tuiss 1775; Malton 1799; Holmes 1801; Carr 1806; Coyne 1803–68; Brewer 1826; Newenham 1830; Ritchie 1837; Noel 1837; Hall 1842; Willis 1842; Howard 1855.

22 Petrie 1845.

23 Apart from working on the English translation of the pioneering work by Didron on Christian Iconography (*Christian Iconography*, translated from the French by E. J. Millington, completed with additions and appendices by Margaret Stokes, 1886, Stokes worked with equal dexterity on architecture (1878) and art (1887). She was one of the pioneering influences in scientifically analyzing objects such as the book shrines, which had never before been studied as a related group. It is clear that she also had a dislike of Gothic art and architecture and saw it as an alien presence: 'Had the Irish been allowed to persevere in the elaboration of their own style, they would probably have applied this expedient to the roofing of larger buildings than they ever attempted, and might in so doing have avoided the greatest fault of Gothic architecture' (Stokes 1878, 11).

24 Foot 1887 and Phelan 1975.

25 Among the most recent studies, and particularly interesting for its previously unresearched subject matter, is Harbison 2001.

26 Stokes 1868.

27 One of the most interesting of all the illustrators, Du Noyer was born in Dublin to parents of French Huguenot origin, but appears always to have been consciously aware of the distinction of what was Irish, in the landscape, and what was not. Among his most interesting drawings is a set of illustrations of everyday life, contained in thirteen small notebooks (Royal Society of Antiquaries of Ireland, Dublin, GVDN Notebook 9) which he describes as being 'very picturesque and *very Irish*'. After his death his wife wrote to the Royal Geological Society for assistance, noting that her 'husband had always been non-sectarian and non-political in his work' (Geological Survey of Dublin MS Letter, Geological Library, Trinity College, Dublin). Herity 1993 and Croke 1995.

28 The date at which this movement is believed to have started range from the 1830s to the 1840s, and even the 1890s. The subject has been studied in Larmour 1977; Sheehy 1980; Edelstein 1992.

29 The approach to the study of Gothic objects in nineteenth-century Ireland is similar to the situation in India at the same period, see Cohn 1996.

30 Reproduced by Edmond Johnson *c*.1891–2 (reproduced in Edelstein 1992, pl. 48, cat. no. 254).

31 Bence-Jones 1973; Jones 1854; Royal Dublin Society 1853.

32 O'Neill 1857, 1.

33 Brooks 1999 and Brand 1998.

34 Davenport-Hines 1998, 315–17.

35 Cocke 1987.

36 Champneys 1910.

37 Leask 1941 and 1955–60; a full list of Leask's studies of individual sites has been compiled in Lucas 1966.

38 Power 1925, 34.

39 Armstrong 1912.

40 Such holistic approaches in archaeology are evident in Barry 1987 and O'Keeffe 2000.

41 Henry 1970, 25.

42 There is no general study of the manuscripts from this period apart from Henry and Marsh-Micheli 1984.

43 Wooden sculpture has been studied by MacLeod in a number of articles: 1945a, 1945b, 1946a and 1946b. She has also studied the medieval vestments from this period (1952). Comparatively little has been published on architectural sculpture of this period apart from the study of the funerary sculpture undertaken in Hunt 1974. In terms of medieval iconography the works of Helen Roe must also be noted. More than any other scholar it was she who pioneered the art historical approach to the study of medieval Ireland (see Ní Shúilliobháin 1988); Rynne 1987. A full biography and bibliography is given in Rynne 1987, 13–28. Roe was also one of the few scholars who unhesitatingly used the term Gothic in relation to the arts of the late medieval period in Ireland and constantly appealed for further research in the field: Roe 1966.

44 A more general study was that undertaken in De Breffny and Mott 1976. More recently, McNeill focused on castles in Ireland (1997) as did Sweetman (1999). The most recent survey on medieval settlement is O'Conor 1998.

45 It is only within the last fifteen years that any attempt has been made to analyze the architecture of this period systematically. The majority of these studies have been undertaken by Roger Stalley, who has looked not only at the development of this style but also attempted to analyze and relate it to the situation in Europe and, more significantly, to England at this time: Stalley 1994 and 1987.

46 Hunt, in association with Harbison, has been the only scholar to deal with the alabasters in studies such as Hunt and Harbison 1975 and 1976. Metalwork has been studied largely in relation to additions to early Christian shrines, apart from Hunt n.d. and, more recently, in Ó Floinn 1996 and Hourihane 2000b.

47 Brooks 1999; Barry 1987; O'Keeffe 2000.

48 Cocke 1987, 185.

49 Although Harbison 1978 used the word Gothic in relation to architecture, it is not used elsewhere in reference to the other arts. More recently O'Conor 1998, xi, refers to the period from the thirteenth to the late fourteenth centuries as 'the medieval period', without any qualifiers.

Chapter Three

1 The nature of this royal kingdom has been discussed by O'Corráin 1972, 35–6.

2 O'Corráin 1972, 34 and De Paor 1967.

3 O'Keeffe 1990.

4 *AFM*, 1101, 967. The politics of this gift have been analysed by Ó Crónín 1995, 281–2.

5 Poor organizational details, such as the consecration of many bishops for one town and their lack of powers, have been detailed in Watt 1972, 10–11.

6 These are Lismore or Waterford, Cork, Ratass, Killaloe, Emily, Limerick, Leighlin, Kildare, Glendalough, Ferns or Wexford and Kilkenny. These are listed and discussed in detail in Gwynn and Hadcock 1988, 49–50.

7 The exceptions are Annaghdown (–1189), Ardmore (1152), Cloyne (–1148), Dair-inis (1152), Derry (1254), Dromore (1192?), Dublin (Holy Trinity 1152; St Patricks 1213), Elphin (*c*.1130), Kells (1152), Kilfenora (1152), Kilmacduagh (1152), Kilmore (1152), Louth (*c*.1138), Maghera (1152), Mayo (1152), Mungret (1152), Roscommon (1152), Roscrea (1152), Roscarbery (1152), Scattery Is. (1152) and Trim (1202).

8 Gwynn and Hadcock 1988, 62.

9 Stalley 1994a, 77.

10 Stalley, 'Cashel (of the Kings)', *Grove Dictionary of Art* (http://www.groveart.com), 1999.

11 Martin 1971.

12 Martin 1971, 61.

13 Hourihane 2000a, 65–7.

14 Leask, *St Patrick's Rock Cashel* (n.d.). This pamphlet has been republished on several occasions since it first appeared in 1940, most recently with revisions to Leask's original text (Wheeler 1990). A short version of this guide, focused specifically on the cathedral, is Wheeler, n.d. A number of guide books, encompassing both fanciful and factual information, not dealing specifically with the cathedral but with Cashel as a whole, have also been published and include McCraith 1923; Gleeson 1927; St Ledger Hunt 1952; O'Donnell 1961; Finn, n.d.; The cathedral has, naturally, been mentioned in a considerable number of architectural, religious and cultural studies for the medieval period in Ireland, the most pertinent of which include Champneys 1910, 157–67; Stalley 1971, 84–7; Anderson and Hicks 1978, 147–9; Galloway 1992, 36–8.

15 Stalley 1994a, 114–19.

16 Stalley 1994a, 117.

17 Camille 1992a, 80.

18 Leask 1967, 89.

19 Leask 1967, 19.

20 Leask 1967, 90.

21 O'Keeffe 1999, 140.

22 Other examples of this use of facial lining include heads at Athassel Priory, Co. Tipperary, Ballybeg Priory, Co. Cork, Duleek Priory, Co. Meath, and Kilkenny Friary; see Hourihane 1984.

23 In this respect the sheela-na-gig presently embedded in the cathedral has been excluded from the study of this subject by Andersen 1977, 16, because he believes it to be post-medieval in date (pl. 41).

24 Illustrated in Kelly 1996, 16, pl. 19.

25 Baumann 1990, 10.

26 Among the most recent studies of this subject is Bennett 1999, which includes an extensive bibliography.

27 Harbison 1977.

28 Payne 1990, 52.

29 The literature on the Abraham–ram association is extensive and includes Wilpert 1887; Le Blant 1896; Smith 1922; Schapiro 1943; Speyart van Woerden 1961; Schapiro 1967; Williams 1977; Bagatti 1984; Gutmann 1984; Finney 1995; Raynaud 1995.

30 Camille 1992a, 77.

31 Hourihane 2000a.

32 Leask, *St Patrick's Rock*, 21.

33 Stalley 1994a, 117–18.

34 Stalley 1994a, 118.

35 Stalley 1994a, 126.

36 Rae 1966.

37 Apart from those mentioned above, other examples include those at Ballybeg Priory, Co. Cork; Kilkenny Priory; Caher Priory, Co. Tipperary; Monaincha Priory, Co. Tipperary; Kilmallock Priory, Co. Limerick; Carrickbeg Priory, Co. Waterford; Downpatrick Cathedral, Co. Down.

38 An interesting discussion on the concept of portraiture and carving from life in thirteenth-century sculpture is given in Coldstream 1983.

39 Leask, *St Patrick's Rock*, 23–4.

40 Leask 1967, 92.

41 Hourihane 2000a.

42 Bridham 1930.

43 Camille 1992, 78.

44 Camille 1992, 78.

45 Spenser 1908, *The Faerie Queene*, 2, 9, 13.

46 Dunboyne 1991.

47 Rae 1966, 82.

48 Langrishe 1906 and Rae 1966.

49 *Calendar of Documents*, 1171–1205, 3 April 1206, p. 44.

50 Lynch 1912.

51 *Calendar of Documents*, 1171–1251, 1224–38, pp. 175–369. Nothing is recorded about this important figure while his successors are frequently mentioned.

52 Watt 1972, 113.

53 Stalley 1987, 110.

54 Leask 1967, 90.

55 Leask 1967, 89.

56 Leask, *St Patrick's Rock*, 19.

57 As listed in the *Handbook of British Chronology* 1939, 249, they are Matthew O'Henry (1186–1206), Donal O Longargain (*c*.1208–1223), Marianus O'Brien (1224–37), David O'Kelly (1238–53), David MacCarwell (1254–89) and Stephen O Brohan (1290–1302).

58 Watt 1972, 114.

59 Otway-Ruthven 1968, 134.

60 *Calendar of Documents*, 1252–84, 4 April 1253, p. 26. Among the repeated references to MacCarwell's spending is the following: 'The King wishing to spare expense and labour to the church of Cashel gives power to the justiciary of Ireland to grant license to the King's name and to the Dean and Chapter of that church to elect an archbishop.'

61 In 1260 protection for one year (from Easter 1261) was granted to MacCarwell to travel to Rome, while in 1281 letters of protection were given for him to remain in England for two years by the king's licence, *Calendar of Documents*, 1252–84, 1281, p. 408, and 1260, p. 112.

62 Holmes 1801, 24, records that 'the choir and nave are strewed over with the mutilated remains of its former decorations; and tombs, weeds, rubbish, so choak up the whole'.

63 Lewis 1837, vol. 1, 284–7.

Chapter Four

1 Among the many studies on this subject are Reiche 1905; Lefevre-Pontalis 1908; Kleinschmidt 1936; Hinkle 1965; Beck 1970; Ladous 1973; McSweeney 1978; Maines 1979; Kopp 1981; Seidel 1981; Adams 1982; Stelak-Garrison 1984; Feldman 1986; Goldman 1986; Dixon 1987; Morant 1995; Schulze 1995; Glass 1997;

Kendall 1998. The two most extensive studies on the subject for the Romanesque period are McAleer 1984 and 1991; the latter includes an article by T. O'Keeffe, 'La Façade Romane en Irelande', 357–65. Doors in particular have been studied in Geddes 1990.

2 These are illustrated in Harbison 1999, 196–7.

3 O'Keeffe, in McHeer, 1991, 357–65.

4 Manning 1996.

5 Harbison 1999, 326–7.

6 McNab 1987.

7 Some well-known examples of the Last Judgement, dating from the twelfth century and found on western façades, include those at St Lazare, Autun; Notre Dame, Corbeil; Notre Dame, Laon; St Vincent, Macon; Saint-Denis, Paris; Saint-Georges-de-Camboulas; Saint-Gilles; Saint-Jouin-de-Marnes; and the Church of St James, Santiago de Compostela.

8 Jantzen 1984.

9 Stalley 1987, 63.

10 Mooney 1955, 1956, 1957; Stalley 1987; O'Keeffe 1999.

11 The social functions of medieval architecture and, in particular, religious architecture have never been systematically evaluated, but it is clear that buildings other than the church were occasionally used for public meetings and functions. McMurray Gibson 1989, 114, has speculated on the use of the abbey at Bury St Edmunds for theatrical performances. The most general study on the social and functional nature of medieval religious architecture is Braun 1971.

12 Leask 1936.

13 Stalley 1987, 245.

14 Leask 1967, 49.

15 Stalley 1994a, 118.

16 Stalley 1971, 76.

17 Leask 1967, 108.

18 Stalley 1971, 76.

19 O'Keeffe 1999, 30.

20 Stalley 1971, 129, believes that this doorway is in its original position and was there from the building of the priory, unlike O'Keeffe 1999, 129, who argues that it may originally have been the western door to the nave which was transferred to this location at a later date. This latter view may be reinforced when the present opening in the western end of the nave is compared to the size of the doorway and it will be seen that in terms of scale it would fit perfectly into such a position.

21 Hourihane 2000a.

22 Stalley 1987, 63–4.

23 Leask 1971, 83, describes this door as having a pointed arch with ogee-headed opening and flanking terminal pinnacles which was once protected by a porch.

24 This doorway is also described by Leask 1967, 75.

25 Stalley 1987, 64.

26 Stalley 1987, 63.

27 O'Keeffe 1999, 110–15.

28 Stalley 1987, 65.

29 O'Keeffe 1999, 114.

30 The capital has a series of small female heads which are radially displaced below the abacus and above a large head of an ecclesiastic. The headdress worn by the small heads was popular in England from the early fourteenth century, but is rarely depicted in Ireland before the fifteenth.

31 A number of fine fifteenth-century doorways which have no architectural sculpture have also been studied in Mooney 1955, 133–7, including, for example, those in the Franciscan houses at Askeaton, Athlone, Buttevant, Claregalway, Dromahair, Galbally, Kilconnell, Kilcrea, Kilnalahan, Lislaughtin, Moyne, Muckross, Multyfarnham, Nenagh, Quin and Waterford.

32 Egan 1946.

33 Gwynn and Hadcock 1988, 165.

34 Twemlow 1893.

35 Fanning 1976.

36 Leask 1971, 74–5.

37 Leask 1971, 75–6, describes the screen as being one bay in depth and erected between nave and chancel. It was originally three bays in width, borne by pillars of polygonal plan and three-sided responds, only one of the latter survives, engaged in the south-east angle. Portions of pillar also remain, lying loose, together with a piece of vault rib.

38 The same mason was responsible for the small male head at the springing point of the arch on the second pier (from the southern end) in the western arcade of the rood gallery at Clontuskert Priory, and for the carving of an equally small ram's head, at exactly the same springing position of an arch in the southern wall of the chancel at Clonmacnoise cathedral.

39 Leask 1971, 72. Apart from the most recent publication on this site by Manning 1998, in which a full bibliography is provided, there have been several other studies including O'Brien and Sweetman 1997, 90–91, and Fitzpatrick and O'Brien 1998, 70–74, 115–16.

40 Scarry 1998.

41 Manning 1998.

42 This motif has been studied in Newman Johnson 1987.

43 Leask 1971, 74.

44 Manning 1998, 81.

45 'The Annals of the Four Masters', written by Michael O'Clery between 1632 and 1636, is a compilation of the ancient annals of Ireland. The manuscript is scattered between various libraries. See *Annals of the Four Masters* 1851.

46 Gwynn and Hadcock 1988, 185.

47 Leask 1971, 78–9.

48 Leask 1971, 76.

49 Leask 1971, 76.

50 These have been described in detail in Leask 1971, 164.

51 The post-medieval practice of inserting carved heads over doorways has created a certain confusion in trying to disentangle their original contexts. This is the case with the southern doorway to the nave at the Priory of St Mary, Drumlane, Co. Cavan, which has a male head over the apex of the doorway that is not in its original position, see Hickey 1976, 80. The mitred head over the southern doorway to the nave in Kilfenora cathedral, Co. Galway, is also a later insert, as is the label stop on the hood moulding of the western door to the nave at Leighlin cathedral, Co. Carlow. That over the fifteenth-century western door to the nave at the Friary of St Thomas, Urlaur, Co. Mayo, appears, however, to be in its original context. The carving, which is centrally placed over the simple pointed opening, has been badly damaged and now lacks a face. Another head, possibly in its original context is the label stop (western end) to the hood moulding of the western door to the nave at Rosserk Friary, Co. Mayo.

52 Stalley 1994b.

53 Salmi 1928, fig. 23 and Aubert 1929, pl. 21.

54 Hunt 1974.

55 Among the many studies on this subject are those in Druce 1911; St John Hope 1911; George 1968; Payne 1990, 46. Animals with interlocking necks have been studied in Harbison 1974.

56 The Narmer palette from Egypt is one of the earliest examples of interlocking necks in Fairservis Jr 1991, 2–3.

57 Pairs of animals with interlocking necks, usually dragons, are frequently found in Gothic Irish art and are particularly reminiscent of Romanesque originals. Among the many examples are carvings at the Priory of St Columba, Inistioge (Manning 1976); the Priory of the Holy Cross, Cloonshanville, Co. Roscommon, and the Friary of St Mary Roscommon. They appear in metalwork on the Clogán Óir (Dublin, National Museum of Ireland, 1919:1), which has been studied in Westropp 1915; Ó Floinn 1983d; Armstrong and Lawlor 1919.

58 The misericord from the cathedral church of St Mary, Limerick, has been studied in Westropp 1892 and Harbison 1971.

59 Ó Floinn 2001.

60 The griffin has been extensively studied in Leibovitch 1955; Robinson 1961, no. 44; Du Mesnil du Buisson 1963, 16; Bisi 1965; Enaud 1968, 30; Armour 1995. This subject is also found on the fourteenth-century Fiacail Padraigh, where two griffins face each other.

61 An orant figure is shown between the two griffins on this small bronze clasp now in the museum at Lausanne (Bouffard 1945, pl. XVII (1)).

62 The style of this example, which dates from the twelfth century, is particularly close to the two dragons with interlocking necks on the Clogan Oir Bell Shrine (National Museum of Ireland, Dublin, 1759 / 1919:1). The enamel vessel is presently in the Treasury of the Abbey of Saint-Maurice d'Agaune (Aubert 1872, pl. XIX–XX).

63 It is found, for example, at the Church of St-Julien, Brioude, the Church of St-Laurent, Auzon, and Saint-Myon, as well as at Ennezat, Volvic and Glaine-Montaugut, all of which date from the twelfth century.

64 Swiechowski 1973, fig. 275.

65 Scholle 1923, 9–10.

66 This relief is believed to come originally from Sorrento cathedral, but is now in the Museo Correale, Sorrento, and has been dated to the ninth or tenth century (Quintavalle 1931, fig. 2, 163).

67 This marble relief is believed to have come from Salerno, but is now at Dumbarton Oaks, Washington, DC (Inv. 36.19); it shows a vase with two confronted griffins (Vikan 1995, pl. 35A).

68 Among the many studies on this subject are those in Benwell and Wauch 1961; Vieillard-Troïekouroff 1969, 61; Murray 1973, 140–41; King 1995; Gaignebet and Lajoux 1985, 148–9; Hassig 1995, 104–15; Hassig 1999.

69 Stalley 1987, 195.

70 The Index of Christian Art, Princeton University, for example, records several fourteenth-century examples which are usually found in choir stalls (Adderbury church, Oxon, exterior; Exeter cathedral, choir stalls; Gloucester cathedral, choir stalls; Hanwell church, exterior; Lincoln cathedral, choir stalls; Wells cathedral, choir stalls). This motif to my knowledge is never found on a portal in England, the exception being the twelfth-century example on the tympanum at the Church of St Botolph at Long Stow, Cambridgeshire).

71 Hourihane 1984. The representations come from Kilcooly Abbey, Co. Tipperary; the Priory of St Mary, Clontuskert, Co. Galway; the Priory of St Columba, Inistioge, Co. Kilkenny; Cashel cathedral, Co. Tipperary; Clonfert cathedral, Co. Galway. The only example in a claustral context is at Inistioge Priory.

72 Hassig 1995, 109–12.

73 Illustrated in Hunt 1974, cat. no. 251d, pl. 335.

74 Illustrated in Hunt 1974, cat. no. 5b1, pl. 236.

75 Illustrated in Hunt 1974, cat. no. 63, pl. 261, and cat. no. 67 a–b, pl. 257. These tombs have the characteristic pilasters, foliate crockets and panels similar to the portal at Clontuskert and also employ the same saintly iconography.

76 This subject has been studied in Roe 1976. Hunt 1974, 256, also lists eight different examples of the motif, two of which are similar in composition to the Clontuskert panel.

77 Manning 1998, 81.

78 Gwynn and Hadock 1988, 64.

79 This form of crozier is also found at Jerpoint Abbey, Co. Kilkenny, and discussed in France 1998, 104–5.

80 Stalley 1987, 195.

81 Hourihane 2000b, 28–9.

82 The most comprehensive studies on this saint are Richter 1896; Stahl 1920; Whaite 1929; Hahn-Woernle 1972; Benker 1975; Salmon 1936, 76–115.

83 The censer is similar to many of those illustrated in Tonnochy 1937.

84 Based on the New Testament, John 15:1–6, where Christ says of himself 'I am the true vine, and my father is the vinegrower'.

Chapter Five

1 Listed in Haworth 1987.

2 See Pliny the Elder 1942, 10:66, 377.

3 See Aelian 1958, III:20, 179.

4 Horapollo 1950, 81.

5 Horapollo 1950, 1:54, 81. Cf. Artemidorus 1965, 2:20; *Artemidori Daldiani Onirocriticon Libri V* (ed. R. Hercher) (1864), 114.

6 Wellman 1930, 50.

7 Horapollo 1950, 1:11, 64–5.

8 Robin 1932, 65; Sbordone 1936, xii–xiii.

9 Robin 1932, 65.

10 Sbordone 1936.

11 Psalm 102:7; *Physiologus* 1979, ix.

12 *Physiologus* 1979, 9–10.

13 Vincent of Beauvais 1481, 127.

14 Migne 1959, 41–3.

15 Guillaume le Clerc 1936, 612.

16 Schiller 1972, 136.

17 Hall 1974, 238.

18 Randall 1966, 197.

19 Anderson 1956, 15.

20 Cave 1948, 73.

21 Gerhardt 1979.

22 Hunt c.1946, 5; Ó Floinn 1996, 37.

23 Hunt c.1946, 17–18.

24 Bàràny-Oberschall 1958.

25 Rossi 1906, 23, fig. 4; Bunt 1926, 124.

26 Cologne, cathedral treasury: Witte 1932, vol. III, pl. 130; Gauthier 1972, 251, fig. 200.

27 Haarlem, cathedral: Vermeulen 1913, 125, fig. 3; Gauthier 1972, 273, fig. 226.

28 An illustration and full bibliography are published in Alexander and Binski 1987, 471–3.

29 Hourihane 2000b.

30 Ó Floinn 1983c, 181.

31 Ó Floinn 1983c, 181.

32 Baltimore, Walters Art Gallery, processional cross, inv. 44.120; Ross 1938, figs 1, 2. Cleveland, Museum of Art, altar cross, inv. 42.1091–93; Milliken 1943, fig. p. 332. New York, Metropolitan Museum of Art, processional cross, inv. 36.134; Harris 1937, fig. p. 95.

33 Derbes 1996.

34 *Irish Monastic and Episcopal Deeds* 1936, 23–4.

35 On both of these points, see Stalley 1987, 115.

36 Stalley 1987, 115.

37 Stalley 1987, 117.

38 Stalley 1987, 117.

39 Hourihane 2000a.

40 Stalley 1987, 194.

41 Healey 1890.

42 Gwynn and Hadcock 1998, 230.

43 Leask 1971, 74.

44 Hunt 1971.

45 Crawford 1909, 129.

46 Roe 1968, 17.

47 Roe 1968, 17.

48 McGarry 1980.

49 Hourihane 2000a.

50 Westropp 1911.

51 Stalley 1987, 216.

52 Westropp 1911, 34–5.

53 Westropp 1911, 35.

54 Westropp 1892, 73.

55 Klingender 1971, 433.

56 Pitcher 1932, 13–14, pl. 41.

57 Cave 1948, 73, cat. no. 257.

58 Millar 1958, 35, pl. 58.

59 Zimmermann 1930–31, 30–32.

60 *Libellus de Natura Animalium* 1958.

61 Kroos 1970, 98, 116–17.

62 Beye 1967.

63 Klingender 1971, 433.

Chapter Six

1 Henry and Marsh-Micheli 1984.

2 Lucas 1986.

3 A number of recent studies by Ó Floinn have added enormously to our understanding of the metalworking tradition in the later Middle Ages: Ó Floinn 1994 and 1996, 35–44.

4 Ó Floinn 2001, 289–312.

5 Armstrong 1912, 1913 and 1915; Ó Floinn 2001, 289–312.

6 Largely unknown and neglected, it is only within the last twenty or so years that the jewellery of the later medieval period in Ireland has been studied. Among the first articles was Cherry 1988. More recently the ring brooches have been studied in Deevey 1998.

7 Hourihane 2000b.

8 Among the first studies on these objects to recognize them as a distinct and cohesive group was that undertaken in Wakeman 1848, 161–4. His work was further extended in Stokes 1887, 72–9.

9 This is an unpublished Ph.D thesis, Mullarkey 2000, which also looks at the iconography of these objects but excludes the Domhnach Airgid from the survey.

10 Sttenbock 1965.

11 Illustrated in De Winter 1985, 118–21.

12 Lucas 1973, 127.

13 Lucas 1973, 66.

14 This shrine, which was found in a dismantled state, held a large manuscript and is discussed in Ó Floinn 1994, 36–7.

15 This shrine came originally from Devenish Island, Co. Fermanagh, where it was held in the care of the O'Meehan family, hereditary custodians of the shrine; it can be dated to several periods ranging from the eighth to the fifteenth century. See Ó Floinn 1983a; Mullarkey 2000, 78–154.

16 The inscription under the large rock crystal on the main face of this shrine dates the object to 1402 and gives the patron as Art Mac Murrough, King of Leinster. The shrine is illustrated in Ó Floinn 1994, 37.

17 The most recent attempt to rename both the shrine and missal was made in O'Riain 1991.

18 Among the references to this object are Warner 1906 and 1915.

19 Translation after Ó Floinn 1983a, 165.

20 Mullarkey 2000, 185–6.

21 The manuscript (Royal Irish Academy, Dublin, D. 11.3) contained, apart from the missal, parts of the Gospel of St John, a tract on the Mass and some miscellaneous texts. See Alexander 1978, 68–70.

22 Referred to by this name in Raftery 1941, 50.

23 The main references for this shrine are Crawford 1923, 152–3; Raftery 1941, 155; Lucas 1986, 17–18; Lucas 1973, 18. The most recent study on the shrine is Ó Floinn 1997, 153. The shrine has also been included in Bannerman 1993, which is one of the most useful analyses of the use of the shrine in the early Christian period. The iconography has been studied in Mullarkey 2000, 235–44.

24 Hennessy and Kelly 1875, 167.

25 O'Kelleher and Schoepperle 1918, 182–3.

26 *Annals of the Four Masters* 1851, 1497, 1499, 1657.

27 Ó Floinn 1995, 124.

28 Gwynn and Hadcock 1970, 147.

29 Probably the best known examples of naturalistic foliage in Gothic Irish art are those from the Cistercian abbey at Corcomroe, Co. Clare (Stalley 1994c and 1994, 297–316), which date from the thirteenth century. Later examples, showing oak leaves and acorns, are also found at the Priory of St Mary, Caher, Co. Tipperary.

30 Among the reliquaries which have Christ in majesty as a prominent theme are those in the Petrikirche, Fritzlar (Van Falke and Frauenberger 1904, pl. 108); the reliquary in the Church of Isidoro, León (Barcelona 1961, no. 1716, pl. LXXXV); Church of St Matthias, Trier (Schnitzler 1959, pl. 10; the Reliquary of St Andrew, Soeurs de Notre Dame, Namur (Courtoy and Schmitz 1932, pl. IX; foot reliquary in Museum Statens Historiska, Stockholm (Goldschmidt 1919, fig. 6).

31 Mullarkey 2000, 240–41.

32 Lawlor 1916, 395; Mullarkey 2000, 215–91.

33 Ó Floinn 1995, 143.

34 Hourihane 2000b.

35 Among the most convincing attempts to disentangle the dating sequence of this shrine is that undertaken in Mullarkey 2000, 325–7, who has also identified the same die for one of the figures on this cross as also being used on the Cross of Clogher.

36 The main references for this shrine include Todd 1850; Armstrong and Lawlor 1922; Raftery 1941, 153; Ó Floinn 1995, 126–31; Ó Floinn 1997, 154; Mullarkey 2000, 292–342.

37 Ó Floinn 1995, 126–31.

38 Todd 1850, 464.

39 Raftery 1941, 164.

40 Mullarkey 2000, 302.

41 Armstrong and Lawlor 1922, 106.

42 Hourihane 2000b, 36–7.

43 Ó Floinn 1982, 25–39.

44 Crawford 1923, 155; Raftery 1941, 163; Stalley 1977, 216; Ó Floinn 1983a, 173; Ó Floinn 1982, 33–8.

45 Raftery 1941, 163.

46 Stalley 1977, 216.

47 Ó Floinn 1982, 28.

48 Ó Floinn 1983a, 83.

49 Stalley 1977, 126; Ó Floinn 1983a, 173

50 Ó Floinn 1982, 37.

51 For example, the Crucifixion is the main motif on the following reliquaries: Book cover (380) in the National Museum, Copenhagen (Goldschmidt 1923, pl. XLVI); pyxis in St Kunibert Treasury, Cologne (Ritz 1960, 373); St Barnabas Reliquary in the Convent of Soeurs de Notre Dame, Namur (Courtoy 1951–2, 226); Reliquary of St Nicholas of Myra in the Convent of Soeurs de Nortre Dame, Namur (Courtoy 1951–2, 160); reliquary in the Church of San Antonio, Padua; book cover in the Cathedral Treasury, Prague (Podlaha, and Sittler 1903, 28); reliquary in the Church Treasury, Quedlinburg (Meier 1932?); reliquary in the Church of Santa Maria in Campitelli, Rome (Valente 1937–8, 261; book reliquary in the Palazzo Venezia, Rome; reliquary in the Convent of Nonnberg, Salzburg (Trietz 1911, pl. XVI; reliquary of Henry II in the San Marco Treasury, Venice (Bloch and Hoster 1965); reliquary in the Kunsthistorisches Museum, Vienna (Pasini 1886, illus. opposite p. C4).

52 The manuscript is now in the library of Trinity College, Dublin (59 / A.4.23).

53 Ó Floinn 1982, 37.

54 Murphy 1888–91 and Murphy 1892.

55 Murphy 1892, 152.

56 Murphy 1892, 444.

57 Raftery 1941, 164. Both Paul Mullarkey and Raighnall Ó Floinn have examined the shrine recently and have concluded that the date is 1536.

58 Hourihane 2000b, 36–7.

59 The three saints are also found on a crusader panel painting in Mount Sinai Monastery which has been dated to the twelfth or thirteenth centuries (Weitzmann 1966, fig. 8).

60 Hunt 1974 has no representations of either Saints Martin or Stephen and only four of St Lawrence in Irish funerary sculpture of the later medieval period.

61 Crawford 1923, 155.

62 Crawford 1923, 155; Stalley 1977, 216–17.

63 Ó Floinn 1983a, 176.

64 Crawford 1923, 155; Ó Floinn 1983a, 176.

65 Ó Floinn 1983a, 177.

66 Bradley 1987; MacLeod 1987.

67 Roe 1976, 255.

68 Roe 1976, 255.

69 Gwynn and Hadcock 1970, 164.

70 O'Reilly 1997, 85.

71 Ó Floinn 1997, 140–43.

72 Ó Floinn 1997, 142.

73 Ó Floinn 1997, 150.

74 Hourihane 2000b.

75 Mâle 1986.

76 O'Reilly 1997, 102.

77 Ó Floinn 1983a, 177.

78 McKenna 1901.

79 Van Os 1999, 8.

Chapter Seven

1 Cosgrove 1979.

2 Sheehy 1980 and Camille 1992.

3 The most comprehensive study on medieval art in Scotland is the catalogue that accompanies an exhibition organized by the National Museum of Scotland, *Angels, Nobles and Unicorns: Art and Patronage in Medieval Scotland* (1982). The architecture of the late medieval period has been studied in Dilworth 1995. Stalley's study on the relationship of Scotland to Ireland is also of considerable interest (1994d), 108–17.

4 Stalley 1994c.

5 Stalley 1994 and Hourihane 2000a.

6 Sheehy 1980, 7.

7 Byrne 1979, 18.

8 Lydon 1995, 154.

9 In a recent manuscript study which focused on the Sadleir Hours in Trinity College, Dublin, the issue of provenance and how well known such continental manuscripts were in medieval Ireland is briefly raised. Osborne 1999.

10 It is virtually impossible to generalize as regards the iconography or execution of many of the later medieval manuscripts and to say that they fall clearly into a native or imported tradition. An example which is more typical of the native style is the Book of Ballymote (Dublin, Royal Irish Academy, MS 23 P 12), which was written sometime around 1391 (*The Book of Ballymote*, 1887). Although the many interlace initials (such as those on pp. 131, 151, 275), some of which are based on abstracted human or animal designs, attempt to continue the Hiberno-Saxon tradition from the pre-invasion period, albeit in a debased form, there are also discrete borrowings from a noticeably foreign style. The large-scale representation of Noah and his family in the Ark (p. 2) attempts to integrate elements from a native repertoire, such as the bird and the geometric designs on the boat, but it is not wholly successful in avoiding what are clearly Anglo-Norman elements as well. These include the veils worn by the female figures, the mens' beards and the modelling of the facial features, which are close to Gothic Irish architectural carvings.

11 Stalley 1994b.

12 Rae 1987, 763.

13 Hourihane 2000a. Remarkably close parallels for some of the more complex and less frequently found interlace designs used

as masons, marks are found on twelfth-century trial pieces (O'Meadhra 1979).

14 One of the first studies on this subject was that undertaken in Leask 1941. Current research and an extensive bibliography on the subject is included in Barry 1987, 186–90; McNeill 1997 and Newman Johnson 1991.

15 Rae 1987, 709.

16 Newman Johnson 1997, 190.

17 Barry 1987, 186.

18 An extensive bibliography for this object is given in Ó Floinn 1983b, 178–9.

19 The need for such research was first mentioned in Mahr 1941, 59–60. Previous research on this subject was undertaken in Buckley 1915.

20 The entire corpus of harps has been studied in Armstrong 1904.

21 Lucas 1986 and Ó Floinn 1994, 11–14.

22 Ó Floinn 1987, 168–88.

23 Hourihane 2000b.

24 Representations of the crucified Christ have a long and in some cases unique history in Irish art. Whereas the subject has also been extensively studied for the early Christian period, no previous research on the Gothic examples has been undertaken. A comprehensive bibliography on the Crucifixion in Irish art is given in Harbison 1992, 273–86.

25 Ó Floinn 1983b, 181.

26 Henry was one of the first scholars to propose a late eleventh-century, metalwork, Iberian origin for this form, (Henry 1970, 113. Rhenish and Danish origins have also been suggested (Kendrick and Senior 1937). McNab has discussed close parallels in Ottonian metalwork (McNab 1997 and 1987–8). In a more recent paper she has proposed an even older origin for these forms (McNab 2001); Ó Floinn 1997, 271–4.

27 Ó Floinn 1987, 180–83.

28 Ó Floinn 1987.

29 Leerssen 1995, 35.

Bibliography

Abbreviations

JGAHS *Journal of the Galway Archaeological and Historical Society*
JRSAI *Journal of the Royal Society of Antiquaries of Ireland*
PRIA *Proceedings of the Royal Irish Academy*

Adams, R. J., *The Eastern Portal of the North Transept at Chartres: 'Christocentric rather than Mariological'* (Frankfurt am Main, 1982).

Aelian, *'On the Characteristics of Animals'* trans. A. F. Scholfield (London, 1958).

Alexander, J., *A Survey of Manuscripts Illustrated in the British Isles*, vol. I, *Insular Manuscripts. Sixth to the Ninth Century* (London, 1978).

Alexander, J., and Binski, P. (eds), *Age of Chivalry: Art in Plantagenet England, 1200–1400* (London, 1987).

Andersen, J., *The Witch on the Wall: Medieval Erotic Sculpture in the British Isles* (London, 1977).

Anderson, M. D., *Misericords: Medieval Life in English Wood Carving* (London, 1956).

Anderson, W., and Hicks, C., *Cathedrals in Britain and Ireland From the Early Times to the Reign of Henry VIII* (London, 1978).

Annals of the Four Masters, ed. John O Donovan (Dublin, 1851).

Armour, P., 'Griffins', in *Mythical Beasts*, ed. J. Cherry (London, 1995), 72–103.

Armstrong, E. C. R., *Irish Seals-Matrices and Seals* (Dublin, 1912).

Armstrong, E. C. R., 'Some Matrices of Irish Seals', *PRIA* 30 (1913), 451–76.

Armstrong, E. C. R., 'Descriptions of Some Irish Seals', *JRSAI* 45 (1915), 143–8.

Armstrong, E. C. R., and Lawlor, H. J., 'The Bell Shrine of St Senan known as the Clogán Óir', *JRSAI* 49 (1919), 132–5.

Armstrong, E. C. R., and Lawlor, H. J., 'The Reliquary Known as the Misach', *JRSAI* 52 (1922), 105–12.

Armstrong, R. B., *The Irish and Highland Harps* (Edinburgh, 1904).

Artemidorus Daldianus, *Onirocriticon*, trans. F. S. Krauss and M. Kaiser (Basel, 1965).

Aubert, E., *Trésor de l'Abbaye de Saint Maurice d'Agaune* (Paris, 1872).

Aubert, M., *L'Art français a l'époque romane: Architecture et sculpture*, vol. I, *Ile-de-France, Champagne, Alsace, Normandie, Vallée de La Loire* (Paris, 1929).

Bagatti, B., 'Posizione dell'ariete', *Liber Annuus* 34 (1984), 283–98.

Bannerman, J., 'Comarba Coluim Chille and the Relics of Columba', *Innes Review* (Spring, 1993), 14–47.

Bàràny-Oberschall, M., 'Baculus Pastoralis: Keltisch-irische Motive auf mittelalterlichen beeingeschnitzteBischofsstäben', *Zeitschrift des Deutschen Verein für Kunstwissenschaft* 12 (1958), 30.

Barcelona, *L'Art Románico: Exposición organizada por el gobierno Espagñol bajo los auspicios del Consejo de Europa*, exh. cat. (Barcelona, 1961).

Barry, T. B., *The Archaeology of Medieval Ireland* (London, 1987).

Baumann, P., 'Deadliest Sin: Warnings Against Avarice and Usury on Romanesque Capitals in Auvergne', *Church History* 59 (1990), 7–18.

Beck, J. H., *Jacopo della Quercia e il portale di San Petronio a Bologna: Richerche storiche, documentatie e iconografiche* (Bologna, 1970).

Bence-Jones, M., 'Ireland's Great Exhibition', *Country Life* 153 (15 March 1973), 666–8.

Benker, G., *Christophorus, Patron der Schiffer Fuhrlente und Kraftfahrer* (Munich, 1975).

Bennett, A., 'A Woman's Power of Prayer', in *Image and Belief: Studies in Celebration of the Eightieth Anniversary of the Index of Christian Art*, ed. C. Hourihane (Princeton, 1999), 89–108.

Benwell, G., and Waugh, A., *Sea Enchantress: The Tale of the Mermaid and her Kin* (London, 1961).

Berry, H. F., 'The Dublin Guild of Carpenters, Millers, Masons and Heliers in the Sixteenth Century', *JRSAI* 15, 1905, 321–37.

Beye, P., 'Ein Unbekanntes Florentiner Kruzifix aus der Zeit um 1330–1340', *Pantheon* 25 (1967), 5–11.

Bisi, A. M., *Il Grifone: Storia di un motivo iconografico nell' antico Oriente Mediterraneo* (Rome, 1965).

Bloch, P., and Hoster, J., 'Miscellenea pro Arte: Hermann Schnitzler zur Vollendung des 60. Lebensjahres am 13. Januar 1965', *Schriften des Pro Arte Medii Aevi – Freunde des Schnütgen-Museums* I (1965).

The Book of Ballymote, introduction by Atkinson, R. (Dublin, 1887).

Bouffard, P., *Nécropoles bourgondes de la Suisse: Les garnitures de ceinture* (Geneva, 1945).

Bradley, J., 'The Ballyhale Madonna and its Iconography', in *Figures from the Past: Studies on Figurative Art in Christian Ireland in Honour of Helen M. Roe*, ed. E. Rynne (Dún Laoighaire, 1987), 258–77.

Brand, V. (ed.), *The Study of the Past in the Victorian Age* (Oxford, 1998).

Braun, H., *English Abbeys* (London, 1971).

Brewer, J. N., *The Beauties of Ireland, Being Original Delineations, Topographical, Historical, and Biographical of Each County*, 2 vols (London, 1825–6).

Bridham, L., *Gargoyles, Chimères and the Grotesque in French Gothic Sculpture* (New York, 1930).

Brooks, C., *The Gothic Revival* (London, 1999).

Buckley, J. J., 'Some Early Ornamented Leatherwork', *JRSAI* 45 (1915), 300–9.

Bunt, C., *The Goldsmiths of Italy: Some Account of Their Guilds, Statutes, and Work* (London, 1926).

Byrne, F. J., *A Thousand Years of Irish Script: Catalogue of an Exhibition of Irish Manuscripts in Oxford Libraries* (Oxford, 1979).

Calendar of Documents Relating to Ireland, Preserved in Her Majesty's Public Record Office (London, 1875–86).

Camille, M., *Images on the Edge: The Margins of Medieval Art* (London, 1992). [1992a]

Camille, M., 'Domesticating the Dragon: The Rediscovery, Reproduction and Re-invention of Early Irish Metalwork', in *Imagining an Irish Past: The Celtic Revival, 1840–1940*, ed. T. J. Edelstein (Chicago, 1992), 1–22. [1992b]

Camille, M., *Gothic Art: Visions and Revelations of the Medieval World* (London, 1996).

Canny, N., *The Elizabethan Conquest of Ireland: A Pattern Established, 1565–76* (New York, 1976).

Canny, N., *From Reformation to Restoration: Ireland 1534–1660* (Dublin, 1987). [1987a]

Canny, N., 'Identity Formation in Ireland: The Emergence of the Anglo-Irish', in *Colonial Identity in the Atlantic World, 1500–1800*, eds Nicholas Canny and Anthony Pagden (Princeton, 1987), 159–89. [1987b]

Cappock, M., 'Pagentry or Propaganda? The *Illustrated London News* and Royal Visitors in Ireland', *Irish Arts Review Yearbook* 16 (2000), 86–93.

Carney, J., 'Literature in Irish, 1169–1534', in *A New History of Ireland*, vol. II, ed. A. Cosgrove (Oxford, 1987), 687–736.

Carr, J., *The Stranger in Ireland or a Tour in the Southern and Western Parts of that Country in the year 1805* (London, 1806).

Cave, C. J. P., *Roof Bosses in Medieval Churches* (Cambridge, 1948).

Champneys, A. C., *Irish Ecclesiastical Architecture with Some Notices of Similar or Related Works in England, Scotland and Elsewhere* (Dublin, 1910).

Cherry, J., 'Medieval Jewellery from Ireland: A Preliminary Survey', in *Keimilia: Studies in Medieval Architecture and History in Memory of Tom Delaney*, eds G. Mac Niocaill and P. Wallace (Galway, 1988), 143–61.

Clark, M., and Refaussé, R., *Directory of Historic Dublin Guilds* (Dublin, 1993).

Cocke, T., 'The Wheel of Fortune: The Appreciation of Gothic Since the Middle Ages', in *Age of Chivalry: Art in Plantagenet England, 1200–1400*, eds J. Alexander and P. Binski (London, 1987), 183–91.

Coffey, G., *Royal Irish Academy Collection: Guide to the Celtic Antiquities of the Christian Period Preserved in the National Museum, Dublin* (Dublin, 1910), 94–8.

Cohn, B., *Colonialism and Its Forms of Knowledge: The British in India* (Princeton, 1996).

Coldstream, N., 'Fourteenth-Century Corbel Heads in the Bishop's House, Ely', in *Studies in Medieval Sculpture*, ed. F. H. Thompson (London, 1983), 165–76.

Cooney, G., 'Building the Future on the Past: Archaeology and the Construction of National Identity in Ireland', in *Nationalism and Archaeology in Europe*, eds M. Díaz-Andreu and T. Champion (London, 1996), 146–63.

Cosgrove, A., 'Hiberniores ipsis Hibernis', in *Studies in Irish History Presented to R. Dudley Edwards*, eds A. Cosgrove and D. McCartney (Dublin, 1979), 1–14.

Courtoy, F., 'Le Trésor du Prieuré D'Oignies aux Soeurs de Notre-Dame à Namur et l'Oeuvre du Frère Hugo', *Bulletin de la Commission Royale des Monuments et des Sites* III (1951–2), 226.

Courtoy, F., and Schmitz, J., *Mémorial de l'exposition des trésors d'art* (Namur, 1932).

Coyne, J. S., *The Scenery and Antiquities of Ireland, Illustrated in one hundred and twenty engravings from drawings by W. H. Bartlett*, 2 vols (London, 1803–68).

Crawford, H. S., 'Notes on the Crosses and Carved Doorways at Lorrha, in North Tipperary', *JRSAI* 39 (1909), 127–31.

Crawford, H. S., 'The Mural Paintings in Holycross Abbey', *JRSAI* 45 (1915), 149–51.

Crawford, H. S., 'The Mural Paintings and Inscriptions at Knockmoy Abbey', *JRSAI* 69 (1919), 25–34.

Crawford, H. S., 'A Descriptive List of Irish Shrines and Reliquaries', *JRSAI* 53 (1923), 74–93.

Croke, F. (ed.), *George Victor Du Noyer, 1817–1869: Hidden Landscapes* (Dublin, 1995).

Cunningham, B., 'Seventeenth-Century Interpretations of the Past: The Case of Geoffrey Keating', *Irish Historical Studies* 25 (1986), 116–28.

Davenport-Hines, R., *Gothic: Four Hundred Years of Excess, Horror, Evil and Ruin* (London, 1998).

De Beer, E., 'Gothic, Origin and Diffusion of the Term: The Idea of Style in Architecture', *Journal of the Warburg and Courtauld Institutes* XI (1948), 143–62.

De Breffny, B., and Mott, G., *The Churches and Abbeys of Ireland* (London, 1976).

Deevey, M., *Medieval Ring Brooches in Ireland: A Study of Jewellery, Dress and Society* (Bray, 1998).

De Paor, L., 'Cormac's Chapel: The Beginnings of Irish Romanesque', in *North Munster Studies*, ed. E. Rynne (Limerick, 1967), 133–45.

De Paor, M., 'Irish Antiquarian Artists', in *Visualising Ireland, National Identity and the Pictorial Tradition*, ed. A. M. Dalsimer (Boston, 1993), 119–32.

Derbes, A., *Picturing the Passion in Late Medieval Italy: Narrative Painting, Franciscan Ideologies, and the Levant* (New York, 1996).

De Vegvar, C. Neuman, 'In the Shadow of the Sidhe: Arthur Kingsley Porter's Vision of Exotic Ireland', *Irish Arts Review Yearbook* 17 (2001), 49–61.

De Winter, P. M., *The Sacred Treasury of the Guelphs* (Cleveland, 1985).

Dilworth, M., *Scottish Monasteries in the Late Middle Ages* (Edinburgh, 1995).

Dixon, S. R., 'The Power of the Gate: The Sculptured Portal of St Pierre, Moissac' (Ph.D thesis, Cornell University, 1987).

Druce, G., 'Notes on the History of the Heraldic Jall or Yale', *Archaeological Journal* 68 (1911), 173–99.

Du Mesnil du Buisson, M. R., 'Le dieu-griffon à Palmyre et chez Hittites', *Ethnographie* 57 (1963), 16–22.

Dunboyne, Lord, *Butler Family History* (Kilkenny, 1991).

Dynes, W. R., *Concept of Gothic* (New York, 1973).

Eames, E. S., and Fanning, T., *Irish Medieval Tiles* (Dublin, 1988).

Edelstein, T. J. (ed.), *Imagining an Irish Past: The Celtic Revival, 1840–1940* (Chicago, 1992).

Egan, P. K., 'The Augustinian Priory of St Mary, Clontuskert o Many', *JGAHS* 22, nos 1 and 2 (1946), 1–14.

Enaud, F., 'Peintures murales découvertes dans une dépendence de la cathedrale du Puy-en-Velay: Problémes d'interprétation', *Les Monuments historique de la France* 14, no. 4 (1968), 30–76.

Fairservis, W. Jr, 'A Revised View of the Na'rmr Palette', *Journal of the American Research Center in Egypt* 28 (1991), 1–20.

Fanning, T., 'Excavations at Clontuskert Priory, Co. Galway', *PRIA* 76 (1976), 97–169.

Faulkiner, L., *Illustrations of Irish History and Topography, Mainly of the Seventeenth Century* (London, 1904).

Feldman, J. S., 'The Narthex Portal of Vezelay: Art and Monastic Self-Image' (Ph.D thesis, University of Texas at Austin, 1986).

Finn, A., *Illustrated Guide to Rock and Ruins of Cashel* (Clonmel, nd).

Finney, C., 'Abraham and Isaac Iconography on Late Antique Amulets and Seals', *Jahrbuch für Antike und Christentum* 38 (1995), 140–66.

Fitzpatrick, E., and O'Brien, C., *The Medieval Churches of County Offaly* (Dublin, 1998).

Foot, A. W., 'In Piam Memoriam, James Graves', *JRSAI* 8 (1887), 8–23.

Ford, A., *The Protestant Reformation in Ireland, 1590–1641* (Dublin, 1997).

France, J., *The Cistercian in Medieval Art* (Stroud, Glos, 1998).

Gaignebet, C., and Lajoux, J. D., *Art profane et religions populaire au Moyen Age* (Paris, 1985).

Galloway, P., *The Cathedrals of Ireland* (Belfast, 1992).

Gauthier, M., *Emaux du Moyen Age occidental* (Fribourg, 1972).

Geddes, J., *Wooden Doors Decorated with Iron in the Middle Ages Porte de bronzo dall' antichita al secolo XIII* (Rome, 1990).

George, W., 'Yale', *Journal of the Warburg and Courtauld Institutes* 31 (1968), 423–8.

Gerald of Wales, *The History and Topography of Ireland*, trans. and intro. by J. J. O'Meara (London, 1982).

Gerhardt, C., *Die Metamorphosen des Pelikans* (Frankfurt, 1979).

Glass, D., *Portals, Pilgrimage and Crusade in Western Tuscany* (Princeton, 1997).

Gleeson, J., *Cashel of the Kings: A History of the Ancient Capital of Munster From the Date of its Foundation Until the Present Day, Including Historical Notices of the Kings of Cashel from the Fourth to the Twelfth Century* (Dublin, 1927).

Goldman, B., *The Sacred Portal: A Primary Symbol in Ancient Judaic Art* (Lanham, Md., 1986).

Goldschmidt, A., 'Ein Mittelalterisches Reliquiar des Stockholmer Museums', *Jahrbuch der Königlich Preussischen Kunstsammlungen* XL (Berlin, 1919), 1–16.

Goldschmidt, A., *Die Elfenbeinskulpturen*, vol. 3 (Berlin, 1923).

Grose, F., *The Antiquities of Ireland*, 2 vols (London, 1791–5).

Guillaume Le Clerc, *The Bestiary of Guillaume Le Clerc*, trans. G. C. Druce (Ashford, 1936).

Gutmann, J., 'The Sacrifice of Isaac: Variations on a Theme in Early Jewish and Christian Art', in *Thiasos ton Mouson: Studien zu Antike und Christentum, Feschrift für Josef Fink zum 70 Geburstag*, ed. D. Ahrens (Cologne, 1984), 115–22.

Gwynn, A., and Hadcock, N., *Medieval Religious Houses in Ireland* (Dublin, 1988).

Hahn-Woernle, B., '*Christophorus in der Schweiz: Seine Verehrung in Bildichen und Kultbischen Zeugnissen* (Basel, 1972).

Hall, J., *Dictionary of Subjects and Symbols in Art* (London, 1974).

Hall, S. C., *Ireland, its Scenery and Character* (London, 1842),

Handbook of British Chronology, eds F. M. Powicke, C. Johnson and W. J. Harte (London, 1939).

Harbison, P., 'The Limerick Cathedral Misericords', *Ireland of the Welcomes* 20, no. 3 (1971), 12–6.

Harbison, P., 'Animals in Irish Art: Animals with Interlocking Necks', *The Arts in Ireland* 2 (1974), 54–63.

Harbison, P., 'Some Further Sculpture in Ennis Friary', *North Munster Antiquarian Journal* 19 (1977), 39–42.

Harbison, P., *Beranger's Views of Ireland* (Dublin, 1991).

Harbison, P., *The High Crosses of Ireland: An Iconographic and Photographic Survey*, vol. 1 (Bonn, 1992).

Harbison, P., *Gabriel Beranger: 'Drawings of the Principal Antique Buildings of Ireland', National Library of Ireland MS 1958 TX* (Dublin, 1998).

Harbison, P., *The Golden Age of Irish Art: The Medieval Achievement, 600–1200* (London, 1999).

Harbison, P., *The Crucifixion in Irish Art: Fifty Selected Examples from the Ninth to the Twentieth Century* (Dublin, 2000).

Harbison, P., 'Irish Artists on Irish Subjects: The Cooper Collection in the National Library', *Irish Arts Review Yearbook* 17 (2001), 618.

Harbison, P., Potterton, H., and Sheehy, J., *Irish Art and Architecture from Prehistory to the Present* (London, 1978).

Harris, P., 'A Processional Cross and Two Roundels', *Bulletin of the Metropolitan Museum of Art* 32 (1937), 95–6.

Hassig, D., *Medieval Bestiaries: Text, Image, Ideology* (Cambridge, 1995).

Hassig, D. (ed.), *The Mark of the Beast: The Medieval Bestiary in Art, Life and Literature* (New York, 1999).

Haworth, R., 'The Published Work of Helen M. Roe', in *Figures from the Past: Studies on Figurative Art in Christian Ireland in Honour of Helen M. Roe*, ed. E. Rynne (Dún Laoighaire, 1987), 20–26.

Healey, W., 'The Cistercian Abbey of Kilcooly', *JRSAI* 20 (1890), 224–5.

Henderson, G., *Gothic* (London, 1978).

Hennessy, W. M., and Kelly, D. H., *The Book of Fenagh* (Dublin, 1875).

Henry, F., *Irish Art in the Romanesque Period (1020–1170 AD)* (London, 1970).

Henry, F., and Marsh-Micheli, G. L., 'The Decoration of Irish Manuscripts from the Norman Conquest to the End of the Sixteenth Century', in *Studies in Early Christian and Medieval Irish Art*, vol. II, *Manuscript Illumination* (London, 1984), 291–334.

Herity, M., 'George Victor Du Noyer, 1817–1869: Artist, Geologist and Antiquary', *JRSAI* 123 (1993), 102–19.

Hickey, H., *Images of Stone* (Belfast, 1976).

Hinkle, W., *The Portal of the Saints of Reims Cathedral: A Study in Medieval Iconography* (New York, 1965).

Holinshed's Irish Chronicle, The Historie of Irelande from the First inhabitation thereof, unto the yeare 1509. Collected by Raphaell Holinshed, and continued till the yeare 1547 by Richard Stanyhurst, eds L. Miller and E. Power (Dublin, 1979).

Holmes, G., *Sketches of Some of the Southern Counties of Ireland, Collected during a Tour in the Autumn of 1797* (London, 1801).

Horapollo, *The Hierogliphs of Horapollo*, trans. G. Boas (New York, 1950).

Hourihane, C., 'The Iconography of Religious Art in Ireland, 1250–1550, and a Catalogue of Architectural Sculpture, Metalwork, Wooden Sculpture, Seals, Alabasters, Mural Paintings and

Miscellanea' (Ph.D thesis, Courtauld Institute of Art, University of London, 1984).

Hourihane, C., *The Mason and His Mark: Masons' Marks in the Medieval Irish Archibishoprics of Cashel and Dublin*, British Archaeological Reports, British Series 294 (Oxford, 2000). [2000a]

Hourihane, C., '"Hollye Crosses": A Catalogue of Processional, Altar, Pendant and Crucifix Figures for Late Medieval Ireland', *PRIA* 100 (2000), 1–85. [2000b]

Howard, J. E., *The Island of Saints, or Ireland in 1855* (London, 1855).

Hunt, J., *The Limerick Crozier and Mitre* (Dublin, nd [*c*.1946]).

Hunt, J., 'Rory O'Tunney and the Ossory Tomb Sculpture', *JRSAI* 80 (1950), 22–8.

Hunt, J., 'The Limerick Cathedral Misericords', *Ireland of the Welcomes* 20, no. 3 (Sept.–Oct. 1971), 12–16.

Hunt, J., *Irish Medieval Figure Sculpture, 1200–1600: A Study of Irish Tombs with Notes on Costume and Armour* (Dublin, 1974).

Hunt, J., and Harbison, P., 'The Influence of Alabaster Carvings on Medieval Sculpture in Ennis Friary', *North Munster Antiquarian Journal* 17 (1975), 35–41.

Hunt, J., and Harbison, P., 'Medieval English Alabasters in Ireland', *Studies* (1976), 310–21.

Hutchinson, J., *The Dynamics of Cultural Nationalism: The Gaelic Revival and the Creation of the Irish Nation State* (London, 1987).

Irish Monastic and Episcopal Deeds, AD 1200–1600, ed. N. B. White (Dublin, 1936).

Jantzen, H., *High Gothic: The Classical Cathedrals of Chartres, Reims, Amiens* (Princeton, 1984).

Jones, T. D., *Record of the Great Industrial Exhibition, 1853* (Dublin, 1854).

Kelly, E. P., *Sheela-na-Gigs: Origins and Functions* (Dublin, 1996).

Kelly, M., *A History of the Black Death in Ireland* (Dublin, 2001).

Kendall, C., *Romanesque Portals and their Verse Inscriptions* (Toronto, 1998).

Kendrick, T. D., and Senior, E., 'St Manchan's Shrine', *Archaeologia* 86 (1937), 114–15.

King, H., 'Half-Human Creatures', in *Mythical Beasts*, ed. J. Cherry (London, 1995), 143–8.

Kleinschmidt, H., *Notes on the Polychromy of the Great Portal at Cluny* (Cambridge, Mass., 1936).

Klingender, F., *Animals in Art and Thought*, ed. E. Antal and J. Harthan (London, 1971).

Kopp, G., *Die Skulpturen der Fassade von San Martino in Lucca* (Worms, 1981).

Kroos, R., *Niedersächsische Bildstickerein* (Berlin, 1970).

Ladous, R., *L'abbé Portal et la Compagne Anglo-Romaine, 1870–1912* (Lyons, 1973).

'La Façade romane', Actes du colloque international organisé par le Centre d'Etudes Supérieures de Civilization Médiévale: Poitiers, 26–9 Septembre 1990, *Cahiers de Civilization Médiévale* x–xii Siècles, 34, nos 3–4, July–December 1991.

Langrishe, R., 'Notes on Jerpoint Abbey, County Kilkenny', *JRSAI* 35 (1906), 179–97.

Larmour, P., 'The Celtic Revival and a National Style of Architecture' (Ph.D thesis, Queen's University, Belfast, 1977).

Lawlor, H. J., 'The Cathach of St Columba', *PRIA* 33 (1916), 241–443.

Le Blant, E., 'De Quelques Représentations du Sacrifice d'Abraham', *Revue archéologique* 28 (1896), 154–99.

Leask, H. G., 'The Collegiate Church of St Nicholas, Galway', *JGAHS* 17 (1936), 1–23.

Leask, H. G., *St Patrick's Rock Cashel* (Dublin, 1940).

Leask, H. G., *Irish Castles and Castellated Houses* (Dundalk, 1941).

Leask, H. G., *Irish Churches and Monastic Buildings*, vol. II, *Gothic Architecture to AD 1400* (Dundalk, 1958).

Leask, H. G., *Irish Churches and Monastic Buildings*, vol. III, *Medieval Gothic and Last Phases* (Dundalk, 1960).

Leerssen, J., *Mere Irish and Fior-Ghael: Studies in the Idea of Irish Nationality, Its Development and Literary Expression Prior to the Nineteenth Century* (Amsterdam, 1986).

Leerssen, J., 'Wildness, Wilderness and Ireland: Medieval and Early-Modern Patterns in the Demarcation of Civility', *Journal of the History of Ideas* 56 (1995), 25–39.

Leerssen, J., *Remembrance and Imagination: Patterns in the Historical and Literary Representation of Ireland in the Nineteenth Century* (Cork, 1996).

Lefevre-Pontalis, E. A., *Le Portail Royal d'Etampes: Portal meriodionel de l'eglise Notre Dame* (Paris, 1908).

Leibovitch, J., 'Le Griffon dans le Moyen-Orient antique', *Antiqot: Journal of the Israel Department of Antiquities* 1 (1955), 75.

Lenox-Conygham, M. (ed.), *Diaries of Ireland: An Anthology, 1590–1987* (Dublin, 1998).

Lewis, S., *A Topographical Dictionary of Ireland comprising the Several Counties, Cities, Boroughs, Corporate, Market and Post Towns, Parishes and Villages; with historical and statistical descriptions embellished with engravings of the arms of the cities, bishopricks, corporate towns and boroughs; and of the seals of the several municipal corporations*, 2 vols (London, 1837).

Libellus de Natura Animalium: A Fifteenth-Century Bestiary Reproduced in Facsimile, introduction by J. I. Davis (London, 1958).

Lucas, A. T., 'Harold G. Leask: A List of Published Works', *JRSAI* 96 (1966), 3–6.

Lucas, A. T., *Treasures of Ireland: Irish Pagan and Early Christian Art* (Dublin, 1973).

Lucas, A. T., 'The Social Role of Relics and Reliquaries in Ancient Ireland', *JRSAI* 116 (1986), 5–37.

Lydon, J. F., 'The Medieval English Colony, Thirteenth and Fourteenth Centuries', in *The Course of Irish History*, eds T. W. Moody and F. X. Martin (Cork, 1995), 144–57.

Lynch, P. J., 'Carvings at the Rock of Cashel', *JRSAI* 42 (1912), 148–50.

MacDonagh, O., Mandle, W. F., and Travers, P., *Irish Culture and Nationalism, 1750–1950* (New York, 1983).

MacKenna, J., 'Two Clogher Relics', *Ulster Journal of Archaeology* 7, no. 3 (1901), 113–25.

MacLeod, C., 'Medieval Wooden Figure Sculpture in Ireland: Medieval Madonnas of the West', *JRSAI* 75 (1945), 167–82. [MacLeod 1945a]

MacLeod, C., 'Medieval Wooden Figure Sculpture in Ireland: The Kilcorban St Catherine and Calvary Figures', *JRSAI* 75 (1945), 195–203. [MacLeod 1945b]

MacLeod, C., 'Medieval Wooden Figure Sculpture in Ireland: Statues in the Holy Ghost Hospital, Waterford', *JRSAI* 76 (1946), 89–100. [MacLeod 1946a]

MacLeod, C., 'Medieval Wooden Figure Sculpture in Ireland: Statues of Irish Saints', *JRSAI* 76 (1946), 155–70. [MacLeod 1946b]

MacLeod, C., 'Fifteenth-Century Vestments in Waterford', *JRSAI* 82 (1952), 85–98.

MacLeod, C., 'A Carved Nursing Madonna from Askeaton, Co. Limerick', in *Figures from the Past: Studies on Figurative Art in Christian Ireland in Honour of Helen M. Roe*, ed. E. Rynne (Dún Laoighaire, 1987), 249–57.

MacNiocaill, G., 'The Irish Language Manuscripts', in *Treasures of the Library, Trinity College, Dublin*, ed. P. Fox (Dublin, 1986), 57–66.

Mahr, A., *Christian Art in Ancient Ireland*, 2 vols (Dublin, 1941), vol. II.

Maines, C., *The Western Portal of Saint-Loup-de-Naud* (New York, 1979).

Màle, E., *Religious Art in France, The Late Middle Ages, A Study of Medieval Iconography* (Princeton, 1986).

Malton, J., *A picturesque and descriptive view of the city of Dublin: described in a series of the most interesting scenes taken in the year 1791 by James Malton; with a brief authentic history from the earliest accounts to the present time* (Dublin, 1799).

Manning, C., 'The Inistioge Priory Cloister Arcade', *Old Kilkenny Review* 1, no. 3 (1976), 190–99.

Manning, C., 'Clonmacnoise Cathedral', in *Clonmacnoise Studies*, vol. 1, *Seminar Papers 1994*, ed. H. King (Dublin, 1998), 57–86.

Manning, C., 'Kilteel Revisited', *Journal of the Kildare Archaeological Society* 18, no. 3 (1996), 296–300.

Martin, F. X., 'The First Normans in Munster', *Journal of the Cork Historical and Archaeological Society* 76 (1971), 48–71.

Martin, F. X., 'The Normans: Arrival and Settlement (1169–c.1300)', in *The Course of Irish History*, eds T. W. Moody and F. X. Martin (Cork, 1995), 142–3.

McAleer, J. P., *The Romanesque Church Façade in Britain* (New York, 1984).

McAleer, J. P. (ed.), 'La Façade romane', *Cahiers de civilisation medievale, X–XII Siècles* 34 (1991).

McBride, L. (ed.), *Images, Icons and the Irish Nationalist Imagination* (Dublin, 1999).

McCraith, L., *Cashel of the Kings: An Illustrated Guide to the Rock of Cashel* (Clonmel, 1923).

McGarry, D., 'Carved Medieval Font at Thomastown,' *Old Kilkenny Review* 22 (1980), 35.

McKenna, J. E., 'The Domhnach Airgid', *Ulster Journal of Archaeology* VII, (1901), 118–25.

McMurray Gibson, G., *The Theatre of Devotion: East Anglian Drama and Society in the Late Middle Ages* (Chicago, 1989).

McNab, S., 'The Romanesque Sculpture of Ardmore Cathedral, Co. Waterford', *JRSAI* 117 (1987), 500–69.

McNab, S., 'Styles Used in Twelfth-Century Irish Figure Sculpture', *Peritia: Journal of the Medieval Academy of Ireland* 6–7 (1987–8), 265–97.

McNab, S., 'From Tomregan to Isiscealtra: Irish Twelfth-Century Sculpture', *Irish Arts Review Yearbook* 13 (1997), 32–4.

McNab, S. 'Celtic Antecedents to the Treatment of the Human Figure in Early Irish Art', in *From Ireland Coming: Irish Art from the Early Christian to the Late Gothic Period and Its European Context*, ed. C. Hourihane (Princeton, 2001), 161–82.

McNeill, T., *Castles in Ireland: Feudal Power in a Gaelic World* (London, 1997).

McSweeney, M. R., 'The Church Triumphant: An Iconographical Study of the Virgin Portal of Amiens Cathedral' (Ph.D thesis, Brown University, R.I., 1978).

Meier, P., 'Die Kuchen in Quedlinburg', *Deutsche Banten* 20 (1932), 71.

Migne, J. P., 'Epiphanius Episcopus Constantiensis', *Patrologia Graeca* (Paris, 1959).

Millar, E. G., *A Thirteenth-Century Bestiary in the Library of Alnwick Castle* (Oxford, 1958).

Milliken, W., 'Copper-Gilt Cross in the Cleveland Museum', *Art Quarterly* 6 (1943), 336–7.

Mooney, C., 'Franciscan Architecture in Pre-Reformation Ireland: I', *JRSAI* 85 (1955), 133–73; Part II, *JRSAI* 86 (1956), 125–69; Part III, *JRSAI* 87 (1957), 1–39; Part IV, *JRSAI* 87 (1957), 103–24.

Morant, R. W., *The Monastic Gatehouse and Other Types of Portal of Medieval Religious Houses* (Sussex, 1995).

Mullally, E., 'Hiberno-Norman Literature and Its Public', in *Settlement and Society in Medieval Ireland: Studies Presented to F. X. Martin, OSA*, ed. J. Bradley (Kilkenny, 1988), 327–43.

Mullarkey, P. A., 'Irish Book Shrines: A Reassessment' (Ph.D thesis, Trinity College, Dublin, 2000).

Murphy, D., 'On an Ancient Life of St Caillin of Fenagh and His Shrine', *PRIA* 17 (1888–91), 444–5.

Murphy, D., 'The Shrine of St Caillin of Fenagh', *JRSAI* 22 (1892), 152–3.

Murray, B., *Animals with Human Faces: A Guide to Animal Symbolism* (Knoxville, 1973).

Myers, J. P., Jr, *Elizabethan Ireland: A Selection of Writings by Elizabethan Writers on Ireland* (Hamden, Ct, 1983).

National Museum of Scotland, *Angels, Nobles and Unicorns: Art and Patronage in Medieval Scotland* (Edinburgh, 1982).

Newenham, R. O'Callaghan, *Picturesque Views of the Antiquities of Ireland* (London, 1830).

Newman Johnson, D., 'An Unusual Amphisbena in Galway', in *Figures from the Past: Studies on Figurative Art in Christian Ireland in Honour of Helen M. Roe*, ed. E. Rynne (Dún Laoighaire, 1987), 233–41.

Newman Johnson, D., 'Later Medieval Castles', in *The Illustrated Archaeology of Ireland*, ed. M. Ryan (Dublin, 1991), 188–92.

Nī Shūilliobháin, N., 'Obituary of H. M. Roe,' *JRSAI* 118 (1988), 166–9.

Noel, B. W., *Notes on a Short Tour through the Midland Counties of Ireland in the summer of 1836, with observations on the conditions of the peasantry* (London, 1837).

O'Brien, C., and Sweetman, P. D., *Archaeological Inventory of County Offaly* (Dublin, 1997).

Ó Ciosain, N., *Print and Popular Culture in Ireland, 1750–1850* (New York, 1997).

O'Conor, K. D., *The Archaeology of Medieval Settlement in Ireland* (Dublin, 1998).

O'Corráin, D., *Ireland Before the Normans*, vol. 2 of *The Gill History of Ireland* (Dublin, 1972).

Ó Crónín, D., *Early Medieval Ireland, 400–1200* (London, 1995).

O'Donnell, A., *Saint Patrick's Rock* (Cashel, 1961).

O Dougan, R., *A Descriptive Guide to Twenty Irish Manuscripts in the Library of Trinity College, Dublin, with an Appendix of Five Early Manuscripts in the Royal Irish Academy* (Dublin, 1955).

Ó Floinn, R., 'The Shrine of the Book of Dimma', *Eile: Journal of the Roscrea Heritage Society* 1 (1982), 25–39.

Ó Floinn, R., 'Bronze and Silver Shrine-Soiscél Molaise', in *Treasures of Ireland: Irish Art, 3000 BC–1500 AD*, ed. M. Ryan (Dublin, 1983), 161–3. [Ó Floinn 1983a]

Ó Floinn, R., 'The Norman Conquest and the Later Middle Ages, 1169 AD–ca. 1500 AD', in *Treasures of Ireland: Irish Art, 3000 BC–1500 AD*, ed. M. Ryan (Dublin, 1983), 178–9. [Ó Floinn 1983b]

Ó Floinn, R., 'Gilt Silver Processional Cross', in *Treasures of Ireland: Irish Art, 3000 BC–1500 AD*, ed. M. Ryan (Dublin, 1983), 181. [Ó Floinn 1983c]

Ó Floinn, R., 'Clogán Óir-Bronze Bell Shrine of St Senan', in *Treasures of Ireland: Irish Art, 3000 BC–1500 AD*, ed. M. Ryan (Dublin, 1983), 187–9. [Ó Floinn 1983d]

Ó Floinn, R., 'Irish Romanesque Crucifix Figures', in *Figures from the Past: Studies on Figurative Art in Christian Art in Honour of Helen M. Roe*, ed. E. Rynne (Dún Laoighaire, 1987), 168–88.

Ó Floinn, R., *Irish Shrines and Reliquaries of the Middle Ages* (Dublin, 1994).

Ó Floinn, R., 'Sandhills, Silver and Shrines: Fine Metalwork of the Medieval Period from Donegal', in *Donegal, History and Society: Interdisciplinery Essays on the History of an Irish County*, eds W. Nolan, L. Ronatne and M. Dunlevy (Dublin, 1995), 85–148.

Ó Floinn, R., 'Irish Goldsmiths' Work of the Later Middle Ages', *Irish Arts Review* 12 (1996), 35–44.

Ó Floinn, R., 'Innovation and Conservatism in Irish Metalwork of the Romanesque Period', in *The Insular Tradition*, eds C. Karkov, R. Farrell and M. Ryan (Albany, 1997), 271–4.

Ó Floinn, R., 'Goldsmiths' Work in Ireland, 1200–1400', in *From Ireland Coming: Irish Art From the Early Christian to the Late Gothic Period and Its European Context*, ed. C. Hourihane (Princeton, 2001), 289–312.

O'Keeffe, T., 'Lismore and Cashel: Reflections on the Beginnings of Romanesque Architecture in Munster', *JRSAI* 124 (1990), 118–52.

O'Keeffe, T., *An Anglo-Norman Monastery: Bridgetown Priory and the Architecture of the Augustinian Canons Regular in Ireland* (Kinsale, 1999).

O'Keeffe, T., *Medieval Ireland: An Archaeology* (Stroud, Glos, 2000).

O'Kelleher, A., and Schoepperle, G. (eds), *Betha Colaim Chille* (Urbana, Ill., 1918).

O'Meadhra, U., *Early Christian, Viking and Romanesque Motif-Pieces from Ireland: An Illustrated and Descriptive Catalogue of the So-called Artists' "Trial-pieces" from c.5th–12th Centuries, Found in Ireland, c.1830–1973* (Stockholm, 1979).

O'Neill, T., *Illustrations of the Most Interesting of the Sculptured Crosses of Ireland* (Dublin, 1857).

O'Neill, T., *The Irish Hand: Scribes and Their Manuscripts from the Earliest Times to the Seventeenth Century, with an Exemplar of Irish Scripts* (Portlaoise, 1984).

O'Neill, T., *Merchants and Mariners in Medieval Ireland* (Dublin, 1987).

O'Reilly, J., 'Reading the Scriptures in the Life of Columba', in *Studies in the Cult of Saint Columba*, ed. C. Bourke (Dublin, 1997), 80–106.

O'Riain, P., 'The Shrine of the Stowe Missal, Redated', *PRIA* 91, no. 1, (1991), 285–95.

Osborne, J., 'From Paris to Dublin: The Sadleir Hours in Trinity College', *Irish Arts Review Yearbook* 15 (1999), 109–17.

Otway-Ruthven, A. J., *A History of Medieval Ireland* (London, 1968).

Pasini, A., *Il Tesoro di San Marco in Venezia*, vol. II (Venice, 1886).

Payne, A., *Medieval Beasts* (London, 1990).

Petrie, G., *The Ecclesiastical Architecture of Ireland, Anterior to the Anglo-Norman Invasion, Comprising an Essay on the Origin and Uses of Round Towers of Ireland* (Dublin, 1845).

Phelan, M., 'John George Augustus Prim and James Graves, 1821–1875', *JRSAI* 105 (1975), 159–63.

Physiologus, trans. M. J. Curley (Austin, 1979).

Pitcher, S., *Medieval Sculpture at Winchester College* (Oxford, 1932).

Platt, C., *King Death: The Black Death and Its Aftermath in Late-Medieval England* (London, 1996).

Pliny the Elder, *Natural History*, trans. H. Rackham (London, 1942).

Power, P., *Early Christian Ireland: A Manual of Irish Christian Archaeology* (Dublin, 1925).

Quintavalle, A. O., 'Plutei e frammenti d'ambone nel Museo Correale a Sorrento', *Rivista del Reale istituto d'archeologia e storia dell'arte* III (1931), 160–83.

Rae, E. C., 'The Sculpture of the Cloister of Jerpoint Abbey', *JRSAI* 96 (1966), 59–91.

Rae, E. C., 'Irish Sepulchral Monuments of the Later Middle Ages, II, The O'Tunney Atelier', *JRSAI* 101 (1971), 1–39.

Rae, E. C., 'Architecture and Sculpture, 1169–1603', in *A New History of Ireland*, vol. II, *Medieval Ireland, 1169–1534*, ed. A. Cosgrove (Oxford, 1987), 737–79.

Raftery, J., *Christian Art in Ancient Ireland*, vol. II (Dublin, 1941).

Randall, L. M. C., *Images in the Margins of Gothic Manuscripts* (Berkeley, Ca., 1966).

Raynaud, C., 'Sacrifice d'Abraham dans quelques représentations de la fin du Moyen Age', *Medieval History* 21 (1995), 249–73.

Reiche, R., *Das Portal des Paradises am Dom zu Padderborn: Ein Beitrag zur Geschichte der Deutschen Bildhauerkunst des Dreizehnten Jahrhunderts* (Munster, 1905).

Richardson, H., 'The Fate of Kingsley Porter', *Donegal Annual* 45 (1993), 83–7.

Richter, K., *Der Deutsch S. Christoph: Eine Historisch-Kritische Untersuchung* (Berlin, 1896).

Ritchie, L., *Ireland Picturesque and Romantic* (London, 1837).

Ritz, G., 'Eucharistia-Austellung Deutsche Eucharistische Kunst', *Das Munster* XIII (1960), 373.

Robin, P. A., *Animal Lore in English Literature* (London, 1932).

Robinson, M. W., *Fictitious Beasts: A Bibliography* (London, 1961).

Roe, H. M., 'Some Aspects of Medieval Culture in Ireland', *JRSAI* 96 (1966), 105–9.

Roe, H. M., *Medieval Fonts of Meath* (Longford, 1968).

Roe, H. M., 'The Cult of St Michael in Ireland', in *Folk and Farm: Essays in Honour of A. T. Lucas*, ed. K. Dancher (Dublin, 1976), 251–64.

Ronan, M. V., *The Reformation in Ireland Under Elizabeth, 1558–1580, from Original Sources* (London, 1930).

Ross, M. C., 'Austrian Gothic Enamels and Metalwork', *Journal of the Walters Art Gallery* 1 (1938), 70–83.

Rossi, A., 'L'Art industriel dans les Abruzzes', *Les Arts* 5 (1906), 15–32.

Royal Dublin Society, *Official Catalogue of the Great Industrial Exhibition 1853* (Dublin, 1853).

Rynne, E. (ed.), *Figures from the Past: Studies on Figurative Art in Christian Ireland In Honour of Helen M. Roe* (Dún Laoighaire, 1987).

St John Hope, W. H., 'A Note on the Jall or Yale in Heraldry', *Archaeological Journal* 68 (1911), 200.

St Ledger Hunt, A., *Cashel and Its Abbeys: A Historical Guide* (Dublin, 1952).

Salmi, M., *La Scultura romanica in Toscana* (Florence, 1928).

Salmon, J., 'St Christopher in English Medieval Art and Life', *Journal of the British Archaeological Association* 41 (1936), 76–115.

Sbordone, F., *Physiologus* (Milan, 1936).

Scarry, J., 'Early Photographs of Clonmacnoise', in *Clonmacnoise Studies, Vol. 1, Seminar Papers 1994*, ed. H. King (Dublin, 1998), 19–33.

Schapiro, M., 'Angel with Ram in Abraham's Sacrifice: A Parallel in Western and Islamic Art', *Ars Islamica* 10 (1943), 134–47.

Schapiro, M., 'An Irish-Latin Text of the Angel with the Ram in Abraham's Sacrifice', in *Essays in the History of Art Presented to*

Rudolf Wittkower, eds D. Fraser, H. Hibbard and M. J. Lewine (London, 1967), 17–19.

Schiller, G., *The Iconography of Christian Art* (London, 1972).

Schnitzler, H., *Rheinische Schatzkammer*, vol. II (Dusseldorf, 1959).

Scholle, H., 'A Romanesque Archivolt', *Metropolitan Museum Bulletin* 18 (1923), 9–10.

Schulze, I., *Der Westlettner des Naumburger Doms: Das Portal als Gleichnis* (Frankfurt am Main, 1995).

Seidel, L., *Songs of Glory: The Romanesque Facades of the Aquitaine* (Chicago, 1981).

Seymour, St John D., 'Three Medieval Poems from Kilkenny', *PRIA* 31 (1933), 205–9.

Sheehy, J., *The Rediscovery of Ireland's Past: The Celtic Revival, 1830–1930* (London, 1980).

Shrewsbury, J. F. D., *A History of the Bubonic Plague in the British Isles* (Cambridge, 1970).

Sittler, E., *Pokladsvatovítský* [Treasures of St Vitus's Cathedral] (Prague, 1903).

Smith, A., 'The Iconography of the Sacrifice of Isaac in Early Christian Art', *American Journal of Archaeology* 26 (1922), 159–73.

Smith, A., 'Landscapes of Power in Nineteenth-Century Ireland: Archaeology and Ordnance Survey Maps', *Archaeological Dialogues* 5 (1998), 69–71.

Spenser, E., *The Complete Poetical Works of Edmund Spenser*, ed. R. E. Neil Dodge (Cambridge, 1908).

Speyart van Woerden, I., 'Iconography of the Sacrifice of Abraham', *Vigiliae Christianae* 15 (1961), 214–55.

Stafford, Sir Thomas, *Pacata Hibernia* (London, 1633).

Stahl, E., *Die Legende vom Heilriesen Christophorus* (Munich, 1920).

Stalley, R. A., *Architecture and Sculpture in Ireland, 1150–1350* (Dublin, 1971).

Stalley, R. A., 'Irish Art in the Romanesque and Gothic Periods', in *Treasures of Early Irish Art, 1500 BC–1500 AD* (New York, 1977), 187–96.

Stalley, R. A., *The Cistercian Monasteries of Ireland: An Account of the History, Art and Architecture of the White Monks in Ireland from 1142 to 1540* (New Haven and London, 1987).

Stalley, R. A., 'Medieval Sculpture of Christchurch Cathedral', in *Ireland and Europe in the Middle Ages: Selected Essays on Architecture and Sculpture* (London, 1994), 75–126. [Stalley 1994a]

Stalley, R. A., 'Irish Gothic and English Fashion', in *Ireland and Europe in the Middle Ages: Selected Essays on Architecture and Sculpture* (London, 1994), 190–219. [Stalley 1994b]

Stalley, R. A., 'Gaelic Friars and Gothic Design', in *Ireland and Europe in the Middle Ages: Selected Essays on Architecture and Sculpture* (London, 1994), 285–96. [Stalley 1994c]

Stalley, R. A., 'Medieval Naturalism and the Botanical Carvings at Corcomroe Abbey, County Clare', in *Ireland and Europe in the Middle Ages: Selected Essays on Architecture and Sculpture* (London, 1994), 297–316. [Stalley 1994d]

Stalley, R. A., 'Ireland and Scotland in the Later Middle Ages', in *Medieval Art and Architecture in the Dioceses of St Andrews: British Archaeological Association Conference Transactions for the Year 1986* (London, 1994), 108–17. [Stalley 1994e]

Stalley, R. A., 'Cashel (of the Kings)', *Grove Dictionary of Art* (London, 1999)/http://www.groveart.com.

Stalley, R. A., 'Sex, Symbol and Myth: Some Observations on the Irish Round Towers', in *From Ireland Coming: Irish Art From the Early* *Christian to the Late Gothic Period and Its European Context*, ed. C. Hourihane (Princeton, 2001), 27–48.

Steenbock, F., *Der Kirchliche Prachteinband im Fruhen Mittelalter, von den Anfangen bis zum Beginn der Gotik* (Berlin, 1965).

Stelak-Garrison, H. S., 'The Capitals of St Lazare at Autun: Their Relationship to the Last Judgement Portal' (Ph.D thesis, University of California, Los Angeles, 1984).

Stokes, M., *Early Christian Architecture in Ireland* (London, 1878).

Stokes, M., *Early Christian Art in Ireland* (London, 1887).

Stokes, W., *The Life and Labours in Art and Archaeology of George Petrie* (London, 1868).

Stubbs, W. Cotter, 'Weavers' Guilds', *JRSAI* 45 (1919), 60–75.

Sweetman, D., *Medieval Castles of Ireland* (Woodbridge, 1999).

'Swiechowski, Z., *Sculpture Romane d'Auvergne* (Clermont-Ferrand, 1973).

Todd, J. H., 'Miscellanea: The Misach', *PRIA* 5 (1850), 464–7.

Tonnochy, A. B., 'The Censer in the Middle Ages', *Journal of the British Archaeological Association* 11 (1937), 47–62.

Trietz, H., *Österreichische Kunsttopographie, von die Denkmale des Politischen Bezirkes Horn* (Vienna, 1911).

Twemlow, J. A. (ed.), *Calendar of Entries in the Papal Registers Relating to Great Britain and Ireland* 9 (London, 1893).

Twiss, R., *A Tour in Ireland in 1775 with a Map and a View of the Salmon-Leap at Ballyshannon* (London, 1778).

Valente, A., 'Intorno ad un Ofafo del Secolo XII', *Bolletino d'arte* 31 (1937–8), 261.

Van Falke, O., and Frauenberger, H., *Deutsche Schmelzarbeiten des Mittelalters und Andere Kunstwerke du Kunst-Historischen Ausstellung zu Düsseldorf* (Frankfurt, 1904).

Van Os, H., *The Power of Memory* (Baarn, Netherlands, 1999).

Vermeulen, F., 'L'Exposition national d'art religieux ancien à Bois-le-Duc,' *Art flamand et hollandais* 20 (1913), 121–36.

Vieillard-Troïekouroff, M., 'Sirènes-Poissons Carolingiennes', *Cahiers archéologique, fin de l'Antiquité et Moyen Age* 19 (1969), 61–82.

Vikan, G., *Catalogue of the Sculpture in the Dumbarton Oaks Collection from the Ptolemaic Period to the Renaissance* (Washington, DC, 1995).

Vincent of Beauvais, *Speculum Naturale* (Strasbourg, 1481), microfilm.

Wakeman, G. F., *Handbook of Irish Antiquities* (Dublin, 1848).

Walsh, K., 'The Clerical Estate in Later Medieval Ireland: Alien Settlement or Element of Conciliation?', in *Settlement and Society in Medieval Ireland: Studies Presented to F. X. Martin, OSA*, ed. J. Bradley (Kilkenny, 1988), 361–77.

Warner, G. F., *The Stowe Missal*, vol. I *Facsimile* (London, 1906); vol. II *Commentary* (London, 1915), The Henry Bradshaw Society.

Watt, J., *The Church in Medieval Ireland*, The Gill History of Ireland (Dublin, 1972).

Weitzmann, K., 'Icon Painting in the Crusader Kingdom', *Dumbarton Oaks Papers* XX (1966), 49–83.

Wellman, M., 'Der Physiologus', in *Philologus Supplementband* 22 (1930), 50.

Westropp, T. J., 'Carvings in St Mary's Cathedral, Limerick', *JRSAI* 22 (1892), 70–9.

Westropp, T. J., 'Notes on Askeaton, County Limerick, Part Three', *JRSAI* 33 (1903), 239–54.

Westropp, T. J., 'Clare Island Survey, Part 2', *PRIA* 31 (1911), 1–78.

Westropp, T. J., 'Ancient Remains on the West Coast of County Clare', *Journal of the North Munster Archaeological Society* 4 (1915), 367–71.

Whaite, H., *St Christopher in English Medieval Wall Painting* (London, 1929).

Wheeler, H. A., *The Cathedral, St Patrick's Rock, Cashel* (Dublin, nd).

Wheeler, H. A., *St Patrick's Rock, Cashel, Based on Text by H. G. Leask, with Revisions by H. A. Wheeler* (Dublin, 1990).

White, T. H., *The Book of Beasts: Being a Translation From a Latin Bestiary of the Twelfth Century* (New York, 1984).

Wilde, O., *The Picture of Dorian Gray* (Oxford, 1999).

Williams, J., 'Reconquest Iconography in León', *Gesta* 16 (1977), 3–14.

Williams, M., 'Constructing the Market Cross at Tuam: The Role of Cultural Patriotism in the Study of Irish High Crosses', in *From Ireland Coming: Irish Art From the Early Christian to the Late Gothic Period and Its European Context*, ed. C. Hourihane (Princeton, 2001), 141–60.

Willis, N. P., *The Scenery and Antiquities of Ireland (illustrated by W. H. Bartlett)* (London, 1842).

Wilpert, J., 'Das Opfer Abrahams in der Altchristlichen. Kunst mit besonder Berücksichtigung zweier Monumente unbekannten', *Römische Quartalschrift* 1 (1887), 126–60.

Wilson, W., *The Post Chaise Companion or Traveller's Directory through Ireland. Containing a new and accurate description of the direct and principal cross roads, with particulars of the noblemen and gentlemen's seats, cities, towns . . . forming an historical and descriptive account of the kingdom. To which is added, A travelling dictionary, or Alphabetical tables, shewing the distances of all the principal cities, boroughs, market & seaport towns in Ireland from each other* (Dublin, 1810).

Witte, F., *Tausend Jahre deutscher Kunst am Rhein: Die Denkmäler der Plastik und des Kunstgewerkes awf die Jahrtausand-austellung in Köln*, 5 vols (Berlin, 1932).

Zimmermann, E., 'Die Tafelmalerei', *Anzeiger des Germanischen Nationalmuseums* (1930–31), 30–32.

Photograph Credits

The author: fig. 1 (after Armstrong), fig. 2 (after Eames and Fanning), fig. 3, fig. 4, fig. 5, fig. 6, fig. 7, fig. 8, fig. 9, fig. 10, fig. 11, fig. 12, fig. 13 (after MacKenna), fig. 14 (after MacKenna), 1, 2, 4, 5, 8, 13, 14, 15, 16, 32, 33, 36, 37, 38, 40, 43, 44, 47, 48, 50, 52, 53, 55, 56, 57, 63, 64, 66, 67, 68, 69, 73, 74, 75, 76, 77, 78, 79, 81, 85, 86, 87, 88, 89, 92, 93, 94, 95, 96, 99, 100, 103, 105, 106, 108, 109, 110, 114, 115, 117, 118, 119, 120, 122, 123, 124, 125, 127, 128, 131, 132, 133, 138, 139, 141, 142, 146, 147, 148, 149, 154, 156 a and b, 157 a–d, 161, 162, 163, 172, 173, 176, 177, 178, 182, 184, 185, 186, 187 a and b

© The British Museum: 191

Courtesy of the Newberry Library, Chicago: 18

The Conway Library, Courtauld Institute of Art (with permission The Board of Trinity College, Dublin): 168

The Conway Library, Courtauld Institute of Art: 129

Dúchas, The Heritage Service: *frontispiece*, 6, 7, 9, 10, 11, 12, 29, 30, 31, 34, 35, 39, 41, 42, 45, 46, 49, 51, 54, 58, 59, 60, 61, 62, 65, 70, 71, 72, 82, 84, 90 a and b, 91, 97 a and b, 98, 101, 102, 104, 107, 111, 112, 113, 116, 121, 126, 130, 136, 137, 140, 170, 174, 175, *p. 164*

The Board of Trinity College, Dublin: 151, 152, 169, 179, 180, 183

© Insight cards: 80

National Museum of Ireland: 3, 28, 134, 135, 143, 144, 145, 150, 153, 155, 158, 159, 160, 164, 171, 181, 188, 189, 190

Courtesy Firestone Library, Princeton University: 17, 19, 20, 21, 22, 27, 83

Courtesy Marquand Library, Princeton University: 23, 24, 25, 26

Royal Irish Academy © RIA: 165, 166, 167

Index